When Pop-art paintings depicted Campbell's soup cans or comic-book scenes of teen romance, did they stoop to the level of their mundane sources, or did they instead transmogrify the detritus of consumer culture into high art? In this study, Cécile Whiting declares the issue fundamentally irresolvable and instead takes the question itself, along with the varied answers it has generated, as the object of her analysis. Whiting presents case studies that focus on works by four artists – Tom Wesselmann, Roy Lichtenstein, Andy Warhol, and Marisol Escobar – who are closely associated with the Pop-art movement. Throughout her engaging analyses, Whiting unravels the gendered overtones of their cultural manoeuverings, noting how the connotations of masculinity as attached to the seriousness of high art and the presumed frivolity and caprice of a feminine world of consumption repositioned cultural frontiers and reformulated the relation between sexes.

A Taste for Pop

CAMBRIDGE STUDIES IN AMERICAN VISUAL CULTURE

Cambridge Studies in American Visual Culture provides a forum for works on aspects of American art that implement methods drawn from related disciplines in the humanities, including literature, postmodern cultural studies, gender studies, and "new history." The series includes studies that focus on a specific set of creative circumstances and critical responses to works of art, and that situate the art and artists within a historical context of changing systems of taste, strategies for self-promotion, and ideological, social, and political tensions.

A Taste for Pop

Pop Art, Gender, and Consumer Culture

Cécile Whiting

University of California, Los Angeles

CAMBRIDGE
UNIVERSITY PRESS

PUBLISHED BY THE PRESS SYNDICATE OF THE UNIVERSITY OF CAMBRIDGE
The Pitt Building, Trumpington Street, Cambridge CB2 1RP, United Kingdom

CAMBRIDGE UNIVERSITY PRESS
The Edinburgh Building, Cambridge CB2 2RU, United Kingdom
40 West 20th Street, New York, NY 10011-4211, USA
10 Stamford Road, Oakleigh, Melbourne 3166, Australia

© Cambridge University Press 1997

First published 1997

Printed in the United States of America

Typeset in Stone Serif and Gill Sans

Library of Congress Cataloging-in-Publication Data

Whiting, Cécile, 1958–

A taste for pop : pop art, gender, and consumer culture / Cécile Whiting.

p. cm.

Includes bibliographical references and index.
ISBN 0-521-45004-7
1. Popular culture – United States. 2. Subculture – United States. I. Title.
NX180.S6W5 1997
700'.73'09045 – dc21

96-49965
CIP

*A catalog record for this book is available from
the British Library*

ISBN 0 521 45004 7

Contents

Contents

Illustrations

PLATES

FIGURES

Illustrations

Illustrations

Illustrations

Acknowledgments

In the decade and a half that have elapsed between a seminar paper written on political imagery in Pop art and this book about Pop's intimate liaison with a consumer culture coded as feminine, I have accrued innumerable intellectual debts. I want to thank the many colleagues and students who have challenged me to rethink Pop art; their impact can be traced on every page. I am particularly appreciative of provocative comments I received from Martha Banta, Ann Bermingham, Albert Boime, Sarah Burns, Tim Clark, John Clarke, Wanda Corn, Melissa Dabakis, Serge Guilbaut, Anne Higonnet, Caroline Jones, Cecelia Klein, David Kunzle, Karen Lucic, Kate Norberg, Christopher Reed, Richard Shiff, Kenneth Silver, Sally Stein, Lisa Tiersten, Ellen Todd, Anne Wagner, Joan Weinstein, Sarah Whiting, and Rebecca Zurier. Undoubtedly, I have forgotten to acknowledge some helpful interlocutors, most obviously the careful listeners who asked probing questions when I presented talks on this material at Indiana University; Kenyon College; the University of British Columbia; the University of California, Berkeley; the University of California, Los Angeles; the University of Kansas; and the University of Texas, Austin; or at meetings of the American Studies Association, the College Art Association, and the Women's Caucus for Art. Also among those who remain unnamed are the referees who provided thorough and thoughtful comments on the earlier versions of several chapters that were published in *American Art*, *Genders*, *Oxford*

Acknowledgments

Art Journal, and *RACAR*. Beatrice Rehl, the Fine Arts Editor at Cambridge, has supervised the project with patience and good will, and Patricia Hills read the manuscript with care, offering many helpful critical suggestions while always remaining supportive.

UCLA not only has provided me with a stimulating intellectual home, but it also has given me the practical resources to complete my research. Over the years, I have received invaluable assistance from a number of resourceful research assistants, including Bill Begert, Roz Bickel, Katie Hauser, Lisa Hofman, Karen Mason, and Lynn Matheny. I was able to hire assistants and pursue my research thanks to annual Academic Senate Research Grants from UCLA as well as to a Mini-Grant from the Center for the Study of Women at UCLA. Finally, I am grateful for a University of California President's Research Fellowship in the Humanities during the year 1994–5, which permitted me to complete the manuscript.

Finally, I wish to thank Jim Herbert, who turned his critical eye to every page of the manuscript and penned rigorous criticisms in the margins; each of his comments greatly sharpened my argument throughout. Thanks as well to Nicole Herbert-Whiting, who, while not yet able to read and to question her mother's authority, provided me with numerous distractions from writing and rewriting this book. Both demonstrated remarkable good spirit, even enthusiasm, as I inevitably made this project an integral part of our shared domestic interior.

Portions of this book have already appeared in various journals. I thank the editors for permission to use the material in revised form:

"Borrowed Spots: The Gendering of Comic Books, Lichtenstein's Paintings and Dishwasher Detergent," *American Art* 6 (June 1992): 8–35.

"Pop Art Domesticated: Class and Taste in Tom Wesselmann's Collages," *Genders* 13 (Spring 1992): 43–72.

"Figuring Marisol's Femininities," *RACAR* (*Revue d'art canadienne/Canadian Art Review*) 18 (1991): 73–90.

"Andy Warhol, the Public Star and the Private Self," *Oxford Art Journal* 10 (1987): 58–75.

A Taste for Pop

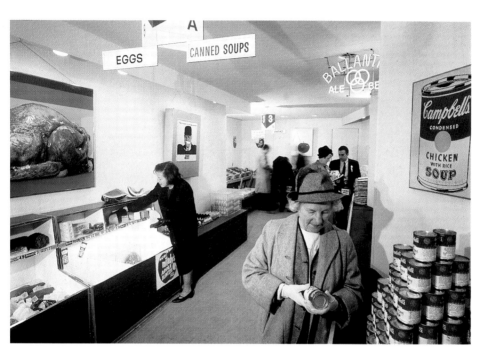

Plate I. Henri Dauman, *Supermarket Exhibition at the Bianchini Gallery.* From "You Think This is a Supermarket?" *Life,* November 20, 1964. Copyright © Henri Dauman, 1964/Dauman Pictures, N.Y.C.

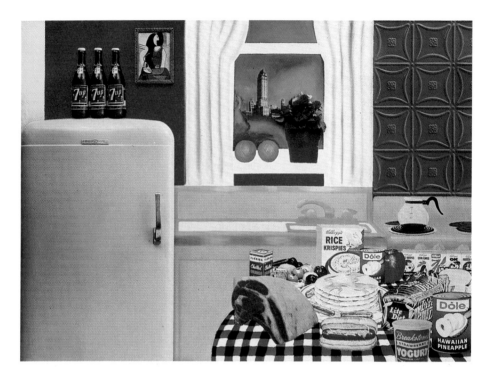

Plate II. Tom Wesselmann, *Still Life #30,* 1963. Assemblage: oil, enamel, and synthetic polymer paint on composition board with collage of printed advertisements, plastic artificial flowers, refrigerator door, plastic replicas of "7-Up" bottles, glazed and framed color reproduction, and stamped metal; 48½ × 66 × 4″. Collection of The Museum of Modern Art, New York. Gift of Philip Johnson, Copyright © 1996 Tom Wesselmann/Licensed by VAGA, New York, NY.

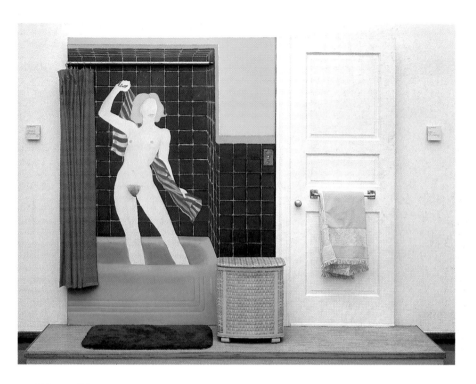

Plate III. Tom Wesselmann, *Bathtub Collage #3,* 1963. Mixed media; 84 ×
106¼ × 20″. Collection Museum Ludwig, Cologne. Courtesy of The
Rheinisches Bildarchiv, Cologne. Copyright © 1996 Tom Wesselmann/
Licensed by VAGA, New York, NY.

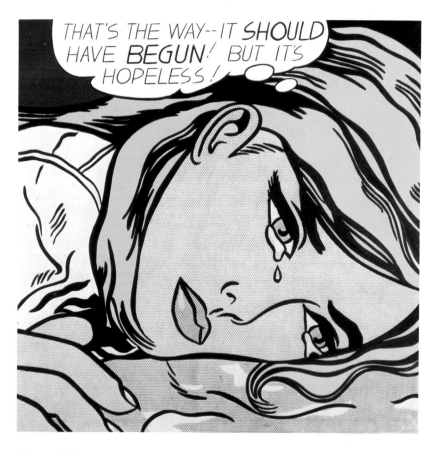

Plate IV. Roy Lichtenstein, *Hopeless*, 1963. Oil on canvas; 44 × 44".
Kunstmuseum Basel, Switzerland, Ludwig Collection. Copyright © Roy
Lichtenstein.

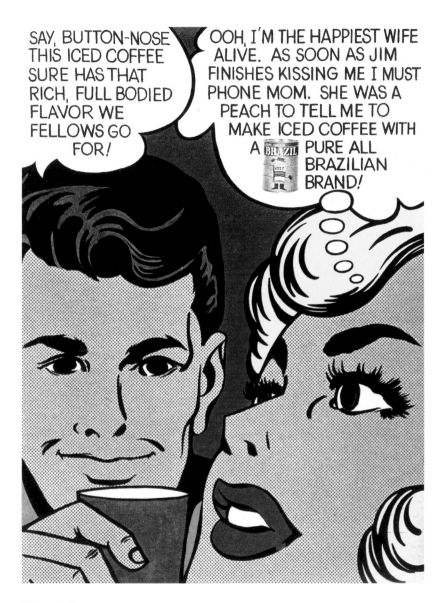

Plate V. Brazil Coffee advertisement. *The New York Times Magazine*, June 28, 1964.

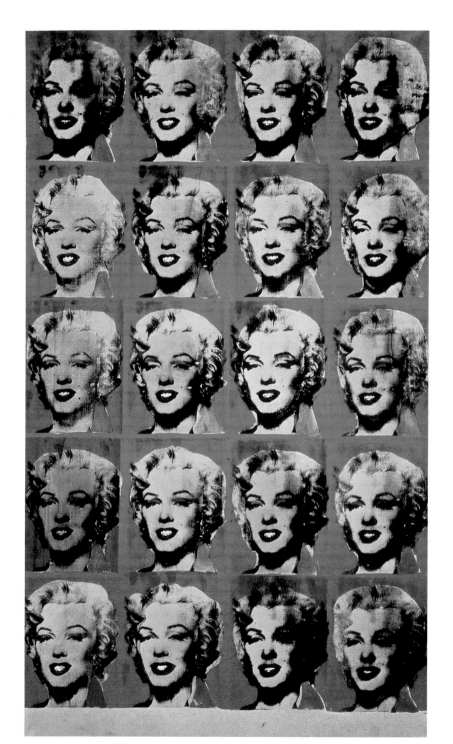

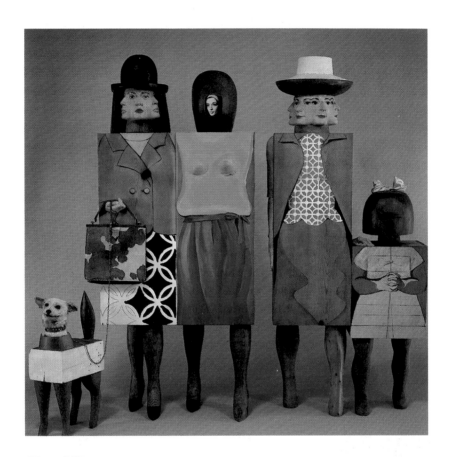

Plate VII. Marisol Escobar, *Women and Dog,* 1964. Wood, plaster, synthetic polymer, and miscellaneous items; 77 × 91″. Collection Whitney Museum of American Art, New York. Copyright © 1995: Whitney Museum of American Art. Copyright © 1996 Marisol/Licensed by VAGA, New York, NY.

Plate VI. *(facing page)* Andy Warhol, *Marilyn Monroe,* 1962. Silk-screen and oil on canvas; 84 × 46″. Private collection. Copyright © 1996 Andy Warhol Foundation for the Visual Arts/ARS. New York.

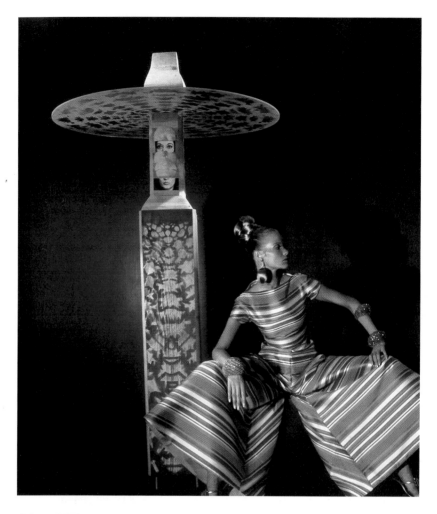

Plate VIII. Horst, *Model with Marisol Escobar's* Untitled. From "Looks Men Like at Home," *Vogue* 148, November 1966. Courtesy of Vogue, Copyright © 1966 by the Condé Nast Publications, Inc.

Introduction

In the early 1960s, the male artists moved into woman's do-
main and pillaged with impunity. The result was Pop Art, the
most popular American art movement ever. . . . If the first
major Pop artists had been women, the movement might never
have gotten out of the kitchen. Then it would have struck those
same critics who welcomed and eulogized Pop Art as just
women making more genre art. But since it was primarily men
who were painting and sculpting the ironing boards, dish-
washers, appliances, food and soap ads, or soup cans, the
choice of imagery was considered a breakthrough.

—Lucy Lippard, *From the Center*, 1976[1]

While in the final stages of completing this manuscript, I chanced
upon Lucy Lippard's sharp rebuke of both Pop art and its champi-
ons for their aggressive colonization of the "woman's domain." I felt
amused, vindicated, and deflated all at once. During the many years
I had devoted to this project I had believed I would be the first to
highlight the central role played by the overwhelming number of
objects in Pop art associated with what was ostensibly the sphere of
women – household fixtures, consumer goods, and fashion. Yet Lip-
pard, whose formalist defense of Pop art dating from the mid-1960s
I knew so well, had already raised the point some twenty years
before me. Writing in the 1970s during the heady days of the femi-
nist movement, Lippard joined with a group of other art historians,
critics, and artists wanting to reclaim and validate the domestic

realm in works of art produced by and for women. Within this political and intellectual context, Lippard reevaluated the precedent of Pop art primarily to argue that the sex of artists made a difference in their critical receptions, especially when such artists based their work on materials ostensibly tainted as feminine.

In fact, Lippard was neither the first to notice the role of the woman's domain in Pop art nor was she the first to belittle Pop art on these grounds – even if a radically different agenda than hers motivated the attack on Pop art mounted by certain critics writing in the early 1960s. If one reads the initial critical responses to Pop art attentively – which I try to do throughout this book – the references to femininity and domesticity multiply. Cleve Gray, writing in *Art in America* in December 1963, attributed the success of Pop art to a public seeking "familiar" subject matter: "The word 'familiar' comes right out of 'family'; it suggests the household, domesticity."[2] An implicit dismissal of the woman's domain can be detected in many of the adjectives critics selected to characterize the motifs represented in Pop art: banal, commonplace, vulgar. Even the efforts to defend Pop art as "art" reveal a certain anxiety, a certain desire to step around its subject matter, filled as it was with objects considered of minor importance and value owing to their strong association with women.

Nevertheless, despite a few allusions to domesticity and femininity, most critics in the early 1960s adopted more generic nomenclature to characterize the commercial imagery and techniques borrowed by Pop art. A sampling of the critical rubrics chosen to modify the type of "culture" evoked by Pop art would include "the mass," "signboard," "commercial," "popular," "mass media." Andreas Huyssen has demonstrated in his perceptive article "Mass Culture as Woman: Modernism's Other" that such apparently broad terms can at times adopt, within the general practices of cultural valuation, connotations of the feminine. Huyssen argues convincingly that "political, psychological, and aesthetic discourse around the turn of the century consistently and obsessively genders mass culture and the masses as feminine, while high culture, whether traditional or modern, clearly remains the privileged realm of male activities." Although Huyssen goes on to claim that "mass culture

theories since the 1920s . . . have by and large abandoned the explicit gendering of mass culture as feminine,"[3] I have found the opposite to be true in the United States. Indeed, I use the term "consumer culture" throughout this book to refer to the woman's domain precisely because the commodities, the retail spaces, the marketing techniques, as well as the many characterizations of shopping behavior that I describe operated within a society that assumed that the principal consumer of quotidian objects of everyday life, and hence the consumer that mattered, was female.

It happens that Huyssen touches upon Pop art in the rather optimistic conclusion of his article where he argues that practices such as Pop art "created an aesthetic climate in which the political aesthetic of feminism could thrive and develop its critique."[4] In a sense, then, Huyssen represents the opposite side of the coin to Lippard: Where she establishes an antagonistic opposition between representations of the woman's domain by male Pop artists and feminist artists, Huyssen celebrates a fruitful continuity between Pop art and feminism. I argue that Pop's engagement with a feminized consumer culture was more multifaceted and vexed than either Lippard's dismissive critique from the 1970s or Huyssen's passing assessment allow.

Since the early 1960s, Pop's appropriation of consumer culture has served both as the grounds for its rejection and as motivation for its defense. Art historians and critics have with great fervor condemned, praised, or simply analyzed the way in which Pop art manipulated commercial imagery and techniques from consumer culture. Pop art's engagement with consumer culture in and of itself would probably not have captured the attention nor raised the hackles of various critics; as many writers and exhibitions then and now have documented, a long tradition of modern art movements featuring references to consumer culture preceded Pop art. It is my contention, rather, that the critical and institutional inability to fix Pop's identity as either high art or commercial artifact generated the overwhelming number of articles about Pop art.[5] Max Kozloff, after dismissing Pop art for its lack of commitment to the type of pictorial self-sufficiency notable in the canvases of predecessors who had depicted icons from consumer culture, asked in his now well-known

review "'Pop' Culture, Metaphysical Disgust, and the New Vulgarians" of 1962:

> Are we supposed to regard our popular signboard culture with greater fondness or insight now that we have Rosenquist? Or is he exhorting us to revile it, that is, to do what has come naturally to every sane and sensitive person in this country for years. If the first, the intent is pathological, and if the second, dull. . . . Not only can't I get romantic about this, I see as little reason to find it appealing as I would an hour of rock and roll into which has been inserted a few notes of modern music.[6]

Critics such as Kozloff concluded that what Pop art had to say, if anything, about either signboard culture or pictorial problems did not earn it the status of high art. Likeminded critics rejected Pop art out of hand by arguing that it could not be distinguished from the consumer culture it so passively reflected. Alternatively, a different set of critics willingly attributed the status of high art to Pop, but argued endlessly over whether Pop art, looking down on consumer culture from such Parnassian heights, granted approval, frowned in discomfort, mocked ironically, or wallowed in ambivalence. The widespread debate about Pop art's definition that took place in both art journals and the popular press in the early 1960s attests to Pop's ability to ride the line between high art and consumer culture, and hence to the permeability and instability of cultural boundaries during this period.

In this book, I, like many of my predecessors, analyze the complex relationship between Pop art and consumer culture, paying special attention to Pop art's appropriation of those aspects of consumer culture associated with women – feminine spaces, feminine motifs, or feminine viewing practices. Yet, I describe not only how Pop art borrowed from consumer culture, but also how consumer culture reappropriated and disseminated Pop art. Commercial artists, designers, and photographers emulated and incorporated Pop paintings and sculptures in images promoting fashion, interior design, and household goods. The exchange did not stop there: editors of high-art journals were quick to parody these commercial layouts

that relied on Pop art. In short, a set of visual icons and techniques that we now associate with the name "Pop art" passed back and forth across a boundary line between high art and consumer culture numerous times.

My goal in examining this exchange is not to prove once and for all that Pop art is either high or low, that it either critiqued consumer culture or was complicit with it. I am not interested in proposing a new solution to an old debate; instead, I take the debate itself as a historical artifact worthy of analysis. Hence, I discuss how Pop art and the cultural practices adjunct to it – the movement's mass media sources and its commercial emulators, art criticism, and contemporary assessments of cultural dynamics – constantly produced, disputed, and assigned the attributes of gender across the dividing line between high art and consumer culture as they contested with each other over its proper placement. Rather than taking that cultural division as a given in my study, in short, I study its manufacture. In so doing, I suggest that the relationship between high and low remains in no way predictable or static; instead, it constitutes a complex, two-way exchange, enacted by Pop paintings and artifacts from consumer culture alike, that continously serves to destabilize and redefine, as well as stabilize and define, cultural boundaries and hierarchies.

While I look at a series of specific instances demonstrating the varied production, dissemination, and critical reception of Pop art, I do not offer a coherent account of the Pop art movement, its history, and development. Nor do I speculate as to the reasons why particular artists might have been attracted to or repulsed by a feminized consumer culture in the first place. Rather I focus on the reception of what at times might appear to be an odd assortment of artifacts – Pop paintings, collectors' interiors, fashion layouts, advertisements – to demonstrate the fluidity of the exchange between Pop art and consumer culture. The first chapter sets the stage for the book by examining several institutional spaces in which the public viewed Pop art, and the four remaining chapters each focus on the circulation of works by a single Pop artist: Tom Wesselmann, Roy Lichtenstein, Andy Warhol, and Marisol Escobar.

Let me emphasize from the outset that I consider the book's most

important task to be an analysis not simply of the complex efforts to define cultural boundaries during this period, but also of the cultural and social work performed by such processes. Each artifact, I contend, participated in contestations not only about the relationship of high art and consumer culture, but also about proper modes of cultural consumption. Hence, I pay particular attention to how Pop artifacts imagined certain viewers and posited appropriate interpretive approaches; where I have evidence, I measure such projections against actual audience responses. At other times, I offer strategic rereadings of artifacts inflected by theoretical perspectives not available at the time they were produced. Each of these readings, actual and projected, had or has the effect of privileging certain viewers – certain consumers, certain artists, certain collectors, certain critics, certain cultural analysts – and from such stuff cultural hierarchies are made. I agree with Lippard that gender can make a difference in an artwork's reception, and I pay attention throughout this book to the way in which manners of viewing or consuming individual artifacts and of understanding Pop art as a whole attributed the characteristics of gender to the various audiences of the artworks and artifacts, thereby favoring some viewers over others. I also regard the modes of cultural consumption of Pop art and related artifacts as the means of producing class and national identities and privileges. In this way, I examine how the dissemination of Pop art constructed cultural distinctions and social privilege: among artists, among cultural products, and among audiences. Ultimately, the book, by analyzing the complex and fluid dynamics between Pop art and a feminized consumer culture, investigates how a new generation of artists, collectors, and critics embraced the Pop aesthetic, assuming a mantle of cultural authority as they positioned themselves with the newly reformulated relation between high and low art in the early 1960s.

Chapter 1

Shopping for Pop

"The truth is, the art galleries are being invaded by the pinheaded and contemptible style of gum chewers, bobby soxers, and worse, delinquents," complained Max Kozloff in March 1962.[1] Dorothy Seckler added: "Gallery walls formerly devoted to dribbles now display mammoth spaghetti. A niche once reserved for crushed tin and picturesque castoffs now bristles with bright and shining tinned merchandise. The invaders have cornered galleries known for their cachet of sophistication."[2] Sounding an alarm, a number of critics in the early 1960s warned of aliens mounting an assault on the hallowed halls of the art gallery. Critical outrage targeted the artists, a number of whom had backgrounds in commercial art, and the visual rhetoric of Pop art, which was largely indebted to the mass media. But critics also bristled at the new audience for Pop art and its novel ways of looking at images.

Displays of Pop art disrupted expectations fostered by gallery shows of Abstract-Expressionism about how works of art should be viewed. In exhibitions of Abstract-Expressionist painting, best exemplified by presentations of Color Field art during the 1940s and 1950s, images hanging side by side dominated the walls of stark, carefully lit, intimate spaces.[3] Such displays implicitly promised the critic and connoisseur a quasi-religious refuge from the clamor of the marketplace in which to focus exclusively on the work of art. In contrast, although Happenings of the late 1950s introduced crowds,

A Taste for Pop

noise, and debris into the space of the art gallery, the multiple references to consumer culture formulated by both Pop art and its exhibition in the early 1960s marked a breach in the protocols of display observed by shows of Abstract Expressionism: For instance, in 1962, Claes Oldenburg's sculptures of food and clothes spilled across the floor of the Green Gallery in New York in an apparently haphazard manner, and at the Ferus Gallery in Los Angeles, Andy Warhol's paintings of Campbell soup cans aligned themselves on a ledge around the wall like so many cans on the shelf of a supermarket. Though diverse in kind, exhibitions of Pop art repudiated the conventions of auratic display and the concomitant hushed modes of viewing promoted by galleries specializing in Abstract Expressionism.

Displays of Pop art did more than disturb the ambience of the gallery; they also welcomed in the practices of consumerism. In this chapter, I examine three exhibition sites from the early 1960s – Bonwit Teller's "art" windows, Claes Oldenburg's installation *The Store*, and the Bianchini Gallery's supermarket exhibition – that specifically highlighted a relationship between Pop art and consumer goods, and simultaneously confused spaces of high art with those of commercial institutions. Three instances from the same island of Manhattan, yet three instances separated by great distances of social geography: a department store on Fifth Avenue catering to a wealthy clientele, a storefront on the Lower East Side rubbing elbows with small junk shops and discount stores, a gallery on the Upper East Side appealing to a sophisticated audience of art connoisseurs. In spite of their apparent heterogeneity, all three spaces invited viewers to wield both the skills for consuming goods and the means for assessing works of art in judging the examples of Pop art on display.

Critics, while perhaps justified in fearing that displays of Pop art rejected the established conventions of Abstract-Expressionist exhibition practices, were mistaken to imagine a general cultural leveling when consumer artifacts met artworks face to face in these spaces. Although all three Pop exhibitions did presume a certain group of visitors incapable of distinguishing works of art from commodities, they also anticipated a privileged set of spectators able to

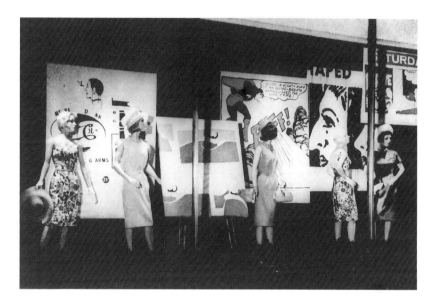

Figure 1. Installation of Andy Warhol's Pop-art canvases in the storefront window of Bonwit Teller, New York, April 1961.

assay, with nuance, the difference between the two. Over and again, we shall see that the most significant cultural work performed by these three Pop exhibitions lay in the manner in which they juxtaposed these two groups of viewers and their ways of evaluating objects.

Bonwit Teller's Warhol Window

In 1961, a surprise awaited fashionable shoppers strolling through midtown Manhattan as they passed before the windows of Bonwit Teller, a department store specializing in luxury apparel for women long established at the heart of New York's posh retail district.[4] A storefront window presumably devoted to the attractive – and tempting – presentation of clothes had on exhibit a group of contemporary works of art. Five recent canvases by Warhol hung in a space also occupied by several female mannequins outfitted in elegant summer dresses and accessories (fig. 1). The Bonwit Teller win-

dow, arranged by display director Gene Moore, re-created the interior of an art gallery complete with afternoon visitors.[5]

A sense of the theatrical pervaded the Warhol window: Both mannequins and paintings, as if arranged on a stage set, faced the audience. The paintings hanging in the space of the window evoked a suitably dramatic setting of an art gallery, while the female mannequins, who assumed a variety of poses, took the role of women observing and evaluating the canvases on display. The Warhol display, moreover, allowed window-shoppers to project themselves imaginatively into the theatrical scene and to identify with the mannequins: They, too, could aspire to be well-dressed women looking at paintings. The spectacle drew them in, enticed them across the proscenium.[6]

Of course, in another sense, the theatrical installation of an art gallery in the storefront window of Bonwit Teller would have hardly provoked surprise in shoppers; or rather, they could well have come to expect such a surprise. Already in 1959, Moore had designed a fictive museum interior for the windows of Bonwit Teller (fig. 2), and at least one critic had praised Moore's displays at the department store as leading examples of windows that at their best "are as craftily arranged and lighted, and almost as convincing, as scenes from a play."[7] Experienced shoppers, moreover, had undoutedly habituated themselves to expect dioramic presentations in the shop windows of Manhattan. Storefront windows had been treated as stage sets since around the turn of the century.[8]

Display as popular spectacle began with L. Frank Baum, who edited the first display trade magazine, established the industry's professional organization of the National Association of Window Trimmers in 1898, and published in 1900 *The Art of Decorating Dry Goods Windows and Interiors*. In the same year as Baum brought out his manual on window display, he authored the more well-known *The Wonderful Wizard of Oz*, a tale revolving around the production of illusions. Manuals on window display from the early twentieth century generally followed Baum's lead in promoting mechanical and electrical wizardry in storefront windows, and illustrated on their pages all sorts of illusionistic devices borrowed from the repertoire of theatrical tricks of dime museums and carnival sideshows.[9]

Figure 2. Gene Moore, Bonwit Teller Window Display, April 19, 1959.

Even when window designers repudiated Baum's sensationalism, they shared his emphasis on the theatrical. In his *Displaying Merchandise for Profit* from 1939, A. E. Hurst instructed: "A good rule to keep in mind is that a merchant's window is really a stage whereon a panorama is presented to the audience in the street, and that the nature of the displays may be as varied as stage productions."[10]

By the 1930s, the storefront windows of Bonwit Teller had acquired a reputation for providing theatrical entertainment, well before Moore had been appointed display director. One guidebook to New York City, for instance, compared Bonwit Teller's display windows in the 1930s to stage sets designed by David Belasco.[11] Au-

thors of how-to manuals and journal articles on window display in the 1950s, continuing to praise the commercial establishments around Bonwit Teller for their storefront windows, discussed the advent of each new display as if attending the opening night of a Broadway theatrical production. Harry Hepner wrote, "Some stores are so well known for their effective and dramatic displays that they actually have followings of people who look forward to the first night of a new display so that they can go to see it. Some of the Fifth Avenue stores in New York City are examples."[12]

The stagecraft of window display played a crucial role in persuading customers to enter the store by arousing their desire for the delights contained inside; ideally, the window drew the shopper not only psychologically across the vitrine, but also physically across the threshold of the store. In his manual on display, Baum set out to teach "what constitutes an attractive exhibit and what will arouse in the observer cupidity and a longing to possess the goods you offer for sale."[13] Baum promoted the "illusion" centerpiece as a particularly effective strategy for, at the very least, arousing the interest of passersby. Claimed Baum: "People are naturally curious. They will always stop to examine anything that moves, and will enjoy studying out the mechanism or wondering how the effect has been obtained."[14] In this statement, Baum treated his viewers as visual naifs, easily intrigued and fooled by illusionistic mechanisms; the riveting display presumably "arouse[d]" in the mesmerized customer the "longing to possess the goods."

Implicitly, Baum's visual naif was a woman. In the opening paragraph to his manual, Baum conceived of the display designer as the successor to the peddler who "awaited patiently while the assembled bevy of women gazed enraptured upon the treasures at their feet." He recommended that his most effective illusionistic device, "a beautiful young lady, the lower half of whose body is invisible to the spectator,"[15] be incorporated into the display of goods obviously meant for a female consumer: millinery, fans, parasols. Baum's wizardry promised to lure gullible female window-shoppers and to seduce them into the pleasures of purchasing goods.

Window designers after Baum openly acknowledged that the primary audience for their theatrical storefront displays consisted of

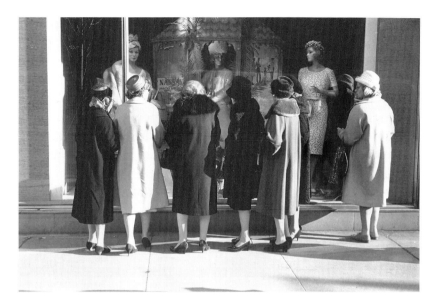

Figure 3. Fred W. McDarrah, *Window Shoppers on Fifth Avenue*, 1964. Copyright © by Fred W. McDarrah.

women. During the Depression era, window designers recognized that women accounted for most sales, and they fashioned their windows accordingly. "Statistics have proved that 85 per cent of the buying is done by women," announced Jack T. Chord in 1931. Hence, he exhorted window dressers: "Make your merchandise tell its own story. Make your windows the most outstanding examples of merchandise dramatization in your city." Drama, it was believed, captured the female consumer's attention and motivated her to buy. To prove the effectiveness of drama, Chord cited a case when "no less than twelve women tried to buy the draped coat" displayed in one of his windows.[16]

By the 1960s, it had become commonplace when visiting Fifth Avenue to expect to find female shoppers absorbed in the drama of display.[17] In one photograph of shoppers in this posh neighborhood, women wearing furs and high heels line up in front of a window display; the photograph mirrors elegant shoppers off against the mannequins facing them, suggesting their mutual identity (fig. 3). A guidebook from this same period characterizing the

attractions of Fifth Avenue promised that "as much a show" as the windows "are the women shoppers themselves."[18] Women, it would appear, did not simply witness the displays of commerce; they became one with the practice.

The success of the storefront window display thus depended on the window-shopper's willingness to absorb herself into a theatrical space and to identify with the mannequins on view. The Warhol window, accordingly, invited the shopper to imagine herself wearing the summer dresses on display while visiting art galleries. Absorption into the display folded her into a social identity: She projected herself as a member of a leisure class who had the time to visit galleries, to be seen in beautiful clothes surrounded by beautiful objects. The dresses held out the promise of conferring such status on the consumer – all the shopper need do was purchase the clothes.

Yet, on second consideration, the Warhol window at Bonwit Teller precluded the complete absorption of its audience of female shoppers into the dramatic spectacle, for it did not fully maintain the fiction of an art gallery. The mannequins, after all, turned their backs to the paintings, eschewing the role of viewing the works of art to instead become the objects of the female shopper's view. The paintings, moreover, did not line up side-by-side at a comfortable viewing level as they might in a gallery interior: Instead, the pictures hung at radically different heights and angles – one even hovered above the heads of the mannequins. And as the fiction of the gallery dissolved, a new mode of viewing emerged. Paintings and dresses now coexisted as compositional elements within the window taken as an aesthetic whole. The scene from a play set in a gallery gave way to a modernist design balancing rectangles against figurative elements; the female shopper absorbed in the drama ceded to the cultured woman appreciating the window as a fine work of art.

Much as Moore had established himself as the producer of window dramas, he had also earned a second – and competing – reputation as the purveyor of the principles of modern art in the design of his windows. Under Moore's direction, the windows at Bonwit Teller, which he arranged from 1942 to 1962, and at Tiffany's, which he had directed since 1955, claimed the status of modern art. Walter

Hoving, the president of Bonwit Teller and Tiffany's, facilitated the success of Moore's windows by granting him free reign to focus on the art of display. In 1960, Hoving explained in the pages of *House Beautiful* that when he hired Moore to supervise window displays, he instructed him "to do two things: Make them very beautiful according to your own view and don't try and sell anything."[19] Designing beautiful windows involved incorporating the compositional strategies of modern art and, periodically, exhibiting actual works of art. When Moore, having attended the Chicago Academy of Fine Arts, turned to the practice of window display in order to earn a living during the Depression, he self-consciously incorporated into his work the lessons of modernism. In a foreword written for a book on window display published in 1950, Moore stated: "Our debt to the visual arts is great. We owe much to painters, especially to the modernists for their free use of form and perceptive handling of color."[20] In cultivating the art of the storefront window, Moore also hired artists such as Warhol, Jasper Johns, and Robert Rauschenberg to design displays and occasionally invited them to exhibit their own artworks in the store windows.[21] As a result, by the early 1960s, the press regularly trumpeted the windows at Bonwit Teller and Tiffany's as showcases for modern art; Aline Saarinen even claimed, "There's a lot more art and artistry in them than you'll find in many of the galleries that are spotted in their neighborhood."[22]

Department stores of the likes of Bonwit Teller had certainly already laid claim to the cultural cachet of art long before Moore appeared on the scene. Many of the grandiose buildings housing department stores had, since the origins of the institution in the nineteenth century, incorporated references to various architectural styles of bygone days. Recalling several exotic empires at once, the Wanamaker store in Philadelphia featured an auditorium with Egyptian motifs and a wide range of period rooms in Greek, Moorish, and Byzantine styles.[23] Such eclectic architectural references brought to the activity of shopping an abundance of aesthetic associations. Department stores conjoined the pleasures of shopping with those of cultural appreciation in other ways as well: Many stores sponsored plays, symphonies, and even art exhibitions.[24]

Wanamaker's even inaugurated an art gallery in 1881, and in 1893 began to purchase art regularly from the Paris Salon. By 1911, John Wanamaker could boast in print that his department store had built "the largest single collection ever imported to America from the Salons of France."[25] These paintings, in the proud owner's words, "convert[ed] the Wanamaker Stores into vast public museums . . . reaching a larger number than many of the museums owned and controlled by the city or the state."[26] A hybrid of museum and shop, Wanamaker's and other department stores like it intermingled cultural enrichment and consumer enticement.

Fifth Avenue storefront windows, placing greater emphasis on refinement than diversion, also found use for the fine arts. In the 1920s and 1930s, Bergdorf Goodman, Saks, and Bonwit Teller exhibited modern art for the first time in their windows, and periodically commissioned artists such as Dali and Archipenko to design display windows.[27] The promotion of modern art in the storefront window implicitly endowed the Fifth Avenue stores with a different social status than those stores featuring illusionistic displays of the Baum variety. A. E. Hurst pointed out in 1939 that "dignified Fifth Avenue, through the Fifth Avenue Association, has put a taboo on animated displays, claiming that the average display of this character tends toward the sensational and leaves the impression of cheapness."[28] Undoubtedly, stores did violate the taboo from time to time, especially for the amusement of children during the holidays, but in general the rule held for stores aspiring to the dignity of art.

Heralding the trend of window display as modern art and replacing Baum's manual as requisite reading for those designers wishing to endow their displays with the sophistication of modern art was Frederick Kiesler's book *Contemporary Art Applied to the Store and its Display* of 1930. Kiesler's book, in essence, consisted of a primer on modern art. The format of the book itself experimented with design, layout, and sans serif typography, and the text included as many reproductions of modern art as of technical diagrams. Kiesler specifically encouraged the window designer to seek "inspiration from the paintings of such artists as Mondrian, Braque, Ozenfant, Doesburg, Arp, Leger, Miro and others." More generally, in his analysis of the value of modern art for window display, Kiesler placed special

emphasis on composition, drawing attention to the way modernists manipulated the elements of line, form, color, and space with an eye toward achieving harmony, balance, and unity. By adopting Kiesler's approach to display, the window designer subsumed the objects for sale to the higher principles of the fine arts to produce a form of modern art – the windows themselves – readily available to a public of window-shoppers.

Window display adopting the mantle of art aspired, in one sense, to serve an educational function. The department store, according to Kiesler, introduced modernism to the United States before any other institution through the patterns of textiles offered for sale, the exhibits of reproductions of modern art in its windows, and the design of its window displays. A lesson in modernism promised more than the ability to recognize famous paintings; it also imparted the possibility of seeing in a modernist way, which is to say, to view things in formal terms. Kiesler's chapter devoted specifically to painting, which included reproductions of works by Picasso and Matisse, and his discussions of modern modes of window display always proceeded through formal analysis. Through the window display, Kiesler believed, American women could pick up the basic concepts of modern design.

In a second sense, however, modernist window display cut against the principles of widespread public education, because supposedly only certain viewers properly appreciated their design. The modernist display allowed a particular group of shoppers to assert its cultural sophistication. Kiesler strongly criticized the taste of most members of the general public, which, according to him, "has wrongly admired, and still admires, in the pictures of the old Masters . . . the skill with which they imitated nature, instead of the balance between line, form and color in which consists the beauty of the picture. It is obvious why they have such difficulty in understanding and appreciating modern painting."[29] Because Kiesler assumed that the shopper was a woman (he used the female pronoun throughout the text), his analysis laid out a program whereby the culturally refined woman could assert her sophistication over the general public through her authoritative knowledge of modern art and her ability to appreciate modernist display through a formalist

lens. The formalist manner of looking exercised by such a viewer measured itself against, and distanced itself from, a simple-minded acceptance of realism, exemplified in this passage by Old Master painting but implicitly constituted by all nonformalist instances of window display including theatrical narrative.

In just this fashion, Moore's windows at Bonwit Teller and Tiffany's also provided a place for a cultured female window-shopper, viewing the window as formalist art, not as dramatic diversion. His windows and the interpretive texts surrounding them encouraged the window-shopper to look at Moore's displays with the aesthetic understanding of a viewer versed in modern art of the twentieth century. Many reviews of Moore's displays, circulating in magazines such as *House Beautiful* and *Cosmopolitan* that specifically targeted women,[30] took pains to align his design techniques with a host of modern art movements. For instance, a restraint perceived in Moore's work prompted Aline Saarinen to evoke Mies van der Rohe's credo "less is more" to describe the windows – and perhaps to pun on the displayman's name as well.[31] Thus, Moore's displays regularly permitted a sophisticated group of women to wield the cultural resources of modern art when window-shopping.

To view objects within Moore's windows in formal terms was not simply a matter of reducing everything to a collection of lines and colors; rather, formalist viewing implied the sophisticated practice of discerning the essential nature of things. Moore frequently included in his displays ordinary materials, such as tissue paper, string, or hammer and nails, used, in the words of Lee Wilcox writing in *House Beautiful*, to "set off objects of the highest intrinsic value – Tiffany diamonds, lead crystal, sterling silver and gold" (the practice earned Moore the reputation of a designer with a somewhat Surrealist sensibility, thereby adding to his modernist credentials). The eye skilled in discriminating the formal quality of objects then could see beyond the activity of selling merchandise to grasp these objects' ostensibly instrinsic properties. Continued Wilcox: "First you see, let us say, diamonds in a pile of something dull and gritty – the very antithesis of diamonds, a marvelous frame for the pure, glittering brightness of the jewels. The background seems to be the essence of the dull and gritty and grainy. Suddenly, a light dawns

and you recognize that the dullness, coarseness, and the grittiness make up into that familiar stuff from the beach, sand."[32] Through such a formal contrast, grittiness and so forth emerge as the inherent properties of sand, but simultaneously the "glittering brightness" of the diamonds is translated into the "highest instrinsic value." Moore's windows thus allowed the cultured woman shopper to have her diamonds and aestheticize them, too, as the value of the objects for sale came to appear the necessary product of its formal properties discerned by the privileged shopper's modernist perception.

Moore's Warhol window at Bonwit Teller, although lacking the inclusion of such ordinary objects, certainly gave the cultured shopper plenty on which to exercise her formalist manner of viewing. Combining paintings by Warhol with *haute couture* in a window organized with an eye toward line, form, and color bid the female shopper to evaluate the aesthetic quality of the art, of the dresses, and of the display itself. The window display thus transformed the activity of shopping into a form of art appreciation; the shopper did not covet so much as contemplate and appreciate.

By providing two modes of viewing, by presenting itself as either theater or as art, the Warhol display thus allowed the sophisticated viewer to distinguish herself from the absorbed dupe. Where the gullible shopper ostensibly fell for the ploy of the stage set and identified with the mannequins on view, the refined window-shopper judged the display, compared it to modern art, and assessed both the aesthetic qualities of the display and its varied contents. The cultured privilege of the sophisticated shopper, in short, depended both on the possession of a set of refined skills of perception that seemed to lift the viewer out of the mundane activities of commerce into the ostensibly higher realm of art and the purported existence of an audience incapable of such perception and distance. Warhol's window provided both.

And yet, there is an important sense in which the Warhol display failed to maintain for its cultured female viewers a proper aestheticized distance from commerce. In the first place, the conjoining of paintings and dresses, unlike the juxtaposition of sand and diamonds, failed to establish an intrinsic sense of value based on the

formal properties of things. The summer dresses, undoubtedly, derived something of an aura of the aesthetic simply by sharing space with paintings of any sort. But in turn, the paintings by Warhol, just then in the process of establishing their standing as legitimate works of art rather than as the products of a glorified advertising artist, enjoyed a substantial cultural boost simply by being included in the chic setting of a Fifth Avenue display window as a representative sampling of modern art. Dresses and paintings gained value from each other; no bedrock of natural inherent qualities, like the grittiness of sand, ground the comparison. Accordingly, the formalist tools of modernism could discern no intrinsic value here.

In the second place – and more debilitating to the process of aestheticization – Warhol's paintings of comics and cheap advertisements included in the display at Bonwit Teller hardly succeeded in pulling themselves definitively out of the world of commerce.[33] Because Warhol's canvases duplicated everyday, commercial imagery, their standing as art depended on some previous act of formalized reading capable of establishing an ironic distance between the painterly qualities of the surface and the picture's crass subject matter. Yet it was precisely such a distance that Pop art did not always maintain; as we shall see throughout this book, the similarities uniting Pop paintings with their popular sources or the differences distinguishing the two were a matter of constant debate. Warhol's pictures in the Bonwit Teller window at the early date of 1961, in particular, had a tenuous hold on the category of art; these paintings by Warhol had never been seen before in an art gallery or museum.[34] Without the ironizing distance of the aesthetic, Warhol's pictures, regarded as the illustration of goods rather than the formalized patterns of painting, did not draw the fancy dresses into the artistic realm of intrinsic value; they reinscribed them as so many additional items of common merchandise.

The potential collapse of the difference between art and commerce, however, need not be taken as a failing of the Warhol window; to the contrary, in the end, it may have facilitated the ultimate purpose of the window display. Aesthetic discernment now reengaged in the activities of commerce, after all, suggests a criterion for judgment that embraced both art and the refined consumer pur-

chase: good taste. Indeed, good taste was a concept dear to Moore himself. In remarks on "Taste in the Marketplace" delivered at a symposium in New York in 1962, Moore asserted: "We displaymen must catch the eye of the passerby if we are to sell, but we must not catch it with an inappropriate bang or any other offensive and irrelevant means – or we will be selling bad taste."[35] The argument slides easily between commerce and art, and back again: One must sell; one must in so doing impart a higher standard; one thereby generated new sales of quality goods. Art, beauty, taste – Moore often equated these terms – in the display window produced women shoppers who consumed *aesthetically*.

From the perspective of the department store, of course, nothing could be finer: The liberated artistic creativity of Moore's windows – in spite of Hoving's injunction not to "try and sell anything" – could lead directly to sales. As *House Beautiful* affirmed, Moore displays resulted in a "reputation for taste, for design, for style, for personality, for an individual point of view: The Bonwit 'look,' the Tiffany 'cachet.'"[36] Moore's license to ignore sales in designing window displays actually produced the enhanced prestige of the house, a prestige that presumably could be translated into greater sales of goods now provided with the reputation for aesthetic quality conferred by their tasteful place of sale.

Moore's approach to window display fit into a fairly widespread practice found in expensive stores of imbricating the aesthetics of display and consumer desire. Designers hired by such stores relied on key concepts such as art, taste, and beauty to describe both their display techniques and the goods on view. More importantly, by exemplifying such aesthetic qualities, the display apparently made a direct appeal specifically to women's consuming desires. In a section of his 1952 book *Window and Interior Display: Principles of Visual Merchandising* entitled "Appealing to Women," Robert Kretschmer stated: "Women are more likely to be impressed by the beauty of an article than by its mechanics; they are more interested in style than in performance. . . . The displayman's approach to women customers must be idealistic rather than realistic."[37] By the 1950s and 1960s, window designers committed to the principles of art almost uniformly took for granted that an address to the female shopper's

appreciation for supposedly higher aesthetic qualities would encourage her to focus her desire on the goods for sale. Wrote Frank J. Bernard, also in 1952, "obviously, an attractive display of merchandise will favorably affect the window-shopper's decision. . . . Display therefore is directed to woman's instinct for beauty, elegance, softness."[38] Ultimately, the art of window display gave women the opportunity to demonstrate that the culturally acquired skill of aesthetic appreciation had become a seemingly intrinsic aspect of a refined manner of buying the goods.

Thus, although the Warhol window confused paintings with dresses, and the art of display with the objects displayed, such confusions succeeded in encouraging consumption of a kind different from the theatrical absorption of the unrefined shopper. The shopper's aesthetic discernment, her visual appreciation of formalist modernism – of the Warhol paintings, of the dresses, of the display itself – transmogrified into the shopping skills of a new tasteful consumer. To prove her refinement, this tasteful consumer need simply purchase the dress, to unite the activities of aesthetic appreciation and consumer acquisition. Thus, even as the "art" of the Warhol window granted to a certain class of female window-shoppers the cultural tools to distinguish themselves from the absorbed consumer duped by theatrics, the window, from the perspective of the department store, generated a new body of consumers, better than the common mass. Ultimately, whether Moore's arrangement of Warhol paintings and summer dresses conjoined or segregated art and commerce, confused or distinguished formalist viewing and consumer desire, depends on the shoes in which one stood when observing the process: the everyday shopper's plain pumps, the sophisticated shopper's designer heels, or the store owner's polished wingtips.

Oldenburg's *Store*

On East Second Street, far from the grand emporia ensconced on Fifth Avenue, a plain shop of one modest room opened its door to the public in December 1961. For a period of two months, Claes Oldenburg converted his small studio on the Lower East Side of

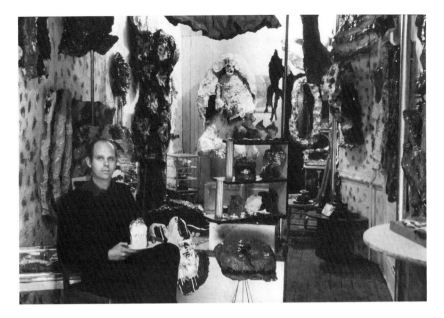

Figure 4. Robert R. McElroy, *Claes Oldenburg in His Store*, 1961. Copyright © by Robert R. McElroy.

Manhattan into a discount store. During its short-lived existence, *The Store* displayed for sale over one hundred sculptures emulating a wide range of inexpensive goods (fig. 4). *The Store*, with its diverse merchandise covering every available surface of the interior, did not immediately leap out from the other neighborhood shops. At first glance, Oldenburg's transformed studio seemed to join the surrounding delis and variety shops in welcoming the shopper to snoop for tempting bargains.

The sculptures in *The Store*, viewed in the literal terms of what they portrayed, duplicated the sort of cheap merchandise available in many of the small shops located in the surrounding Lower East Side. Oldenburg's slices of pie evoked the sweets produced by local bakeries; his sandwiches corresponded to those found in delis on Houston Street; his wedding mannequin and bouquet mimicked the type displayed along "brides' row" on Grand Street; and his girdle, dresses, and jacket echoed the inexpensive clothes in the open air shops along Orchard Street. One did not go to *The Store*, or

for that matter to any of the shops on the Lower East Side, to purchase the newest, mass-produced appliances and packaged foods for sale in the chains of department stores, supermarkets, and fast-food restaurants that proliferated across the country after the Second World War.

Oldenburg, moreover, borrowed the display techniques of the small discount shops of the area. "After seeing Oldenburg's *Store*, or a performance of his theatre," critic Ellen Johnson confessed, "one feels compelled to walk and linger through the Lower East Side, suddenly aware of the curious, tawdry beauty of store-windows full of stale hors d'oeuvres, hamburgers on Rheingold ads, stockinged legs."[39] "Full," Johnson said, and the term applied equally well to both *The Store* and its neighboring shops. Oldenburg's clothing, food, and assorted wares crowded the storefront window, hung from the ceiling and walls, rested on chairs and tables, or lay in glass cases.[40] Similarly, the closely packed shops in the neighborhood, whether specializing in one type of merchandise such as hardware or offering a variety of goods for sale, placed all of their stock on view. Merchandise even spilled onto the streets: Clothes at one apparel shop, for instance, hung on racks standing on the sidewalk and swung from the signs above the door (fig. 5). The display techniques at *The Store* and the surrounding shops invariably stressed an abundance and diversity of cheaply manufactured goods.

With their teeming, disorderly array of goods, both *The Store* and the neighborhood shops exhibited precisely those principles of merchandising that window-dressing "how-to" manuals criticized as outdated and ineffectual. "Another lost cause in display is 'mass' merchandise," Emily Mauger carped. "Some store owners feel compelled to stack, pile and place as much merchandise in their windows as possible. . . . Focused attention on one item is much more powerful than on a dozen."[41] As early as the turn of the century, certain stores selected a handful of articles, rather than flaunting a cornucopia of varied goods, as a strategy to sell precious items.[42] By the 1950s, selectivity contributed to the "art" of display in most expensive stores. As Kretschmer commented in 1952: "The modern high-class store shows a few carefully chosen articles in a single unit of a display to give an atmosphere of quality and exclusiveness of

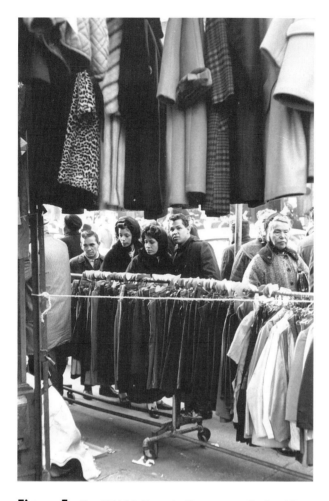

Figure 5. Fred W. McDarrah, *Shoppers on Orchard Street*, 1964. Copyright © by Fred W. McDarrah.

style."[43] Based on the criterion of selectivity, *The Store* failed to demonstrate modern display techniques and to espouse the standard of good taste expected on Fifth Avenue; it adopted instead the practices of shops targeting a broader and more popular audience.

Nothing about the type of goods, mode of display, or scale of operation of *The Store* summoned forth the practices of modern-day consumerism. The thematic selection of Oldenburg's artworks cer-

tainly associated them with a bygone age. Writing in 1963, Johnson recalled her assessment of *The Store*: "On first impression the cash register and other 'machines' in the *Store* looked surprisingly nostalgic and old-fashioned."[44] Sidney Tillim similarly concluded about *The Store*, "it was all so hopelessly nostalgic."[45] Tillim's reaction conformed to the retrospective tone characteristic of many descriptions of the neighborhood in general. Although only a few guidebooks to New York City mentioned the area in passing, they filled their pages, then as now, with black-and-white documentary photographs from the turn of the century, and reminisced about the immigrants from Eastern Europe who had flooded into the Lower East Side at that time.[46] All touristic descriptions of the Lower East Side, whether they expressed sentiments of fascination or repulsion, associated this neighborhood with the historical past.[47]

Divorced from midtown by both display practices and time, the Lower East Side shops – and seemingly Oldenburg's *Store* as well – addressed a different type of shopper than did Bonwit Teller. Guidebooks from the 1960s revealed expectations about who shopped in each neighborhood in New York, and how they purchased goods. In photographs of the Lower East Side, modestly dressed women scrutinized products hanging on racks or piled on tables, and picked up individual items one by one (fig. 5).[48] They selected goods through the sensory mode of touch rather than relying on vision; and certainly the practice of displaying like items in open abundance catered to this shopper's habit of tactile selection. Careful scrutiny of merchandise and modest attire suggested a consumer ethic of common sense and thrift. *The Store*, with its apparently inexpensive, slightly outmoded merchandise arrayed on easily accessible tables and walls, would seem to have conformed to the conventions of display and consumption operative in the neighborhood.

And yet, *The Store* obviously did not actually sell cheap merchandise even as it emulated that mode of commerce. It offered for sale Pop sculptures instead. The handcrafted appearance of Oldenburg's objects – their rippling edges, irregular shapes, odd sizes, and richly encrusted surfaces – repudiated the external uniformity of the machine-made products available in neighboring shops. Oldenburg's objects, moreover, disdained the imperative of the bargain

store whereby all objects had to have a functional use. The brightly painted strawberry shortcake could not be eaten; the dress seemingly blowing in the wind could, in its rocklike stiffness, never be worn. And, of course, as the prices on the tags, which reflected the actual expense of the artworks in dollars rather than the cost of cheap consumer goods, far surpassed the pocketbook of the hunter of real bargain wares.

Even as its parodies represented the activities of the bargain shopper, *The Store* actually welcomed a different class of viewer to the Lower East Side: the art connoisseur well-versed in recent trends in contemporary art, exercising distanced, aesthetic evaluation of the sculptures. No need for such viewers to manipulate the objects of display to assess their worth; no need to choose by the sense of touch to determine value among a collection of like items. Rather, artistic vision claimed this space as its rightful domain: To appreciate the thick, lavish drips of enamel paint covering the surfaces of Oldenburg's food and clothing depended on a familiarity with the Abstract-Expressionist brushstroke. Critic Jill Johnston articulated the point most bluntly: "Oldenburg has refined an Action-like technique, many objects being pleasurable in pure color and spontaneous design."[49] Among Johnston and her like, the trained eye, not the instinctive hand, ferreted out quality in the works of art.

Yet knowledge of contemporary art also allowed for a humorous response to the formal aspects of the sculptures. Detecting an ironic turn, a crossing of cultural if not class lines, between the spontaneous surface brushstroke and the sausage or hamburger that it bedecked offered obvious comic relief to the high seriousness of Abstract Expressionism. A number of critics reveled in the humor. Sonya Rudikoff, writing about Oldenburg's objects when they were later exhibited at the Green Gallery uptown, asserted: "My first reaction was one of enormous amusement and pleasure. . . . The paint is applied with equal disdain, is high in colour, weird: who ever saw such hideously green salad, such orange-y and brown-y bread?"[50]

As Rudikoff's question suggests, recognition of the formal and parodic qualities of Oldenburg's sculptures secured the difference of these objects from their commonplace sources. Indeed, the extent and meaning of the distinctions between Oldenburg's sculptures

and actual consumer goods developed among commentators into a topic of analysis and debate built upon the distinction between real items and artistic representations of them. All critics writing about *The Store* and its contents shared the presupposition that the world of lower-class commerce evoked by Oldenburg's installation really existed out there in the tiny stores of the Lower East Side, distinctly beyond the realm of artistic representation. And these same critics, even when they argued over whether *The Store* nostalgically recalled the real world or parodied it mercilessly,[51] regarded the work not as a true example of such commerce but a representation of it. The difference between the surfaces of Oldenburg's sculptures and the hefted weight of functional objects in the bargain store thus not only marked out the distance between vision and touch, refined sensibility and consumer acquisition; it also defined the distinction between representation and the real.

The two corresponding manners of viewing objects on display, however, lacked symmetry: Where shoppers apparently lived only in the world of the real, the critic and connoisseur could see both and assay the relation between the reality of commerce and the representations of art. Even more, the critic and connoisseur, unlike the lower-class shopper, could apply the skills of aesthetic evaluation to both realms. "He is the Cecil Beaton of the regressive Skid Row of our lost and slightly smelly innocence,"[52] pronounced Jack Kroll about Oldenburg in *Art News*. To compare Oldenburg to Beaton, the famous postwar photographer of *haute couture*, and to see the Lower East Side through Beaton's lens repudiated the claim to objective reportage implicitly asserted by documentary photographs and historical reminiscenes of the neighborhood. Many critics hinted that they had discovered an aesthetic in the mundane objects that they had previously taken for granted;[53] they viewed this world of commerce as if it were a work of art. Where bargain shoppers appeared engaged directly in the real as they handled and bought artifacts, critics established their distance from the neighborhood – and lower-class commerce – by treating it as aesthetic spectacle.

Evaluating the objects in Oldenburg's *Store* based on their formal qualities, assessing their differences from the real, and subsequently

treating the real as an object of aesthetic contemplation were the critical pleasures made possible by Oldenburg's *Store*. In savoring the aesthetic dimensions of the sculptures and goods in surrounding stores, art critics such as Tillim and Johnston distinguished themselves from the bargain shopper and her practices of judging real objects in the neighboring shops. Like the sophisticated shopper viewing Moore's Warhol window on Fifth Avenue, the critic and connoisseur deployed the skills of aesthetic visual analysis in order to differentiate themselves from those viewers – mere shoppers, lacking aesthetic sensibility – who seemingly failed to maintain a proper analytic distance from the objects on display.

From the perspective of the department store owner, I have argued, the sophisticated shopper in front of the Bonwit Teller window ultimately lost that distance as she entered the store to buy the dresses sharing space with the paintings. From the perspective of Oldenburg in his role as the proprietor of a temporary storefront gallery, connoisseurs potentially could follow that same path as they purchased real works of art. Critics, not themselves making purchases of either the bargain or artistic variety, might seem to avoid this collapse of analytic distance, this slide from aesthetic contemplation to commercial engagement. In practice, however, even the critics appeared to succumb to commercial allure. After trotting out his predictable set of formalist pronouncements on Oldenburg's painted surfaces, for instance, Tillim felt the tug of a consumer's urge generated by the subject matter of the works: "It was a pleasure, and then it became disturbing, and I fell into the critic's habit – or was it the consumer's – of examining individual items. I began, in other words, to draw away from the experience via the aesthetic outlet that had been so carefully provided. I found the candy sticks too unformed, mere varied blobs of plaster and color."[54] Johnston, like Tillim, switched from analytical observer to yearning shopper with striking ease: "Oldenburg's painted plaster food, clothing and other living accessories are as personal as any sculpture has ever been. Yet most of his objects simulate the original product to the point of arousing the same desire associated with the original."[55] The confusion of roles in these texts discloses a type of aesthetic judgment that did not necessarily keep consumer desire

safely at bay. Aesthetic taste, which had served to differentiate the sophisticated shopper from her unrefined compatriot on Fifth Avenue before collapsing into the good taste of the high-class shopper, here devolves further into taste of a purely alimentary sort: The critic's mouth waters at the prospect of cake and candy stick.

The critics, of course, hardly succumbed wantonly to the tugs of such basic desires.[56] Indeed, the critics' prose could toy with the conceit of equating art to food precisely because their aesthetic pose held sufficient self-assurance to play it all as a joke: not consuming the cakes actually but rather parodying the consumption of this parody food. Their comments, however, may reveal more than the conceit intended. For if the critics could control their appetites for food, the parody could collapse on itself to disclose a hunger for art that ultimately underwrote the critical enterprise. What purpose, ultimately, for this scribbling around painted surfaces and such if art was not something to be desired? It was a premise of the art market, after all, that the aesthetically inclined needed art in a manner akin to the needs for basic survival of less sensitive souls. In the end, the temptation for art set up by the practice of criticism for one class of viewers paralleled the temptation for consumer goods set up for another by the displays of abundance on the Lower East Side. Just as the Warhol window at Bonwit Teller could draw its various female consumers together at the moment of the tasteful purchase, Oldenburg's *Store* could unite its class-stratified audience under the sign of desire.

Campbell Soup at the Bianchini Gallery

Institutional masquerade spread to the Upper East Side when in the fall of 1964 the Bianchini Gallery disguised itself as a small-scale supermarket (Plate I). Large signs hanging in the aisles indicated the location of various comestibles: "Eggs," "Canned Soups," "Bread," "Fresh Vegetables," and "Fresh Fruits." Packing crates, shelves, freezers, and refrigerated shelves stocked real products such as Campbell soup cans, as well as wax replicas of various cheeses and meats. The artworks interspersed among these goods included Brillo boxes by Warhol, chrome fruits and vegetables by Robert Watts, and a

painted bronze slice of watermelon by Billy Apple. Bright labels identified individual food items and their prices, and other signs alerted visitors to such bargains as the "pick of the market," "week-end specials," and "price reductions." This installation, it would seem, appealed to both the price-conscious homemaker and the Pop-art expert.

In the colorful spread on the Bianchini exhibition published in *Life* magazine in November 1964, the most visible visitor – she stands prominently in the foreground of the gallery – assumes the guise of a shopper.[57] As if in an actual supermarket, a middle-aged woman scrutinizes a real can of Campbell soup with an expression of serious intensity. Her pose reveals certain assumptions about supermarket consumers, suppositions most likely shared by the readers of *Life* magazine. An examination of debates within the world of advertising during the 1950s and early 1960s concerning the shopping practices of supermarket consumers elucidates how *Life* and its readers imagined the manner in which shoppers such as this woman evaluated products at the Bianchini Gallery. Given the ever-increasing expenditure by American businesses on marketing after the Second World War, discussions about the impact of advertising could not help but shape public perceptions about consumption.

The Bianchini Gallery's conceit acknowledged the increasingly influential role of the supermarket after the Second World War. In 1940 supermarkets accounted for 24 percent of grocery sales, whereas by 1960, the figure had soared to 70 percent.[58] At the same time, the sheer number of mass-produced, ready-to-serve goods on display at the supermarket expanded dramatically during this period. Advertising manuals published during the 1950s and early 1960s claimed that each individual product at the supermarket competed for the shopper's attention with approximately 6,500 other goods.[59]

Because, as many admitted, the actual products for sale in the supermarket were often more or less identical,[60] advertisers concentrated their attention on how best to sway the shopper to choose a specific brand name. Many advertisers promised to increase sales by developing product "images" or "personalities." These two terms, which were used interchangeably, referred not only to the actual

good, its packaging, and its advertisements, but also to the ensuing abstract ideas the consumer entertained about the product. As Harry Henry explained in his *Motivation Research: Its Practices and Uses for Advertising, Marketing and Other Business Purposes* of 1958:

> What the consumer wants and buys is not simply the end-result of a production-line, manufactured to a given specification: it is the *total personality* of the product, which consists not only of its chemical composition and formulation, but also of all the *ideas* which the public has about it. . . . It consists, in other words, of the picture which the consumer has in his mind of the qualities inherent in it, real or imaginary (frequently the latter).[61]

Only images, advertising experts concluded, could produce significant differences among products: "Difference (or differences) in the *product* itself," as one industry insider put it, "may be in the way it is *packaged*, or in the *advertising and promotion* which give you an 'image' of the product as being different."[62] Aware of the crucial function of the image in selling products, American businesses doubled the amount of money that they spent on advertising between between 1947 and 1957.[63]

Some writers within the industry praised product labels and advertisements for the information they provided. Its truthfulness presumably underwritten by various regulatory agencies, such information emerged as a scientific resource for the consumer.[64] Asserted Steuart Henderson Britt, professor of marketing and advertising at Northwestern University, "consumers do an excellent job of choosing among packaged brand-name products, because we have learned over the years how to shop efficiently. A good deal of this is because of the effectiveness of advertising, which has given us a certain amount of information even *before* we shop or see the product."[65] The product image, according to Britt and others, enabled the shopper to select among goods in an informed manner.

To treat the product image as an asset for shoppers presumed both the trustworthiness of the images and also the rationality of consumers.[66] Some writers insisted women possessed such rationality. As Gilbert Burck declared in the pages of *Fortune* magazine:

> One of the harshest canards of our time, if eminent mer-
> chandisers are to be believed, is the common assumption
> that women are impulsive buyers, with an almost neurotic
> compulsion to squander their household money on any
> bauble that chances to catch their fancy. . . . Sol Polk, chair-
> man, owner, and operator of Chicago's aggressive Polk City
> emporium, is . . . emphatic about the American woman.
> "She has become very sharp," he says, "very efficient in
> shopping." . . . Most merchandisers, however, depend on
> the old observation, which in turn is substantiated by mod-
> ern psychology that women as a rule are more intuitive than
> men. . . . But it seems that their emotional approach does
> not affect their ability to make sound judgments.[67]

Even when authors such as Burck acknowledged that unconscious
factors sometimes guided consumer choices, they rejected the no-
tion that advertisements compelled the consumer to buy goods un-
wisely or created false needs.

The supermarket, according to the script of rational consump-
tion, facilitated the shopper's efficient and objective choice among
products. Texts delineating the historical progression from the small
grocery store to the supermarket heralded the greater abundance
and variety of goods, better sanitary conditions, lower prices, and
increased convenience of the supermarket. In *How American Buying
Habits Change*, a photograph of "an old-fashioned grocery store"
displayed staples sold in bulk within a small, dark interior; in anoth-
er photograph, the transparent pane of glass on the face of the
supermarket opened onto a brightly lit interior with multiple goods
classified and arranged along neat aisles (fig. 6). The supermarket in
this comparison emerged, like the package and advertisement, as a
beacon of legibility and truth. Within the supermarket's walls, it
would seem, the busy housewife could formulate sound decisions:
"The supermarket shopper," Harry Hepner proclaimed, "can exam-
ine a brand, place it on her shopping basket, return it to the shelf,
examine another brand, and choose or reject to her heart's content.
She feels that she is buying wisely."[68]

Despite such optimistic assessments of the shopper's decision-

making process, however, a chorus of voices after the Second World War questioned the notion that consumption was, in fact, a rational practice. In essence, the skeptics argued that woman lacked control over advertising images and product personalities, owing to her inherent irrationality. The defensive tone of Burck's previous formulation insisting on the shopper's rationality already hinted at the predominance of this attitude toward the female shopper. The emerging practice of motivation research seized upon the shopper's supposed irrationality as an advantage for the merchant and capitalized on her purported susceptibility to images.

To package and market goods more effectively, advertising firms increasingly relied on studies produced by psychologists and social scientists, many of whom were affiliated with institutes specializing in the field of motivation research.[69] Although a partnership between the advertising industry and the discipline of psychology started as early as the turn of the century, motivation research did not become a widespread and institutionalized practice until after the Second World War.[70] Promoters of motivation research, promising information that cut through the dry statistics of sales figures and market research, pledged to reveal the actual unconscious reasons why consumers purchased particular products.

According to advocates of motivation research, various techniques such as "depth interviews" and "word-association tests" exposed the consumer's "actual" – which is to say deep and unconscious – motives for buying goods. The reasons consumers offered for buying products in quantitative studies, according to this line of thought, resulted from conscious rationalizations generated after the fact and thus could not be trusted to reveal the true desires behind the purchase. As Ernest Dichter, one of the leading figures in the practice of motivation research, stated: "When even 90 per cent of your customers say that they buy your product because it has such a pleasing appearance, that does not have to be true."[71] Truth could only be uncovered by plumbing the depths of the unconscious. Edward H. Weiss, president of Weiss and Geller, an advertising firm in Chicago, operated on the assumption that he learned the truth about shoppers from psychologists, sociologists, psychiatrists, and psychoanalysts: "What we try to get at are the *unconscious or*

Figure 6. *Old Fashioned Grocery Store vs. Supermarket.* From United States Bureau of Labor Statistics, *How American Buying Habits Change* (Washington, D.C.: U.S. Department of Labor, 1959).

hidden ideas, associations and attitudes of the consumer in connection with his or her relationship to the particular product being researched. What we have learned to look for is the consumer's *real* feelings, his *real* buying motives."[72] Implicitly, motivation research pitted conscious representations formulated by people to explain why they bought goods against real unconscious desires.

A Taste for Pop

Because studies in motivation research assumed that women purchased most goods or, at the very least, exerted determining influence on the decisions made by other family members, they focused their attentions almost entirely on the secret desires of the female shopper. Of the numerous books and articles published during this period that promised to explain in objective terms the unconscious impulses causing women to buy, the most frequently quoted was Janet Wolff's *What Makes Women Buy*. Wolff attributed the female consumer's irrationality, which she regarded as inherent, to her physical constitution: "A woman's sex is a very deep part of her life, due to the constant reminders of her reproductive system and sexual characteristics. These factors make women more emotional, less predictable."[73] Other texts, stopping short of ascribing woman's consuming practices to her reproductive organs, adopted a pseudo-scientific language to describe the shopper's subterranean emotional fantasies, fears, anxieties, and desires.

When debating the role of the image in selling products, advocates and critics of motivation research concentrated on whether the image, in appealing to the female consumer's unconscious desires, compelled her to buy products against her better judgment. Participants on both sides of the controversy, despite their particular differences, agreed that women when shopping had difficulty discerning between the real item for sale and the image generated around it, between her rational need for the good and her unconscious desire for its personality.

Promulgators of motivation research cheered their ability to shape the consumer's unconscious desires through images. Women shoppers, a number of studies concluded, purchased goods because they liked well-designed, colorful packages. The visual aspects of packaging and advertising, especially the use of photographs and the color red, could apparently arouse interest, spur associations, and instill desire. For instance, Louis Cheskin, director of the Color Research Institute, claimed: "Shoppers are not aware that they are influenced by a color or an image. They are not conscious of the effect a package has on them. . . . She does not know that the imagery, color and design caused her to take that particular package. By testing with psychoanalytic techniques on an unconscious level, we

learned that consumers are influenced favorably or unfavorably by images such as triangles, ovals, circles, crests and crowns."[74]

The resulting personality of products influenced the shopper as strongly as the specific design of packages, labels, and advertisements. Pierre Martineau, head of the research division at the *Chicago Tribune* and one of the most influential writers in the field of motivation research, proposed that status anxiety in particular led the consumer to identify with the abstract personality of certain products: "In this yearning for self-expression, we reach for products, for brands, for institutions which will be compatible with our schemes of what we think we are or want to be."[75] The shopper, implied Martineau, sought out stores and products with images compatible with her notion of her social class. Women of all classes in his schema shopped for representations of themselves, not real things.

Where advocates enjoyed their ability to manipulate shoppers through images, overwrought critics of motivation research expressed great anxiety about the power of images over women. In his sensationalist book *The Hidden Persuaders* of 1957, Vance Packard warned that "hidden persuaders" devised according to studies in motivation research lurked everywhere in packages, labels, and advertisements; these devices manipulated the consumer, creating false desires and compelling her to buy goods for which she had no real need. As an example of the dangerous power of hidden persuaders, Packard referred to a study by the Color Research Institute: Owing to package design alone, homemakers detected differences among three boxes containing, unbeknownst to them, the same laundry detergent.[76] The exposé tone of Packard's text generated much public attention. As one article in *Business Week* pointed out: "For a year or so tantalizing rumors have been drifting around the fringes of Madison Avenue – rumors about a startling kind of 'invisible' advertising that sells products while leaving buyers unaware they are getting a sales pitch. An intriguing reference in *The Hidden Persuaders*, Vance Packard's bestselling book about the use of depth psychology in advertising, added more fuel to the rumor mills."[77]

Brimming with hidden persuaders, the supermarket came in for particular attack in Packard's chapter entitled "Babes in Consumerland." In a study by motivation analyst James Vicary, which Packard

cited as a particularly revealing example, the rate at which a woman's eyes blinked dropped precipitously in the supermarket. Vicary concluded that women entered into a hallucinatory trance when faced with shelves and shelves of product labels. Having lost her ability to appraise the true value of goods, the hypnotized shopper indulged in rampant impulse buying.[78] Driving home the point even further, Packard cited other dramatic case studies "proving" that the large number of package designs on display in the supermarket provoked hynotic trances and impulse buying in the female consumer.

Writers debating the role of images in selling products thus juggled two competing conceptions of the female shopper: on the one hand, the scientific and informed consumer who, in the process of obtaining real products, rationally evaluated representational information; on the other hand, the irrational and manipulated consumer, who, deceived by representation, lost her grip on the real. Either the shopper asserted her control over representation by learning how to scrutinize labels, packages, and advertisements, or images fatally seduced her.

By the standards of the advertising industry, the woman posing as a shopper in the foreground of the Bianchini Gallery for *Life* magazine would seem at first to be exercising the skills of an informed, rational consumer. Displaying her powers of visual discrimination, she holds the soup can firmly in her hands and studies the label intently. Presumably, like all rational consumers, she examines the image carefully in order to make an informed choice among products; she appears to be a woman far indeed from the trance of image-generated hypnosis. The behavior of the shopper in the Bianchini Gallery seemingly lays to rest any anxieties – or hopes – about the irrationality of consumers or their susceptibility to the influence of images.

And yet the posed shopper at the Bianchini Gallery emerges in this photograph as the butt of a joke. An astute consumer, perhaps; but even the discerning eye of the female shopper could be taken in by the gallery's disguise of itself as a supermarket. Her fixation on the can of Campbell's soup thus becomes an indication of her cultural naïveté; as she gathers information about the supermarket

product, her rapt attention causes her to fail to comprehend the real nature of the space. Her focused interest in the can of Campbell's soup, rather than in the Warhol painting *Campbell's Soup Cans (Chicken with Rice, Bean with Bacon)* of 1962 hanging above her head, makes it clear that this seemingly rational woman has, within a new setting, lost control of her once-firm grasp on the proper relation between the image and the real: She mistakes the gallery's representation of a supermarket for the real, while failing to recognize the reality of the gallery's artistic images.

This is not a real shopper, of course: She appears in this photograph of the Bianchini Gallery as a rhetorical figure, a presumed viewer against which actual readers of *Life* could measure their sophistication, for they, unlike her, recognized the gallery for what it was. The layout of the page, which surrounded the photograph with the explanatory authority of words, facilitated the establishment of a difference between the discerning reader and the shopper lacking such cultural mastery. The opening lines of the article chortled: "The lady shoppers would have good reason to cluck over the high cost of living – $27 for a hunk of Swiss cheese, eggs at $144 a dozen, loins of pork for $49. And especially since the cheese is inedible and the pork uncookable. But this is not a supermarket. It is an honest-to-goodness gallery." The title of the article similarly works to eliminate any confusion about the true nature of the depicted space: "You think this is a SUPERMARKET? NO Hold your hats. . . . It's an ART GALLERY." With such knowledge spoon-fed by the article in *Life*, the initial "you" of the title becomes the "her" of the depicted woman. Readers of the magazine thereby appeared to master the reality of the gallery space, distancing themselves with a laugh from the posed shopper who seemingly mistook the gallery for a supermarket.

In a certain sense, the layout and text of the article placed the reader of *Life* in a position quite close to that of the motivation research scientist ready to evaluate the shopper's performance. The authoritative and rational position of scientist studying the apparently irrational behavior of the female shopper typified the perspective from which most studies in the field of motivation research were written. Consider the illustration accompanying an article on

motivation research published in *Fortune* in 1956 (fig. 7). In the center of the drawing, a woman standing on a small island hovers with a beatific smile on her face before a variety of packaged goods arrayed on a sales counter. Meanwhile men in suits hiding behind trees peer intently at her, express their curiosity, and jot notes, as if engaged in an ethnographic study of some baffling and strange new race.[79] The illustration in *Fortune* invites the reader to identify with the male scientists as they observe the female shopper's mysterious process of selecting goods. The layout on the Bianchini exhibition in *Life* magazine likewise situates the reader at a remove from the female shopper occupying the gallery space. Granted information about the nature of the gallery display, the reader assumes a position of superior knowledge from which to study and judge the shopper's overabsorption in the processes of product selection and her inability to see through the practices of display.

A second shopper in the *Life* photograph, however, throws the authority of the reader into doubt. In the middle ground of the gallery, a woman grasps a hunk of cheese in one hand, while reaching for a second cheese with her other hand. She handles the cheese as if manipulating actual supermarket products that can be taken from and returned to the shelf. Yet the article fails to clarify whether this second shopper holds a real wedge of cheese or a work of art; perhaps, even, she is exchanging one for the other. The written text increases the reader's confusion by pointing out that although artists created some of the mock foodstuffs, in other cases, a commercial display artist produced wax replicas; the second shopper's two options thus expand to three. The reader of *Life* had no means of judging if the supermarket conceit had succeeded in fooling this second woman or if she had seen through the gallery's illusion and had knowingly selected artworks on display for closer examination. In the end, the reader of *Life* could claim no more control over artistic representation and gallery display practices than the shoppers.

In comparison to the readers of *Life*, however, certain visitors to the Bianchini exhibition did enjoy the cultural resources not only to pierce through the gallery's display practices, but also to differentiate between artworks, real products, and wax replicas. Speaking

Figure 7. Nonni, *What Makes Women Buy.* From *Fortune* 54 (August 1956).

from a secure position of cultural knowledge, Calvin Tomkins, the author of the article on the supermarket exhibition published in *Life*, instructed the reader as to the proper way to recognize and evaluate the works of art at the Bianchini Gallery. He asserted that only artworks could raise the question of what defined art and what constituted reality, even though he did not unveil precisely how art addressed such weighty issues. At the same time, Tomkins breezily dismissed the wax food: "Miss Inman's replicas are almost indistinguishable from the foods they represent and, as everyone knows, mere imitation of nature is not art."[80] Tomkins apparently did not believe that the actual supermarket products on display even merited discussion, nor did the difference between the real products and

the works of art require demonstration. Taking for granted the status of the supermarket products as real, Tomkins focused his attention entirely on explaining which of the representations on view – wax replicas or Pop paintings and sculptures – qualified as art.

Other male visitors to the Bianchini exhibition flaunted their cultural expertise through the manner in which they interacted with the objects on display. The men talking among themselves in the background of the *Life* photograph of the Bianchini Gallery appear indifferent to the part of the gallery dedicated to replicating a supermarket. In comparison to the shopper in the foreground whose physical manipulation of an actual product implied her acceptance of the supermarket illusion, such indifference suggests these men's sophisticated understanding of the gallery's display practices. At the very least, because none of the male visitors – whether critics, dealers, or connoisseurs – participates in an act of shopping, much less of handling and evaluating real commercial products, the men indicate that they have not been duped by the supermarket illusion.

When the male visitors do turn their attention to the objects on display, they look at artworks rather than handle real artifacts. In a second photograph of visitors to the Bianchini exhibition published in John Rublowsky's book *Pop Art* of 1965, two men observe paintings on the wall from a physical distance; they adopt attentive postures, implying visual assessment of the artwork (fig. 8). Undeceived, the men in these photographs discern real representations from faked commercial goods: they pick out for contemplation the works of art from the actual supermarket products and wax replicas. Unlike the motivation researcher who gained authority in the cartoon from *Fortune* thanks to the analytic distance of science, these men assume a position of cultural awareness owing to an appreciation of the difference between art and the real, a difference not registered by either the female shopper or motivation research scientist.

By reengaging the ideas of contemporaneous advertising – a realm of commerce from which the art expert wished to distance himself – we can, nevertheless, discover a manner in which the Pop-art expert failed to maintain the cultural authority to which he lay

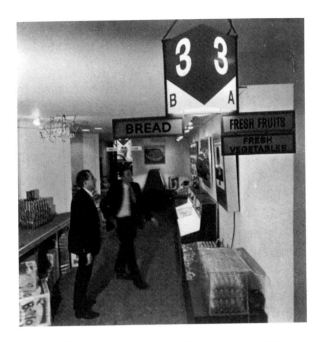

Figure 8. Kenneth Heyman, *Supermarket Exhibition at Bianchini Gallery*, 1964. From John Rublowsky, *Pop Art*. Photo by Kenneth Heyman. Copyright © 1965 by John Rublowsky and Kenneth Heyman. Copyright renewed. Reprinted by permission of Basic Books, a division of HarperCollins Publishers, Inc.

claim through his activity of viewing artistic representations. After all, the savvy viewer's ability to discern the difference between (unworthy) real goods and (worthy) artistic representations of them depended, in part, on the assumption that the commercial goods on displays constituted a form of the real, not some representation of it. And yet, as we have seen, items on display at the supermarket could be considered as much images – representations – as real objects. Debates about product images, when applied back to this gallery setting, render suspect the distinction Pop-art experts drew between the real and the representation.

The Bianchini exhibition included a number of canned and packaged products for which the advertising industry had spent an enormous amount of time and money to establish distinctive images

and product personalities. The cans of Campbell's soup stacked next to Warhol's painting *Campbell's Soup Cans (Chicken with Rice, Bean with Bacon)* could be considered precisely this type of product; the distinctive Campbell's soup label and its promotion constructed a product image. But, as we have seen, the proliferation of product images raised the question of whether the shopper purchased images or real products in the supermarket. This question could not be resolved as long as the status of the image – was it accurate information about the reality of the product or false representation appealing to unconscious desires? – remained undecided in advertising circles.

Campbell's soup advertisements stood as something of an archetype in the attempt to tip this balance in one direction, forging a direct link between the surface image of the package and the actual good concealed within the container. An advertisement for Campbell's soup published in *House and Garden* in January 1960 juxtaposed each of five labels with its respective bowl of fully prepared, steaming soup, ready to consume (fig. 9). Establishing a direct one-to-one correspondence between the actual product and its image, the layout implicitly asserted that the can labeled tomato soup *really* contained tomato soup. An actual product visibly stood behind the image, and in turn that product underwrote the reality of the product's public personality.

Yet it was precisely the seeming honesty of advertisements such as this that lay them open to charges, from critics of advertising and motivation research, to deception. What, after all, was the advertisement for Campbell's soup in *House and Garden* trying to sell? Not pureed tomatoes, certainly; not bits of beef suspended in a watery mixture with noodles and slices of carrots. The Campbell company benefited not from the sale of such actual comestibles, but rather from that specific subset of the nation's foodstuffs that made its way into cans marked red and white with a little gold seal. Thus, the advertisement in *House and Garden*, even as it insisted on a direct link between label and content that distinguished the five cans one from another by flavor, also posited a shared quality – a shared personality – that drew the five cans together under the Campbell name. That personality – "goodness," say, or "heartiness," or "fami-

ly togetherness" – became an attribute not of the food but of the can, of the image carefully forwarded to the public by the makers of advertisements.

Given the archetypal nature of the Campbell example, it is particularly apt that a featured comparison at the Bianchini Gallery – perhaps *the* featured comparison; certainly the principal contrast set up in the photograph from *Life* – was the juxtaposition of actual soup cans and Warhol's *Campbell Soup Cans (Chicken with Rice, Bean with Bacon)*. The relation thus established between commercial product and artwork, moreover, oscillated between the same two poles as the relation between actual soup and label: maintenance of a rational difference between image and real, on one hand, and their irrational collapse into pure image, on the other.

The display at the Bianchini Gallery, on initial appearance, did distinguish Warhol painting from real soup, and did so by insisting on the formal properties of the image on canvas. The gallery's juxtaposition of stacked cans and painting invited its visitors to discover the extent to which Warhol had transformed an actual, commercial source into aesthetic image. *Campbell's Soup Cans (Chicken with Rice, Bean with Bacon)* provides ample evidence of such transformation. The direct, frontal position of the cans reduces any content-containing volume into the flat surface of image. Warhol's simplifications of the label itself – the abstraction of the quality-guaranteeing seal into an illegible disk of gold, for instance – treat the labels as shapes, colors, and forms, not valuable consumer information. And the contrast set up within this two-part canvas between a minute picture of a can on the right and a gargantuan version on the left addresses artistic issues of viewing distance and the visual impact of surface expanse; no one would mistake this image as a truthful depiction of the one-serving and battalion-feeding sizes of actual cans of soup. In many of Warhol's similar canvases of multiple soup cans, discerning subtle differences between the treatment of nearly identical cans requires a veritable connoisseurship directed toward color, shadows, and typeface. Together, all these practices served to distinguish the artistic properties of Warhol's representations from the mundane reality of actual soup cans, and the appreciator of art from the purchaser of soup.

Figure 9. Campbell's Soup advertisement. From *Better Homes and Gardens* 38 (January 1960). Courtesy of the Campbell Soup Company.

And yet, the term of comparison within the gallery, the cans of soup, hardly provided a firm foundation of reality against which to measure Warhol's representational transformations. Unlike the advertisement in *House and Garden*, after all, the Bianchini Gallery never actually presented the consumer with any actual soup: No portable stove tops and can openers were provided by the gallery to

Shopping for Pop

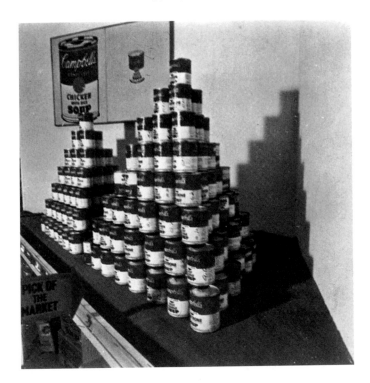

Figure 10. Kenneth Heyman, *Andy Warhol and Campbell Soup Can Pyramids at Bianchini Gallery.* From John Rublowsky, *Pop Art.* Photo by Kenneth Heyman. Copyright © 1965 by John Rublowsky and Kenneth Heyman. Copyright renewed. Reprinted by permission of Basic Books, a division of HarperCollins, Publishers, Inc.

establish beyond a doubt the legitimacy of the contents of the cans on display. Rather, the cans appeared in the gallery as representations: representations, to be precise, of real cans full of real soup really on sale in real supermarkets. Indeed, by stacking the cans within the gallery into pyramidal shapes, the organizers of the exhibition stressed the formal patterns created by the red-and-white labels in uniform reiteration, much as did Warhol's canvases of multiple soup labels (fig. 10). Several cans placed upside down within the stacks in the gallery emphasize the design of the labels by interrupting the otherwise even rows of red and white. Even were one to regard the pyramidal stacks as a representation of real display practices within supermarkets, the foundation of the real only slipped

away further, for this similarity of display practices between gallery and supermarket revealed that even the shopper's appreciation of the market's abundance contained an element of the formal properties of representational pattern. In the Bianchini Gallery, the actual Campbell's soup labels lost their direct link to real soup, and, consequently, Warhol's painting lost its representational distance from the real labels.

With the distinction between work of art and commercial label collapsing, the difference between Pop-art expert and shopper no longer could be drawn with much clarity. Although seemingly the connoisseur in the Rublowsky photograph stood at a distance from the artwork in order to evaluate its formal properties and although presumably the shopper in *Life* scrutinized a label closely to obtain important consumer information, both in the end assessed the value of representation, not the real. Consequently, neither exercised complete control over representation: The shopper failed to see through the gallery's display practices and acknowledge the works of art, and the connoisseur incorrectly took for granted the reality of supermarket products.

The exhibitions of Pop art at Bonwit Teller, *The Store*, and the Bianchini Gallery each juxtaposed the viewing practices associated with looking at works of art against those linked to shopping for commercial artifacts. All three spaces invited visitors to evaluate Pop art through a form of distanced aesthetic vision, while explicitly or implicitly positing a person lacking cultural authority against whom visitors could measure their sophistication: the absorbed shopper, the bargain hunter, the supermarket consumer. The visual perspective adopted at each site influenced how a visitor defined Pop art's status as high art or consumer artifact, and also determined his or her own cultural standing. No one, ultimately, ever managed to gain the high ground of absolute cultural certainty – even my retrospective analyses can undoubtedly be faulted for confusing and conflating high art and consumer culture, representation and reality, in manners of which I myself may not be aware. Absolute certainty in such matters, however, is precisely beside the point. Privilege between artifacts, privilege between modes of viewing manifested itself – must always manifest itself – in a relative manner. Although

the sophisticated shopper at the Bonwit Teller window might well have withered beneath the scorn of the critic of *The Store* or the Bianchini Gallery connoisseur, she nevertheless asserted her superiority over the absorbed consumer lacking her cultural resources, whereas the illusions of critic and connoisseur appear in stark clarity from our perspective of historical analysis. The relative nature of such cultural machinations in no way belies their efficacy. The aesthetic hierarchies among artifacts artistic or otherwise, and the social hierarchies among their viewers, arise from nowhere else than the differential positionings between things and people actuated in places such as the liminal sites – simultaneously commercial and artistic, feminine and masculine, real and representational – selected for the first displays of Pop art.

Chapter 2

Wesselmann and Pop at Home

In the early 1960s, art collector Leon Kraushar bought Tom Wesselmann's *Bathtub Collage #1* of 1963 and hung it on the wall of his home (fig. 11). In the manner of collecting nearly as age-old as art itself, the purchase and the display of a valued work of art converted the owner's financial success into a certain cultural capital. Wesselmann's collage – in art-historical parlance, a genre scene – introduced the aura of art into Kraushar's home, distinguishing this space from other interiors, this collector from other individuals.

And yet in this photograph, first published in Rublowsky's *Pop Art*, the distance between art and the rest of the domestic interior is less pronounced than it might be; indeed, the photograph puns on their similarity. A woman, Mrs. Kraushar in fact, strikes a pose next to Wesselmann's work, and like the depicted nude in the picture, she busies herself, at the left side of the image, with her *toilette*. The wife models herself here on the work of art. But this emulation only became possible owing to a previous act of cultural plagiarism, for clearly Wesselmann – unlike, say, the previous generation of artists such as Jackson Pollock – had taken on the task in his picture of arranging the space of the domestic interior, a task usually performed at the time by the female homemaker, not the modernist painter.

This chapter examines the manifold acts of borrowing suggested by this photograph, as Wesselmann took up and reworked the visu-

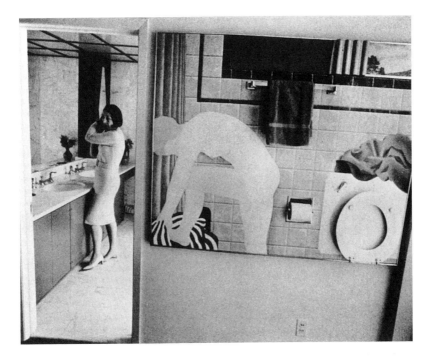

Figure 11. Kenneth Heyman, *Mrs. Kraushar in Her Bathroom*. From John Rublowsky, *Pop Art*. Photo by Kenneth Heyman. Copyright © 1965 by John Rublowsky and Kenneth Heyman. Copyright renewed. Reprinted by permission of Basic Books, a division of HarperCollins Publishers, Inc.

al codes of the booming, postwar American domestic economy, and collectors in turn incorporated works by Wesselmann and other Pop artists into their homes. Two standards of taste, the aesthetic taste of artist and collector and the consumer taste of the female homemaker, faced off but also intermingled with each other, and in that process certain prerogatives – of class, of gender, ultimately concerning the control of American domesticity – emerged.

The Economy of Domesticity

All of Wesselmann's series from the early 1960s – the Great American Nudes and Little American Nudes, the Still Lifes, the Bathtubs – depict interiors of the postwar suburban American home. Many of Wesselmann's images expose the private sanctums of the home –

the bathroom and the bedroom – whereas others display the more public and family-oriented space of the suburban kitchen.[1] Wesselmann's domestic interiors invoke a great variety of other representations of the postwar home. My interest here is in how Wesselmann's interiors, when examined intertextually alongside these other representations, participated in the definition of the economy of domestic life in the United States after the Second World War and in the construction of the middle-class consumer culture that that economy underwrote. Though obvious differences of material production, circulation, and audience distinguished Wesselmann's pictures from interiors published in women's magazines, advertisements of the home, written commentaries, and government reports about domestic life, all of these artifacts converged in formulating certain key assumptions about the American economy of domesticity.

Wesselmann's interiors transport the viewer to the hearth of an economy of domesticity characterized by the increased number of goods and services marketed to the female consumer and homemaker after the Second World War. *Still Life #30* of 1963, for instance, situates the spectator in a suburban kitchen containing postwar goods and appliances (Plate II). Modest in size, the kitchen incorporates only the most basic units of a range, refrigerator, and sink. Neither at the bottom nor the top of the line in quality, the kitchen appliances – an actual refrigerator door with a General Electric logo and painted images of a sink and a stainless steel stove top with four electric burners – bore moderate price tags at the time. Consumers could purchase such midrange, labor-saving devices on a national scale only after the Second World War.[2] The juxtaposition of the kitchen interior and the view of New York City through the window locates the home geographically outside of a major metropolis, but within commuting distance of it: This could be one of the many suburban bedroom communities built in the United States after the Second World War.

Lined up along the wall in Wesselmann's *Still Life #30*, the kitchen appliances form an orderly backdrop for a rather haphazard display of foods amassed on the kitchen table in the foreground. Packaged foods – canned, boxed, wrapped in cellophane – take their

place alongside a fast-food hotdog, prepared pancakes and sausages dripping with syrup and butter, and fresh fruits, vegetables, and meats. Wesselmann's collection of products on the kitchen table constitutes a diet rich in mass-produced, readily available, convenience foods. Even the roast testifies to advanced technologies for the distribution of foodstuffs because fresh meat in all seasons only became widely available after the war with the development of new refrigeration techniques.[3] Piled upon the checkered tablecloth, which it covered almost entirely, Wesselmann's cornucopia inventories variety in amassment: The sheer number, diversity, and casual arrangement of goods proclaim their availability and affordability.

Still Life #30 includes precisely those mass-produced appliances and foods that postwar economists regarded as indicators of the growth and health of the American national economy. In short, the picture can be seen as imbedded within the ethos of consumption in the early 1960s. Statistics as to the number of homes, televisions, refrigerators, freezers, washing machines, and packaged foods sold each year provided the ostensibly solid data for assessing the nation's well-being in the 1950s and 1960s. In 1958, for example, the United States Department of Labor's publication *How American Buying Habits Change* praised the steady improvement in the American standard of living since 1900, offering proof in the form of numerical comparisons, decade by decade, of the quantity of single-family dwellings, specific household goods, mass-produced foods, and leisure activities available to Americans.

Such numbers served as the foundation for the conviction held by many Americans that the economy and standard of living in the United States outstripped that of all other countries in the world. David M. Potter's book of 1954 *People of Plenty: Economic Abundance and the American Character* compared the American standard of living at midcentury to that of other countries on the basis of the number of available household goods. "The compilation of statistics might be extended endlessly," he concluded,

> but it would only prove repetitively that in every aspect of material plenty America possesses unprecedented riches and that these are very widely distributed among one hundred

and fifty million American people. If few can cite the figures, everyone knows that we have, per capita, more automobiles, more telephones, more radios, more vacuum cleaners, more electric lights, more bathtubs, more supermarkets and movie palaces and hospitals, than any other nation. Even at mid-century prices we can afford college educations and T-bone steaks for a far greater proportion of our people than receive them anywhere else on the globe. It approaches the commonplace, then, to observe that the factor of relative abundance is, by general consent, a basic condition of American life.[4]

Potter's text located the domestic sphere at the center of America's sense of economic recovery and national identity after the Depression.

As the embodiment of American success, the economy of domesticity bolstered public posturing on the advantages of capitalism over the Soviet Union during the Cold War. Elaine May, in a discussion of the famous "kitchen debate" between Vice-President Richard Nixon and Soviet Premier Nikita Khrushchev in 1959, has recently highlighted the importance of the domestic sphere in the U.S. government's efforts to demonstrate the superiority of the "American Way of Life" over the communist system. Photographs of this event published in American mass-circulation news magazines portray Nixon and Khrushchev leaning over a railing looking into the exhibition space of a model suburban kitchen at the opening of the American National Exhibition in Moscow (fig. 12). Nixon, in a widely reported verbal exchange, extolled the benefits of democracy as exemplified by household appliances: "Let us start with some of the things in this exhibit. You will see a house, a car, a television set – each the newest and most modern of its type we produce. But can only the rich in the United States afford such things? If this were the case we would have to include in our definition of rich the millions of America's wage earners."[5] The spoils in this Cold War, it seemed, consisted of refrigerators and frozen food.

Nixon's argument in the kitchen debate implicitly claimed that the American capitalist system, by surpassing the Soviet system in

Wesselmann and Pop at Home

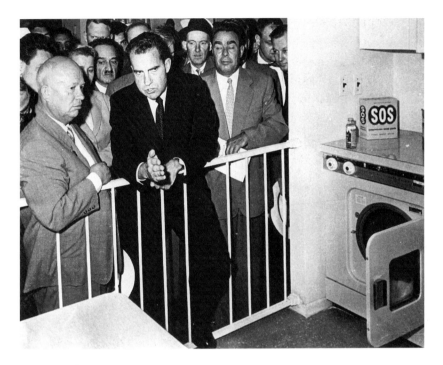

Figure 12. *When Nixon Met Khrushchev During Their Tour of an American Exhibition in Moscow, 1959.* Courtesy of AP/Wide World Photos.

the provision of consumer goods to all, had created a truly classless society.[6] That a modest middle-class kitchen exemplified the "American Way of Life" in the debate between Nixon and Khrushchev, however, pointed to a fundamental contradiction embedded within the postwar American economy of domesticity. On the one hand, social fulfillment was measured by conformity to the economic standard of a particular class: ownership of a single-family home in the suburbs equipped with the most recent labor-saving devices, as Clifford E. Clark, Jr., has suggested, signaled the achievement of a specifically middle-class standard of living.[7] On the other hand, because these conveniences, and even the tract homes they filled, were mass-produced and nationally marketed at comparatively moderate prices, they also represented the abundance supposedly available to all after the Second World War. The myth of economic egalitarianism depended upon ignoring all ways of

life – established urban wealth, say, or rural poverty – that deviated from the strict standard of the middle-class norm. Suburbs did indeed swell during the 1950s with families whose purchases accounted for the soaring consumption of mass-produced goods, but in fact, Roland Marchand has claimed, only households among the top 40 percent in family income could afford this life-style.[8] Analysts of American culture who spoke of a uniformly national way of life – and there were many – ignored the other 60 percent of households. In 1957, for instance, historian Max Lerner argued in his book *America as a Civilization* that the middle class exemplified the United States to such an extent that class difference had ceased to exist.[9] Similarly, advertisers and producers of television situation comedies cast the suburban family as typical of the national way of life.[10] All of these representations did not simply describe classlessness, they enacted it.

Still Life #30 performs the myth of postwar American economic egalitarianism, presenting a middle-class domestic space as the norm. The relatively modest size of the interior and the quantity and midrange price of the appliances and goods establish the middle-class status of Wesselmann's domestic space. The lack of any luxury items, which would openly declare class distinction, allows mere standard issue to become national standard. A *national* standard, I say, because all of the appliance and foods in this picture were manufactured in the United States and often displayed American brand names. The inclusion of the word "American" in many of the titles of Wesselmann's other works and the equally frequent inclusion of national icons ranging from presidential portraits to the American flag further grant a specifically American character to these interiors.

The criteria of selection used to arrange the goods and to compose the middle-class space of *Still Life #30* did not manifest any form of ostentatious economic privilege but conformed instead to postwar precepts of moderation and good taste in interior design. The kitchen's fully automated interior boasts first and foremost of practicality: All of the modern, ostensibly functional appliances remain close at hand for maximum efficiency. A coordinated color scheme of bright hues unites the clean lines and sharply defined

geometric forms of the appliances. Wesselmann himself played amateur decorator in this case, repainting the real refrigerator door pink and adding a blue tint to the pressure-pressed formica tiles mounted on the back wall. *Still Life #30* thus offers the fantasy of completely up-to-date appliances harmoniously and sensibly arranged in a pristine space.

The suburban kitchen in *Still Life #30* appropriated the visual codes developed in women's home and service magazines to display tasteful spaces of consumption managed and directed by the efficient middle-class female homemaker and consumer. Middle-class women's magazines such as *Good Housekeeping* and *Ladies Home Journal* contained both advertisements for kitchen appliances and articles on interior decoration; *Ladies Home Journal* also published advice manuals on how to outfit the home in an economical and attractive fashion.[11] The small-scale kitchens in these magazines and manuals, arrayed with mass-produced and moderately priced appliances, seem ordinary, especially when compared to the lavish kitchens replete with luxury items published in upper-middle-class home magazines such as *Better Homes and Gardens, House Beautiful,* and *House and Garden*.[12] *Good Housekeeping* and *Ladies Home Journal* contained comparatively more humble goods in spaces organized by middle-class codes of modesty and efficiency.

Photographs of kitchens in women's middle-class magazines and advice manuals demonstrate the way that the kitchen, conceived of as a public space in the postwar suburban home, could be flaunted by interior decorators as a room combining modern functional design and coordinated color schemes. For instance, a photograph of a kitchen published in an article entitled "Beautiful, Budgetwise Three-Room Apartment," which appeared in *Good Housekeeping* in 1963, features one tidy corner of the kitchen arranged like an empty stage set and flooded with bright and consistent light (fig. 13).[13] This clean-swept and compact space, fully equipped with brand new, practical appliances, looks absolutely still and orderly. The pristine appliances and kitchen cabinets all exhibit a taste that values spare, geometric forms in solid colors: white for the plastic laminated counters, blue for the cabinets, and copper for the refrigerator, dishwasher, and stove. This kitchen exemplifies efficiency of

space with an eye to coordinating appliances in both color and form.

Addressing their advice to middle-class women, manuals on interior design as well as home and service magazines of the 1950s and 1960s took for granted that the female consumer and homemaker supervised the decoration of the home. "Every woman," Kay Hardy insisted in *Room by Room: A Guide to Wise Buying*, "can best plan her own kitchen storage space. Only you know whether you use several serving trays and will need a tray file."[14] As several authors have recently argued, the advertising industry and women's magazines in the 1950s increasingly imagined the consumer as a woman and directed her consumption almost entirely toward furnishing her home efficiently and in good taste.[15]

Experts cautioned female homemakers against the novel, the fashionable and the outré. Wrote William Pahlmann in *The Pahlmann Book of Interior Design*: "The understatement is always the greatest taste – the avoidance of gaudy junk or spurious values in everything. . . . Real taste despises the vulgar in anything."[16] Advice manuals, assuming a universal standard of good taste, instructed women to learn artistic principles of color and design and to familiarize themselves with the historical sequence of styles exemplified by period rooms in museums, books on interior decoration, and department store display rooms. Knowledge and observation promised to provide the homemaker with the skills of discrimination and judgment required to express good taste.

Good taste was, therefore, an acquired habit; yet, paradoxically, experts maintained, that genuine good taste had to be intuitive, personal, and individual. Only through learning rules and mastering conventions could the homemaker cultivate a form of taste that manifested a distinctive and personal point of view. As Harriet Burket stated in the introduction to *House and Garden's Complete Guide to Interior Decoration*: "Our aim in this book is not only to supply you with knowledge . . . but also to encourage you to express your personal taste freely in the decoration of your home."[17]

Defined as a combination of "intuition" and "knowledge" in the selection and arrangement of the interior, the formula for good taste in interior decoration invoked the qualities of "sense and sensi-

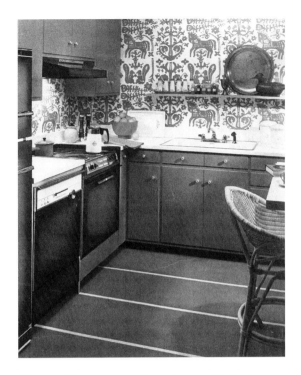

Figure 13. Kitchen. From "Beautiful, Budgetwise Three-Room Apartment," *Good Housekeeping* 157 (November 1963).

bility" attributed by the eighteenth- and nineteenth-century senti-mental novel to the middle-class female.[18] Good taste, manifested in the felicitous choice and arrangement of goods, functioned in the place of wealth or family name as a sign and reaffirmation of dis-tinction; taste served as the standard for defining a middle-class life-style without making explicit the economic basis of that standard.[19] In the United States during the 1950s and 1960s, good taste in interior design translated a "feminine" system of selection into a means of distinguishing middle-class membership when moder-ately priced, mass-produced commodities had purportedly elimi-nated class distinction.

Wesselmann's pictures – like the postwar American domestic economy that they addressed – thus contained a contradiction be-

tween the apparent universal access to goods under a democracy
and a standard of good taste and restraint derived from one specific
section of that society: the middle class. Neither collages nor domes-
tic culture, however, allowed much of that contradiction to come to
light: They both passed off the criteria of good taste as universally
valid for all Americans.

Postwar Cultural Hierarchies

To the extent that Wesselmann's representations of suburban interi-
ors such as *Still Life #30* embraced the middle-class economy of
domesticity and its standard of consumer taste, they would appear
to be objects easily scorned and rejected by critics committed to
preserving the sanctity of high-art modernism. Many critics in the
early 1960s did in fact dismiss Wesselmann in the pages of art maga-
zines. These reviewers took for granted that anything that hinted of
domesticity and consumer taste was unworthy of treatment in high-
art painting. Wesselmann's kitchens, commented Suzi Gablik, "are
curiously inert like some housewife's day-dream."[20] Quipped Vivien
Raynor about Wesselmann's still lifes: "Everything is intended to
look like, and does, some of those double-spread food ads in *Life*
that nobody looks at"[21] – nobody, that is, except perhaps female
consumers. These reviews formulated pejorative judgments issued
from a discourse on taste that assumed a qualitative difference be-
tween high-art modernism and consumer culture.

Many cultural critics and social analysts in the 1950s and 1960s,
although often writing for different ends, shared a disdain for middle-
class consumerism. Increasingly preoccupied with the growth of the
middle class after the Second World War, a number of educators,
writers, and sociologists analyzed its socioeconomic foundation and
evaluated its culture. *The Organization Man* of 1954 by William H.
Whyte, Jr., a writer and editor of *Fortune* magazine, emerged as pos-
sibly the most widely read and often quoted analysis of suburbia.[22]
Recalling his impression of being one of the few men present in the
community of Park Forest when he conducted daytime interviews
for his study, Whyte concluded that the suburbs were dominated by
the female consumer and homemaker: She watched over family,

home, and community while her white-collar husband commuted to work in the city. Whyte, in support of his conclusions about Park Forest, enumerated the metaphors coined by suburban dwellers themselves to describe their communities: "Russia, only with money," "a sorority house with kids," "a womb with a view."[23] This list revealed an association of suburbia with conformity and the female body; indeed, the "feminized" suburb served as Whyte's primary site for defining a social ethic of the middle class that required adjustment and conformity to its norms.

Whyte did not stand alone in his disparagement of the suburban middle class. Greenberg devoted his critical project to the defense of high-art modernism against what he perceived as the encroachment of middle-class culture – what he, borrowing the term from Van Wyck Brooks, called "the middlebrow."[24] Greenberg assumed, like Whyte, that middlebrow culture nurtured conformity in its consumers. He wrote in 1952: "Middlebrow culture, because of the way in which it is produced, consumed, and transmitted, reinforces everything else in our present civilization that promotes standardization and inhibits idiosyncrasy, temperament, and strong-mindedness."[25] Greenberg shared this pessimistic evaluation of middlebrow culture with a number of other cultural critics writing in the postwar period. *Mass Culture: The Popular Arts in America,* edited by Bernard Rosenberg and David Manning White, joined together the most extensive collection of writings on consumer culture published in the 1950s by cultural critics (including Greenberg) and social scientists who represented a wide range of political and aesthetic perspectives.[26] In their introductions to the collection, Rosenberg and White touched on many of the key charges leveled against consumer culture: Easily and passively consumed, consumer culture dulled the mind, debasing and leveling the standards of its audience. Warned Rosenberg: "At its worst, mass culture threatens not merely to cretinize our taste but to brutalize our senses while paving the way to totalitarianism."[27] Even the handful of cultural critics who published articles defending consumer culture in Rosenberg's and White's book (usually because they felt it was a useful tool for disseminating great art to the general population) agreed that consumer culture was generally banal and dehumanizing.[28]

A Taste for Pop

Cultural critics, worried about the growth and impact of consumer culture, endorsed high-art modernism as a means to reaffirm standards of value and thereby counter the reputed brutalizing effects of consumer culture. The originality of modernism, they argued, required discrimination and effort in order to be appreciated.[29] In 1959, Irving Howe, lamenting the advent of "postmodern literature" (by which he meant primarily Beat literature), recalled nostalgically the "anxious and persistent" search for values of the modern novelists.[30] Similarly, Greenberg promoted Abstract-Expressionist painting by claiming that it embodied quality and authenticity. These writers assumed that no critical standards – or certainly no worthwhile ones – existed within middle-class culture. They recognized only those standards of judgment and evaluation that pertained to high art, and claimed for themselves alone the prerogative of ascribing value and exhibiting taste.[31] Aesthetic taste, in other words, superseded the taste of consumers.

A number of critics in the 1950s feminized consumer culture. In his introduction to *Mass Culture*, Rosenberg, for instance, described the contemporary consumer of consumer culture as a twentieth-century version of a bored and debauched Emma Bovary.[32] In the words of sociologists Paul Lazarsfeld and Robert Merton, whose essay "Mass Communication, Popular Taste and Organized Social Action" appeared in *Mass Culture*, these consumers were "women who are daily entranced for three or four hours by some twelve consecutive soap operas." Lazarsfeld and Merton dismissed these women with a single damning phrase: They "exhibit an appalling lack of aesthetic judgment."[33] These writers pointed to female genres as examples of the most deadening forms of middle-class culture, which, they suggested, threatened to drown rapt female consumers in a sea of mediocrity.

Even Russell Lynes's famous book *The Tastemakers* of 1949, which debunked the cultural hierarchies described with such seriousness by Greenberg and others, ultimately figured the difference between cultural spheres in gendered terms.[34] Lynes, a writer and editor at *Harper's* magazine, playfully described a cultural and social hierarchy based on a general concept of taste that encompassed both

Figure 14. Herb Gehr, *High-brow, Low-brow, Middle-brow, Life* 26 (April 11, 1949). Copyright © Time Inc.

aesthetic and consumer choices: He guided the readers to their place on the social ladder according to their preferences in both art and consumer goods. According to Lynes, the highbrow, for instance, favored paintings by Picasso, Eames furniture, and French omelettes made with sweet butter, whereas the lower middlebrow preferred hunting prints, reproduction Sheraton furniture, and barbecues. In excerpting a section from Lynes's book, *Life* magazine published a photograph that linked three men, each with his class clearly demarcated by body type and clothes, with their seemingingly natural preferences for visual images: A highbrow in tweed contemplates a Picasso, a middlebrow observes a reproduction of Grant Wood's *American Gothic*, while a heavyset lowbrow in shirtsleeves stands below a poster of a showgirl (fig. 14).[35] The terms "highbrow," "middlebrow," and "lowbrow," which Lynes used to label social classes by the criterion of taste, enjoyed enormous popularity in writings of

the 1950s, especially in those texts that admitted to more than a binary opposition between modernism and consumer culture. The choice of these terms, rather than the obviously related "upper class," "middle class," and "lower class," located the criterion for distinguishing between social groups in taste rather than in wealth.

Nevertheless, even as Lynes poked fun at the categories of highbrow, middlebrow, and lowbrow by caricaturing the taste for high art and consumer goods in each social group, he also reasserted class difference specifically in gendered terms. Lynes used the pronoun "he" to refer to the highbrow and emphasized *his* understanding of "art and pure beauty." In discussing the highbrow's selection of furnishings and foods, Lynes suggested that the interior reflected highbrow taste only if it displayed genuine works of art; otherwise, the home of the highbrow was decorated by his wife, whose taste, Lynes claimed, the highbrow ignored. Farther down Lynes's hierarchy, women dominated the lower middlebrow in "matters of taste"; they decorated the home under the guidance of *Good Housekeeping* and *Ladies Home Journal*.[36] Lynes thus maintained the privilege, established by postwar cultural critics, of canonical works of art over consumer goods and of aesthetic discernment over consumer taste, and simply reinforced these hierarchies by inserting each pair into the already clearly hierarchic antithesis between masculine and feminine. In the end, Lynes hardly erased the difference between high art and consumer culture – terms highly charged in terms of class – by recognizing the existence of taste in both realms. Rather, that division emerged newly reinforced, stabilized by the categories of gender.

The means of distinction set forth by women's magazines, means that cultural critics and social scientists of the 1950s either failed to acknowledge or rejected as middlebrow, were precisely those that Wesselmann incorporated into his pictures. When critics dismissed Wesselmann's paintings by comparing them to advertisements for the middle-class female homemaker and consumer, they called forth a firmly entrenched cultural discourse that distinguished social strata by a difference in taste and that valued highbrow aesthetic culture over a feminized consumer culture.

Collapsing Cultural Hierarchies

And yet, Wesselmann's interiors could not be dismissed by art critics as easily as could a photograph from the pages of *Good Housekeeping* or *Ladies Home Journal*. If Wesselmann's interiors had simply reproduced the products of consumer culture and the visual codes of middle-class taste, they might well have been disregarded by critics as simply unfortunate representations of middlebrow taste. Disturbing perhaps, but only because the housewife's daydreams and double-spread food ads had left their appropriate place in mass-circulation magazines and ventured into the space of the gallery and art magazine. Were Wesselmann truly beside the point of high-art painting, these critics could have simply ignored him. But they did not. The sharpness of their attacks on Wesselmann may reveal a need to reassert the established cultural hierarchy in the face of a challenge to its authority. Something else about Wesselmann's images, it would seem, provoked these critics.

Perhaps what vexed the critics was that Wesselmann's interiors were not consistently middlebrow. Rather, as cultural hybrids, they mixed together the categories of middlebrow and highbrow. Over and again, these pictures confused the difference between the ideal of good taste in interior decoration and the principles of composition in high-art modernism. From the perspective of critics operating according to the cultural hierarchies of the 1950s, Wesselmann's pictures must have seemed to eliminate the difference between high-art painting and consumer culture.

Wesselmann's pictures integrated reproductions of paintings by European modern artists into a decorated ensemble designed according to the precepts of female consumer taste. Often posters and postcards of modernist icons hung on the wall alongside snippets of patterned wallpaper or as backdrops to vases of flowers and bowls of fruit. In *Great American Nude #6* of 1961, for example, a portrait of a young woman by Modigliani hangs on the back wall next to a swatch of rose-covered wallpaper and above an intricately patterned oriental carpet (fig. 15). Together these elements, including the painting, formulate a decorative and emphatically feminine interior

Figure 15. Tom Wesselmann, *Great American Nude #6*, 1961. Mixed media; 48 × 48". Collection Museum of Modern Art, Shiga. Photo Courtesy Sidney Janis Gallery, New York. Copyright © 1996 Tom Wesselmann/Licensed by VAGA, New York, NY.

Figure 16. (*facing page top*) Tom Wesselmann, *Still Life #31*, 1963. Mixed media; 48 × 60". Private collection. Courtesy Sidney Janis Gallery, New York. Copyright © 1996 Tom Wesselmann/Licensed by VAGA, New York, NY.

Figure 17. (*facing page bottom*) Tom Wesselmann, *Great American Nude #48*, 1963. Mixed media; 84 × 108 × 34". Courtesy Kaiser Wilhelm Museum, Krefeld, Germany. Copyright © 1996 Tom Wesselmann/Licensed by VAGA, New York, NY.

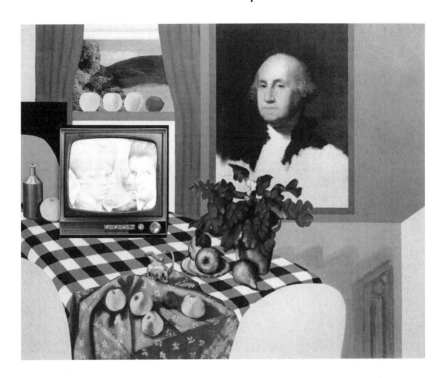

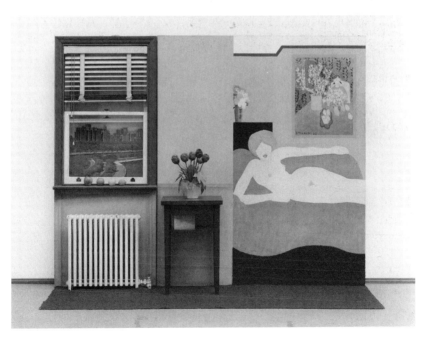

space. Or in *Still Life #31* of 1963, a table located in a modern-day, country-style kitchen has pasted onto it a section of a reproduction of a still-life painting by Matisse (fig. 16). In their new setting, the lime and four apples by Matisse play the part of the bounty brought home by an American shopper who has emptied the grocery bags on the kitchen table. The pieces of fruit by Matisse are, moreover, echoed by the lime and four apples painted by Wesselmann, which sit on the window sill or lie next to the television. Pictures by Wesselmann did not grant European modern art visual independence from 1950s suburban surroundings, but rather wove reproductions of paintings by Modigliani and Matisse into the fabric of a harmonious and decorative ensemble.

Other paintings by Wesselmann established a structural homology between European modern art and American suburban spaces. The Great American Nude and Little American Nude series from the years before 1965, for instance, often featured bodies that echoed the curves and took the poses of nudes painted by Matisse and Modigliani, yet at the same time appeared as modern-day women with blonde hair either left long and loose or cut in a Marilyn Monroe bob.[37] Alternatively, Wesselmann's interiors explicitly mimicked the arrangement of motifs in high-art pictures that ostensibly hang within their wall. A reproduction of Matisse's *Plum Blossom, Green Background* of 1948, suspended above the bed in *Great American Nude #48* of 1963, depicts a young woman behind a table laden with fruit and flowers (fig. 17). Their counterparts dwell in this contemporary American bedroom: The blonde nude poses on a divan situated next to a wood veneer table upon which rests a glazed white flower pot with six plastic red tulips. Plastic fruit, moreover, lines up nearby on the windowsill. The suburban interior reproduced the Matisse painting twice: as a poster on the wall and as an updated American version of the same scene.

Wesselmann's interiors, it might be argued, only partially disrupted cultural hierarchies, because for the most part they matched feminine consumer culture with modern artists considered, more or less, feminine. The majority of the paintings reproduced in Wesselmann's interiors were by Matisse and Renoir and themselves depicted women or fruit and flowers within a bourgeois setting.

Wesselmann and Pop at Home

Matisse and Renoir, with their use of arabesques, Impressionist strokes, and pleasing colors, formed a branch of modernism generally considered feminine and decorative, at least by postwar Americans. Texts published in the United States that analyzed representations of women by these artists consistently employed adjectives associated with the feminine: grace, tranquility, charm, elegance, delicacy.[38]

Yet even modern artists treated as unequivocally masculine, such as the hard-edge and rigidly rational Mondrian, were drawn into the compass of Wesselmann's interiors.[39] *Still Life #20* of 1962 echoes the arrangement of rectilinear forms and primary colors of the Mondrian reproduction that hangs on the wall within the depicted kitchen interior (fig. 18). The sink at bottom left constitutes a rectangle of white; the table at bottom right acts as a block of blue; the back wall forms an inverted "L" in red. Even the bunch of bananas with their black tips wittily matches the vertical strip of yellow topped by a black square in the Mondrian. The smoothly applied bright colors and precise geometric shapes of Wesselmann's kitchen emulate the austerity of Mondrian's purist painting. Thus, Wesselmann's images elided the essential difference posited by postwar critics between the rigorous and rational control associated with the arrangement of colors and forms in Mondrian's abstract painting and the "sense and sensibility" demonstrated by the 1950s housewife designing her kitchen decor.

It is not just that works by Matisse, Mondrian, and others have to share space with refrigerators and Heinz tomato catsup. Wesselmann's pictures also equated high art and commercial culture by including mass reproductions of these paintings. Famous paintings in Wesselmann's interiors took the guise of posters or postcards, and as reproductions, these high-art images lost their status as unique objects above the economic fray. Indeed, posters and postcards blurred the line between commerce and art because they transformed modernist icons into reproductions disseminated for a profit on a mass scale.[40]

The interiors featured in both middle- and upper-middle-class women's magazines and manuals on interior decoration, it is true, also occasionally included either original artworks or reproductions

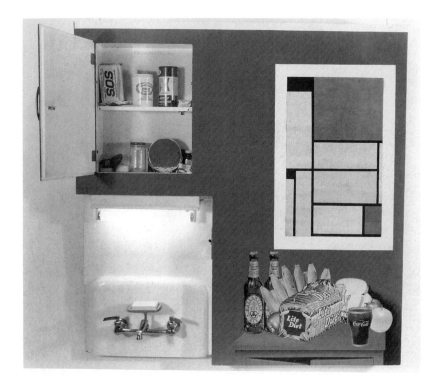

Figure 18. Tom Wesselmann, *Still Life #20*, 1962. Mixed media; 41 × 48 × 5½". Courtesy of The Albright-Knox Art Gallery, Buffalo, New York. Gift of Seymour H. Knox, 1962. Copyright © 1996 Tom Wesselmann/Licensed by VAGA, New York, NY.

on the walls; the living rooms illustrating an article, "How to Live with Taste," in *House and Garden*, for instance, hangs examples of European modern art above the sofas (fig. 19).[41] Texts on interior decoration rarely acknowledged the difference between an original and a reproduction: "Original works have a special charm because they are one of a kind," conceded Elizabeth Halsey; "however, it is wiser to hang the reproduction of a worthy painting than to display a poorly executed original. Some reproduction processes are so excellent they faithfully duplicate even the slightest brush mark. The best of these you will be able to purchase through art museums and shops."[42] Most texts on interior decoration did not dwell on the picture itself as much as on the means to integrate it successfully

Wesselmann and Pop at Home

Figure 19. Living Room with Renoir Painting. From "How to Live with Taste," in *House and Garden* 104 (October 1953).

into the home. The painting, most texts agreed, should serve as the focal point of the room and at the same time it needed to match the color of the furnishings.[43] On the one hand, interiors in women's magazines and handbooks on interior decoration reinforced a conceptual division between high art and consumer culture by granting the image, as a sign of "aesthetic value," the most important place in the room; on the other hand, they blurred the difference between the original work of art and the reproduction, and subordinated the image to the goal of a harmonious color scheme.

Wesselmann's collages similarly denied the uniqueness of the modern-art image, for they used commercially reproduced works of art and matched them to the interior furnishings by subject matter, composition, and color. Furthermore, reproductions of artworks in Wesselmann's collages join television screens and food labels as participants in the duplication and dissemination of mass entertainment and consumer goods. Wesselmann's interiors treated the circulation of high-art images as equivalent to various other economic systems that depended on the mass reproduction of images.

Wesselmann's interiors implicated high art in consumer culture, subordinating the high-art aesthetic to consumer taste. Of course, this argument could be turned on its head: Rather than suggesting that consumer culture had commandeered high-art modernism, it could be argued that consumer culture in Wesselmann's images aspired to the aesthetic merit of high art. In terms of the maintenance of cultural hierarchies, however, it made little difference which direction the argument flows: Either way, high-art modernism lost its privileged aesthetic position in opposition to consumer taste. Wesselmann's interiors blurred the line between the formal arrangement of a modern painting and the practical arrangement of the modern kitchen, between appreciating the fine arts and managing the suburban household.

Recoding Cultural Hierarchies

Yet even as Wesselmann's images conflated highbrow and middlebrow taste, they maintained a difference between high art and consumer culture by distinguishing between two forms of gendered vision. Various critics of the 1950s had gendered the concept of taste, but they did so essentially for the sake of buttressing their previous categories of class. For them to label the highbrow male and the middlebrow female was simply to inscribe the hierarchy of gender onto terms already defined along class lines. Wesselmann's pictures foregrounded the role of gendered vision, rather than taste coded by class, in formulating desire and demarcating cultural distinctions.

Wesselmann's pictures posited two types of gendered vision. On the one hand, they invited viewers to align their gaze with that of the female consumer. *Bathtub Collage #3* of 1963, for instance, displays the material possessions and well-organized household as objects of desire for the middle-class homemaker (Plate III). The presumed occupant of the bathroom was the home manager who oversaw the rational organization and cleanliness of the interior space. On the other hand, the presence of the nude positions the female body as the object of the voyeuristic male gaze.[44] Indeed, critics frequently judged Wesselmann's nudes in terms of the allure

of their bodies and evaluated the extent to which the nudes suc-
ceeded in arousing desire: Wrote one critic for *Art News*, "the Great
American Nude series, each with its curving voluptuous section of
rose-pink female arching or lolling across her vivid American envi-
ronment, is more appealing than any Miss Rheingold poster."[45]
Wesselmann's pictures thus figured woman as both subject and ob-
ject of the gaze; that is, she took the role of both consumer and
commodity. The viewer could meanwhile oscillate between the two
spectatorial positions of female consumer and male voyeur.

Nevertheless, despite this oscillation, Wesselmann's pictures over
and again granted priority to the male gaze. The presence of the
nude irrevocably transformed *Bathtub Collage #3* from a sanitized
middle-class interior seen in a woman's magazine to a representa-
tion of the female body as object of interested male attention. The
nude in *Bathtub Collage #3* hardly resembled the well-groomed and
efficient-looking homemaker of women's magazines with whom
the female consumer was often invited to identify. In advertise-
ments promoting bathroom fittings, the homemaker tends to her
children in a sparkling bathroom, or if she bathes, she nevertheless
makes use of her time to catch up on her reading (fig. 20). *Still Life
#17* of 1962, a rare example of a Wesselmann collage that includes a
homemaker of the type appearing in women's magazine, has her
smiling and beckoning to the viewer to partake in the display of
alcoholic beverages and food on the kitchen table. For the most
part, however, the women in Wesselmann's interiors take pleasure
in flaunting their bodies rather than in assuming the role of the
efficient and rational homemaker and consumer.

The vast majority of the women depicted in Wesselmann's col-
lages have blank faces or, at the most, smiling lips, and almost all of
them are nude. Seen against the homemaker of women's magazines,
the nudes in Wesselmann's collages functioned as transgressive
signs of sexuality with whom the female viewer could identify only
by becoming a body coded to arouse male desire. The young svelte
woman in *Bathtub Collage #3*, provocatively posed with thrust-out
hip, more likely embodies the postwar fantasy of the sexually avail-
able woman of leisure, the imagined playmate awaiting the playboy
more than the proper homemaker managing the suburban home of

A Taste for Pop

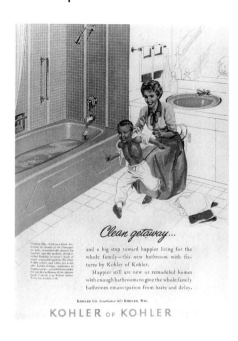

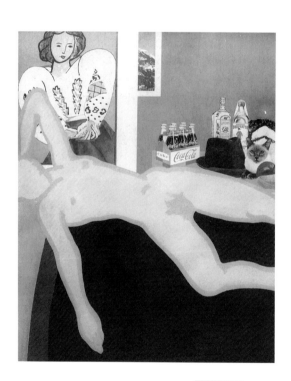

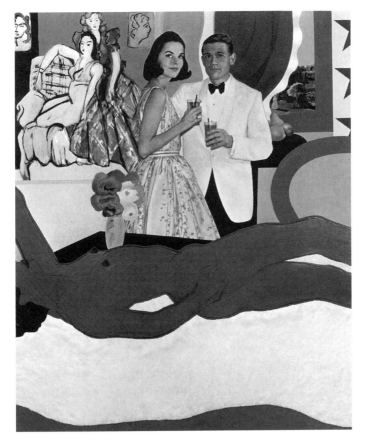

Figure 22. Tom Wesselmann, *Great American Nude #52*, 1962. Mixed media; 60 × 48″. Private collection. Courtesy Sidney Janis Gallery, New York. Copyright © 1996 Tom Wesselmann/Licensed by VAGA, New York, NY.

Figure 20. (facing page top) Kohler of Kohler advertisement. From *Better Homes and Gardens* 38 (March 1960).

Figure 21. (*facing page bottom*) Tom Wesselmann, *Great American Nude #26*, 1962. Mixed media; 60 × 48″. Private collection. Courtesy of Sidney Janis Gallery, New York. Copyright © 1996 Tom Wesselmann/Licensed by VAGA, New York, NY.

the man in the grey flannel suit.[46] In Wesselmann's pictures from after 1965, which increasingly adopted the codes of sexual display from pornographic magazines, the female became even more explicitly the object of the voyeuristic male gaze. The female object of vision, most notably the nude woman in *Bathtub Collage #3* who has clearly articulated lips but no eyes, lacks the capacity to see.[47]

Some interiors eliminated the female consumer gaze altogether. *Great American Nude #26* of 1962 recasts consumption as masculine by including on a table in the background two bottles of gin, a product that contemporary advertisements marketed primarily to men (fig. 21). A fedora of the 1950s, an obvious metonym for the white-collar man, also rests on the table and similarly claims the space of the picture as a masculine domain. The most prominent object in the room nevertheless remains a reclining female nude. The nude lacks facial features, and her body stretches out solely for the pleasure that the male viewer is invited to take in her image. Compositionally, the painting recalls Manet's *Olympia*, which itself can be read as a scene of sexual exchange between prostitute and male consumer. Wesselmann's image transforms Manet's black maid into the Russian peasant woman of Matisse's *La Blouse Roumaine* of 1940, and the startled black feline into a soft white cat; finally, it replaces the bouquet of flowers from a male admirer with the fedora. But whereas Manet's painting problematizes the male viewership position by granting Olympia a gaze of her own, Wesselmann's sightless nude cedes vision wholly to the voyeuristic consumer.[48]

On the extremely rare occasions when men themselves entered into Wesselmann's interiors, they did not function as the objects of the desiring voyeuristic or consumer gazes. From time to time, posters and postcards of early American presidents cropped up on the walls of Wesselmann's middle-class homes, portraits that personified the institutions of government and law. In *Great American Nude #34* of 1962, a bust of President Madison stares out at the viewer from behind a female nude posed in the foreground. A "father of the nation," quite literally, a giver of the law, he reigns over both the domestic interior and the female body. The painting thus included

the presence of a man only to reinvent a dichotomy between the male mind and the female body.

Great American Nude #52 of 1962 is one of the only paintings to include a portrayal of a white-collar professional (fig. 22). At first glance, this picture situates the contemporary male within the "feminized" interior as the object of the homemaker's gaze. Wearing a dinner jacket and sipping a drink, he stands at the center of an interior dominated by women and decorated with flowers, fruit, and frilly curtains. Both the man and the smiling woman in a party dress by his side look at the viewer, including her as part of their group. I say "her" because the activity and the setting establishes the scene as a cocktail party, a social gathering taking place within a well-appointed domestic interior that is properly overseen by the hostess. The middle ground of Wesselmann's picture, in other words, figures the viewer as female, and as someone capable of looking at men.

The scene in *Great American Nude #52*, however, is not a proper cocktail party. Between the guests and the viewer lies a prominent dark-skinned and nude female body. The inclusion of the woman reclining in the foreground with exposed body and erect nipples posits a male spectatorial position. The sheer size of the body, and its placement that literally blocks the hostess's access to her guests, grants sexually motivated male vision the upper hand. In the end, even this picture, which contains a man as object of the hostess's gaze, transforms the home into a site primarily for the display of the female body as object of desire for the male spectator.

Many of Wesselmann's works also prioritized the male gaze over consumer vision through their use of parody. Subtle details in Wesselmann's interiors often served to undercut the visual codes used during the postwar period for representing the well-appointed domestic interior and the standards of middle-class propriety. In *Still Life #30*, a small, framed reproduction of Picasso's *Seated Woman* of 1927 hangs above the refrigerator door (Plate II). This picture, with its surrealist reference to the unconscious and its violence to the female body, unhinges the carefully coordinated and cheerful feminine interior. Next to the Picasso, at the window, the two or-

anges on the window sill together with the erect skyscraper in the distance form a phallus.[49] Joining the domestic and public spheres and establishing its mastery over both, the phallus introduces a disruptive joke into the interior space. Wesselmann's other interiors are similarly filled with visual puns that transformed foodstuffs into sex symbols: *Great American Nude #55* of 1964, for instance, juxtaposes breasts with mounds of ice cream topped by bright red maraschino cherries. Such bawdy sex jokes, which were only to increase in the late 1960s as Wesselmann's paintings conformed ever more closely to the codes of pornographic display, violated the consumer's standard of restraint and modesty seen in women's magazines (as well as the seriousness, purity, and self-sufficiency of Greenbergian modernism).

In the early 1960s, Claes Oldenburg also appropriated and parodied the standard of good taste exemplified by interiors published in women's magazines. The orchestration of space and furnishings in Oldenburg's *Bedroom Ensemble* of 1963, for instance, roughly mimics the layout of bedroom interiors in women's magazines and books on interior decoration; yet each individual piece of furniture is grossly out of scale and skewed into a rhomboidal shape (fig. 23). The glossy, black-and-white vinyl bedspread, the fake-fur rug, the imitation zebra-skin cushions, and the absurdly marbelized lampshades hint at a homemaker unable to discern the difference between authentic and synthetic fabrics. By the standards of women's magazines, the clash of bold patterns, the simulated materials, and the exaggerated scale of the furnishings in Oldenburg's *Bedroom* violated all measures of restraint, efficiency, and honesty of materials; it manifested a taste gone bad.

Even *Art in America* joined in the fun and undercut the standards of homemaking taste through parody. In an article from 1965 entitled "The New Interior Decorators," *Art in America* embraced Oldenburg's and Wesselmann's interiors to spoof the type of pictorial essays that appeared in such women's magazines as *House and Garden*. The parody began with: "As Art in America sees it, the 'so different, so appealing' ideal home environment presented on the following pages is a New York city brownstone floor-thru inhabited by Mr. and Mrs. Ideal Couple, their teenage son and teenage daugh-

Wesselmann and Pop at Home

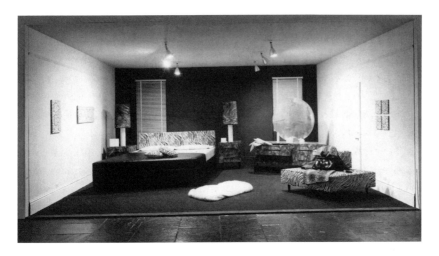

Figure 23. Claes Oldenburg, *Bedroom Ensemble*, 1963. Wood, vinyl, metal, artificial fur, cloth, and paper; 3 × 6½ × 5¼m; installation space. Courtesy of National Gallery of Canada, Ottawa.

ter. We describe the decor as you might read about it in the influential home furnishing magazine 'Apartment & Roof Garden.'"[50] Captions dripping with sarcasm guide the reader through a fictive interior consisting entirely of installations and images by various Pop artists; *Art in America* treated all of these works as accomplices in its own ironic troping of *House and Garden*.

Wesselmann's bawdy humor and parodic inversions in the home, however, amused from a specifically male perspective, because they typically drew their humor from a joke about the female body. Wesselmann's visual witticisms resemble the type of sex jokes purportedly exchanged between men in homosocial spaces such as locker rooms – jokes and places that function to exclude the proper middle-class female. Indeed, the humor of Wesselmann's images paralleled the cartoons in *Playboy* magazine that exposed the breasts of women in public places and social situations, such as restaurants or parties, in which middle-class conventions dictated proper attire and behavior.[51] A female viewer could undoubtedly laugh at the jokes in *Playboy* or at Wesselmann's witticisms, but she did so by identifying with the masculine point of view.[52] Wesselmann's dirty jokes thereby reinforced the effect of his depictions of the female

nude: Both privileged a masculine viewership position over the gaze of the female consumer.

Most important, Wesselmann's pictures hierarchized vision along gender lines by granting only the male gaze control over the very processes of representation. The nudes, objects of male desire, were always painted representations, painted, that is, by Wesselmann himself. These figures appeared as two-dimensional forms, typically in solid pink, rendered with a bare minimum of distinguishing features and outlined by thick strokes and arabesques reminiscent of Matisse. Such images hardly tried to pass themselves off as real physical women. With their multiple and overt references to art-historical precedents, Wesselmann's nudes invoked instead a long heritage of previous depictions of the nude, most notably those by Matisse and Modigliani. Indeed, critics repeatedly compared Wesselmann's nudes to high art and focused on how they were made – painted in pink, flat, sliced by the frame – rather than treating them as "real" or transparent representations of nudes.[53] The male gaze, it seemed, knew the difference between the real and the represented; it could discriminate between the two.

In contrast, the mass-produced goods and household appliances that were objects of the female consumer gaze took a variety of representational forms in Wesselmann's pictures: actual household fixtures, painted representations, and cutout advertisements that functioned either as real commercial labels or as representations of actual goods. In *Bathtub Collage #3*, an actual shower curtain hangs over the painted image of a bathtub; a real light switch is mounted on painted tiles (Plate III). Similarly, the still-life tableau of food-stuffs in *Still Life #30* combines items that were both painted by Wesselmann and cut out from magazines and various other sources[54]; yet it is impossible to tell which is which without close and careful examination (Plate II). The confusion between the real and the represented occurred in another way as well. Although both the painted and actual food labels act as representational elements in a still-life arrangement, they also attempt in the tradition of the *trompe l'oeil*, as Walter Benn Michaels argues in discussing the nineteenth-century American *trompe l'oeil*, to conceal their status as representation.[55] Not coincidentally, as we saw in Chapter 1, this

confusion of the real and the represented also happened to be the logic of advertising: Advertising depended to a large extent on the interchangeability of a label with its product. The tension between the presence of the image and the absence of the as-yet-unpurchased commodity generated the form of desire known as consumerism. Wesselmann's pictures capitalized on that confusion; his images, in short, attributed the inability to differentiate between the sign and referent to the female consumer.

Wesselmann's treatment of the female consumer gaze exemplified that which Mary Ann Doane has pointed out to be a common practice in our culture: ascribing to women a susceptibility to the image. "There is," argues Doane, "a certain naiveté assigned to women in relation to systems of signification – a tendency to deny the process of representation, to collapse the opposition between the sign (image) and the real." In contrast, the male viewer, according to Doane, has access to "spectatorial fetishism [that] is evidenced as a process of balancing knowledge and belief in relation to the reality status of the image."[56] Wesselmann's paintings constructed the same relationship of gendered gazes to systems of signification that Doane uncovers in classic Hollywood cinema: Male vision understood and commanded the processes of representation whereas female vision did not.

Wesselmann's pictures did not stop at simply gendering and thereby prioritizing vision; they also mapped that hierarchy back onto the dialectic of high art and consumer culture. In Wesselmann's pictures, the female gaze, which confused sign and referent, took as its object the various artifacts of the woman's economy of domesticity. The male gaze, in contrast, asserted its privilege over the female body through the activity of looking at high-art paintings by Matisse, by Modigliani, and by Wesselmann himself. Thus, the interiors that included nudes, whose poses were mediated through the conventions of high art, forged a link between the aesthetic and the voyeuristic gaze.

Even the kitchen interiors that did not include the nude female ultimately prioritized the high-art aesthetic gaze over the consumer gaze. Female consumer vision may at first appear to have held sway in *Still Life #30* because, for the most part, the image presents a

domestic interior that invites the homemaker to exercise her middle-class skills of consumer discernment (Plate II). The consumer gaze could judge that whereas *Still Life #30* displayed a harmonious and efficient arrangement of modern, functional appliances, it did not quite observe fashions for color and styling current in 1963. The shade of pink applied to the refrigerator, cabinets, and stove top was a few years out of date (it was more in fashion around 1958), and the bold blue, red, and yellow of the back wall did not resemble the more rustic colors seen that year in women's magazines. Similarly, the pressure-pressed formica tiles were at odds with the "natural" woods in style in 1963. The abundant and disorderly display of food on the kitchen table in Wesselmann's work, moreover, failed to conform to the codes of measured restraint seen in kitchens reproduced in women's magazines. Up-to-date consumer vision would find this scene somewhat lacking; in the end, the picture's refusal to follow the dictates of current homemaking taste remained rather inexplicable to such vision.

Yet where consumer vision reached its limits, aesthetic vision made sense of the small incongruities in *Still Life #30*. The bold colors on the back wall imitate the color schemes of Mondrian's paintings, not the contemporary standards of taste in women's magazines. And the disorderly arrangement of the food, incoherent to the consumer's eye, conforms rather closely to the high-art precedent of Dutch still-life painting.[57] The practices of painting brought order to a setting where the practices of consumerism cannot.

Wesselmann's pictures, in the end, injected new life – in new terms – to the prioritization of high art over consumer culture. In the social hierarchy described by many cultural critics and social analysts in the 1950s, highbrow and middlebrow were code words for class difference, and thus the consumption of cultural and consumer goods produced class identity. Wesselmann's images renegotiated the difference between highbrow and middlebrow. On one level, his pictures conflated icons of the highbrow modernist tradition and middlebrow mass-produced goods within the same pictorial space, thereby destroying the segregation of taste out of which various cultural critics had implicitly defined class. On another level, Wesselmann's pictures preserved the priority of painting over

other cultural artifacts by associating it with the power and control of the male gaze over the female body and over the processes of representation. That which many 1950s cultural critics performed with the categories of class, Wesselmann's pictures accomplished with the categories of gender.

Masculinity at Home

Viewers would have seen Wesselmann's collages and their reformulation of the prerogative of high art over consumer culture first within the institutional spaces of high art such as the gallery or museum; in such contexts, Pop art affirmed the priority of high art over domesticity, but never really challenged domesticity on its home turf: inside the house. Pop-art collectors, however, shifted Wesselmann's pictures, along with other Pop paintings and sculpture, back into the domestic interior. This did not go unnoticed. Beginning in 1964, bold headlines in the popular press directed attention to the way in which various collectors integrated Pop art into their homes: "Life with Pop," "The House that Pop Art Built," or "You Bought It, Now Live With It," they blared.[58] Lavish accompanying photographs exposed the interiors – and frequently the collectors and their families – to the public's scrutiny. These layouts revealed that collectors not only packed their homes with Pop art, but that they also adopted Pop's aesthetic principles to organize their domestic spaces.

Pop collectors fitted their artworks into a specific type of domestic space: the high-design modern interior. The living room in the Manhattan apartment of collectors Robert and Ethel Scull included Mies van der Rohe's famous Barcelona Chair, promoted by the Museum of Modern Art in its publication *Introduction to Twentieth Century Design* of 1959 as "the classic 'monumental' chair of the twentieth century."[59] Collectors Mr. and Mrs. Kraushar commissioned an architect to design a modern home in Lawrence, New York, specifically for their Pop-art collection. They explicitly opposed their choice of architecture, complete with soaring ceilings, exposed beams, and sliding glass doors, to the predominant style of suburban homes (fig. 24). "They both wanted to get away from the con-

formist ranch-style look which they felt was dominating suburban architecture," reported *House and Garden.* "Mrs. Kraushar, who has a larger margin of nostalgia for tradition than her husband, admits that it took her some months to be reconciled to the uncompromising modernism that her husband had chosen to build in." Although in this anecdote Mrs. Kraushar expressed a more cautious taste than her husband, she nevertheless joined him in rejecting the standard conventions of suburban interior decoration: "The decor . . . was left up to interior designer David Barrett, and the decisions, to Mrs. Kraushar, who feels that most contemporary houses are too feminine as well as too conformist."[60]

Contrary to this stereotype of conformity, the economy of domesticity actually encompassed a wide variety of styles in architecture and interior decoration ranging from traditional to modern. In the 1950s and early 1960s, women's magazines and handbooks on interior design participated in efforts to define an ideal of modern architecture appropriate for members of the middle class moving to suburbia. In 1954, the *Ladies Home Journal Book of Interior Decoration,* a volume addressed to a relatively modest middle-class reader, promoted homes in a modern style with these words:

> Gradually architects developed houses in the new style which were both functional and beautiful. . . . Understanding the principle of modern architecture is simple. It has taken many forms and will take many more, but basically the houses are horizontal in line with flat roofs, and there is a great emphasis on oneness with the outdoors. Large glass windows are everywhere, sometimes making an entire wall and opening on a porch or terrace so that the living room becomes part of the outdoors.

The houses illustrating this passage have flat low roofs, with the exception of the living rooms where sloped roofs permit one dramatic picture window. *Ladies Home Journal* drew a slight distinction between the "House of Today" in a modern style and the ranch house: "The ranch house uses many features of what we know as modern, but is apt to be more conservative."[61] Even so, popular magazines such as *Life* and *Sunset* promoted the ranch house in the

1950s as modern. Based on California prototypes and characterized by a low silhouette, large glass windows, and sliding glass doors, the ranch house promised an informal, family-oriented life-style.[62] Indeed, the appeal of what Clifford E. Clark, Jr., has dubbed the "ranch house modern" made it one of the most popular architectural styles across the nation after the Second World War.

Although some women's magazines and handbooks on interior decoration expressed concern that the modern interior was overly functional and thus inhuman, many also advocated a "casual" or "informal" modernism for the domestic space.[63] Interiors labeled as specifically "modern" or "contemporary," such as the living rooms published in *Design for Modern Living: A Practical Guide to Home Furnishing and Interior Decoration,* display large, open, pristine spaces that incorporate a limited number of spare furnishings into balanced compositions (fig. 25). The relatively inexpensive and functional furniture, designed with an eye toward simplicity of line, constructed with natural light woods or bleach wood finishes and covered with textured fabrics in solid colors, played a key role in identifying an interior as modern. Describing such spaces in 1960, *House and Garden's Complete Guide to Interior Decoration* pointed out:

> Invariably apparent is a respect and appreciation for architectural materials – marble, wood, glass, stone and metal – which are played against each other for interesting textural contrasts in backgrounds and low-slung, linear furniture. The arrangements of furniture and accessories are studiedly asymmetrical. . . . Color is used to weight small areas with brightness or lightness as a balance to large, darker masses, much as an abstract painter might compose a canvas.[64]

As the furniture demonstrated a commitment to honesty of materials and form, its arrangement in the domestic space accorded with an aesthetic of restraint and discipline. In *Design for Modern Living: A Practical Guide to Home Furnishing and Interior Decoration* of 1962, Gerd and Ursula Hatje explicitly linked this modern aesthetic to an ethic of behavior: "Whether the word 'function' was applied to intent, to manufacturing process, or to a psychological and social

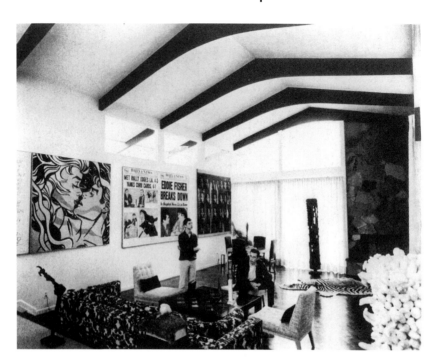

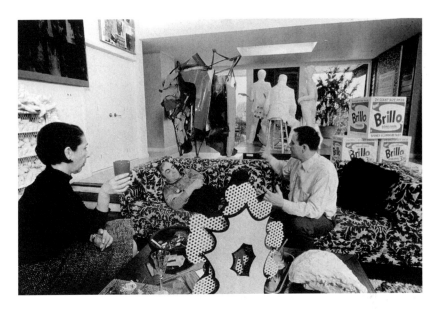

Figure 26. Henri Dauman, *Mr. and Mrs. Kraushar with art dealer Ben Birillo in the collectors' living room*. From "You Bought It, Now Live With It," *Life* (July 16, 1965). Copyright © Henri Dauman, 1965/Dauman Pictures, N.Y.C.

situation, the argument behind it was always a moral one. It was a matter of honesty and sincerity."[65]

The Kraushars were not alone in their attitudes toward suburban architecture. Many social critics and modern architects in the 1950s and 1960s also associated the ranch-style home with a social ethic of conformity. As Clifford E. Clark, Jr., explains: "Some social critics, especially sociologists who wrote about suburbia, gleefully lam-

Figure 24. *(facing page top)* Kenneth Heyman, *View of Interior of Kraushar Home in Lawrence, New York*. From John Rublowsky, *Pop Art*. Photo by Kenneth Heyman. Copyright © 1965 by John Rublowsky and Kenneth Heyman. Copyright renewed. Reprinted by permission of Basic Books, a division of Harper-Collins Publishers, Inc.

Figure 25. *(facing page bottom)* Contemporary living room interior. From Gerd and Ursula Hatje, *Design for Modern Living: A Practical Guide to Home Furnishing and Interior Decoration* (New York: Abrams, 1962).

basted ranch house developments as the tasteless hallmark of a homogenized society."[66] Owing to the link between ranch-style domesticity and conformity, the high-design modern architecture and interiors of Pop-art collectors could constitute a distancing mechanism from the middle class.

The arrangement of the interior spaces in the homes of the Pop-art collectors repudiated the spare, disciplined aesthetic of the ranch-style home. To violate the homemaker's standard of restraint, Pop-art collectors relied on some of the same strategies practiced by the Pop artworks they acquired. First and foremost, the collectors appropriated the device of hyperbole from Pop art. We have seen how countless products spilled over the tables and counter tops of Wesselmann's kitchens, and how Oldenburg's *Bedroom Ensemble* exaggerated the size of the furniture and the artifice of the fabrics to the point of excess. Likewise a disorderly array of art, furniture, and people overtook the homes of Pop-art collectors. In the pages of *Life*, for instance, a dizzying display of artworks surround Mr. and Mrs. Kraushar and art dealer Ben Birillo as they engage in animated conversation while seated in the collectors' living room (fig. 26). Art, according to various news reports, "plastered" the walls and "cluttered" the interior of the Scull apartment in New York City; art aficionados filled the space with gossip.[67] Far from the pristine and empty stagelike spaces reproduced in women's magazines, the library in the Scull's home, according to Allene Talmey in the pages of *Vogue*, "is not a passive room, built for contemplatives. It is an active one, for active readers, with hi-fi hidden in the far wall. There is jounce and bounce – like the Sculls themselves."[68] The Pop collector's home, teeming with art, music, and people, transformed the interior into a site of pleasure, leisure, and entertainment. Domestic restraint gave way to unrestrained sociability.

The interiors of Pop-art collectors as presented in the print media rejected not only the disciplined order of the female homemaker's interior, but also her self-effacement. The wives of Pop-art collectors adopted the role of perfomers in their domestic spaces rather than receding from sight once she had prepared these spaces for the use of others. In the photograph at the beginning of this chapter, Mrs. Kraushar's pose – conventional in its own right – assumes a dramat-

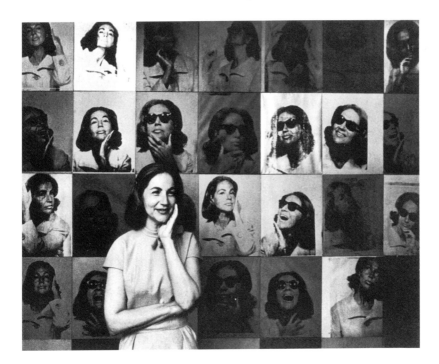

Figure 27. Kenneth Heyman, *Ethel Scull with Portrait by Andy Warhol*. From John Rublowsky, *Pop Art*. Photo by Kenneth Heyman. Copyright © 1965 by John Rublowsky and Kenneth Heyman. Copyright renewed. Reprinted by permission of Basic Books, a division of HarperCollins Publishers, Inc.

ic flavor once the viewer recognizes that she playfully emulates the activity of the nude within the Wesselmann collage on the wall near her – much as Wesselmann's interiors themselves often reiterated elements lifted from paintings reproduced within their fictive walls (fig. 11). Similarly, a photograph in Rublowsky's book of Mrs. Scull posing before a Warhol multiple portrait of her hanging on a wall in the Scull household has Mrs. Scull broadly smiling as she puts her hand to chin in imitation of one of the poses used by Warhol within the portrait itself (fig. 27). These women, far from disappearing behind the inconspicuous role of maintaining a proper household, postured, primped, and emulated artworks; indeed, by confounding the difference between themselves and the women who posed and displayed themselves in the Pop-art images hanging in their homes,

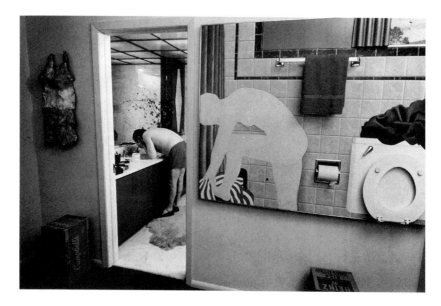

Figure 28. Henri Dauman, *Mr. Kraushar in Bathroom.* "You Bought It, Now Live With It," *Life* 59 (July 16, 1965). Copyright © Henri Dauman, 1965/Dauman Pictures, N.Y.C.

Mrs. Scull and Mrs. Kraushar demanded the same visual attention accorded to the works of art.

Similar photographs of male collectors posed in their homes near their Pop-art acquisitions had a different effect; these images suggested flirtation, or even sexual trysts, between real men and depicted women, thereby violating the moral propriety of the conventional American home. In yet other photographs published in Rublowsky's book, collector Leon Manuchin leans forward on the edge of his sofa, cigarette in hand, suavely looking over at the female nude by George Segal seated in a chair next to him; and collector Richard Brown-Baker sits beside a Roy Lichtenstein scene of romantic despair in such a position that it appears the depicted woman might actually be shedding a tear for him. A few photographs situated such implied encounters within the bathroom and bedroom, enhancing the licentious overtones. In a photograph appearing in *Life*, Mr. Kraushar bends over the bathroom sink, imitating the pose of the female nude who dries herself in Wesselmann's

Wesselmann and Pop at Home

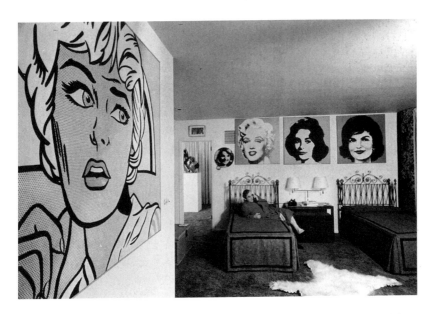

Figure 29. Henri Dauman, *Mr. Kraushar in Bedroom*. "You Bought It, Now Live With It," *Life* 59 (July 16, 1965). Copyright © Henri Dauman, 1965/Dauman Pictures, N.Y.C.

Bathtub Collage #1 (fig. 28). Although the scene almost exactly reiterates the picture of Mrs. Kraushar in Rublowsky's book, the opposite sex of the collector in the bathroom – and his lack of clothes – hint strongly at a liaison between the man in boxer shorts and the depicted female nude. In another photograph from *Life*, Mr. Kraushar lounges on his bed dressed only in a bathrobe while surrounded by a bevy of women: Warhol's silkscreens of Marilyn Monroe, Elizabeth Taylor, and Jackie Kennedy, and a nurse painted by Lichtenstein hang on the walls (fig. 29). The Pop-art collectors distanced themselves from the homemaker's world of propriety and restraint; these interiors appeared to be the domain of a set of ribald male collectors seemingly given over to sexual excess.

The sexualization and masculinization of the Pop-art collector's interior paralleled another cultural figure of the 1950s and 1960s who rejected the supposed conformity and femininity of conventional domesticity: the Playboy. As Barbara Ehrenreich points out, Hugh Hefner, in *Playboy*'s inaugural editorial in 1953, "announced

his intention to reclaim *the indoors for men.*" The Playboy initially procured the urban penthouse as his pad, but by the late 1950s and early 1960s, the house joined the apartment as an object of Playboy desire. The magazine emphatically insisted, however, that he not select a home in the suburbs:

> When it comes to buying or building a weekend retreat, his options in design are woefully few: instead of having his choice of country or country houses to complement his city penthouse, he finds himself confronted with Kozy Kottages or split-personality ranch houses or gas-station-modern monstrosities. These, he discovers, are all "oriented." They may be family oriented, kitchen oriented, children oriented, suburb oriented, economy oriented. None seems to have been designed for the man who, perhaps like you, wants his own place away from the city's hurly-burly. . . . [69]

The Playboy escaped this morass of homemaker's housing options by living instead in decidedly modern structures, often designed by name architects and located in exotic and unpopulated geographic locations such as "the country," "the oceanside," and "the desert oasis." In 1959, for instance, the pages of *Playboy* offered as a suitable "Weekend Hideaway" a sprawling modern "bachelor's haven" tucked away in the woods (fig. 30).[70] All glass construction – recalling Philip Johnson's famous Glass House of 1949 in New Canaan, Connecticut – allows dramatic views from the interior onto the lake, pool, woods; the living room has two fixed and six sliding glass panels so that a full twenty feet of floor-to-ceiling glass walls can be opened onto the pool. The Playboy filled his hideaway with furniture by name designers, including a Charles Eames lounge chair, a drop leaf table by Bruno Mathesson, a Jens Risom stacked modular chest and stools by George Tanier. Whereas the homemaker may have borrowed some principles from abstract art to balance the composition of her interior, the Playboy chose both buildings and interior furnishings that were themselves works of modern art and design.

The Playboy's selection of architecture and furniture aligned him with the modern artistic taste promoted by institutions such as the

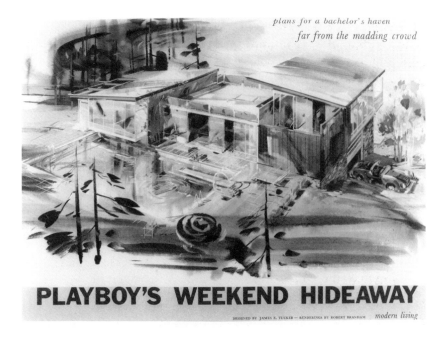

plans for a bachelor's haven
far from the madding crowd

PLAYBOY'S WEEKEND HIDEAWAY
DESIGNED BY JAMES E. TUCKER — RENDERINGS BY ROBERT BRANHAM *modern living*

Figure 30. *Playboy's Weekend Hideaway. Playboy* magazine (April 1959). Copyright © 1959, 1987 by Playboy. Used with permission. All rights reserved.

Museum of Modern Art in New York. Beginning in the 1930s with two landmark exhibitions – Philip Johnson's and Henry Russell Hitchcock's exhibition "Modern Architecture: International Exhibition" of 1932, and Philip Johnson's exhibition "Machine Art" of 1934 – the Museum of Modern Art defined a standard of quality in modern architecture and design based on Bauhaus functionalism.[71] After the Second World War, the museum continued to promote modern architecture and design with its permanent collection, its International Competitions for Low-cost Furniture Design begun in 1947, and Edgar Kaufmann's series of exhibits entitled "Good Design" held between 1950 and 1955. In the 1950s, the museum also published several important educational treatises on architecture and design that championed many of the same practitioners and principles of modernism first promoted in the 1930s. For instance, *Built in USA: Post-War Architecture* of 1952 canonized Frank Lloyd

93

Wright, Mies van der Rohe, and Le Corbusier as the inspiration for all modern architecture while acknowledging the variety of its stylistic practice. Likewise, *What Is Modern Interior Design?* of 1953 included numerous interior spaces designed by the likes of Wright, Mies van der Rohe, Richard Neutra, Marcel Breuer, and Aino and Alvar Aalto; these harmonious and coherent ensembles filled with lightweight furniture defined the museum's ideal of a modern interior. The buildings and the interiors in these texts – even the range of household objects included in *Introduction to Twentieth Century Design from the Collection of the Museum of Modern Art* of 1959 – shared an aesthetic of simplicity and functionalism.[72]

The museum's publications of the 1950s promoted a clear standard of judgment and evaluation when it came to selecting modern architecture and design. In the opening paragraph of *Built in USA: Post-War Architecture*, Philip Johnson pronounced with enormous self-assurance: "The battle of modern architecture has long been won. Twenty years ago the Museum was in the thick of the fight, but now our exhibitions and catalogues take part in that unending campaign described by Alfred Barr as 'simply the continuous, conscientious, resolute distinction of quality from mediocrity – the discovery and proclamation of excellence.'"[73] A committee of experts selected the buildings reproduced in this book with Henry Russell Hitchcock, with whom Johnson had organized the exhibition of International Architecture in 1932, as the final judge. Hitchcock stated his criteria explicitly: quality and significance of the moment. Similarly, Arthur Drexler in *Introduction to Twentieth Century Design* insisted that curators at the museum selected the objects in the Design Collection based on standards of aesthetic quality, formal ideals of beauty, and historical significance.[74]

The Playboy's domestic aesthetic was thus modeled on a form of taste that cast itself as artistic appreciation. This taste encompassed more than just architecture and furniture. The *Playboy* reader, as the magazine imagined and formed him, favored expensive sports cars, fine foods, quality wines, jazz, and Abstract Expressionism. The seriousness and individuality of Abstract Expressionism made it the Playboy's art of choice. Hugh Hefner himself hung a painting by Jackson Pollock in the main hall of his mansion, and in his mani-

festo, "The Playboy Philosophy" of 1963, he cited Pollock, Willem de Kooning, and Franz Kline as "creators of the most important and most influential work of any artists of our time." Pollock, in particular, exemplified a rebellious independent spirit that the Playboy hoped to claim as his own.[75]

The Playboy's knowledge and appreciation of fine art aligned him with the connoisseur's approach to collecting. Most ranked some motives for collecting art as more admirable than others. In "The Collector as a Guide to Taste" of 1958, George Heard Hamilton heaped accolades on the collector driven by aesthetic appreciation: "An art collection, formed with knowledge, experience, and that rare capacity to love works of art in and for themselves, this being the combination of qualities which make up that elusive element known as taste, demonstrates our understanding of the profound spiritual realities of our time."[76] Art journals in the late 1950s and early 1960s pointed to Ben Heller, who owned many examples of Abstract Expressionism, as a model art collector; he combined judiciousness with aesthetic appreciation of high-quality works of art. He even published an article on "The Roots of Abstract Expressionism" in 1961 in which he adopted the authoritative role of art critic and demonstrated his erudition by explicating the origins of Abstract Expressionism, defining it as an art movement, and quoting from one of the leading art critics of the day, Harold Rosenberg.[77] In photographs of Heller's living room and dining room spare modern furniture is grouped in the center of the room to leave plenty of space to view the paintings by Pollock, Rothko, and Kline on the walls. Heller's interior functioned as a silent, evenly lit stage for the reverential contemplation of artworks (fig. 31).

The Pop-art collector shared with the Playboy and art collectors such as Heller an appreciation for high-design modern architecture and furniture, and, like them, he assumed the role of the collector in charge of both the art and the domestic interior. The articles on Pop-art collectors recounted the same tale of adventuresome male collectors whose wives initially expressed skepticism about the artworks they selected; the wives in these narratives thus personified conservative taste. "[Mr. Scull] goes alone on these expeditions, leaving Mrs. Scull, an attractive blonde, with a slight figure and a talent for

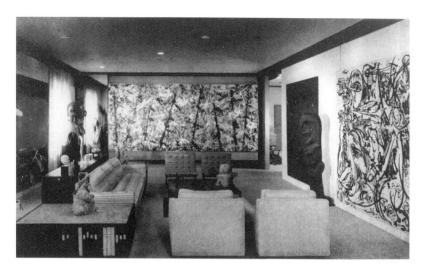

Figure 31. Ben Heller's Living Room with Pollock's *Blue Poles*. From *ARTnews* 60 (September 1961).

small talk, with the children," confided *Vogue*. "Sometimes Mrs. Scull likes what he buys, sometimes she can not stand it. . . . He is the boss, he is the buyer."[78] *Life* magazine reported that Mr. Kraushar "was first smitten by pop art two years ago when he came upon a painting forthrightly titled *Hand with Sponge*. His wife was unimpressed."[79] Kraushar implicitly dismissed his wife's preference for Impressionism as too conventional and refined in contrast to his bold taste for Pop: "My wife introduced me to art. About five years ago we began collecting – mostly French postimpressionist and other European works. I was never particularly sympathetic to these paintings. I found the preciousness of the image stale. . . . It was when I discovered pop art that I became really involved. Here was a timely and aggressive image that spoke directly to me about things I understood."[80]

And yet in crucial ways, the Pop-art collectors repudiated the practices of the Playboy and the connoisseur as surely as they eschewed the standards of the female homemaker. Mr. Kraushar, relegating the Playboy's and Heller's taste for Abstract Expressionism to the past, described himself as "strictly a Big Beat Man who con-

siders jazz as passé and as dead as abstract expressionism." Indeed, Pop-art collectors presented themselves as a brash alternative to the type of taste and erudition exemplified by the Playboy and the connoisseur. Kraushar, who began collecting art in 1961 and quickly amassed one of the largest private collections of Pop art, did not justify his taste by claiming knowledge or aesthetic appreciation when he explained in *House and Garden*: "I decided to get a few paintings. It seemed to be the thing to do; everyone else was doing it. . . . Collecting became a big thing in my life. I had never set foot in a museum until four years ago. . . . I became addicted, unequivocally hooked by pop art."[81] These collectors relied upon sheer enthusiasm combined with business acumen, rather than the connoisseur's standard of quality and aesthetic distinction to acquire and display Pop art. Mr. Scull, described as "a dark-haired man with explosive energies, a neat way with wit, and a garrulous, amusing way of talking,"[82] pronounced in *Time* magazine: "I don't presume to know a great work of art from a so-so effort. I simply buy what I feel I want to own, and I live with these things. I just love them."[83]

Pop-art collectors, moreover, refused to maintain the tone of high seriousness about home, furniture, and art that characterized the Playboy and the connoisseur. The Playboy might joke about women and sex – indeed the *Playboy* party jokes featured in each issue on the back of the centerfold focused on little else – but art, jazz, architecture, and interior decor required earnest attention and the careful exercise of a refined appreciation for honest craftsmanship, quality, and beauty. Pop-art collectors, in contrast, adopted a humorous stance toward their collection and their homes quite similar to Wesselmann's bawdy humor. The Sculls, for instance, played around with their art rather than maintaining a reverential distance from it, as *Time* magazine reported: "In the lobby [sits] a life-size plaster cast of one of the Met's curators, Henry Geldzahler, made by sculptor George Segal. For the Sculls, the plastered Henry has become a household pet. Scull likes to feel Henry's pulse. 'How pale you look,' he murmers."[84] In *Ladies Home Journal*, Mr. Scull gleefully poses seated next to Segal's sculpture of Henry Geldzahler as if deep in

conversation with him. The photograph in the pages of *Life* display-
ing Mr. Kraushar in his boxer shorts manifests a naughtiness on the
part of the collector that echoes Wesselmann's risqué demeanor; it
would have been unimaginable to see the distinguished Ben Heller
in such a pose. Satire sprung as well from the play between real and
representation; like Wesselmann punning visually between real re-
frigerators, fake fruit, and painted nudes, Pop-art collectors drew a
laugh as they knowingly treated sculpted figures as people and
posed real people as works of art. Again, Ben Heller's living room
provides a fine counterpoint, where a *cordon sanitaire*, a veritable
moat of unencumbered carpet separated the art on the walls from
the space for the living. The Pop-art collectors' ribald humor came
frequently at the expense of women, to be sure, but their humor was
directed as well toward the self-importance and solemnity main-
tained by the Playboy and the connoisseur toward works of art and
their own finely crafted interiors.

Most significantly, the Pop-art collectors exercised their ribald
taste not in some urban pad or isolated hideaway, but rather at the
very heart of the domestic interior and the family. Whereas the Play-
boy retreated from the world of female domesticity by escaping into
his private bachlordom, the Pop-art collectors, identifying them-
selves as husbands and fathers, asserted their manner of organizing
the home within the space of the family itself. The entire Scull family
gathers around the dining room table for dinner in the pages of
Rublowsky's *Pop Art*. In the pages of *Life*, Mr. and Mrs. Scull enact a
scene of domestic partnership in front of Oldenburg's stove. And the
scene of Mrs. Kraushar posing in the bathroom in emulation of
Wesslemann's *Bathroom Collage #1* brings the svelte playmate of the
picture into the marital *boudoir* of the long-married couple.

The Pop aesthetic, in essence, had returned home. If Wessel-
mann's paintings had recast along gendered lines the priority of
high art over consumer culture, of highbrow over middlebrow, of
male artist over female homemaker, that reassertion of prerogative
remained isolated from the American domestic setting – as isolated
as the Playboy in his pad or hideaway – as long as Pop-art paintings
such as Wesselmann's remained confined in the established sancta
of high art, the gallery and the museum. Only when the Pop-art

collectors integrated Wesselmann's paintings back into the family's domestic interior had the cycle been completed. Wesselmann had appropriated and reworked the visual codes of the postwar domestic economy; his collectors used his standards of taste to reestablish masculine control over the home.

Chapter 3

Lichtenstein's Borrowed Spots

A young brunette stares, horror-struck, at the glass she balances between her well-manicured fingertips (fig. 32). Black Ben Day dots, large and regularly spaced, bedeck the enormous, offending goblet. The heroine – we can read her despairing cry in the comic-book dialogue bubble floating above her head – wails: "SPOTS! AND DAVE'S BOSS IS COMING FOR DINNER! HOW WILL I COPE?!" Is this a frame from a romance comic book published in the 1950s? A painting from the early 1960s by Pop artist Roy Lichtenstein? No! It is a coupon from 1988 offering the consumer a savings of one dollar off the purchase price of Sunlight automatic dishwasher detergent.

In recent years, advertising firms have revived a period style derived from Lichtenstein's paintings of the 1960s that the industry itself refers to as a "Pop-art" or "cartoon" style.[1] This, however, has not been a new practice: The advertising industry has appropriated Pop art since the early 1960s when it frequently emulated Lichtenstein's comic-book style and his scenes of romance. Of course, to produce his paintings Lichtenstein, conversely, borrowed from a source in consumer culture: comic books with themes of war and romance published in the years following the Second World War.[2] To borrow, however, was not necessarily to reiterate blindly. Each appropriation participated in contestations about the relationship between high art and consumer culture, about standards of taste in art and advertising, and about the gender politics of representation.

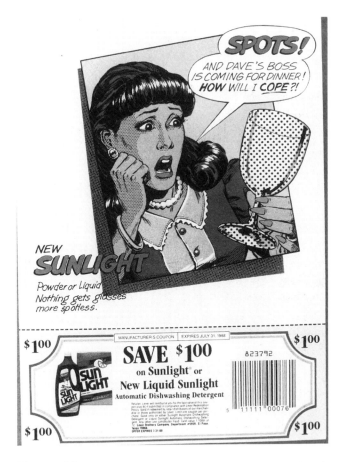

Figure 32. Coupon for Sunlight automatic dishwasher detergent.

Lichtenstein's paintings of war and romance from the early 1960s locate gender at the heart of the relationship they establish between high art and consumer culture. On one level, the issue of gender in the war and romance paintings seems obvious, even openly acknowledged by the paintings themselves: the paintings foreground the gender conventions that distinguish the war comic books from the romance comic books. A comparison between the paintings and their sources demonstrates, however, that the paintings exaggerate the difference between the proper space, voice and affect of masculinity and femininity as they are expressed in the war and ro-

mance comic books. The paintings not only codify the gender roles in comic books, but they also draw attention to these roles as figured representations; that is, they highlight the manner in which gender differences are rhetorically constructed. This practice reestablishes a priority for high art over consumer culture by claiming for the paintings the ability to define both the gender roles and the processes of representation that are performed, ostensibly without self-consciousness, in comic books.

On another level, the gender politics of Lichtenstein's paintings derive from the heated critical debate that raged in the early 1960s about whether Lichtenstein parroted his comic-book sources or transformed them. Indignant critics accused Lichtenstein of "copying" his comic-book sources and thereby undermining the difference between high art and consumer culture. In turn, various other critics marshaled the stylistic differences between Lichtenstein's paintings and his comic-book sources to a defense of his paintings as art. In the process, this second group of critics granted Lichtenstein's paintings a distance from his sources on formalist grounds. More importantly, they implicitly coded this type of formalist detachment as masculine just at a moment when the masculinity of American high-art modernism was in crisis.

Nevertheless, the high-art authority of Lichtenstein's style was not stable; his style could be appropriated by different groups for different purposes. In several cases, the advertising industry borrowed Lichtenstein's comic-book style and romance themes for the purpose of selling consumer goods to female shoppers. These advertisements reclaimed Lichtenstein's style – and powers of transformation – for consumer culture. The advertisements did so, however, in a manner that did not challenge basic assumptions prevalent after the Second World War about the relationship between homemakers and consumer goods.

Love and War

Lichtenstein's reliance on comic books has, over the years, been amply documented: We know that Lichtenstein, instead of inventing his scenes, pirated his characters and dialogue from published

comic-book stories.[3] With few exceptions, Lichtenstein avoided identifiable comic-book superheroes such as Superman and Wonder Woman. He also steered clear of the controversial genres of crime and horror comic books believed by some in the 1950s to cause juvenile delinquency and subsequently regulated by the Comics Code Authority established in 1954.[4] Instead, he selected recognizable types and standard scenes from the growing number of war and romance comic books published for a burgeoning teenage market in the period after the Second World War. Although comic books directed toward a male audience greatly outnumbered those intended for both sexes or for a specifically female readership, Lichtenstein chose his examples about evenly – perhaps slightly favoring the romance comic books – from the two genres that divided the teenage audience by sex into two distinct halves. Moreover, despite the range of Lichtenstein's subject matter in the early and mid-1960s, journals, newspapers, and catalogues most often selected his war and romance comic-book paintings for inclusion in their pages; of all of Lichtenstein's paintings, *Drowning Girl* of 1963 was the most frequently reproduced, even gracing the cover of *Artforum* in June 1966.

The pleasure offered by the war and romance comic books to the teenage reader of the 1950s and early 1960s probably lay to a large extent in their predictability: the basic features of narrative development and conclusion – multiple crises leading to a happy ending – were already known and reconfirmed on each reading. Indeed, numerous writers on mass culture have pointed out that although many cultural critics have dismissed various popular texts for their formulaic narrative structures, these formulas are precisely what make the texts appealing to their readers.[5] As a crucial component of that predictability, the comic books provided the pleasure of creating and managing gender roles in a relatively unambiguous manner through their plots. Men fought and won battles, and women fell in love and married. The narrative structures of the comic books constructed, contained, and fulfilled the desires, anxieties, and satisfactions that in the United States of the 1950s constituted a normative view of masculinity and femininity.

Through the scenes that they depict, Lichtenstein's paintings

consistently establish an absolute difference between the gender roles in the war and romance comic books. Lichtenstein's war canvases of preponderantly young, clean-shaven men engaged in battle reiterate the way in which war comic books assign their young, action-oriented heroes to inhospitable spaces – treacherous jungles, deserts, oceans, and skies – marked as war zones by the presence of artillery, explosions, tanks, planes, and Nazi and Asian enemies. In this respect, paintings and comic books alike conform to Jane Tompkins's analysis of the western in that these images present male heroes battling other men far from the "civilizing" signs of women and domesticity.[6]

Lichtenstein's romance paintings, in contrast, almost always situate women in domestic settings. Here the paintings draw lines more narrowly than do the romance comic books, which position women not exclusively in the home, but also in offices, restaurants, and domesticated outdoor spaces such as beaches, backyards, and shopping districts. In the story from a comic book entitled *Secret Hearts* (fig. 33), from which Lichtenstein lifted the image for the painting *Hopeless* of 1963 (Plate IV), the heroine takes an active role outside the home – capably assisting a man with car repairs, for instance – and enjoys the authority of speaking to others in a first-person voice. Lichtenstein, however, avoided such public scenes and instead chose the final frame of the story, in which the heroine retreats to her bedroom to brood to herself in romantic despair.

Over and again, Lichtenstein, by selecting the tense, climactic moments in the narratives when the affects of masculinity and femininity are at their most extreme, polarizes gender roles in his paintings that are constructed less rigidly by the comic books. In the war paintings, soldiers prove their manhood by demonstrating control and determination in their actions. Such acts in the war comic books are the means through which greenhorns earn acceptance into the adult male ranks of hardened soldiers. Yet whereas comic books also portray scenes in which young G.I.s undergo various setbacks, Lichtenstein's war paintings virtually always depict pilots and soldiers only as they confront and defeat the enemy. *Whaam!* of 1963, for instance, presents a panel from the comic-book story *Star Jockey* in which a lone pilot, who has been mercilessly chased, at-

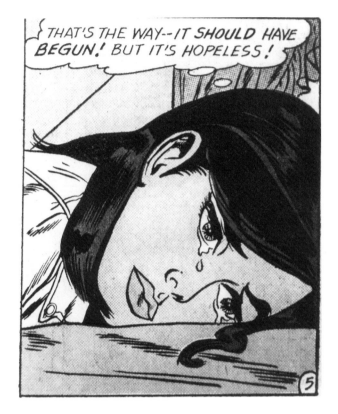

Figure 33. Tony Abruzzo, panel from "Run for Love!" *Secret Hearts* 83. Lettering by Ira Schnapp. Copyright © 1962 DC Comics. All rights reserved. Used with permission.

tacked, and disoriented by the enemy, finally turns his fighter jet around and bravely faces his pursuers in a climactic scene of gunfire and explosion. In *Whaam!*, the black-and-white helmet, its rounded shape and colors imitating the bucket seat and the glass bubble of the cockpit, transforms the male body into a sleek mechanical component indistinguishable from the plane itself – a military machine of the sort that Susan Jeffords has labeled the deferred male body (fig. 34).[7] Male body and technological weapon fuse to demonstrate their potency in a climactic scene of spectacular action.

With the single exception of *Scared Witless* of 1962, Lichtenstein's canvases avoid the numerous scenes in war comic books where the

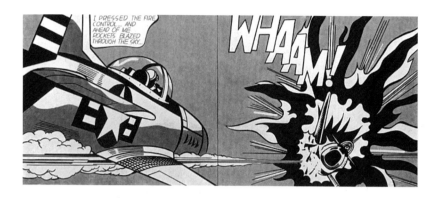

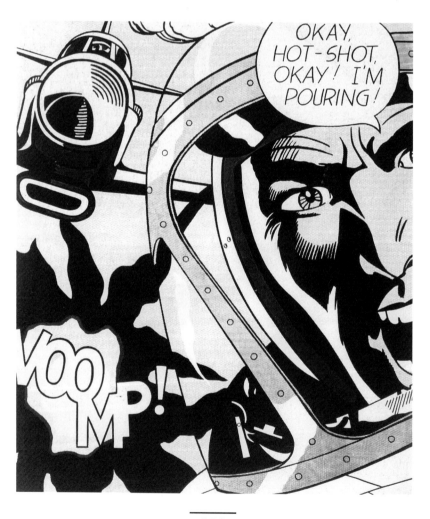

Figure 36. Russ Heath, panel from "Haunted Tank vs. Killer Tank": *G.I. Combat* 94. Lettering by Gaspar Saladino. Copyright © 1962 DC Comics. All rights reserved. Used with permission.

Figure 34. *(facing page top)* Roy Lichtenstein, *Whaam*, 1963. Magna on canvas; two panels, overall 68 × 160″. The Trustees of the Tate Gallery, London. Photo courtesy of Leo Castelli. Copyright © Roy Lichtenstein.

Figure 35. *(facing page bottom)* Roy Lichtenstein, *O.K. Hot Shot*, 1963. Oil and magna on canvas; 80 × 68″. Collection of Mr. Remo Morone, Turin, Italy. Photo courtesy of Leo Castelli. Copyright © Roy Lichtenstein.

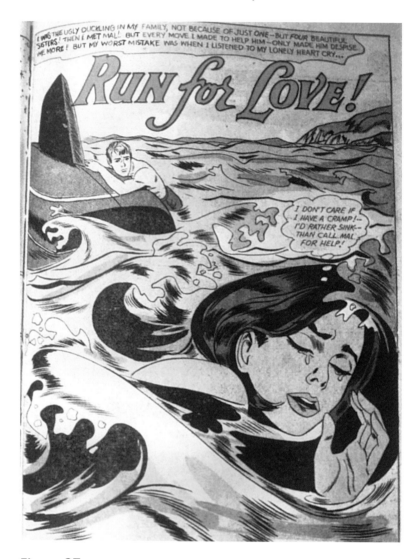

Figure 37. Tony Abruzzo, panel from "Run for Love!" *Secret Hearts* 83. Lettering by Ira Schnapp. Copyright © 1962 DC Comics. All rights reserved. Used with permission.

faces of the greenhorns express anxiety and fear. These pictures portray instead the likes of the pilot from *O.K. Hot Shot* of 1963, who contorts his finely chiseled face into a grimace of focused fury as he attacks the enemy (fig. 35); Lichtenstein even eliminated from this countenance the droplets of sweat that suggest panic and fear in the

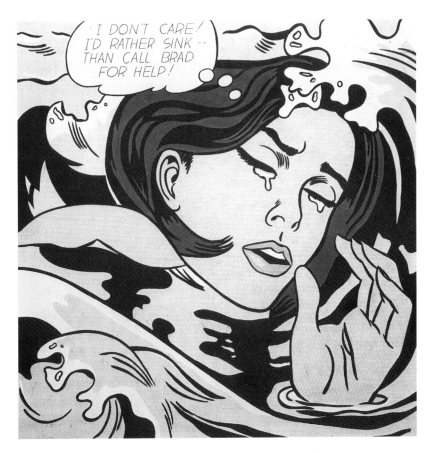

Figure 38. Roy Lichtenstein, *Drowning Girl*, 1963. Oil on canvas; 68 × 68″. The Museum of Modern Art, New York, Philip Johnson Fund and gift of Mr. and Mrs. Bagley Wright. Photo courtesy Leo Castelli. Copyright © Roy Lichtenstein.

painting's comic-book source (fig. 36).[8] Expressions of grim determination and anger in Lichtenstein's war paintings manifest the resolution of fighters to emerge victorious from battle.

If Lichtenstein's soldiers enjoy moments of success, the women in Lichtenstein's romance paintings are caught in the throes of anguish. Almost all of the young, middle-class blondes and brunettes in Lichtenstein's paintings – their status indicated by stylish hairdos, manicured fingernails, and trim dresses ornamented with a few tasteful jewels – pucker their pert mouths and wrinkle their eye-

brows and upturned noses into grimaces of tension and anxiety. In the romance comic books, frames featuring close-up views of over-wrought female faces occasionally interrupt extended narratives that uniformly culminate in the fulfillment of love. Among Lichten-stein's paintings, however, only a few scenes of resolution, in which men offer tokens of commitment in the form of a kiss or an engage-ment ring, interrupt a virtually consistent collection of women in crisis. Yet even in Lichtenstein's *Engagement Ring* of 1961, a possible marriage proposal between a well-heeled young couple appears to cause anxiety rather than pleasure.

These canvases of overwrought emotion frequently eliminate from the comic-book sources parts of text, incidental characters, and features of the setting in such a way as to highlight the tense, anxious female face alone while dispensing with narrative context or resolution. Whereas a frame from the story *Run for Love* of 1962 (fig. 37) includes a hero hanging onto an overturned boat, a cliff that gives a sense of distance to the shoreline, and text that fills out the story, Lichtenstein's *Drowning Girl* of 1963 zooms in on the isolated head of the heroine (fig. 38). Surrounded only by the waves and foam of the sea, the woman closes her eyes, while tears run down her cheeks; she appears to drown as much in her emotional sorrow as in the threatening waters. *Hopeless* (Plate IV), which reiter-ates quite closely the tear-drenched face of a young heroine, does include the complete text from the comic-book source (fig. 33). Yet Lichtenstein's painting omits the window curtain in the back-ground and instead fills almost the entire frame with the heroine's tear-streaked face. With the thought bubble narrowed, centered, and lowered next to the head, the heroine's words are more closely associated with her emotional expression; Lichtenstein's stylistic al-terations accentuate the feminine affect of debilitating emotion. Femininity in the comic books, according to these paintings, con-sists of the display of inner emotional turmoil; facial expressions serve as the traces of the effects of actions that have taken place elsewhere, and testify transparently to the heroines' personal re-sponses to romantic crises.

Women only manifest the same level of self-control as the sol-diers in the war paintings in a handful of paintings of homemakers

with household merchandise. In *Refrigerator* of 1962, originally titled *Women Cleaning*,[9] an efficient homemaker glows with happiness as she invites the viewer to admire the gleaming shelves of her refrigerator. In other paintings such as *Spray* of 1962, *Sponge* of 1962, and *Step on Can with Leg* of 1961, manicured hands and high-heeled shoes effortlessly operate various household products and appliances. These paintings parrot images from contemporary advertisements that promoted labor-saving devices by promising more ease and efficiency in household work and greater cleanliness of the home; this type of advertisement actually dated to the 1920s when housework was first turned into a profession compatible with middle-class status.[10] Lichtenstein's paintings reconstruct a homemaking sphere in which women consume household merchandise rationally and manage immaculate and well-ordered interiors; in *Refrigerator*, the homemaker's labor generates a happy face and hardly disturbs the woman's well-groomed appearance. Lichtenstein's women, in short, attain self-control and emotional stability in an orderly homemaking world devoid of men.

The war and romance paintings accentuate the difference between masculinity and femininity through the relationships they establish between image and text in the two types of scenes. For the war paintings, Lichtenstein did not copy the abundant musings and conflicting emotions that in the comic books fill the thought bubbles of young and scared greenhorns. Rather, the paintings deliver concise, decisive, and action-oriented commands or assertions – the type of text reserved for taciturn veterans and battle scenes in the comic books. The text in *O.K. Hot Shot*, "OKAY, HOT-SHOT, OKAY! I'M POURING!," is even more abbreviated than its source because it retains only one of the original three phrases from the comic-book frame.[11] The titles of Lichtenstein's paintings accentuate the close-clipped language of the heroes by repeating the terse statements and explosive sounds in the images: *Tex, Torpedo Los, Blam, Takka Takka*. When occasional thought bubbles appear in the war paintings, the words, rather than opening up an arena of internal rumination, direct the viewer back toward other soldiers or battle scenes. In *Bratatat* of 1963, the thought bubble reads: "THIS HOT-SHOT JET OUTFIT I'M IN WILL TREAT ME LIKE A VET PILOT WHEN I RETURN FROM MY NO.1

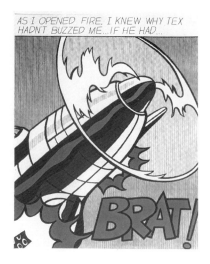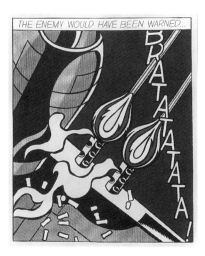

Figure 39. Roy Lichtenstein, *As I Opened Fire* . . . , 1964. Magna on canvas; three panels, each 68 × 56". Stedelijk Museum, Amsterdam. Photo courtesy Leo Castelli. Copyright © Roy Lichtenstein.

WINGDING WITH A REPORT OF − TARGET DESTROYED!" In Lichtenstein's paintings, the laconic heroes prefer action to words.

The sparse language in the war paintings often grants the fighting men authoritative and wide-ranging knowledge about the world they inhabit. Wendy Steiner has noted that the text in Lichtenstein's war pictures, although usually referring to external action, does not always describe the specific scene shown in the paintings. Rather, the first-person declarative statements or narrative captions often call attention to an activity that takes place outside of the frame. In *As I Opened Fire* of 1964, for instance, a sequence of three panels takes a progressively closer view of machine gun barrels attached to the wing of an airplane at the same time as the words introduce the bigger picture of tactics involved in the battle (fig. 39): "AS I OPENED FIRE, I KNEW WHY TEX HADN'T BUZZED ME. . . . IF HE HAD . . . THE ENEMY WOULD HAVE BEEN WARNED . . . THAT MY SHIP WAS BELOW THEM. . . . " The hero's words turn him into an omniscient narrator, and the captions thus play a role quite similar to that of the voice-over in films. Kaja Silverman has argued that the voice-over in cinema serves as a disembodied authority: "On other occasions, as in many traditional docu-

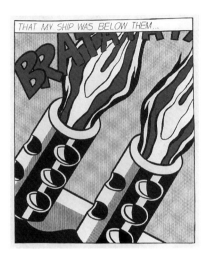

mentaries, the voice-over seems separated from the fiction by an absolute partition . . . it becomes a 'voice on high' . . . a voice which speaks from a position of superior knowledge, and which superimposes itself 'on top' of the diegesis. To the degree that the voice-over preserves its integrity, it also becomes an exclusively male voice."[12] The captions in *As I Opened Fire*, though phrased in a first-person voice that locates the speaker in the action, suggest in this same manner a consciousness that grasps the entirety of the battle; the conflation of first-person and narrative voices has the effect of attributing to fighting men omniscient knowledge of their situations.

The dialogue bubbles of the romance paintings contain anguished internal thoughts rather than external directives. They expose the romantic desires and anxieties – words of empathy, hurt pride, frustration, and despair – that seem to overwhelm the heroines. In the romance paintings, the emotionally fraught words do not grant the women linguistic mastery nor control over their circumstances. Often, in fact, they emphasize the heroine's lack of resolution: the repetition and the ellipsis in the caption "IT'S . . . IT'S NOT AN ENGAGEMENT RING, IS IT?" from *Engagement Ring* of 1961 and

the doubling of the letter "M" in the phrase "M-MAYBE HE BECAME ILL AND COULDN'T LEAVE THE STUDIO!" from *M-Maybe* of 1965 exaggerate the heroines' hesitations. The unresolved emotional thoughts of Lichtenstein's heroines place them in a state of suspension. Moreover, titles such as *Drowning Girl, Crying Girl, Sleeping Girl,* and *Blonde Waiting* often describe ongoing passive states.[13] Whereas the romance paintings repeatedly deny the heroine the capacity to act that signifies masculinity in the war paintings, the comic-book sources of Lichtenstein's paintings are seldom so unremitting. The heroine on whom Lichtenstein modeled *Hopeless,* for instance, earlier in her comic-book story assumes the upper hand when she declares with exasperation to her male companion with automotive difficulties: "START IT! GO AHEAD . . . START IT!"

The women in Lichtenstein's romance paintings, in any case, are turned inward and confined by their internal voices.[14] Steiner has noted a close relationship between the women's words and their facial expressions in these paintings: "It is striking that verbal text and pictorial image seem so mutually reinforcing in the panels lifted from comicbook romances. There, titles seem precisely correlated with images, bubbles contain words consonant with their speakers' facial expressions, and words actually constitute whole panels with pictures matched against them, image to text."[15] Steiner's insight applies to many of Lichtenstein's romance paintings, such as *Hopeless,* in which the despairing words reinforce the heroine's state of helplessness captured by her tear-streaked face. In some of the romance paintings, however, words do not neatly correlate with the images. Yet even when the text points to other actors and includes other voices, it does not allow the heroine omniscient knowledge or mastery over her actions. In the serial picture *Eddie Diptych* of 1962, the implied actions of an unseen Eddie unleash the depicted woman's flow of words and emotional conflict (fig. 40). Even though a man provokes the crisis, Lichtenstein depicts only women in the right side of the diptych: a troubled heroine flanked by a concerned mother with furrowed brow. The left panel, entirely devoted to text, formulates an internal dialogue within the heroine between the authoritative voice of reason belonging to "Mom and Dad" and her own voice of emotional excess: "I TRIED TO REASON IT OUT! I TRIED TO

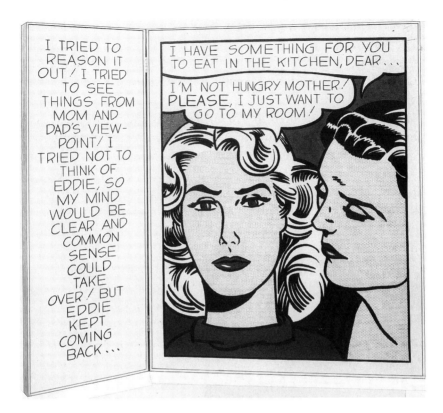

Figure 40. Roy Lichtenstein, *Eddie Diptych*, 1962. Oil on canvas; two panels, overall 44 × 52″. Collection of Mr. and Mrs. Sonnabend. Photo courtesy of Leo Castelli. Copyright © Roy Lictenstein.

SEE THINGS FROM MOM AND DAD'S VIEWPOINT! I TRIED NOT TO THINK OF EDDIE, SO MY MIND WOULD BE CLEAR AND COMMON SENSE COULD TAKE OVER! BUT EDDIE KEPT COMING BACK. . . . " Her words form a hetero-glossic text with at least two competing voices. As such her speech is multiple and confused; it denies her the single controlling consciousness attributed to men in the war paintings.

In accentuating the characteristics that distinguish femininity and masculinity in the comic books, Lichtenstein's paintings call attention to the artifice of these gender conventions. The comic-book panels themselves contain their gender conventions within a signifying system of naturalism achieved through a detailed rendering of the characters and their settings. For example, the source for

Hopeless includes a frilly green window curtain that situates the heroine in a recognizable site – the domestic interior – and establishes the distance between her head and the back wall (fig. 33). Small hatch marks, which articulate the creases in the heroine's shirt and bedspread, describe the weight of a three-dimensional figure in space, while highlights on her hair indicate a single and consistent source of light. Dispensing with such naturalistic details, Lichtenstein's painting *Hopeless* instead lays stress on the artifice of the scene by flattening out the space – replacing the green window curtain and orange wall with a solid red-and-black background – and radically simplifying and stylizing the heroine's face and costume. The painting transforms the woman's hair from brunette to an unnatural shade of yellow streaked with broad jet-black lines. These same black lines turn the creases in her shirt and bedspread into abstract linear patterns that no longer function well as naturalistic shading. Likewise, the black outline draws attention to the teardrops first and foremost as highly stylized shapes.

Lichtenstein's transformations foreground the role of the representational medium itself in formulating the conventions of femininity and masculinity. This is most obviously the case in his manipulation of Ben Day dots. On the comic-book page, the tiny, regularly spaced Ben Day dots, used to color and shade areas of the image, are individually too small to discern easily. In the painting *Hopeless*, however, the dots have grown to such a remarkable size that they visibly mottle the heroine's flesh. The painting does not treat the medium as a transparent window onto the heroine's internal emotional state, but rather emphasizes the role of the Ben Day dots, stylized lines, and bold colors in formulating her posture of despair. In short, the painting both focuses on the heroine's display of romantic anguish and presents it as a figured representation.

Lichtenstein's paintings thus incorporate sources from consumer culture while asserting authoritative knowledge about them. His paintings draw attention to the conventions of gender that the war and romance comic books naturalize through narrative structure and seemingly realistic rendering. The paintings distill gender roles by exaggerating the difference between feminine emotion and masculine action and simultaneously emphasizing the representaional

practices through which comic books define gender – practices apparently ignored by the comic books themselves. Exaggeration, stylization, and emphatic artifice of form and color transform statements of romantic anguish and masculine bravado into humorous and hyperbolic expressions of gender stereotypes. The paintings thereby offer their viewers the opportunity to perceive and to parody the conventions of representation and gender that the readers of comic books ostensibly accept as natural.

Criticism and the Crisis in Masculinity

In analyzing the treatment of gender in Lichtenstein's paintings, the discussion of the differences between Lichtenstein's war and romance paintings and their comic-book sources participates in a longstanding critical practice that has devoted itself to demonstrating how Lichtenstein transformed his sources. When this practice began in the early 1960s, critics, writing for the major art journals and a number of popular news magazines, were mounting a defense of Lichtenstein against charges that he simply copied his consumer-culture sources; this practice culminated in a spate of articles in the mid-1960s. To reclaim Lichtenstein's paintings as high art, critics insisted that his works transformed their sources and addressed strictly formalist issues. Indeed, these critics defended Lichtenstein's paintings on the formalist grounds staked out by Clement Greenberg's analysis of Color-Field painting and Post-Painterly Abstraction. The formalist defense of Lichtenstein itself raises a second issue of gender, for Greenberg and other critics who adopted a formalist language of control and detachment to praise abstract art in the late 1950s and early 1960s implicitly provided such painting with masculine authority. Those critics who appropriated formalism as a means of defending Lichtenstein's paintings consequently presented him and his art as constituting a new form of masculinity.

The success of the formalist defense of Lichtenstein makes it difficult today to re-create the vehemence of the original debate among critics, because during the intervening thirty years Lichtenstein's paintings have hung comfortably in many modern art museums and have been juxtaposed to their comic-book sources in numerous

publications and exhibitions devoted to differentiating between them.[16] However, critics who in the early 1960s argued that Lichtenstein's paintings qualified as formalist art wrote with a remarkably defensive tone.

In 1966, Ellen Johnson penned one of the more forceful and lengthy justifications of Lichtenstein's comic-book paintings in an article entitled "The Image Duplicators – Lichtenstein, Rauschenberg and Warhol." The article, at the head of which appeared reproductions of Lichtenstein's *I Know How You Must Feel, Brad* of 1963 and of its comic-book source, opened by situating Pop art within a tradition of modern artworks, originating with Manet's *Dejeuner sur l'herbe* of 1863, that appropriated and altered other images. Ultimately, what mattered, according to Johnson, was less the source chosen than the way in which the artist manipulated it. More specifically, in the case of Lichtenstein, she focused on how he cropped the forms, redesigned the composition, and altered the colors of his sources. For instance, Johnson enumerated the stylistic differences between *I Know How You Must Feel, Brad* and its source:

> Eliminating inessentials, he dispenses with finger-nails and forearm muscle indications, cuts the number of lines through out and more tellingly states and varies their curved or angular character. He changes the colours and gives them more force . . . he intensifies the range and contrast of values; makes the flabby landscape background into a jagged, expressive pattern; transforms the vague rocket-like shape on the left into a neat vertical column . . . and realigns the whole into a quiet, steady vertical–horizontal–pyramidal structure.

Johnson offered these formal transformations as evidence of an individual signature style: "All of these second-hand pictures are unmistakably Lichtensteins."

Lichtenstein's stylistic manipulation of his sources, according to Johnson, could, secondarily, serve to undercut comic-book conventions. "The subject of Lichtenstein's painting is not so much the subject of the selected comic or advertisement as it is the style in which those images are presented. . . . It is about comics, their conventions, style, artifice and sentimentality. . . . A man of Lichten-

stein's sensitivity and sophisticated humour could not be other than amused by the pretentious seriousness of comic romances." In discussing Lichtenstein's paintings, writers such as Johnson applied the terms parody, satire, and irony interchangeably to mean more or less the same thing: a critical evaluation of the original source. As Johnson saw it, Lichtenstein's paintings subverted the style of comic-book romances by simultaneously incorporating and exaggerating the "mannered drawing" of their sources: "The slick black contours in *I Know How You Must Feel, Brad* wittily parody the crazy 'grace' of the pointed fingers, narrow wrist, swelling hips and breast and the flowing blond hair of the comic."

Overall, however, Johnson placed less emphasis on the parodic aspects of Lichtenstein's paintings than on their stylistic transformations of the comic-book sources: "Mockery is, I think, a peripheral factor in Lichtenstein's choice of subject matter."[17] Other critics even claimed that the paintings succeeded as art only when they overcame the parodic impulse altogether. Aline Saarinen wrote of Lichtenstein: "When he is at his best, he transforms the comic strips and mindless clichés of American-girl images a step beyond super-caricature or satire into concentrated works of art."[18] The apparent distrust these critics expressed about parody was perhaps a result of the threat parody seemed to pose to the seriousness of modern art. Dorothy Seiberling asked of Lichtenstein in the pages of *Life*: "He leaves the viewer wondering if his paintings are only parodies, ironic gestures, or if they will outlast their shock and give a new shape to art?"[19] Her question voiced a longstanding modernist preconception that parody was a practice inherently without originality and lasting significance.[20] The assumption that parody lacked sobriety and consequence seemed to underpin the critical evaluations of Lichtenstein's paintings that emphatically pointed to their formal qualities over and above their parodic aspects.

Critics such as Johnson who stressed the way Lichtenstein composed his comic-book images developed their argument through formal analysis of his paintings. Initially, in the early 1960s, such critics concluded that Lichtenstein's formalist transformations encouraged viewers either to consider the aesthetic potential of commercial illustration or to focus their attention on aspects of the

everyday environment they usually took for granted;[21] but by the mid-1960s, most critics pointed to Lichtenstein's formalist transformations as evidence that he was really an abstract artist after all. Thus, some critics claimed that the viewer could ignore the comic-book imagery altogether. John Rublowsky wrote: "In order to divorce himself as decisively as possible from the subject matter of his paintings, Lichtenstein works on the canvas from various angles. He turns the painting upside down, on its side, diagonally, and studies the reversed image in a mirror. In this way, he is able to treat the over-all composition of his visual elements as an abstract problem in space delineation and form."[22] An "over-all composition," the use of imagery that – as Leo Steinberg put it – was "known and seen to be flat,"[23] sources treated as formal elements; by singling out such attributes, critics treated Lichtenstein's paintings as abstractions concerned with strictly formal issues.

Critics in the 1960s essentially praised Lichtenstein for having achieved the modernist ideal of formalist detachment in which the controlling gaze is directed toward but never seduced by consumer culture. Huyssen has discussed modernist writers who, since the nineteenth century, have subsumed the world of mass culture, figured as feminine, to their ironic and detached aesthetic control. As an example, he singles out Flaubert's *Madame Bovary*: "Woman (Madame Bovary) is positioned as reader of inferior literature – subjective, emotional and passive – while man (Flaubert) emerges as writer of genuine, authentic literature – objective, ironic, and in control of his aesthetic means."[24] As we have seen in Chapter 2, American intellectuals and critics of the 1950s likewise associated consumer culture with female consumers and concluded that its formulaic nature absorbed and pacified its audience. Thus, to distinguish Lichtenstein's paintings from their comic-book sources was implicitly to defend the masculinist definition of the cool and controlled creator against the feminine threat of absorption by consumer culture.

The constant need to assert that Lichtenstein transformed his sources nevertheless reveals that Lichtenstein's position as a modernist painter was in doubt and was not secure. The painter and art professor Erle Loran launched what was probably the most notorious attack against Lichtenstein's paintings; it came in the form of

Lichtenstein's Borrowed Spots

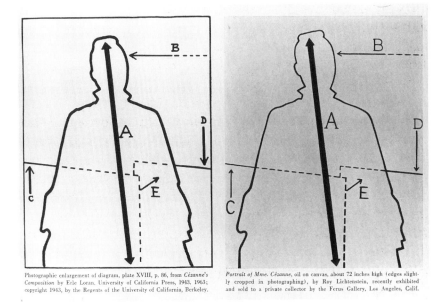

Figure 41. Comparison of diagram in Erle Loran's book *Cézanne's Composition* with Roy Lichtenstein's *Portrait of Mme. Cézanne*. From *ArtNews* 62 (September 1963).

an article entitled "Pop Artists or Copy Cats?" published in *Art News* in September 1963.[25] Loran criticized Lichtenstein's reproductive technique, suggesting that Lichtenstein had produced *Portrait of Mme. Cézanne* of 1962 by projecting a slide of a diagram from Loran's own book *Cézanne's Composition* and drawing around the outlines.[26] Against this visual evidence, Loran juxtaposed a collection of citations from a long list of art historians, dealers, curators, and critics such as Lawrence Alloway, Henry Geldzahler, Ivan Karp, Robert Rosenblum, Aline B. Saarinen, and Leo Steinberg who praised Lichtenstein for the way he transformed and manipulated his sources. Dripping with irony, Loran left it to his readers to choose: "The reader need only look at the illustrations [of Loran's diagram and Lichtenstein's painting] to appreciate the 'changes' that take place in the black outlines Lichtenstein has copied from my modest diagram."[27] And indeed the diagram and the painting, reproduced side-by-side and at approximately the same size in the pages of *Art News*, appeared remarkably similar (fig. 41).

121

A Taste for Pop

Loran's article became a touchstone for defenders and critics of Lichtenstein alike. Letters to the editors about Loran's article appeared in *Art News* and subsequent reviewers of the artist often referred to it. Lichtenstein himself participated in the debate about his work in several interviews when he was asked specifically about Loran's accusations. In "What is Pop Art" published in *Art News* in November 1963, G. R. Swenson asked: "Antagonistic critics say that Pop Art does not transform its models. Does it?" Lichtenstein asserted: "Transformation is a strange word to use. It implies that art transforms. It doesn't, it just plain forms. . . . The comics have shapes but there has been no effort to make them intensely unified. The purpose is different, one intends to depict and I intend to unify."[28] Lichtenstein consistently stressed his attention to form and visual unity in his comic-book paintings.

In spite of Lichtenstein's efforts to influence the critical interpretation of his images, Max Kozloff published the lengthiest elaboration of Loran's critique in *The Nation* in November 1963. "The present avant-garde," Kozloff wrote, "has subverted not only 'action' painting, but also the ethic of most twentieth-century art, as formulated in its structural and expressive aspects by Cézanne. The particular path chosen by this avant-garde . . . is to deny that art is a metamorphosis of experience, and to affirm that it is a copy of artifacts." Lichtenstein failed to employ the artistic techniques that, by Kozloff's standards, signaled the individual transformation of experience. To copy images in a hard-edge style that erased evidence of the artist's hand was, the argument ran, to undercut the principle of originality. Lichtenstein's practice of copying machine-made sources led Kozloff to conclude: "Behind the borrowing propensities of such new American painting as Lichtenstein's . . . lies a rejection of the deepest values of modern art."[29]

Writing about this period with the hindsight of some twenty years, the artist and critic Mary Kelly has argued: "In the 1960s, when the 'avant-garde' expelled gesture, denied expression, contested the notion of an essential creativity, the spectator was called upon to sustain a certain loss; the presence (or rather, presentified absence) of the artistic subject."[30] The gendered underpinnings of "presence" in modernist aesthetic discourse have only recently been

teased out by poststructuralist and feminist criticism. Craig Owens, in differentiating between the modern and postmodern, has explained that in the modern era, "the representational systems of the West admit only one vision – that of the constitutive male subject – or, rather, they posit the subject of representation as absolutely centered, unitary, masculine."[31] In other words, the absence of gesture in the 1960s marked the loss of a centered, unitary, and masculine presence.

In the end, the critical debate about whether or not Lichtenstein altered his sources constituted two sides of the same modernist coin. Both factions not only maintained that a difference must and did exist between high art and consumer culture, but they also both granted priority to the former by opposing an autographic style – whether expressionistic or cool – to copying. For writers such as Loran and Kozloff, the rejection of all that they recognized as constituting high-art standards reduced Lichtenstein's paintings to copying. Other critics overcame this objection and repositioned Lichtenstein as a member of the modernist canon by attributing to him formalist concerns. Both sides of the debate affirmed the importance of transformation as a sign of modernism, which they privileged over copying and consumer culture.

The critical debate about Lichtenstein did more than reinforce old dichotomies, however. Beliefs about the way in which an artist transformed were in turmoil in the late 1950s and early 1960s, as doubts arose about whether Abstract-Expressionist painting in fact embodied a heroic perfomance of masculine transformation. The critical defense of Lichtenstein's Pop-art paintings not only presented them as exemplifying a new type of formalist transformation, but also implicitly offered them as an alternative form of masculinity. The nature of the alternative supplied by Lichtenstein paintings only becomes clear in light of the crisis in masculinity – artistic and societal – in which it participated.

The rejection of gesture by Lichtenstein – indeed by virtually all Pop artists – repudiated the conjunction formulated in one tradition of Abstract-Expressionist criticism between the stroke of paint and anxious, brooding, angst-ridden masculinity. Abstract Expressionism had stood – and as Kozloff's comments indicate, still stood

for some critics in the early 1960s – as the hallmark of a modernist practice in which the evidence of the artist's hand in the form of the gestural stroke of paint manifested his transformative presence. The Abstract-Expressionist brush stroke, in the critical discourse initiated by Hans Namuth's photographs of Jackson Pollock at work and Harold Rosenberg's writings on Abstract Expressionism, ostensibly recorded the individual expression of the creative artist (fig. 42).[32] Rosenberg's writings, which argued that Abstract Expressionism was inseparable from the artist's biography and psychological state of mind, had a powerful impact on much of the criticism published in the 1950s and 1960s about Pollock and gave rise to an auto-biographical account of Pollock's paintings. Pollock himself contributed to this reading of his work. B. H. Friedman wrote of Pollock in 1955: "When this article was discussed, Pollock said that he didn't want any direct quotes or revelations of his private life. He said he'd stand on his painting. . . . He's never going to write an autobiography. He's painted it."[33]

The critical interpretation of Pollock's paintings depended in part on popular accounts of his turbulent life. The press secured Pollock's reputation as a tortured and inspired creator, particularly after his premature death in 1956. For instance, *Life* magazine, which first paid tribute to Pollock in 1949, published an article on the artist by Dorothy Seiberling in 1959 that described Pollock as a brooding, restless, and reckless rebel who worked on his art with focused fury.[34] Such texts participated in constructing popular memory about Pollock as a tortured creator, living on the edge of society.

Many high-art critics found the same fierce passion in his drip paintings. Robert Rosenblum, for instance, commented about *Number 1, 1948*: "we are almost physically lost in this boundless web of inexhaustible energy."[35] Ultimately, however, these critical accounts of Pollock highlighted the transformative force of the artist: Pollock translated his self during the act of painting into "meaning." Frank O'Hara said of Pollock: "In considering his work as a whole one finds the ego totally absorbed in the work. . . . This is not automatism or self-expression, but insight."[36] In the criticism on Abstract Expressionism, the gestural stroke of paint indexed the transformative power and personal vision of the individual artist,

and in Pollock's case most obviously "embodied" male presence as aggressive and tragic.

No Pop-art canvas repudiated gesture as a sign of authentic masculinity more decisively than Lichtenstein's series of "drip" paintings from 1965. These canvases depicted enormous dripping Abstract-Expressionist brushstrokes rendered, with obvious irony, in Lichtenstein's comic-book technique of Ben Day dots and crisp impersonal lines. In *Little Big Painting* of 1965, five broad overlapping strokes of red, white, and yellow sweep across the surface of the canvas (fig. 43). The direction and curve of each of the brushstrokes may at first suggest the thrust and movement of a painter's hand, and the splatters forming off the edge of the two white swatches in the foreground might similarly testify to the spontaneity of paint application. Yet this impression of a spontaneous outburst of energy is undercut by the firm, consistent, black outlines of the brushstrokes, the clean surface of the canvas, and the mechanical blue Ben Day dots of the background. And once we remind ourselves of the scale of these brushstrokes on Lichtenstein's large canvas – rather than their more manageable size in the photographic reproduction – the possibility that any artist laid down those strokes with the quick passage of a single brush becomes patently absurd. The cool machine appearance of Lichtenstein's style reconfigures the bravura of Abstract Expressionism in such a way as to draw attention to the processes of representation in Abstract Expressionism, much in the same manner as Lichtenstein's style made visible the processes of representation of the comic-book medium. *Little Big Painting* discredits the meaning of the gesture, and does so in a humorous way. Critics writing about the brushstroke paintings in the 1960s invariably read them as parodic or ironic: "They are paintings of brushstrokes which could also be bandages, ribbons or scarves: the drips and spatters relate as well to tears from a comic-strip heroine's eyes. . . . The gestures 'reproduced' are broad, unsightly, absurd."[37] The painting stripped the brushstroke of its claim to the authenticity, individuality, and tragedy that constituted male presence in Abstract Expressionism.

Lichtenstein's persona likewise countered the popular mythology about Pollock. Whereas Pollock had acquired a reputation in the

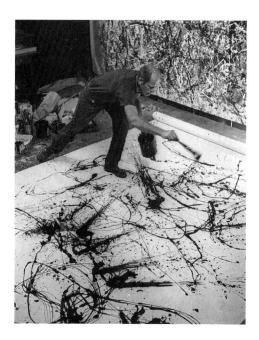

Figure 42. Hans Namuth, *Jackson Pollock,* 1950. Photograph by Hans Namuth. Collection Center for Creative Photography, The University of Arizona. Copyright © 1991 Hans Namuth Estate.

press as the ferocious outsider, the working-class rebel, and the lonesome cowboy, Lichtenstein emerged in journalistic reviews of his work as the boyish, college-educated, professional artist. Described as a youthful, "pixie-faced" man, Lichtenstein combined a clean-cut appearance with academic credentials, including a master's degree in fine arts from Ohio State University.[38] Far from instinctual, Lichtenstein was reputed in the press to be an intellectual artist, not easily perturbed. Aline Saarinen wrote in the pages of *Vogue* in 1963: "Roy Lichtenstein, at thirty-nine, is a cool, neat, slight man, with pale-blue eyes, pale sandy hair, a rather linear smile, and a face that seems as angular as Dick Tracy's. He gives the immediate impression of being cerebral rather than intuitive, and so is his art."[39] Lichtenstein's sense of order and self-control manifested itself in the photographs of his spacious, clean-swept, well-lit workplace with canvases neatly stacked against the walls; in contrast, photographs of the severely constricted studio space of Jackson Pollock revealed an un-

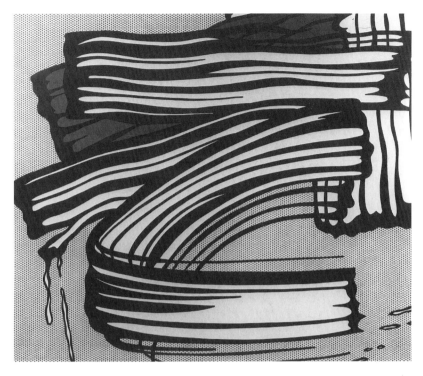

Figure 43. Roy Lichtenstein, *Little Big Painting*, 1965. Oil and synthetic polymer on canvas; 68 × 80″. Collection Whitney Museum of American Art, New York. Purchase, with funds from the Friends of the Whitney Museum of American Art. Photograph copyright © 1995: Whitney Museum of American Art.

ruly array of canvases, open cans of paint, stools, and brushes of various sizes covering every inch of the floor and walls. And if photographs of Pollock painting in his studio publicized the serious-looking artist performing a private choreography around the canvas and painting in a direct and unmediated fashion, Lichtenstein assumed the role of the careful craftsman. He cheerfully displayed the tools with which he measured his forms, the screens with which he painted his Ben Day dots, and the media sources that he imitated.

Perhaps most significantly, Lichtenstein, in critical accounts, assumed the role of the family man. John Rublowsky began his chapter on Lichtenstein in his book *Pop Art* of 1965 with the sentence: "Roy Lichtenstein has two sons, for whom he painted a Mickey

Mouse canvas late in 1960." Numerous photographs in Rublowsky's book pictured Lichtenstein as the dutiful father, hugging his sons, putting them to bed, and taking them to school without the assistance of a woman (fig. 44).[40] Lichtenstein, in short, played not the part of the isolated rebel, but rather that of the white-collar professional and father.

The alternative form of masculinity that Lichtenstein and his art provided came on the heels of a crisis in the direction and future of Abstract Expressionism.[41] A number of critics and artists began in the late 1950s to bemoan the way that the gesture school of Abstract Expressionism had spawned an academy of second-rate Action painters. Condemning such artists as passive and formulaic, these writers implicitly framed the demise of Abstract Expressionism as a crisis of masculinity.

William Rubin first gave written form to this crisis in his two-part article, "The New York School – Then and Now," of 1958.[42] A certain nostalgia haunts Rubin's argument, for the late Pollock emerges as a masculine benchmark against which Rubin measures the inadequacy of many contemporary artists. Pollock, according to Rubin, painted with the single-minded drive and force of a soldier and an athlete: "The immense canvases became fields of battle into which Pollock flung himself, attacking the canvas with a violence and athleticism that constituted the birth of 'Action' painting."[43] Rubin feared that the day of such vigorous painting practice had come to an end; he believed that Abstract Expressionism was in decline. As he wrote in a slightly later article, "Younger American Painters," of 1960: "Action painting may not be dead, but as a vital and pioneering adventure it is dying at the very moment when it is being almost universally imitated by beginners and weaker painters."[44]

One of the ways in which Rubin conceived of the decline from great to second-rate Abstract Expressionism was as a passage from male to female artists. "But for the most part the painters under forty today have tended to be relatively conservative," he argued in "The New York School"; "and few have sustained the kind of adventurousness and vitality we see in the older men. . . . Curiously, the strongest second-generation advocates of athletic art have been women."[45] In lamenting the demise of Abstract Expressionism,

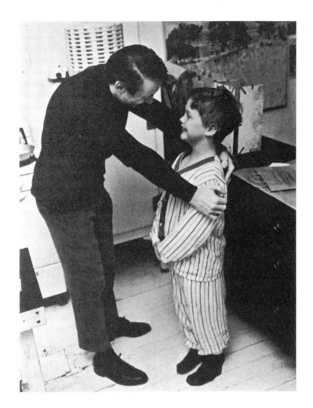

Figure 44. Kenneth Heyman, *Roy Lichtenstein and his son Mitchell.* From John Rublowsky, *Pop Art.* Photo by Kenneth Heyman. Copyright © 1965 by John Rublowsky and Kenneth Heyman. Copyright renewed. Reprinted by permission of Basic Books, a division of HarperCollins Publishers, Inc.

Rubin made explicit the gender change in the artists: when "women" took over from "older men" the vitality of Abstract Expressionism suffered a marked loss. Rubin dismissed recent art with a number of labels, including "formulaic," "decorative," "conservative," and "passive." "Though first-rate action painters still abound," he wrote, "I have sensed in the last few years a trend away from the dynamic Abstract-Expressionism of painters like Pollock and De Kooning towards a more passive, detached, and meditative art of sensations."[46]

A Taste for Pop

"Passivity" was a loaded word in the late 1950s, used by many social scientists, psychologists, and cultural critics in the United States to characterize a purportedly widespread crisis of masculinity.[47] In the United States after the Second World War, numerous articles appeared in the popular press analyzing the way in which American men had been emasculated at the hands of their mothers and wives; in 1966, Myron Brenton's *The American Male*, which enjoyed three printings, capped off this journalistic leitmotif.[48] These texts, adopting the pseudo-technical language of social scientists and psychologists studying the middle-class home and workplace, fretted over the fate of the infamous "man in the grey flannel suit," the potentially compliant "organization man" of modern corporate America.

In the 1940s, the plight of the American man went by the name of "Momism," a term coined and popularized by the writer and social critic Philip Wylie and the psychiatrist Edward Strecker, who both attributed the purported infantilism of men to a cult of mother worship.[49] Later in the 1950s, in a series of articles on both the "American Man" and the "American Woman," the wives of white-collar professionals began to bear the blame for unseating the male from his throne. These articles shared the conviction that American society had achieved equality of the sexes, but that such equality actually favored women. Amaury de Reincourt went so far as to claim in 1957 that the American woman had achieved a position of "unchallengeable supremacy." Many others agreed with de Reincourt's assessment, arguing that wives outnumbered and outlived their husbands, and, moreover, that they foisted new and extraordinary domestic, economic, and sexual demands on their husbands. Finally, women controlled the purse strings of not only the home but also the nation.

Such female dominance had apparently drained men of their vital forces. A woman's "feminine instinct for security, social respectability and comfort," maintained de Reincourt, "stifle[d] the rather uncomfortable but necessary masculine instinct for risk and creative originality."[50] Pursuing this logic, J. Robert Moskin argued in 1958 that the organization man was plagued by "fatigue," "passivity," "anxiety," and "impotency."[51] In 1959, Diana Trilling sum-

marized the accusations against the American woman in the pages of *Look*:

> For some years now, the American woman has been under persistent attack as the cause of the major ills of modern American life. She is blamed for the marked decline in masculine self-esteem and for the nervous tension that seems to characterize both men and women. The instability of the modern home, the rise in juvenile delinquency and male homosexuality, even the alarming incidence of heart disease among American men – all of these are blamed on the American woman's distortion of her traditional female role.

Allocating responsibility, Trilling also implicated men in this state of affairs: "But the modern man seems incapable of the traditional assertions of masculinity. . . . He often retreats into passivity."[52] Trilling perpetuated an image of the ideal male as forthright and active even as she regretted his demise.

According to these authors, equality of the sexes not only meant the dominance of women, it also decisively blurred traditional concepts of masculinity and femininity. "The housework-participating fathers," as J. Robert Moskin dubbed him, was "no longer the masculine, strong-minded men who pioneered the continent and built America's greatness." Arthur Schlesinger, Jr., in an article entitled "The Crisis of American Masculinity" published in *Esquire* in 1958, summarized the common wisdom of the day when he pointed out that the conflict between traditional and new sex roles caused men to feel a debilitating level of anxiety:

> Today men are more and more conscious of maleness not as a fact but as a problem. The way by which American men affirm their masculinity are uncertain and obscure. There are multiplying signs, indeed, that something has gone badly wrong with the American male's conception of himself. On the most superficial level, the roles of male and female are increasingly merged in the American household. The American man is found as never before as a substitute for wife and mother – changing diapers, washing dishes, cooking meals

and performing a whole series of what once were considered female duties.[53]

Even Brenton, who in his book urged men to get out of the "masculinity trap" and embrace new definitions of manliness based on the ideal of the nurturing husband and father, posited a previous set of gender relations based on strictly polarized roles and behaviors, and attributed anxiety about masculinity to the demise of this system.

Lichtenstein's comic-book paintings from the early 1960s negotiated and managed the crisis in gender roles. Humorously drawing attention to gender stereotypes and polarized behavior, Lichtenstein's images, like many texts about masculinity in the 1950s and 1960s, simultaneously reinscribed these divisions as the norm.[54] At the same time, Lichtenstein's persona as the white-collar professional and affable father recalled the description of the typical middle-class man, of the potentially emasculated American male. Yet Lichtenstein's performance in the role of the cool and disciplined artist could also allay fears that his domestic responsibilities or profession effeminized him. The cerebral and detached artist could be seen to reinfuse the normative male with a cool, masculine veneer. Likewise, his paintings, defended in formalist terms that abandoned some of the precepts of Abstract Expressionism, could demonstrate the masculine control that the professional artist exerted over his medium.

In retrospect, we can see that Clement Greenberg's formalist criticism of the late 1950s and early 1960s pointed in the direction for the "remasculinization" of American modernism.[55] Over and against the fierceness of Pollock's drip paintings and the perceived passivity of the second generation of Action painters, Greenberg promoted artists who exerted detached control over their medium. "The essence of modernism," he wrote in his article "Modernist Painting" in 1960, "lies in the use of the characteristic methods of a discipline to criticize the discipline itself, not in order to subvert it, but in order to entrench it more firmly in its area of competence."[56] Although initially an advocate of Pollock, by the late 1950s and early 1960s, Greenberg treated Abstract Expressionism of the ges-

tural variety as a mannerism and redirected his critical support to the Color-Field artists. In particular, he championed Clyfford Still, Mark Rothko, and Barnett Newman, and those he considered their heirs, Morris Louis, Kenneth Noland, and Jules Olitski, whose art he christened "Post Painterly Abstraction." Greenberg specifically stressed that the integrity of these artists manifested itself in their commitment to the purity of the medium and the advancement of the avant-garde tradition toward flatness.

One of the artists from Greenberg's new stable of champions emerged through critical writings by Greenberg and others at the beginning of the 1960s as the embodiment of a new form of masculinity: Barnett Newman.[57] The prophet Newman – he was cast as Moses and Elijah in the catalogue for his one-man exhibition at the New York gallery of French and Company in March 1959 – offered, according to Greenberg writing in the catalogue for the exhibition, a "noble" example of the "splendor" of recent American painting.[58] Greenberg praised Newman's art for its restraint and discretion, while delivering an implicit criticism of the bravado of gesture painting: "His art is all statement, all content; and fullness of content can be attained only through an execution that calls the least possible attention to itself. We are not offered the dexterity of a hand."

The gender connotations of such language were so self-evident as to require hardly any articulation at all. Explicit formulations appeared, perhaps, only at moments of sarcastic taunting. Hubert Crehan offered a scathing review of Newman's heroization of masculinity:

> Newman believes in a masculine environment, and he gets this idea across in his paintings. . . . His paintings seem to me the apogee of the spirit of this he-man cult. The most ambitious painting, 96 by 214½ inches, titled *Vir Heroicus Sublimus* (which can be translated *Heroic Man Erect*) is a red mural with white studs. . . . It is a proud and inflexible archaic male sensibility that Newman expresses, lifted from the Old Testament. But we live in another world, really, one certainly that is in need of the phallic charge. . . . [59]

Crehan acknowledged the current crisis of masculinity, only raising doubts over whether Newman was too much of a man for his own era. Newman, furious at the implied critique, fired off a vitriolic response to *Art News*. In so doing, he nevertheless endorsed Crehan's basic assessment of Color-Field painting as an art of pronounced masculinity: "It takes only one real man to create a work of art."[60] Newman's blatant endorsements of masculinity often took the form of distinguishing the men from the boys and defending men from the threat of women. For instance, when justifying the location of his studio in the Wall Street neighborhood in *Newsweek*, he stated: "I really like it down here. It's a very masculine atmosphere. There isn't anybody walking dogs, and you don't trip over fur coats."[61]

The masculine connotations of the formalist language selected to praise the abstractions of Newman and the younger artists Noland and Louis become clear when that language is compared to the terms with which critics described Helen Frankenthaler's paintings. These paintings carried a certain importance at the time; Louis credited them with serving as the "bridge between Pollock and what was possible."[62] In the late 1950s, however, critics who categorized Frankenthaler's work with Abstract Expressionism typically found her brushstrokes "loose," "nervous," and "idiosyncratic," and her colors "thin," "pale," and "sensitive."[63] In 1960, for instance, the sculptor Donald Judd, who wrote criticism for *Arts* between 1959 and 1965, compared Frankenthaler's "soft" brevity of strokes, "lambent" stains, and "allusive" quality unfavorably to Pollock's "cool," "tough," and "rigor."[64] Critic James Schuyler explicitly gendered her style in relation to Abstract Expressionism: "Part of Miss Frankenthaler's special courage was in going against the think-tough and paint-tough grain of New York School abstract painting . . . but she has relied upon a sensibility altogether feminine."[65] And E. C. Goossen stated decisively: "Frankenthaler's painting is manifestly that of a woman. . . . Without Pollock's painting hers is unthinkable. What she took from him was masculine; the almost hard-edged, linear splashes of duco enamel. What she made with it was distinctly feminine."[66] In the early 1960s, even as critics detected changes in her paintings that brought them closer in line with the

economy and control of the abstract canvases by Newman, Noland, and Louis, they tended to find her style lacking. Judd, for instance, concluded in 1963 that "Frankenthaler's softness is fine but it would be more profound if it were also hard."[67] Schuyler and Judd, joining other critics of the period in positioning Frankenthaler's painting as the feminine exemplar of Color-Field painting, judged her painting practice less "profound" than Post-Painterly Abstraction and less "tough" than Abstract Expressionism.

In the early 1960s, various critics adopted Greenberg's formalist machinery, wielded by him in support of Post-Painterly Abstraction, to champion instead Lichtenstein and other Pop artists. Although Greenberg himself demonstrated little enthusiasm for Pop art,[68] other critics celebrated Pop art as a regenerating force for American modernism. The first critical responses to Lichtenstein specifically located his work in relationship to the crisis in American modernism. Robert Rosenblum, for instance, was quite explicit in situating Lichtenstein over and against an effeminized second-generation Abstract Expressionism:

> To be sure, some recent painters have succeeded against these enormous odds in producing work of extremely high quality and originality (Stella, Louis, and Noland, among them); but in general, most abstract painting of the later 1950's and early 1960's has begun to look increasingly stale and effete. . . . A newer and more adventurous path has rejected still more definitively this dominating father image by espousing, both in style and in frame of reference, exactly what most of the masterful older generation had excluded. . . . The sheer quantity of these artists amounts virtually to a revolution or, at the very least, a revolt, among whose major manifestoes are the paintings of Roy Lichtenstein.[69]

As late as 1965, Lippard, who listed Lichtenstein as one of five "hard-core" Pop artists in New York, wrote: "These artists do not see themselves as destroyers of Art, but as the donors of a much-needed transfusion to counteract the effects of a rarified Abstract Expressionist atmosphere."

A Taste for Pop

The five "hard-core" Pop artists, according to Lippard, infused the art world with a dose of detached cool by depicting new commercial objects using clean surfaces and clearly defined shapes that derived from the Color-Field branch of Abstract Expressionism. Lippard linked Pop art with Color-Field painting much in the way that Greenberg had situated Color-Field art as the precedent for Post-Painterly Abstraction. Lippard wrote, "While the older painters were generally repelled by the rise of Pop, the 'cool' strain of Abstract Expressionism – Rothko, Still, and especially Barnett Newman – had become the main force in the new abstraction; aspects of this style seemed equally applicable to the depiction of anonymous objects with no history and no evocative impedimenta." Lippard was explicit in associating Lichtenstein with Post-Painterly Abstraction: "Roy Lichtenstein has been most closely associated with the 'new' or 'cool' abstraction. . . . Lichtenstein shares with 'post-painterly abstraction' his enlarged scale, broad flat forms on colour fields, carefully depersonalized line, reductive composition, and expanded forms that seem to exist beyond the framing edge."[70]

Lippard was not alone in positioning Lichtenstein as the link between Post-Painterly Abstraction and Pop art. In their articles from the mid-1960s, Barbara Rose and Irving Sandler characterized a new aesthetic sensibility of the 1960s that rejected the emotionalism and romanticism of Abstract Expressionism, and investigated with an attitude of detached control many of the same pictorial problems as Newman and Rothko.[71] Rose and Sandler claimed that Pop artists, sharing the impassive attitude of Post-Painterly Abstraction, also addressed the flatness of the picture plane by choosing two-dimensional, nonillusionistic motifs and by defining their shapes with clear, hard-edge contours. "Hence," Sandler concluded, "Lichtenstein's blown-up comic-strips are closer to Noland's or Kelly's abstract images than to any other figure paintings."[72] Likewise, Rose asserted that of all the Pop artists, Lichtenstein's compositions had the most in common with recent abstract painting.[73] These critics adapted Greenberg's formalist principles to build a case for the masculine control and detachment of Lichtenstein's painting practice.[74]

The new form of artistic masculinity attributed to Pop art by the

likes of Lippard, Sandler, and Rose authorized, rather than disowned, Lichtenstein's engagement with consumer culture. The archetypal Abstract Expressionist could only express his masculinity and his powers of transformation within the realm of pure art – the cowboy Pollock roamed the range of unadulterated expression rather than that of modern commercial society. Lichtenstein, on the other hand, could be seen to adopt the themes and even the technical devices of consumer culture and yet, by transforming them with his cool intellect, reaffirm the privileges of high art and the masculinity of the artist. The new hard-edge aesthetic allowed for the representation *within* the picture itself of the superiority of masculine high art over feminized consumer culture: The comic book appeared, but so did the sophisticated transformation of it at the hand of Lichtenstein.

Likewise, Lichtenstein's persona could embody a form of masculinity that was not weakened by its contact with the domestic sphere. Lichtenstein-the-father portrayed in Rublowsky's book asserted the same transformative powers as a parent that he exerted as an artist; he "made" Mickey Mouse for his sons, after all, he did not have Mickey Mouse forced upon him. In an age that feared the emasculating potential of women, Lichtenstein emerged as an artist who mastered domestic responsibilities in a home, moreover, freed from the presence of women.

The art and persona of Lichtenstein thus together came to figure a form of masculinity that finessed many of the threats perceived in the late 1950s and early 1960s to men and to high art. The artist, it would seem, could assert his powers of cool and detached transformation, even when – especially when – enmeshed with the feminized affairs of domesticity and consumer culture.

Advertising with Pop

Lichtenstein may have lifted images from comic books, and critics may have praised him for his cool and disciplined transformation of these sources into high art. Consumer culture, however, exercised its revenge: Commercial artists working in the mass media appropriated Lichtenstein's comic-book style for advertisements geared for

an audience of female consumers. The advertising industry thereby claimed the artist's detached formalist transformation of comic books for itself. Nevertheless, these advertisements maintained a hierarchical distinction between high art and consumer culture congruent with the hierarchy between those spheres articulated by Lichtenstein's paintings and the critical debate generated by them. Moreover, the advertisements, like the paintings, coded the power to transform, and to engage in parody, as masculine. They differed from the paintings, however, in their use of transformation and parody to produce cultural distinctions of class and gender among consumers rather than between consumers and those who imagined themselves above the forces of commerce.

Pop-art advertisements first appeared in abundance between 1964 and 1966 in home and service magazines for women of the middle and upper-middle class, as well as in publications for an educated audience of both sexes.[75] Although trade journals coined the generic label "Pop art" to refer to these ad campaigns, most such advertisements were inspired by Lichtenstein's paintings. Lichtenstein-type romance themes promoted food as well as fashion; and his colossal Ben Day dots covered advertisements for clothing and skin products and the sound effects from his war paintings demonstrated the gusto of various household goods. Since the mid-1960s, the advertising industry has continued periodically to revive Lichtenstein's comic-book style, most recently in both the print and television media.

A full-page promotion for Brazilian Coffee, one of the first examples of an advertisement inspired by Lichtenstein's romance paintings, appeared in the pages of the *New York Times Magazine* on June 28, 1964 (Plate V). Though the young couple featured in the advertisement could have been plucked from the final frame of a romance comic book rather than from the sort of melodramatic scenes of crisis and irresolution favored by Lichtenstein, the blissful faces and saccharin dialogue fill the frame as do the characters and text in Lichtenstein's Pop-art paintings. The dark-haired hero, holding a cup of coffee to his mouth, breaks into a smile and croons: "SAY, BUTTON-NOSE THIS ICED COFFEE SURE HAS THAT RICH, FULL BODIED FLAVOR WE FELLOWS GO FOR!" The young blonde gazes happily into the dis-

tance and thinks: "OOH, I'M THE HAPPIEST WIFE ALIVE. AS SOON AS JIM FINISHES KISSING ME I MUST PHONE MOM. SHE WAS A PEACH TO TELL ME TO MAKE ICED COFFEE WITH A PURE ALL BRAZILIAN BRAND!" Like the men and women in Lichtenstein's paintings, the hero in this advertisement speaks authoritatively, while romantic thoughts absorb the heroine. The firm black line, the bold red background, the bright yellow of the heroine's hair, and the large red Ben Day dots recognizably derive from Lichtenstein's romance paintings. Consequently, the advertisement, like Lichtenstein's paintings, parodies – with a distanced, doubled voice – the couple's affect of pleasure and draws attention to it as a figured representation.

The Brazilian Coffee advertisement offered the "highbrow" homemaker and consumer the possibility of distinguishing herself from the merely "middlebrow" characters featured in this domestic encounter through her recognition of the references to Lichtenstein's comic-book paintings. References to high-art paintings – for by 1964, Lichtenstein's paintings had acquired that status – assumed that the viewer had a cultural capital obtained, for example, from reading the art criticism regularly included within the pages of the *New York Times*. Indeed, only one month before the Brazilian Coffee advertisement appeared, the *New York Times Magazine* published a lengthy article by John Canaday on Pop art's success among critics and collectors entitled "Pop Art Sells On and On – Why?"[76] The advertisement invited the viewer to locate herself among the group of critics and collectors who applauded Pop art, and thus reconfirm her membership within a specific group of the culturally literate readership of the *New York Times*.

In this advertisement, however, the panache of high art served to underwrite conventional gender roles associated after Second World War with the middle class. The scene in the Brazilian Coffee advertisement positioned the potential purchaser of coffee as female by setting up a correspondence between her activity as a consumer and the heroine's. It also promised her a share of the heroine's romantic and domestic bliss if she purchased this brand of coffee. The title printed below the image was in fact "Happiness." The Brazilian Coffee advertisement thereby reiterated a set of gender-based assumptions about fulfillment through consumption widely associ-

ated, as we have seen in Chapters 1 and 2, by the advertising industry after the Second World War specifically with the middle-class female. Serving as one of the primary means through which desire is elicited for the female viewer, much advertising in the twentieth century has invited women to take pleasure in the display of commodities and of other women as spectacles. In advertisements designed after the Second World War, Michael Renov has suggested, "the predominant strain of address to the postwar woman was toward unmitigated consumption but within a restrictive, domesticated sphere."[77]

The advertisement for Brazilian Coffee, while positioning the viewer as both middle-class homemaker and member of the high-art literati, nevertheless threw her cultural authority into doubt. Was this advertisement, after all, a copy of a specific painting by Lichtenstein or was it only a general allusion to Lichtenstein's comic-book style? The confusion emerged – or rather, was produced – in the small print below the colorful picture. The caption, which implied that the advertisement reproduced an artwork hanging in a private collection, read: "*Happiness* from the collection of Mr. and Mrs. Frank Attardi, Old Bridge, New Jersey. For reprints ($1.00) write Pop Art Forever, 210 East 50th St., N.Y." Industry insiders who subscribed to the advertising trade journal *Advertising Age* could resolve the confusion, for they could read in that periodical's pages that "Mr. Attardi, the collector, is art director with the institute's agency, Handman & Sklar, and also the artist creating the ad itself. The Pop Art Forever address is that of the agency."[78] For the reader of the *New York Times Magazine*, however, the status of the advertisement as artwork remained uncertain. The advertising executive, normatively male, held the key to distinguishing consumer culture from high art; the consumer viewing the advertisement, normatively female, did not.

The Brazilian Coffee advertisement thereby denied the female consumer precisely the skill that art criticism assigned to informed viewers of Lichtenstein's paintings on the look out for signs of artistic transformation: the ability to distinguish high-art paintings from consumer-cultural artifacts. Art critics asked viewers of Lichten-

stein's paintings to recognize the artist's detached pose and his formalist transformations of his consumer cultural-sources. This form of masculine detachment and discipline was the unstated norm over and against which the advertisement for Brazilian Coffee formulated the attribute of female consumer vision. Curiously, then, the Brazilian advertisement reiterated the same gendered hierarchy of detached high-art transformation over feminized consumerism as had the post-Greenbergian critics of the early 1960s. Where the advertisement parted ways with the art critics was in positioning Lichtenstein's paintings as the object rather than the subject of transformation, and in granting the advertising executive – literally a connoisseur of consumer-cultural practices – the capacity to appreciate the difference between high art and the double-voiced utterance of its consumer-cultural parody.

While most advertisements derived from Lichtenstein's comic-book paintings similarly attribute the powers of transformation to the admen who made them, a "Pop-art" style television commercial recently produced by the agency BBDO for Sunlight dishwasher detergent exceptionally assigns precisely those skills to the homemaker: It positions the female consumer as a member of the cultural literati capable not only of enjoying the references to Pop art, but also of troping other cultural representations. Aired on the major networks during prime time, the Sunlight commercial – with visible Ben Day dots and a tear-streaked female face – parroted Lichtenstein's painting technique and his scenes of romantic melodrama. The commercial, set in a recognizably suburban kitchen of the 1950s, opens with a young blonde homemaker sobbing as her husband storms out the door. The source of her distress takes the form of a wine glass covered with huge, menacing, black Ben Day dots resembling dishwasher spots. Violin strings play in the background, as neighbor Marge enters and asks (we both hear her voice and read the words in a dialogue bubble): "WHAT'S WRONG SALLY???" Sally cries, "DARN DISHWASHER SPOTS MARGE. THEY'RE DRIVING BUD AWAY." Marge recommends Sunlight, and the next day the young husband bursts through the kitchen door, flexing his muscles as he declares: "SALLY YOUR GLASSES ARE BEAUTIFUL. I'LL NEVER STRAY AGAIN." The scene

culminates with the proverbial kiss. And yet, as a parting shot, the young blonde's thought bubble and a voice-over ponder the question: "WHO WRITES THIS STUFF??"

The Sunlight commercial permits the female homemaker and consumer to distance herself from the scenario through her ability to trope its representation of domesticity. The commercial, in fact, distances the viewer in two ways: It ascribes middle-class domesticity with the past, and it engages in a heavy-handed parody of that way of life. The 1950s kitchen set historicizes the scene, while a variety of motifs – including the comic-book style, violin strings, Sally's high-pitched voice and her flowing tears – poke fun at the suburban home, at gender roles strictly divided, and at domestic crisis. Sally's closing question even introduces a self-conscious and ironic commentary on the script. "It's the commercial acknowledging to itself that it's a joke," said Tony La Monte, an advertising executive from BBDO.[79] In fact, Sally, by ending the scene with a marked note of self-irony, allows the viewer, through identification with her, the last laugh about her predicament.

The homemaker's powers of transformation hardly end here. The commercial, in its most iconoclastic gesture, grants the female consumer the capacity to trope Pop art. Specifically, it gives her back the dot. In the comic book, minute Ben Day dots served as the iconic rendition of a certain hue in the real world, without calling attention to their representational function. In Lichtenstein's romance paintings, the now enlarged Ben Day dots not only make visible that representational function; viewed by his critics who saw such dots as the sign of Lichtenstein's transformation of his sources, they also became an index of the artist's prowess as a formalist. In the Sunlight commercial, large black Ben Day dots appear on the object of domestic consternation, the glass goblet; they play the role of the water spots from hell. In essence, the commercial turns Lichtenstein's dot back on itself, reclaiming his high-art index as the icon of something in the realm of concern of the typical housewife. The housewife, moreover, can take action against these offending spots: With an appropriate purchase, she can simply wipe them out.

Yet the Sunlight commercial failed to transfer the powers of transformation to the female consumer. It managed, in fact, to offend a

crucial segment of Sunlight's market: the professional homemaker. BBDO, in trying to reach a broad demographic group of women – working women as well as homemakers in the age range of 25 to 54 – did not take into account the important differences within that audience. Many of what BBDO executives called "professional homemakers from the Midwest" wrote letters criticizing the advertisement. These viewers did not take lightly a situation uncannily similar to domestic crises many of them had experienced themselves. They recognized the element of parody in the commercial, to be sure, yet they read that parody as being directed against Sally, not potentially placed in her hands. Their identification with the middle-class homemaker apparently outweighed any desire to define themselves as viewers with sufficient ironic distance from conventional gender roles and Lichtenstein's comic-book style to trope them both. In short, many women who viewed this commercial were still heavily invested in the domestic values BBDO thought it could safely refigure and parody. They refused the pose of distance and detachment created for the viewer by the commercial – precisely the pose that empowered viewers of Lichtenstein's paintings as members of a high-art elite.[80]

A second version of the Sunlight commercial produced by BBDO in response to complaints against the first, had the effect of reassigning the production of distance and parody to men. This later commercial continued to credit the homemaker with the powers of transformation, yet it inverted gender roles to position a young professional male in charge of the household – and in charge of cultural troping. A postmodern urban apartment forms the setting for the melodrama, while a 1980s "new man" faces the crisis of the spots. Roger's guest Rhonda, a young woman clad in a business suit, stands up, waving a wine glass covered with Ben Day dots in her hand, and announces, "ROGER IT'S OFF. I COULD NEVER MARRY YOU." After she storms off, muscle-bound Rex, replacing neighbor Marge, counsels Roger in a deeply resonant voice: "WE MODERN GUYS USE SUNLIGHT." The next week Rhonda sweeps into Roger's apartment and praises the beauty of his glasses. Flashing an engagement ring she coyly adds: "I HEAR WEDDING BELLS." They kiss, while Roger's thought bubble reads, "IT'S HARD BEING A MAN THESE DAYS."

A Taste for Pop

The new version of the commercial posits a young professional man as the culturally literate consumer who can parody 1980s gender roles and Pop art. The "new man," while domestic, possesses ironic distance from his role. Offering yet another version of the "new man," Rex, bursting with health and flexing his muscles, assumes the role of the homemaker without forgoing conventional notions of masculinity. Yet he, unlike Roger, possesses no ironic distance from his role. Rex, one might say, is a Jackson Pollock – type "new man," whereas Roger embodies a Roy Lichtenstein variety. The commercial privileges this Lichtensteinesque Roger over and against both Rex and Rhonda by ascribing to him the skills to appropriate, transform, and parody representation.

The final version of the Sunlight commercial singles out a young professional male much in the same way as the Brazilian Coffee advertisement authorized the advertising executive as the culturally elite. In the end, both advertisement and commercial adopted a technology of vision developed within the realm of high art to reproduce conventional class and gender divisions and established cultural hierarchies within consumer culture. Or, more precisely, these advertisements positioned a new set of actors, admen and "new men" equipped with a knowledge of the conventions of Pop painting, as a new sort of high-art elite, privileged in relation to other consumers considered incapable of their sophisticated manipulations. Just as the refiguration of Lichtenstein as a cool and detached artist by the likes of Lippard and Sandler extended the privileges of high art and masculinity into the realms of consumer culture and domesticity, the advertising industry's appropriation of a "Pop-art" style reproduced these same structures of privilege within the world of consumer culture.

In the process of passing from comic books to Pop art to advertisements, the imagery and techniques we now associate with the name of Lichtenstein generated much careful consideration and much heated debate among artists, art critics, and advertising executives; crossing and recrossing the border line between consumer culture and high art like this could potentially constitute a major cultural transgression. And yet, in the end, these passages affirmed

more than they transgressed. High art – whether in the hands of artists or admen – appropriates, transforms, and tropes representation; consumer culture does not. Men appropriate, transform, and trope; women do not. Ultimately, much more than just spots were borrowed up and down the cultural scale.

Chapter 4

Warhol, the Public Star and the Private Self

A painting of a person's face may have little to do with the sitter's personality: Andy Warhol portrayed Marilyn Monroe, Elizabeth Taylor, Elvis Presley, and other movie stars in the early 1960s strictly in their role as public icons. In contrast, the media, from which Warhol often procured the photographs for his silk-screens, never relinquished its claim on the private selves of these stars, even while it maintained their public identities as celebrities. Still today, popular periodicals, movie magazines, and tabloids publish photographs and articles portraying the scandalous romances and extravagant life-styles of famous people in the hope of uncovering the private self that propels the public star. Warhol denied the existence of a private self lurking behind the façade of the celebrity. Similarly, in formulating his own persona as an artist, Warhol exploited the media to transform his private life – or lack of it – into public spectacle. As a consequence, Warhol's persona challenged the artistic identity of a previous generation of Abstract Expressionists, who presented themselves as profoundly tortured, solitary, and private individuals. The negation of the private, individual self in both Warhol's portraits and his own public persona not only subverted assumptions cherished in the 1950s about the self, but also, paradoxically, served as one means through which a new generation of consumers defined its identity in the swinging sixties.

The Private Lives of Public Stars

Warhol's *Marilyn Monroe* of 1962 casts Monroe in the role of the sex goddess with her famous blonde hair, heavy eye shadow, and full lips (Plate VI). Even though Warhol depicted Monroe after her death in 1962, he selected as his model publicity stills of her from the early 1950s when she reached the height of her career as the Blonde Bombshell (fig. 45).[1] Likewise, Warhol portrayed Taylor either as she appeared in movies and fan magazines of the late 1950s, in works such as *Liz* of 1963, where she dons teased jet-black hair and a sultry smile (fig. 46), or as in *Blue Liz as Cleopatra* of 1962, in her most renowned role as Cleopatra, Queen of the Nile (fig. 47). Warhol did not obscure the fact that the sources for his silk-screens of Monroe and Taylor lay in some of the most widely known photographic images of these women circulated by film studios and published in popular magazines; for instance, he based *Blue Liz as Cleopatra* on a photograph of Taylor published in *Life*.[2] We can immediately identify the women in Warhol's silk-screens precisely because the mass media have so successfully typecast the appearance of these stars: Each "brand name" is a public self, an immediately identifiable face and figure.

Warhol emphasized the "brand faces" of his stars by minimizing detail, emphasizing outline and exaggerating expression. In *Marilyn Monroe*, for example, he focused on the surface features by which we recognize the blonde star – hair, lips, eye shadow – even to the verge of caricature: Monroe's hair resembles a straw-yellow cap, sharply outlined, stiffly sculpted, and perched firmly upon her forehead (Plate VI). In a similar spirit in *Liz*, Taylor's red lipstick extends prominently beyond the outline of her lips, and her blue-green eye shadow takes the form of two cut-out shapes haphazardly pasted across her eyelids and eyebrows (fig. 46). In both portraits, Warhol insisted upon the exterior physical signs by which we know these stars.

Warhol signaled his reliance on the print media in a second way: He emphasized the formal aspects of mass media photography – the black-and-white contrasts, garish color, graininess – that act as the transmitters of the image of the public star. The grainy shadows on

Monroe's cheek and neck and the way in which broad streaks of white show through Taylor's hair emulate the low resolution of photographs published in newspapers. Although clearly imitating the way the popular press presents movie stars, Warhol exaggerated the appearance and style of both the stars themselves and the mass-produced photographic images by which they were known. Warhol's silk-screens are not, therefore, about Taylor and Monroe as real people at all, but about their public image in its purest form.

Despite the fact that Warhol's silk-screens of Monroe and Taylor rely on mass-produced photographs of these stars, the rhetoric of his silk-screens differs radically from that of the popular press: Warhol's silk-screens are at odds with the popular mythology according to which a star's "true" identity lies trapped within a public image. The existence of the public image in the mass media rests on the foundation of this supposed private life, a private life that legitimizes the reality of the public image. The popular press of the 1950s and early 1960s ventured to unmask the private individuals who lay behind the public personas of Monroe and Taylor by publishing interviews, articles, and, aided by the perfection and availability of telephoto lenses after the Second World War, photographs of stolen moments from their private lives.

During Monroe's life, the press, driven by the question "What is Monroe *really* like?," exposed her fickle nature, her insecurities, her rocky marriages, and her mental breakdown in 1961.[3] Up to the week before her suicide, the photographs accompanying most articles, however, tended to capture the kittenish, private Monroe. In a set of four photographs illustrating an interview with her entitled "Marilyn Lets Her Hair Down About Being Famous," she smiles playfully.[4] Stacked vertically like a series of snapshots taken in a coin-operated photo booth, the photographs show her in a variety of poses: In one, her head is turned; in another, she has her finger in her mouth; in another, she growls and grimaces. Apparently catching her in spontaneous and natural poses, the photographs establish the fiction that the viewer glimpses the private, fun-loving Monroe, just as the interviewer, serving as a surrogate for the reader, promises to bridge the unbridgeable distance between the private Monroe and the public readership.

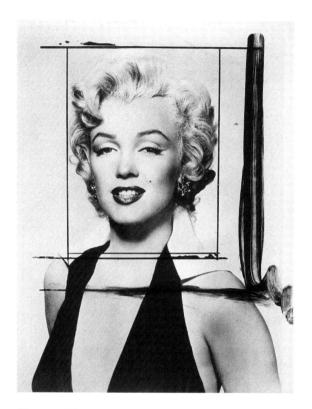

Figure 45. Marilyn Monroe. Publicity still for the film *Niagara*, 1953. Courtesy of The Andy Warhol Museum. Founding Collection, Contribution of The Andy Warhol Foundation for the Visual Arts, Inc.

Similarly, the popular press excavated a constant supply of private scandal in the person of Taylor: her diamond necklaces, her million dollar contract for the movie *Cleopatra*, her affair with costar Richard Burton at the *Cleopatra* set, her five marriages, and her near death in 1961.[5] Articles about Taylor's tumultuous career and love life included photographs of her, usually arm in arm with one of her paramours, snapped on and off the movie set, and at all times of day and night. As *Vogue* magazine wrote in 1962 during the production of *Cleopatra*: "The papers are full of Liz; and the Queen of the Nile coiffure can be felt at least as far north as Paris."[6] The combined photographs and texts published in the popular press flaunted Tay-

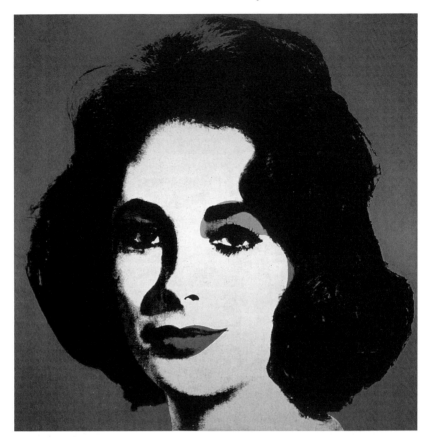

Figure 46. Andy Warhol, *Liz*, 1963. Silk-screen and oil on canvas; 40 × 40″. Courtesy of the Leo Castelli Gallery. Copyright © 1996 Andy Warhol Foundation for the Visual Arts/ARS, New York.

lor's and Monroe's capricious personalities, adulteries, marriages, and divorces to the public eye, transforming the private lives of these female stars into public spectacle.

The mystique of the public persona depends, however, on the supposition that the star's private life always remains at least partially unrevealed by the publicity pages. Although each revelation converts a piece of private self into public knowledge, it also increases the drive for more information about the star's private life. Each new sensational photograph or item of startling gossip only pushes back the ever-receding horizon of the unrevealed private

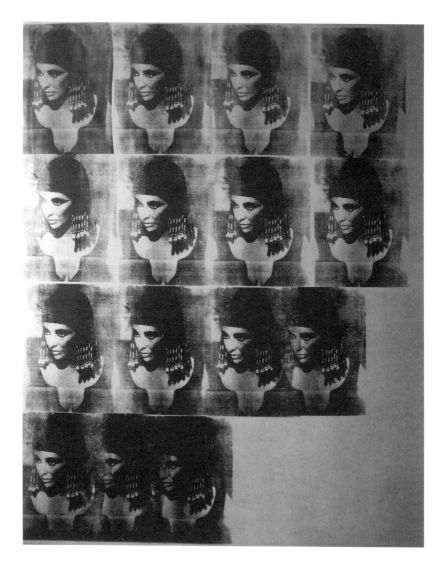

Figure 47. Andy Warhol, *Blue Liz as Cleopatra*, 1963. Synthetic polymer paint and silk-screen ink on canvas; 82¼ × 65″. Private collection. Copyright © 1996 Andy Warhol Foundation for the Visual Arts/ARS, New York.

self. Here the press engages in an undertaking whose ongoing success depends on the ultimate futility of its goal: That there is always something left unrevealed and beyond the public's grasp gives the press reason to continue trying to uncover the star's private self and the public reason to continue to buy its wares. The photographs of Monroe in the famous nude swimming scene shot for the movie *Something's Got to Give* published in June 1962 in *Life*, a magazine meant for a broad, family-oriented audience, function as a thinly disguised metaphor for the effort to uncover the true private Monroe.[7] Yet precisely at the point where Monroe is most "revealed," the failure of the press to unmask the private self becomes all too evident. The image of the seminaked woman standing by the pool pulling on her robe, half turned toward the viewer, with tousled hair and tongue between lips automatically falls into the public category of the nude well-rehearsed by centuries of painting and pornography. And, as in pornography, the exposed Monroe cannot satiate the viewer's desire because the moment of nearly complete physical revelation only highlights the fact that he cannot actually consummate his relationship with the real Monroe. The dynamic of the popular press operates like the striptease, promising access to the private self but never delivering it.

Monroe and Taylor were, perhaps unwittingly, complicitous in the dichotomy between public and private established in the popular press, because they themselves publicly insisted on the existence of a still-unrevealed private life. Taylor, by speaking of her star status as if it were a dress she could put on or take off, hinted that her essential identity lay somewhere else, hidden from public view. In a *Life* magazine interview entitled "I Refuse To Cure My Public Image," she commented: "The Elizabeth Taylor who's famous, the one on film, really has no depth or meaning to me. She's a totally superficial working thing, a commodity. I really don't know what the ingredients of the image are exactly – just that it makes money."[8] Moreover, both women voiced a desire to guard their private selves. Taylor declared in the same interview: "Whether I have been fickle or not fickle . . . is none of the public's business. In living my private life, my responsibility is to the people who are directly involved with me. . . . I have such an ingrained sense of privacy. There's a

point past which I cannot go just for the public's benefit."[9] In Monroe's case, her privacy served as a conscious means of maintaining an aura of mystery and fantasy. She refused *Life* any pictures of her new home, saying, "I don't want *everybody* to see exactly where I live, what my sofa or fireplace looks like. . . . I want to stay just in the fantasy of Everyman."[10] Once again, the popular press converted Monroe's unrevealed private self into the stuff of unfulfilled sexual desire.

Monroe's greatest contribution to the mass media's dynamic of public and private was her suicide in 1962, for this single act generated the ultimate exercise in the exploitation of private identity to legitimize public myth in the press. Monroe's personal tragedy raised both the mystique of an uncovered private life and the public act of revelation to new extremes. Although, on the one hand, Monroe's suicide asserted her ultimate control over her private life, on the other hand, it issued a challenge to the popular press to discover the reasons for her death and present them to its audience. The press cast Monroe in the role of a tragic victim, a woman whom no one had really understood and whose Hollywood image had driven her to take her life.[11] *Newsweek*, for instance, lamented: "That she withstood the incredible, unknowable pressures of her public legend as long as she did is evidence of the stamina of the human spirit. Too late one can only wish that somehow, somewhere that pressure might have been lifted long enough to let her find the key to the self behind the public image."[12] It was the pressure of the Monroe legend, these articles insisted, that had caused her to drink, to take drugs, and finally to kill herself. Recognition of the Monroe image as a separate entity created by Hollywood, an image that had victimized the "real" Monroe, hinted at the existence of a far more complex private Monroe than any previously shown to the public. The press thus had to redouble its quest to reveal Monroe's private desires and personality, this time in order to discover those aspects that had been crushed by the movie-star legend. Splashy news stories divulged Monroe's personal frustrations with her movie career; they blamed Hollywood for having typecast Monroe as a breathy, vacant sex symbol in B-grade movies despite the fact that she had aspired to more serious acting roles. Photographs of Monroe pub-

lished after her suicide disclosed a wide range of private emotions to demonstrate that her personality was more complex than her public image as the sexy blonde, or even the presuicide private image of the tempermental-yet-playful Monroe, might have suggested. In photographs taken by Bert Stern immediately before her suicide and published in *Vogue* magazine after her death, she appears wistful, helpless, and forlorn (fig. 48). The popular press succeeded in developing a far more complicated vision of a private Monroe after her suicide, a Monroe who, although often silly and loving, was also fraught with anxieties.

This image of Monroe has continued until the present day and is perhaps best exemplified by Norman Mailer's 1973 book on Monroe. Mailer included myriad photographs ostensibly showing both the public and private Monroe, which function as a mosaic of her life, career, and the different facets of her shifting personality.[13] In the chapter of his book entitled "The Lonely Lady," which recounts Monroe's approaching suicide, the number of photographs of Monroe looking sad and helpless increases dramatically. Nevertheless, this new postsuicide image was in no way closer to the "real" Monroe than the presuicide one; rather, Mailer's book served as a more extreme example of the press digging deeper into the star's private life and dredging forth new material to convert into an even more spectacular public image.

Artists working in the high-art medium of oil on canvas could – and did – share the popular press's dynamic of the private self legitimizing the public star. In Willem de Kooning's *Marilyn Monroe* of 1954, a painting produced well before Monroe's suicide, the body and face of the star invite the viewer to draw conclusions about her private self: the large doe eyes and broad, red lips parted into a smile express an invitation, perhaps, or convey an impression of warm vulnerability; and the curvaceous body, which is scantily clad and painted in glowing red and yellow colors, promises a voluptuous sexual experience (fig. 49). Similarly, the bodies of de Kooning's *Women* series from the early 1950s appear to display traces of the inner personalities of the women portrayed. For instance, in *Woman I* (1952), a large female body fills the picture frame, confronting the viewer head-on with her distorted eyes, open hissing mouth, and

Warhol, the Public Star and the Private Self

huge breasts. Slashing lines of color extend outside of the black lines that define her form as if an aggressive, inner force and potent sexuality have exploded beyond the contours of her body. It should come as no surprise that critics of the 1950s, as Michael Leja has pointed out, often interpreted the *Women* series as *embodying* the primitive and irrational essence of woman, an essence that was not, in other words, socialized and public.[14]

A number of paintings of Monroe completed after her death developed a vision of her presuicide angst similar to that of the popular press: the tortured Monroe trapped within the smiling public façade. James Gill's painting *Marilyn* of 1962 situates a full-color view of Monroe before three framed black-and-white images of the star (fig. 50). Juxtaposed against the three pictures in the background, all of which resemble publicity photographs, the foreground figure in red becomes the "real" Monroe behind – or in this case, in front of – the popular image. All three images in the background show her multifaceted public allure: her hairstyle, the angle of her head, and the twist of her body differs in each image. And all three images demonstrate a public expression of pleasure; she is all smiles. However, a deep shadow cuts diagonally across the mouth of the Monroe figure in the foreground, and her smile also stretches open much wider than that of the background figures; read in contrast to the smiling Monroe in the background, the expression on the face of the foreground Monroe transforms itself into a grimace of seeming inner anguish. Yet because Gill's image can actually get

Figure 48. (*top, page 156*) Bert Stern, *Marilyn in Vogue*. From *Vogue* (September 1, 1962). © Bert Stern. All rights reserved.

Figure 49. (*bottom, page 156*) Willem de Kooning, *Marilyn Monroe*, 1954. Oil on canvas; 50 × 30″. Collection Neuberger Museum of Art, Purchase College, State University of New York, gift of Roy R. Neuberger. Photo by Jim Frank.

Figure 50. (*top, page 157*) James Gill, *Marilyn*, 1962. From "Growing Cult of Marilyn," *Life* 54 (January 25, 1963).

Figure 51. (*bottom, page 157*) Derek Marlowe, *A Slight Misfit*, 1962. From "Growing Cult of Marilyn," *Life* 54 (January 25, 1963).

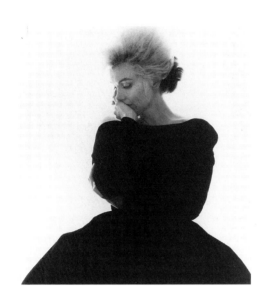

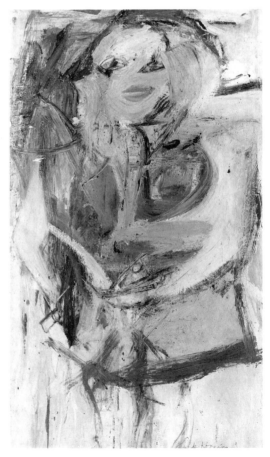

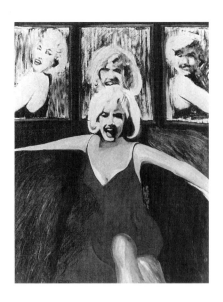

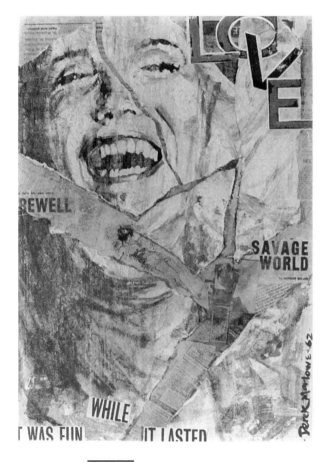

no closer to the real Monroe than any of the products of the popular press, his supposed juxtaposition of public and private ends up as no more than yet another echo of the suicide vision of Monroe manufactured by the portrait pictorials in the popular press.

In a similar spirit, Derek Marlowe's painting *A Slight Misfit* of 1962 portrays the destructive effect of the publicity world on the private Monroe (fig. 51). In Marlowe's canvas, elements of Monroe's public image, most notably her smiling face, mingle with hints of her private tragedy indicated by the split that cleaves apart the two halves of her face. The scraps of newsprint filling this facial fissure point to the villain responsible for Monroe's destruction. In other sections of the canvas, several words printed in bold black newsprint stand out and constitute a sort of eulogy to Monroe. They read: "[Fa]rewell," "[I]t was Fun while it Lasted," "Love," and "Savage World." All of the words (except perhaps "Love") must of necessity be addressed to the private Monroe because they speak of something that has passed, whereas the public Monroe did not die with her mortal body; she is in fact very much still with us to this day. Marlowe's painting, like Gill's, posits the presence of a private tragic figure behind the smiling public image.

Not only did high-art painters parrot the rhetoric of the popular press, the mass media also adopted such images for their own purposes. *Vogue* magazine reproduced both Gill's and Marlowe's paintings as moralizing works dealing with the publicity world of stardom that enveloped and eventually doomed the private Monroe.[15] The popular press had little difficulty recognizing in these paintings the textual and photographic strategies that it itself practiced; these were artists who spoke the media's own language by conjoining the private self and the public image of the star.

Warhol's Selfless Celebrities

Are there any traces of the private self in Warhol's portraits of Monroe and Taylor? The timing would certainly have been right for Warhol to turn toward the private, because he painted these two stars just at the moment when the press was examining their private lives with the greatest scrutiny. Warhol was certainly not oblivious

to the popular press. Walter Hopps, recalling a visit to Warhol in 1961, commented: "What really made an impression was that the floor – I may exaggerate a little – was not a foot deep, but certainly covered wall to wall with every sort of pulp movie magazine, fan magazine, and trade sheet, having to do with popular stars from the movies or rock 'n' roll. Warhol wallowed in it."[16] Moreover, Warhol began to depict Monroe immediately after her suicide when the press focused its investigatory powers on her private life with a renewed vengeance. Similarly, his series of paintings devoted to Taylor, which began in 1961 shortly after her near brush with death, continued throughout the scandal unleashed by the movie *Cleopatra.*

Warhol, however, avoided the sensationalism of their private lives. His portraits of Monroe and Taylor depict these women in their professional roles as movie actresses. Warhol did more than simply avoid the private self; he actively transformed the mass media's interplay between the public and the private into a purely aesthetic phenomenon. He disembodied mass-produced photographs of his stars from their textual and narrative sources – whether newspapers, magazines, or publicity stills – and silk-screened them as either single or multiple images painted with bright metallic colors. The differences between Warhol's many single-image Monroe canvases lie in the various colors or graininess of the silkscreens, not in the diverse emotional states of the sitter. A viewer's impulse may be to read the changing colors or shades of graininess in these images as representative of different moods.[17] But in Warhol's canvases, there is no correlation between alterations in colors or shadows and the feelings or emotions of his model. In each image, Monroe's face is essentially the same; it lacks significant change in facial expression or in posture of the head. Warhol simply applied different colors to the same basic face. Moreover, Warhol selected psychedelic and metallic colors that, in their newness and artificiality, resist attachment to human emotions. Even the titles of the Monroe and Taylor silk-screens, in which the star's name is qualified by either the number of images within the frame, the predominant color of the canvas, the size of the work, or its date, draw attention to aesthetic processes rather than to personality. If

anything, the namesake colors in Warhol's *Gold Monroe* and *Silver Monroe* silk-screens refer more to the monetary value of the public image than to the mood of the private sitter. Much as Warhol's *Soup Cans (Chicken with Rice, Bean with Bacon)* refused reference back to the reality of actual manufactured broth (fig. 10), Warhol's canvases of Monroe shut off engagement with the ostensibly real life of the private self.

A composite image of Monroe, such as *Marilyn Monroe*, might seem more likely to come into line with the mass media's dynamic of public and private, because it promises an emulation of the popular press's strategy of presenting serial images of the star as a means of gaining insight into the multiple moods of the individual subject. We have already seen, for example, how an artist such as Gill adopted from the popular press the strategy of differentiation within repetition to imply a contrast between the public and private self. The images in Warhol's composite silk-screens, however, lack any such distinctions. Warhol discriminated between his multiple, stacked Monroe images with nothing more than the aesthetic characteristics of the pictorial form: All twenty images of Monroe in *Marilyn Monroe* are based on the same photograph; and each is distinguished from its neighbors only because some are blurred, others streaked, some washed out, others darkened. Each representation of Monroe is simply an aesthetic contrivance, for all appearances the mere result of a sloppy application of Warhol's silk-screen technique.

This same device of effacing the private and presenting the public operated equally well in Warhol's silk-screens of male movie stars: depictions of Marlon Brando and Elvis Presley, who like Monroe and Taylor developed their star status in the 1950s, as well as of newcomers to the movie screen such as the "fair-haired and clean-cut" Troy Donahue and the "brooding but brawny" Warren Beatty.[18] Once again Warhol avoided snapshots of these stars' private lives off screen and instead based his silk-screens of Brando and Presley on stills from, respectively, *The Wild One* of 1953 and *Flaming Star* of 1960, while borrowing head shots published in fan magazines for his silk-screens of Donahue and Beatty.[19] And, as in the case of the silk-screens of Taylor and Monroe, variation in Warhol's

pictures of the male stars occurs only in the public realm of visual aesthetics, not in the private sphere of emotions.

The public identity and fame of these men as movie stars, like that of Monroe and Taylor, depended in large part on their sexual desirability. Male sex symbols constitute a hybrid category when the male body is cast into a traditionally female role. To adopt visual conventions normatively applied to women in order to display the male body in the movies and print media potentially troubles strictly divided sexual and gender categories. Indeed, the popular press itself often revealed, perhaps inadvertently, the contradictory gender status of the male sex symbol when it dubbed Donahue "the male Jayne Mansfield" and "Blonde Goddess," and described Presley as the male counterpart to Monroe.[20] Nevertheless, on an overt level, the rhetoric of the press secured the masculinity and hetero-sexuality of the male stars by including anecdotes about the uncon-trollable desire they unleashed in their fans, invariably described as "hysterical, screeching girls."[21]

The aesthetic contrivances of Warhol's silk-screens of male movie stars draw attention to the way in which the public image of these men, including its most distinguishing feature of heterosexual mas-culinity, is fabricated through pose, costume, and makeup. As in the case of the female stars, Warhol concentrated for the most part on the faces and not the bodies of the men. Yet, in Warhol's silk-screens of Donahue and Beatty, like those of Monroe and Taylor, the facial expressions of these stars fail to convey an impression of "natural" sensuality as they did in their original context of the fan magazine. Warhol's silk-screens instead transform the star's surface appearance into pure artifice by repeating the same shot of the head over and again, employing electric colors, emphasizing graininess, and, through off-register printing, mismatching facial features and shading.

The silk-screens of Brando and Presley depict the stars in memo-rable moments from their movies when they pose with all of the accoutrements of tough masculinity: motorcycle, gun, black leather jacket, cowboy boots. By extracting these images of Presley and Brando from their narrative context and repeating them in shining metallic colors, however, Warhol's silk-screens have the conse-quence of revealing the stars' masculine bravado as nothing more

than a combination of ostentatious costumes and stiffly staged poses. In the case of Presley, Warhol's aesthetic contrivances actually end up unsettling the star's display of masculine heterosexuality. Although Presley assumes the movie role of the gun-toting cowboy in *Elvis I* of 1964 with feet spread and gun cocked, the silkscreen undercuts Presley's demonstration of cowboy machismo by coloring his costume a garish red and purple, while smearing his face with orange lipstick and purple eye shadow (fig. 52). Warhol's silk-screens of male stars focus on the public image of these men, and in so doing suggest that their masculine heterosexuality is not inherent, natural, or private. Rather, these silk-screens draw attention to masculine heterosexuality of the stars as public, theatrical performances, which, at least in the case of Presley, do not even promise a secure or stable gender identity.[22]

By November 1967, when Harold Rosenberg penned the article "Masculinity" in *Vogue*, the challenge to signs of authentic masculinity had become so widespread, most obviously in the hippie movement, that he concluded: "On the neon-lighted lonesome prairie, masculinity is a matter of certain traditional costume details: the cowboy hat, jeans, and guitar. It has become clear that the traditional traits of the man's man (and the ladies' man) can be put on, too. One *plays* manliness." In response, "analysts of mass culture," according to Rosenberg, lamented a so-called "decline of the American male and . . . the 'masculinity crisis'" while urging "masculinity-building" as a solution. Suggesting that such reassertions of conventional masculinity could lead to the violence of rape, Rosenberg called on men instead to embrace the feminine characteristic of "gentleness": "True maleness," he asserted, "is never without its vein of femininity."[23] Masculinity as manifested in Warhol's depictions of male stars endorses neither "true" maleness or femaleness; dismantling essentialist assumptions about gender behavior, it conceives of gender as a form of dressing up in public.

Warhol's silk-screens emphasize the public image of stars as images, contrived through surface artifice and the very processes of representation. Slicing off the private side of the popular press's dichotomy between the public and private self, Warhol's silk-screens deny the very possibility of the private, the authentic, and

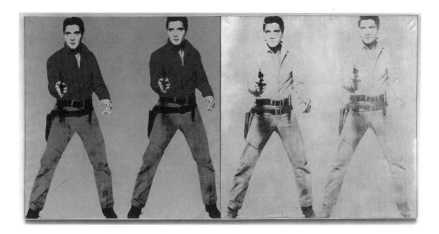

Figure 52. Andy Warhol, *Elvis I*, 1964. Silk-screen on acrylic; 208.3 × 208.3 cm, first of two panels. Collection Art Gallery of Ontario, Toronto. Gift from the Women's Committee Fund, 1966. Copyright © 1996 Andy Warhol Foundation for the Visual Arts/ARS, New York.

the real. Whereas pictorials in the popular press transform the private into public spectacle, Warhol displays the public symbol as straightforward aesthetic spectacle.

The "public image" of stars, their "brand names": in characterizing Warhol's silk-screens and their source photographs, I have tended to adopt terminology prevalent in the advertising culture of the 1950s and early 1960s. As we saw in Chapter 1, advertisers, social scientists, psychologists, and historians after the Second World War devoted many pages of writing to analyzing and debating the role of images, personalities, brand names, and trademarks in selling products. By the late 1950s, self-consciousness about the power of a product's image extended beyond the realm of goods and services, triggering discussions about how best to package presidential candidates as well as generating critical evaluations, some of them sensationalist, about the consequences of producing images to sell goods or people. One of the most searing critiques of the role of the image in American culture from this period came from the pen of a historian at the University of Chicago, Daniel Boorstin. In his book, *The Image*, published first in 1962 and reissued in paperback in 1964, Boorstin lamented the shift in American culture from the emphasis

on greatness to fame, from the hero to the celebrity, and from character to personality. All of these changes he attributed to the "Graphic Revolution," or the media. He saved some of his most caustic remarks for the celebrity, who was, according to him, an image-created name distinguished only by foibles of personality in contrast to the hero identified by admirable character traits:

> The Hero was distinguished by his achievement; the celebrity by his image or trademark. The hero created himself; the celebrity is created by the media. . . . While heroes are assimilated to one another by the great simple virtues of their character, celebrities are differentiated mainly by trivia of personality. . . . When we talk or read or write about celebrities, our emphasis on their marital relations and sexual habits, on their tastes in smoking, drinking, dress, sports cars, and interior decoration is our desperate effort to distinguish among the indistinguishable.[24]

Warhol's silk-screens of stars do Boorstin one better: Whereas Boorstin assumed that the celebrity's image was based on personality traits – albeit pathetically inconsequential ones – Warhol refused all grounding of the star's brand name in the behavior and habits of the private self. Where Boorstin sputters with self-righteous indignation about the degradation he perceived of the public figure from Hero to Celebrity, Warhol's pictures, with the measured dispassion of purely aesthetic manipulation, appear to pass no judgment on the purely public nature of the star's image. Boorstin bemoans a loss, where Warhol's pictures never register private personality or character traits, much less a Hero, to be missed.

Warhol's series of silk-screens of Jackie Kennedy painted after the assassination of John F. Kennedy would seem to be a blatant exception to his usual operation of effacement of the private individual in favor of the public celebrity role. These canvases appear to catch Jackie Kennedy at a moment of private grief; the images of Jackie Kennedy mourning the loss of her husband in the prime of his life seem to penetrate to the real woman behind the public role of the First Lady. But in fact Warhol's elimination of the private took its most extreme form when he adopted Jackie Kennedy as his subject,

Warhol, the Public Star and the Private Self

because the funeral of the President was the premier instance in the early 1960s of the public presentation of private emotion.

Both the print media and television converted the funeral of the assassinated President and his family's private grief into a spectacular public ceremony.[25] Jackie Kennedy herself laid the groundwork for this press extravaganza by personally helping to plan the details of the funeral: The press amply publicized her central role in arranging the funeral, which she modeled on Abraham Lincoln's, and it characterized her as being as courageous and as dignified as the tragic Mary Todd Lincoln. The parallel between the Kennedys and the Lincolns demonstrates the extent to which the funeral and Jackie Kennedy's public display of grief followed an established protocol.[26] The nation witnessed the pageantry and emotions of the funeral on live television and relived the event through the print media, which published photographs of the ceremony in chronological sequence.

Warhol borrowed the vast majority of photographs for his Jackie series from two issues of *Life* magazine devoted to the death of Kennedy: the feature story entitled "The Assassination of President Kennedy" published on November 29, 1963, and the following issue published on December 6, 1963, "President Kennedy is Laid to Rest," which described the funeral ceremony. True to the genre of news magazines, the accounts in *Life* magazine of the death and funeral of the President presented themselves as transparent records of the events. They laid out "documentary" photographs in strict chronological order with beginning, middle, and end. The narrative completeness and closure assured members of its audience that they were getting the full story. The account from November 29 began with a photograph showing the Kennedy pair standing tall and smiling before their plane in Dallas; the middle of the story consisted of four pages of individual frames from the Zapruder film, the famous home movie of the assassination taken by a bystander; the end included photographs of Lyndon B. Johnson being sworn into office with Jackie Kennedy at his side. From this series, Warhol appropriated the photograph of Jackie Kennedy arriving in Dallas and the picture of her at Johnson's impromptu swearing-in ceremony.

Warhol culled five photographs from the narrative about the funeral from the issue of *Life* dated December 6. Full-page, black-and-

white or color photographs, each accompanied by explanatory texts, allowed the reader to follow the funeral procession from the Capitol rotunda where Kennedy lay in state, down the Capitol steps, and through the streets of Washington to Arlington Cemetery. The ceremonial procession of the flag-covered coffin through the seat of government marked the passing of Kennedy's presence as the head of state; at the same time, the movement of the coffin through Washington drew the reader through the story of the funeral. Seriality in this case displayed not only the funeral procession, but also the family's mourning for all to see. Single, full-page, close-up photographs of the veiled widow interrupted the progress of the procession. The dynamic, in other words, played the emotional catharsis registered in the female face off against the narrative flow signaled by the movement of the coffin through Washington; at points, emotion momentarily arrested the story.[27] Within the popular periodical, the photographs of Jackie Kennedy documented, before the public eyes of the nation, her private sorrow over the loss of her husband in the prime of his life. The captions beneath one photograph read: "A woman knelt and gently kissed the flag. A little girl's hand tenderly fumbled under the flag to reach closer. Thus, in a privacy open to all the world, John F. Kennedy's wife and daughter touched at a barrier that no mortal ever can pass again. . . . Through all this mournful splendor Jacqueline Kennedy marched enfolded in courage and a regal dignity."[28] The media served as the conduit between Jackie Kennedy and the nation; the nation collectively mourned Kennedy's death through Jackie Kennedy's private grief. Her private grief became public ritual; her sorrow was not just hers, it belonged to the nation.

Warhol's aesthetic manipulations of these images make clear that he was dealing with the nationally known public Jackie Kennedy, not the privately mourning spouse. In Warhol's *The Week That Was I* of 1963, which contains all eight images Warhol appropriated for the Jackie Kennedy series, the image of the widow completely dominates (fig. 53). Warhol has decontextualized the image of the mourning widow, cropping away the accoutrements – Capitol, coffin, Kennedy brothers and children – that in the popular press had placed Jackie Kennedy within a public ritual. However, stripping

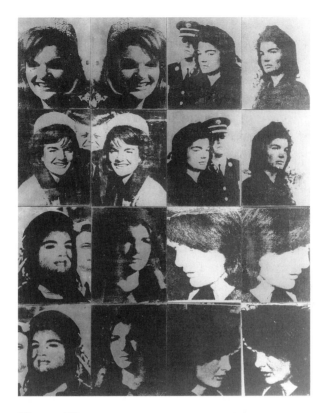

Figure 53. Andy Warhol, *The Week That Was I*, 1963. Silk-screen on synthetic polymer paint on canvas; 6'8" × 64". Private Collection. Copyright © 1996 Andy Warhol Foundation for the Visual Arts/ARS, New York.

away the public context does not necessarily leave a residue of the private mourning widow. Warhol zooms in on her face, blowing it up in size, thereby increasing the graininess of the image and decreasing the details of her face. As a result, Jackie Kennedy's face in each register is a highly schematized and coded expression of emotion.

Warhol's canvas eliminates the back-and-forth dynamic between narrative development and emotional release. Nor are the photographs presented in chronological order: the photographs in the top left quadrant show Jackie Kennedy in the limousine in Dallas moments before the assassination; the images in the bottom right quad-

rant, which depict Jackie Kennedy at Johnson's swearing-in, are the next set of pictures in actual narrative time; the photographs in the upper right and lower left quadrants all come from the funeral ceremony but are hopelessly out of chronological order. As a result, Warhol's silk-screen denies any story about either the sequence of events or the change of Jackie Kennedy's emotional state of mind.

Once again, Warhol subjected these images to purely aesthetic variations. Warhol paired each of the eight photographs with its mirrored reversal; this tactic not only guaranteed that half the images must necessarily be inaccurate as documentary photographs, it also created playful visual impressions for purely aesthetic effect. In the upper left quadrant, the mirroring goes so far as to evoke a visual joke at the expense of John F. Kennedy; one side of his face matches the same side of his face reversed in order to constitute one distorted, "exploded" frontal view of his head. All eight reversals form striking geometric patterns: while in the top left and bottom right quadrants the pairs of heads face toward and away from each other alternatively, in the top right and bottom left horizontally neighboring images line up like soldiers pointing in the same direction, first left then right or vice versa.

The Week That Was I treats the image of Jackie Kennedy's face not as a record of private grief but as a public icon, already produced by the popular press and subject to Warhol's aesthetic manipulations. Indeed, such aesthetic play cuts off any reference back to the private self; the actual Jackie Kennedy, like the real Monroe and Presley, is strikingly absent in Warhol's pictorial essays. Whereas *Life* magazine maintains the illusion of private grief within the context of public ceremony, Warhol takes up the public image while both shunning the narrative that defined the ceremony and effacing that which in the photographs of Jackie Kennedy signaled personal emotion. Instead, Warhol's silk-screens draw attention to these photographs as media *images* – produced in the press for the public purpose of mourning.

Warhol's silk-screens, however, do not entirely escape the suggestion of change over time in that they do include highly publicized images from both before and after the assassination, fragmentary remnants of a once narrativized series of events. Given that the

images Warhol borrowed are so well known within our culture, they cannot help but evoke that moment of the assassination that brought to an end the conception of the Kennedy administration as Camelot, as an active and youthful engine of national renewal. Even this characterization of the Kennedy White House as Camelot is itself as much a result of the postassassination period as it is of the era of his presidency. In retrospect, Kennedy's death produced a two-part periodization about his life and its impact on the nation: the lost age of Camelot and the age without Kennedy that has followed. That juxtaposition has been put to myriad uses, describing, for instance, the loss of American innocence or the dawning of the age of conspiracies. Kennedy's death has unleashed an unending reworking of images – in the popular press and in high art – competing to construct the representation of Kennedy that among other purposes has served to fill the void left by his death. All of these representations implicitly or explicitly recognize the absence created by his aberrant and premature death, and to that recognition of the passage from presence to absence we may give the name of mourning.

Warhol's silk-screens of Jackie Kennedy thus refer to public rituals of mourning in two ways. First, they borrow photographs of widely publicized moments from before and after the assassination, including scenes from the actual funeral ceremony; and, second, they mark a point in time when the production of narratives about Kennedy and his administration changed definitively. In Warhol's hands, however, the photographs purport neither to document actual displays of private grief nor to provide a coherent evaluation of the assassination or the Kennedy administration. Rather by self-consciously rearranging the photographs into insistently formal patterns, the silk-screens direct our attention to the role of images in narrating public rituals and filtering memories of the deceased.

Warhol's silk-screens of public figures, whether movie stars such as Monroe, Taylor, and Presley or the President's wife Jackie Kennedy, never claim to recapture an authentic private self. They do not reveal the private; they elide it. They depict these women and men only in their public roles as stars or as grieving widow, and emphasize the pure image value of those roles.

Warhol's Selfless Self

While Warhol dismantled the popular press's dynamic between public and private, the popular press was not the only visual language of its time. Given that Warhol's silk-screens portray famous people on canvas, another visual heritage suggests itself immediately: high-art portraiture. At first, this avenue does not promise much because the primary function of portraiture is remarkably similar to the interplay of public and private in the popular press: Although high-art portraiture usually does not practice serial repetition, it does try to find an expression, pose, or painting style that gives insight into the real person behind the picture. Particularly, portraiture in the twentieth century, when being modern has often been equated with an examination of interior experience, has striven to reveal the sitter's deeper psychological self. Because Warhol's silk-screens of Monroe, Taylor, Presley, and Jackie Kennedy resist all connection to a private reality, they have no meaning as portraits of individuals. That we hesitate to call Warhol's silk-screens of these women and men "portraits" reveals their inherent incompatibility with the rhetoric of high-art portraiture. His works would therefore appear not to fit into the primary dynamic of high-art portraiture any better than they do into that of the popular press pictorials.

Yet a second dynamic exists within modern high-art portraiture: Technique and aesthetic manipulations can refer to the private artist as much as, if not more than, the private sitter. In Francis Bacon's *Portrait of Isabel Rawsthorne* of 1966, for example, the grossly twisted and disfigured face of the sitter, the sweeping gestural brushstrokes, and the lurid colors seem less to concern the tortured private self of the sitter than the private agony of the painter himself (fig. 54). Such a connection between style and artist, of course, is not limited just to modern portraiture, and Bacon adopted much of his stylistic angst from an art movement that was custom-designed to minimize reference to the subject matter and to maximize reference to the artist: Abstract Expressionism. As we have seen in Chapter 3, the gestural brushstrokes of a Pollock painting were often assumed in the critical reception of Abstract Expressionism to convey the spon-

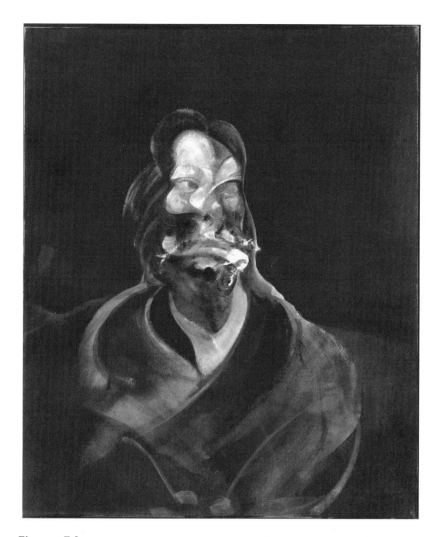

Figure 54. Francis Bacon, *Portrait of Isabel Rawsthorne*, 1966. Oil on canvas; 32 × 27″. Collection of The Tate Gallery, London. Copyright © Francis Bacon Estate.

taneous expression of the artist's personal confrontation with the blank canvas and to reveal the artist's interior emotion in its heroic proportions.

To a large extent, Warhol, much as he severed the connection between the public star and the private self, broke the link between

aesthetic manipulation and the individual painter. His silk-screens specifically avoid the language of Abstract Expressionism and stress instead the impersonality of the artist. As a technical medium, the silk-screen – Warhol called it an "assembly-line" technique[29] – prevents the direct physical and personal encounter between artist and canvas that ensued in Abstract Expressionist painting. Warhol's silk-screens did not even need to be reproduced by the artist himself but could be – and were – mass-produced in the "Factory"; Warhol's chosen name for his studio implies impersonal production. As he once commented to G. R. Swenson: "I think it would be so great if more people took up silk screens so that no one would know whether my picture was mine or somebody else's."[30] Warhol's technique self-consciously eschewed the flourish of the gestural brushstroke, which in Abstract Expressionism served as a signifier of the artist's presence, personal vision, or individual torment; all that remained were mechanical silk-screen stains. Warhol seemed aware – retrospectively, at the very least – of the implications of his technique when he said in 1980: "I still wasn't sure if you could completely remove all the hand gesture from art and become noncommittal, anonymous. I knew that I definitely wanted to take away the commentary of the gestures."[31]

The absence of any aesthetic sign of artistic personality on the surface of his silk-screens mirrored Warhol's public identity as an artist who consisted of only a façade, lacking any internal depth of personality. As Warhol once pointed out: "If you want to know all about Andy Warhol, just look at the surface of my films and paintings and me, and there I am. There's nothing behind it."[32] Warhol did not only avoid the presentation of personality on the canvas itself: In his day-to-day life, he also challenged the entire Abstract-Expressionist artistic persona. Resolutely rejecting the Abstract-Expressionist myth of the artist as the profoundly tortured and solitary individual, Warhol adopted the guise in the 1960s of a public star without a private or unique identity.

His interactions with the media consistently functioned to deny the individuality of the self. In the rare cases when Warhol employed the formulation "I think" in his statements to reporters – a construction which by its very nature would suggest an indepen-

dent identity – he advocated the elimination of the "I" or the individual self: "I think everyone should be like everyone else."[33] Warhol went so far as to suggest in *Art News* in 1963 that everyone should become a machine, the character trait attributed in the 1950s to the comfortable suburban middle-class citizen and, in a red-baiting era, to people who lived in communist states.[34] Indeed, in the interview published in *Art News*, his now famous machine statement followed an extended remark on communism: "I want everybody to think alike. . . . Russia is doing it under government. It's happening here all by itself without being under strict government; so if its working without trying why can't it work without being Communist? Everybody looks alike and acts alike, and we're getting more and more that way."[35] This is almost exactly what certain social critics in the 1950s might have concluded about life in the United States, but they certainly would not have added Warhol's tone of approval. The repudiation of conformity, a leveling of society that seemed to be manifesting itself almost everywhere in American life in the 1950s, was, as we saw in Chapter 2, at the very heart of the intellectual project of such critics as Greenberg. Profound individuality became for them a sacrosanct value that the artist – and art critic – were best equipped to protect. In this context, Warhol's quips can be read as a direct attack on the sacred cow of individuality.

In order to insist on the absence of individuality in his public persona, Warhol denied any sort of personal point of view: he tended either to react to every question in the same way or to respond with monosyllabic answers of "yes" or "no," as if nothing could possibly stir a private emotional response, an individual outburst of indignation or approval. Warhol's public statements of the early 1960s lack a stance on current issues, much less a commitment or even a judgment. Warhol effaced his own ego, instructing that "The interviewer should just tell me the words he wants me to say and I'll repeat them after him. I'm so empty I can't think of anything to say."[36] In another interview, Ivan Karp of the Castelli Gallery simply answered all of the questions directed to Warhol.[37]

Warhol did not claim either an individual or private identity; rather, he emptied his private life into the public arena. The promo-

tional blurb on the back cover of the Harper paperback of Warhol's *The Philosophy of Andy Warhol* tantalizes the reader with: "At last, the private Andy Warhol talks: about love, sex, food, beauty, fame, work, money, success." This sensationalist advertisement places Warhol's *Philosophy* within the genre of confessional autobiographies ghostwritten for movie stars. But Warhol's book does no such thing. Instead, it functions as a parody of personal revelation; it overflows with chatty banalities and frequent reassertions that he is "nothingness." In the end, the Warhol *Philosophy* reveals no more than that he is a nonentity without politics, personal life, sex, or age. Obviously, a self operates here to promote the image of the nonself; however, to say that Warhol was a *self*-promoter is not a contradiction in terms, because self-promotion for Warhol functioned as a means for emptying the private into the public sphere. Although Warhol may have been self-emptying, he emphasized the empty and not the self. He thereby became doubly transparent: He offered himself up as an empty receptacle that could be filled with whatever others want to see in him, and as a mirror that could reflect back to others an image of themselves and their culture. As Warhol himself wrote in the *Philosophy*: "I'm sure I'm going to look in the mirror and see nothing. People are always calling me a mirror and if a mirror looks into a mirror, what is there to see?"[38]

The claim can be made, of course, that the nonself Warhol presents – his empty, detached, or cool persona – is nonetheless an idiosyncratic character or even an individualistic stance. Yet Warhol so effectively typecast himself – both his physical appearance and his personal behavior – that his idiosyncrasies can also be understood as being generic. Thus, he could be successfully impersonated on college campuses in 1967 by Alan Midgette, a man who did not much look like Warhol, but nevertheless managed to pull off the act simply by spraying his hair silver and imitating Warhol's monosyllabic responses to questions. It is, therefore, not a paradox to say that Warhol was both idiosyncratic and generic because the private remains indistinguishable from the public self; for him, the private simply did not exist, or, alternatively, the absence of the private constituted his public persona.

Warhol's relationship with his entire Factory entourage, most

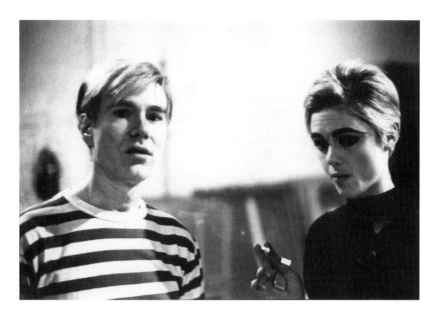

Figure 55. Billy Name, *Look Alike*. Edie Sedgewick and Andy Warhol at the Silver Factory, 1965.

notably with his Factory sidekick Edie Sedgewick, emerged as one of the most successful techniques for denying the existence of his own private self. Warhol surrounded himself with people such as Sedgewick who were willing to strip themselves of their own individual personalities and adopt Warhol's generic husk. Sedgewick, a wealthy young woman from a well-established family, joined the Factory in 1965 and soon became Warhol's "pop girl of the year."[39] As Warhol's fiction of an instant celebrity, Sedgewick represented a public star without a private self come to life. Warhol himself wrote of Sedgewick: "[She] could be anything you wanted her to be – a little girl, a woman, intelligent, dumb, rich, poor – anything. She was a wonderful, beautiful blank."[40] More important, however, her vacuousness made Sedgewick a perfect clone of Warhol's own emptiness. Slim, rich, and pretty, she presented herself as an empty receptacle whom Warhol, himself seemingly totally vacuous, could manipulate as a reflection of himself, a mirror reflecting a mirror. And Warhol and Sedgewick played on the interchangeability of their two nonexistent selves for all it was worth. Sedgewick dyed her

hair silver to match Warhol's, and dressed in clothes like his (fig. 55). In Jean Stein's biography of Edie Sedgewick, René Ricard comments on Warhol's and Sedgewick's appearance together at a party: "Edie and Andy! . . . Both wearing the same sort of thing – boat-neck, striped T-shirts. . . . Edie was pasted up to look just like him – but looking so good!" Pop art collector Ethel Scull describes Warhol's and Sedgewick's behavior at another party: "Andy, who sat humbly with his head down, wearing his leather jacket, and whispering to Edie what to do. Directing her. I could hear him say: 'Stand up. Move around. Pose for them.'"[41] Sedgewick lacked a private self, and even her public identity did not belong to her: she reflected back to Warhol the empty public self he projected onto her. And, conversely, as the alter-nonego of Warhol, Sedgewick highlighted the fact that Warhol's generic image was not even attached to his single unique body. The generic Warhol image could be pasted onto any human receptacle that happened along.

Mutual reflection between Warhol and his self-image (or nonself-image) Sedgewick was so close as to border on love, or at least that which comes closest to love when no active subject or object of affection exists.[42] Indeed, Sedgewick was the one person whom he claimed to have allowed to share his bed. Yet even on the one occasion when Warhol spent the night with Sedgewick, he never let down his generic guard, for he did not sleep himself, but stayed awake all night to watch her sleep. During that night, it was Sedgewick's private self that emerged, served up to Warhol's scrutiny. Warhol recounted to Jean Stein his "fascinated-but-horrified" reaction as he watched Sedgewick's private self emerge during the night: "One night, when the parties were over, I guess she didn't want to sleep with somebody, so she asked me to share a room with her. In her sleep her hands kept crawling; they couldn't sleep. I couldn't keep my eyes off them. She kept scratching with them. Perhaps she just had bad dreams . . . I don't know, it was really sad."[43] Quite unconsciously, of course, Sedgewick reversed the process from the movie *Invasion of the Body Snatchers* of 1956, that archetypal allegory of conformity, for Sedgewick's individuality emerged out of Warhol's generic mold during sleep, reclaiming control over her body. And Warhol, having gone to such efforts to

eliminate the private in his own life and that of his Pop "superstar" follower, thought it "sad" when Sedgewick's tortured private self rose to the surface.

Sedgewick's emulation of Warhol highlights the way in which Warhol's antiself repudiated not only the Abstract-Expressionist ideal of the private, individual self but also its normative masculinity. Pollock, as we have seen in Chapter 3, emerged in the early and mid-1950s as the model of Abstract-Expressionist individuality: aggressive, brawling, antisocial – a form of subjectivity for the most part unavailable to women in the 1950s. Morever, such expressions of manliness underwrote the style of Abstract-Expressionist painting: In much of the criticism of Pollock's art, painting style testified to both the authenticity of the artist's private emotion and his heroic masculinity.[44] Warhol's public self, like his silk-screens of male movie stars, did not locate either identity or gender in private behavior. Rather, Warhol's antiself could be adopted by males or females – and it was by both Alan Midgette and Edie Sedgewick. Exchangeable among men and women, Warhol's antiself served to blur gender differences, to produce an androgynous self, and to cast doubt on any psychological foundation of gender behavior.[45]

Camp and the New "In Crowd"

In the mid-1960s, the popular press seized upon Warhol's persona and his artistic practice to define two forms of aesthetic taste: Camp and Pop. Ultimately these aesthetic tastes, which were sometimes confused with one another in the press, enabled a newly emerging social elite to define its cultural identity. Paradoxically, then, Warhol's negation of the self provided the foundation for a new identity – an inauthentic, artificial form of the self – for others to use in the place of the private self that Warhol had rejected for himself.

Numerous journalists in the mid-1960s borrowed Susan Sontag's definition of Camp and reformulated it around Warhol. Sontag first drew attention to Camp when she published her now famous "Notes on Camp" in the *Partisan Review* in 1964. Although classifying Camp as a sensibility distinguished by its love of artifice and exaggeration, Sontag refused to provide a neat and conclusive gloss

on Camp and instead listed fifty-eight of its characteristics. Her article quickly piqued the interest of a number of journalists, who repeated and reworked her interpretation of Camp in the popular press. The articles published on Camp in the wake of Sontag's essay most often adopted her strategy of cataloging what seemed like a random number of items, ranging from Tiffany lamps to feather boas, as Camp. Unlike Sontag, however, these articles invariably included Warhol under the Camp rubric.

Although Sontag maintained a distinction between Pop art and Camp,[46] other journalists cited Warhol as a premier example of Camp, which Thomas Meehan writing in the *New York Times* in 1965 defined as a "third stream of taste, entirely apart from good taste or bad taste, that encompasses the curious attraction that everyone – to some degree, at least – has for the bizarre, the unnatural, the artificial and the blatantly outrageous."[47] For instance, Meehan listed Andy Warhol's eight-hour film *Sleep* second in his roster of Camp items, and he designated "Andy Warhol, the most prominent single figure on the New York Camp scene."[48] One of Warhol's *Heinz Tomato Ketchup* boxes even illustrated Meehan's article. Perhaps inspired by the overwhelming tendency to associate Warhol with Camp in the popular press, one art critic in 1965 adopted the term "high camp" to describe Warhol and his art.[49]

Vivian Gornick's article, "It's a Queer Hand Stoking the Campfire," claimed to bring Camp out of the closet, aligning the apparently new aesthetic taste that Warhol represented with homosexuality. However, Gornick adopted a biting and judgmental tone toward Camp – and toward homosexuality – dismissing this aesthetic as "pure and simple, self-hatred." To exemplify her case that Camp represented a debased homosexual taste that threatened to undermine the standards of high art, Gornick attacked Warhol:

> The most directly stunning result of camp's influence is, of course, the raucous Pop Art vogue . . . which has probably set the course of American art back some hundred years or so. One has the feeling that it all started one day when a bunch of sweet young things got together after a mad, mad day at the decorator's; in sarcastic imitation of the Mrs. Bab-

bitts they serve the boys began to whoop it up, painting the objects best fitted to describe Mrs. B's crass taste. One painted a huge lettuce and tomato sandwich . . . and one sees Andy Warhol staring serenely across the private, peroxided spaces, smiling Sphinx-like as the critics describe one of his Brillo boxes.[50]

Homophobia and misogyny make common cause in this passage as Gornick casts Camp as a homosexual aesthetic based on feminine bad taste. In so doing, Gornick clearly implicated Warhol as the key figure, who bridged the domestic sphere of Mrs. Babbitt and the production of Campy Pop art.

All of the authors on Camp, including Sontag, situated its origin in various homosexual subcultures, although no others expressed the explicit homophobia of Gornick. Sontag affirmed that "homosexuals, by and large, constitute the vanguard – and the most articulate audience – of Camp."[51] Other authors located the source of the word Camp in the British homosexual world of the 1920s or its New York counterpart of the 1950s. Simultaneously, these authors all distanced Camp from homosexuality by insisting that the term now referred to an aesthetic, a "third stream of taste," that was not specific to the gay community. Gloria Steinem, for instance, explained in *Life* magazine: "Homosexuals . . . are in the vanguard of Camp, though no longer its sole custodians."[52] The gay connotations of Camp, which were attached by association to Warhol, remained implicit in these articles.[53] Hence, in the mid-1960s, Warhol's name came to personify a Camp aesthetic in the popular press, exemplifying a taste for artifice that reflected explicitly or implicitly a gay sensibility.

Warhol simultaneously served as a pivotal figure in efforts to define another aesthetic taste, not necessarily at odds with Camp, that went by the name of "Pop." Pop did not in the popular press refer to Pop art, but rather constituted an aesthetic that cut across high art and consumer culture through its emphasis on fashionability, youthfulness, and fun. A few articles narrowed their definition of Pop to commercial objects that demonstrated the specific influence of Pop art. In February 1965, *Life* illustrated an article on

Pop fashion, home appliances, and advertising with a dress based on Warhol's silk-screens of Campbell's soup cans.[54] Most articles, however, applied the term Pop to a wide range of artifacts and, more importantly, drew no distinction among Pop art, Camp, and commercial culture. In "The Ins and Outs of Pop Culture," published in *Life* magazine, Gloria Steinem defined Pop as an aesthetic of playfulness, a category in which she included Warhol, Camp, Hollywood stars, and consumer products.[55] The illustrations to her article captured the thrust of her argument: They included several photographs of the author in Pop fashion collaged together to form a farcical board game, a roulette wheel with faces of celebrities instead of numbers, and a series of Campbell's soup cans sporting movie stars or fast-food items in the spot usually reserved for the company's gold medallions. Likewise, in *Newsweek*, Pop, exemplified equally well by Warhol's nightclub the Plastic Inevitable and the television program "Batman," emerged as "anything that is imaginative, nonserious, rebellious, new, or nostalgic; anything, basically, fun."[56] All of these articles mentioned Warhol in the same breath as the frug or miniskirts as embodiments of Pop culture's "spirit of Now."[57]

Journalists identified Warhol, his artistic practice, and implicitly Pop art in general, either as reflecting an extravagant, artificial, and gay sensibility in their discussions of Camp, or as demonstrating a consumerist, feminine, and frivolous orientation in their characterizations of Pop. The definition of Warhol and his art that emerged in either instance contradicted the understanding of the Pop-art movement then gaining prominence among art critics. As we have seen in Chapter 3, one group of critics began in the mid-1960s to promote Pop art, including Warhol's images, as a rigorous and serious effort to subsume its feminized sources in consumer culture to a formalist program. Implicitly, at least, Lucy Lippard, Ellen Johnson, Barbara Rose, and others distanced Pop art from Camp and consumer culture when they claimed that Pop represented a "cool" sensibility, far indeed from a taste for artifice, exaggeration, and playfulness.

When associated with either a Camp or Pop aesthetic in the popular press, Warhol could not represent a continuation of the modernist concerns of the 1950s nor a reassertion of that era's cultural

order and hierarchies of taste. Warhol's artistic practice understood as indistinguishable from consumer culture and as manifesting a taste for irreverence, extravagance, and artifice necessarily repudiated the divisions constructed in the 1950s between avant-garde and kitsch, highbrow, middlebrow, and lowbrow, or high art and consumer culture. Warhol's practice simultaneously challenged the dichotomies of gender that played such an important role in defining cultural hierarchies of the 1950s in the first place. We saw in Chapter 2, for instance, that Lynes opposed the male highbrow's understanding of "art and pure beauty" and the lower-middlebrow homemaker's decorating skills, and that *Life* magazine distinguished preferences for highbrow, middlebrow, and lowbrow images by male body types associated with particular social classes. With their connotations of youth, femininity, and homosexuality, Warhol and his art troubled the gendered divisions of cultural practice as these were characterized in the 1950s.

Yet while Warhol's art, when seen through a Camp or Pop aesthetic lens, succeeded in subverting assumptions about culture in the 1950s, such a reversal of prevailing ideas could also serve as a very conventional strategy for claiming avant-garde status, of executing an established tactic of modernist high art. Warhol's art and his generic persona could thereby be adopted by a new set of tastemakers in New York to define their cultural identity.

In the postwar era, many articles in the popular press – taking a different tack from Lynes's famous cultural taxonomy in the pages of *Life* – heralded the emergence of an aesthetic parity among all Americans rather than recognizing the formation of social groups according to differences in aesthetic taste. An increasing number of publications announced in the 1950s and early 1960s that a culture explosion bursting across the United States meant that many Americans, enjoying more money and leisure time, benefited from newly available theater, music, literature, and art.[58] This blatantly self-congratulatory assessment of cultural egalitarianism in the United States ran headlong into an anxious debate among cultural critics concerning whether widespread cultural achievement was compatible with a democratic society. Although there were those who, as we have seen in Chapter 2, applauded the greater availability of high

culture to more people and did not cringe at the thought that some gained access to the fine arts through the mass media as long as they did not "confuse soap opera with Mozart or Wagner," others worried about how to maintain standards of quality in a mass society.[59]

Ultimately, as Lynes and others pointed out, the culture boom, far from creating an egalitarian society, allowed certain social groups in the 1950s to distinguish themselves from others through their manifestations of aesthetic taste; the advent of Pop art in the early 1960s, however, split open Lynes's category of highbrow. In the early 1960s, it is certainly the case that a highbrow taste for art, music, and literature did function to establish one social grouping, the so-called "In crowd." Efforts to define such a group in New York during the early 1960s maintained that art, style, and fashionability rather than social register or family fortune now demarcated social boundaries. As art critic Sidney Tillim announced in "Art au Go-Go, or The Spirit of '65": "'In' society, a kind of jet-set Four Hundred described by Sherman L. Morrow as 'emphatically culture oriented,' has become the unofficial taste-making body of the nation."[60] Tillim was referring to an article by Morrow published in the *New York Times* on the "In and Out Crowd," which explained that the "In crowd" had "taken recognizable public shape only in the past four or five [years and] has now emphatically replaced the Four Hundred Café Society and the Jet Set as New York's most envied social group."[61] The "In crowd," according to Morrow, relied on culture as a means to define themselves as a community: "Because the In crowd is so emphatically culture-oriented, creators and performers from the worlds of highbrow culture are the In crowd's most respected members."[62] With Jacqueline Kennedy at its pinnacle, the "In crowd" embraced such leaders in the fine arts as Leonard Bernstein, Saul Bellow, and Willem de Kooning. Warhol, Morrow announced, was definitely "Out."

Embracing Warhol, however, as a sign of the outré, Camp or Pop aesthetic served as a means of defining a social subset apart from the highbrows, a new "In crowd." We have already seen how collectors such as the Kraushars and the Sculls adopted Pop art to distinguish themselves from a previous generation of highbrow collectors; similarly, socialites affiliated themselves in public with Warhol over and

against those luminaries such as the Kennedys who preferred de Kooning and the like.

Around 1964, Warhol's name began to appear in the society columns published by *Newsweek* and *Time*, and even the art reviews in these news magazines stressed his affiliation with a specific cultural milieu in New York. *Newsweek*, for instance, opened its review of Warhol's latest exhibition at the Castelli Gallery with a description of a party in a West Side apartment that included Norman Mailer, hardly a representative of the tasteful highbrow gentry. Warhol, christened by *Newsweek* as "Saint Andrew" and the "legend of pop art," emerged as the leader of a new generation gathered at the party; a "new hip world of blurred genders," as *Newsweek* characterized it. The magazine continued by explaining that "these violently groomed, perversely beautiful people want art, fun, ease, and unimpeded momentum, if only toward apathy."[63] Similarly, *Time* magazine located Warhol among a new elite of New York, who now favored sensationalism over social rules and propriety: "Oscar Wilde once noted that the way to get into the best society is to amuse or shock. That theory may have worked in Victorian London, particularly for witty, shocking Oscar Wilde. But it never went over in New York. . . . In recent years, however, New York has gone Wilde, and the newest darlings on its social circuit are artists and artisans. . . . At the moment, the magic names are Andy and Edie."[64]

Socialites and journalists alike associated Warhol with various features attributed to a Camp and Pop aesthetic: artifice, androgyny, perversion, fun. Warhol thus sanctioned the repudiation of rules of polite behavior, good taste, and "proper" gender and sexual roles. Ultimately, a coterie of socialites, by affiliating itself with Warhol not as an arbiter of good taste but as a representative of the Camp or Pop aesthetic, was able to secure its identity as the cultural avant-garde within the New York social scene.

Ironically, in the 1970s, Warhol transformed the social identity of the new "In crowd" based on his antiself, into a personal artistic style. Warhol's social coterie in New York had by the 1970s transmogrified into a circle of wealthy and well-established celebrities, fashion designers, business moguls, art dealers, and collectors that included Brigitte Bardot, Yves St. Laurent, Nelson and Happy Rock-

efeller, and Philip Johnson. These individuals asserted their identity as cultural tastemakers and members of Warhol's circle through portraits commissioned from the artist. Warhol's commissioned portraits of the 1970s, wholesale in number, reveal the extent to which the antiself had become a recognizable and personalized aesthetic.

Warhol's portraits, fully in the tradition of high-art portraiture, now referred to the individuality of the sitter. The negotiation between artist and client over aesthetic details of the silk-screens guaranteed that specific differences would emerge among the various portraits. Marco Livingstone explains that "since Warhol wanted the clients to be happy with the results [he] was quite prepared to involve them in the choices of image and color."[65] Indeed, Warhol's portraits appear to treat each sitter as unique by depicting him or her most often in single rather than in multiple images; each was titled either by "Portrait of . . . " or by the sitter's full name rather than, as in the images of the early 1960s, by color, number, size, or date. Moreover, each client adopted an apparently spontaneous pose: frontal or from the side, head turned or tossed back, smiling or serious – in other words, the standard portrait conventions for suggesting real personality and individuality. In *Portrait of Yves St. Laurent* of 1972, for instance, St. Laurent rests his cheek on his fist and casts his eyes downward with a serious and contemplative expression on his face. The fact that he wears his own clothing and sits in an apparently spontaneous pose suggests that the portrait has succeeded in conveying the personal self, not a flattened image of the public figure.

The portraits from the 1970s, moreover, register not only the individuality of the sitter, but also that of the artist. A standardized set of personal conventions manufacture a self for the artist based on surface artifice and flourish. In each portrait, Warhol juxtaposed silk-screened photographs of his sitters with bold, painterly strokes of garish color, for the most part absent from the paintings of the 1960s.[66] In the portrait of St. Laurent, for example, thick strokes of red paint appear around the sitter's head and arm. Warhol's brushstrokes in these portraits recall the verve of Abstract Expressionism, but transformed into highly stylized gestures: They signal the presence of Warhol's own artistic personality, precisely because they are

Warhol, the Public Star and the Private Self

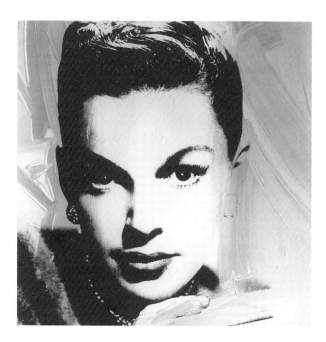

Figure 56. Andy Warhol, *Judy Garland*, c. 1979. Synthetic polymer paint and silk-screen ink on canvas; 40 × 40″. Copyright © 1995 Andy Warhol Foundation for the Visual Arts/ARS, New York.

figured and artificial. For example, in the posthumous portrait of movie star Judy Garland of c. 1979 (fig. 56), based on a publicity still from around the time when Garland made her spectacular comeback in *A Star is Born* of 1954, Warhol stamps her identity with his personalized artistic style. The pink and acqua paint that enframe Garland's face and even brush across her cheeks and hair bring to the portrait the elegant theatricality of Warhol's surface flourish. And although the use of a publicity photograph from another era might at first appear to conform to Warhol's earlier practice of latching onto the artifice of the public image, this canvas treats its source as if it were indeed a private portrait: Warhol's thick luminous paints veer away from the middle of the face to leave intact the steady gaze that seems to reveal the personal core of the real Judy Garland. How appropriate, then, that the portrait was most likely

commissioned by Liza Minnelli to serve the private purpose of preserving the family memory of a loved individual.[67]

Ironically, Warhol's nonself of the 1960s turned into a way of individuating the self and securing a social milieu in the 1970s. In contrast to his earlier silk-screens of stars, Warhol's portraits of the 1970s claimed individual private selves for himself and his sitters. Where the images of the early 1960s asserted a nonself, those of the 1970s recorded a self, albeit a surface self expressed by the artifice of style.

Chapter 5

Figuring Marisol's Femininities

In Marisol's sculpture *Women and Dog* of 1964, three fashionably dressed women and a little girl stroll side-by-side, a well-groomed dog in tow (Plate VII). Erect posture and attention to dress signal that all four females share an awareness that they are women on display. They don attire appropriate for an elegant urban setting; two of the women wear hats and suits, one of whom prominently clasps a real fur purse in her hand. The third woman dresses somewhat less formally in a pink sweater and a green skirt, and the girl sports a splendid blue dress and a pink bow in her hair. These women, however, not only present themselves as decorous objects to be looked at, they themselves also enjoy the power of the gaze. Two of them stare confidently ahead, and the remaining two, it would seem, swing their heads from side to side to survey the scene – rings of faces around their heads mark out the trajectory of their panoramic vision. The commanding presence of all four women that results attests to their comfortable social status and composure in public.

Yet several idiosyncrasies undercut this initial impression of leisured sophistication and solid assurance. All four figures seem oblivious to the plaster cast of buttocks and "falsies" attached to the young woman without the hat – attached to the outside of her clothes, no less – an exposure of the body not in keeping with the group's semblance of elegance and propriety (fig. 57). Nor do their

costumes look quite as polished and elegant as they should: Three of the women lack shoes, and the pattern of a black-and-white skirt that makes up the outfit of one of the women is only partly painted onto her torso. Moreover, the stance of the women can, on a second viewing, appear rather stiff; the figures are, after all, literally wooden. Their grouping consequently takes on a rather regimental appearance. Together these details transform the scene into a parodic representation of urbane feminine display.

Marisol, however, did not poke fun at these women from a distance, because she represented herself in their various guises of upper-middle-class femininity. The swinging heads of the two women with hats consist of multiple casts of Marisol's own face, the third woman has a disproportionately small photograph of Marisol's face attached to the front of her abstracted wooden head, and the girl's countenance consists of a drawing of Marisol's own features. *Women and Dog* is only one of a large number of sculptural groups completed between 1961 and 1966 in which Marisol assumed in this manner different roles of women primarily of the middle and upper-middle classes. Plaster casts of Marisol's face adorn almost her entire collection of blocky female figures, which she constructed from wooden boxes combined with carved heads and legs, contemporary clothing and accessories.[1] Her figures – her selves – portray brides, mothers, and wives; these women promenade with their families or socialize with other women. In these sculptures, Marisol appropriated and played with various female identities, including her own.

Although Marisol has since the 1960s received scant critical and scholarly attention, during the period in which she produced her cast of female characters, numerous reviews about her filled the pages of art journals, newspapers, and women's fashion magazines; probably more reviews, in fact, were published on her contemporaneously than on any of the male Pop artists. These critical reviews and fashion photographs feminized her sculpture in a variety of ways, and tried to make sense of her as the problematic character of "the woman artist." The contemporaneous surge and subsequent decline of interest in her work, moreover, are not unrelated: The critical fashioning (and self-fashioning) of Marisol and her sculpture

as feminine ultimately marginalized her from the modernist canon formulated in the mid-1960s and, ironically, even from the group of artists championed by the feminist art movement of the 1970s.

Recent feminist theory, however, allows a reconsideration and repositioning of Marisol, unavailable at the time of the production of her sculptures in the 1960s. In the final section of this chapter, I will, therefore, reread Marisol as a feminine subject in control of the processes of representation and self-representation, rather than as entirely determined by them.

Hard- and Soft-Core Pop

In *Pop Art* of 1966, Lucy Lippard opened the chapter on "New York Pop" by cautioning the reader:

> There are so many misconceptions about what is or is not Pop Art that for the purpose of the following discussion I should say that I admit to only five hard-core Pop artists in New York. . . . They all employ more or less hard-edge, commercial techniques and colours to convey their unmistakably popular, representational images. . . . The New York five, in order of their commitment to these principles, are: Andy Warhol, Roy Lichtenstein, Tom Wesselmann, James Rosenquist, and Claes Oldenburg.[2]

Having revealed her list of Pop masters, Lippard named a number of other artists who, owing to their choice of iconography, she considered had mistakenly been grouped by some critics with the first wave of the art movement. This group included one woman artist, Marisol Escobar.[3]

Although Marisol had been a figure frequently discussed in the art and fashion press during the preceding half decade, it was only when the first retrospective books on Pop art emerged around 1965 – Lippard's *Pop Art* and John Rublowsky's *Pop Art* – that writers first consistently grouped Marisol's sculpture uneasily with Pop art. Prior to that time, only a handful of critics and curators had mentioned Marisol's work in relation to Pop art at all.[4] In the retrospectives, nonetheless, Marisol assumed a marginal position, cast as the feminine opposite to an established canon of male Pop artists. Rhetori-

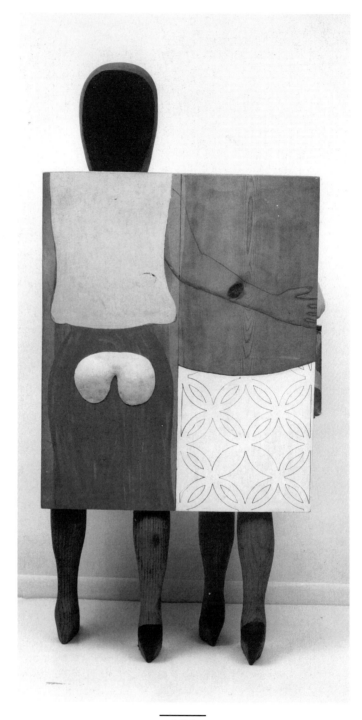

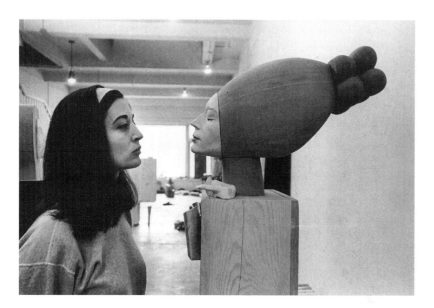

Figure 58. Lew Merrim, *Marisol Escobar with One of the Sculptures from* The Party, photograph, *The New York Times Magazine*, March 7, 1965. Courtesy of Monkmeyer Press Photo Service.

cally, this figure of the marginalized Marisol served, in the retrospectives and more generally in much criticism on Marisol's sculpture at mid-decade, to demarcate the boundaries of Pop art at a point when that art was being codified into a seemingly coherent movement.

As we saw in Chapter 3, despite particular differences in emphasis and interpretation in their books, Lippard and Rublowsky consolidated a relatively consistent definition of American Pop art: Pop's formalist dispassion characterized the movement and marked its difference from previous aesthetic practices, particularly the gestural branch of Abstract Expressionism. Both authors identified a group of genuine Pop artists by style and subject matter – Rublowsky named the same five artists as the main exponents of Pop art

Figure 57. (*facing page*) Marisol Escobar, *Women and Dog*, 1964, detail: back view of two figures. Wood, plaster, synthetic polymer, and miscellaneous items; 77 × 91″. Collection Whitney Museum of American Art, New York. Copyright © 1996 Marisol/Licensed by VAGA, New York, NY.

as did Lippard in his *Pop Art* of 1965 – and delineated a history for the art movement. Lippard, for instance, grouped the five "hard-core" members of Pop art together because they all depicted new mass-produced objects and adopted commercial techniques such as silk-screen and the Ben Day system for color reproduction. Pop art's "cool style" distinguished it from what Lippard called the "human-ist" schools of art, ranging from Social Realism to Abstract-Expressionist painting, that manifested any sort of anecdote or sentimentality. Similarly, Rublowsky established an opposition between the "sensibility" of Abstract Expressionism and the "antisensibility" of Pop.[5]

In a number of articles published at mid-decade, other art critics similarly defined a cadre of genuine Pop artists characterized by a cool sensibility. To describe Pop art, Barbara Rose and Irving Sandler relied on adjectives such as "impersonal," "deadpan," "impassive," "objective," and "neutral." Basing their analyses on style, Rose and Sandler suggested that several other contemporary art movements shared Pop's cool sensibility, including Op, Abstract Imagism (or Post-Painterly Abstraction), and Minimalism.[6] According to these critics, the younger artists – like their predecessors, the Color-Field artists Barnett Newman and Mark Rothko – concentrated entirely on analytical formal problems and rejected the ardent romanticism of Abstract-Expressionist painting. Sandler, in his article "The New Cool Art" of 1965, named Andy Warhol, Roy Lichtenstein, Frank Stella, Larry Poons, and Donald Judd as the principal artists producing a new deadpan art "so devoid of signs of emotion that I have called it cool-art."[7]

Whether discussing Pop art more narrowly or the sensibility of the 1960s more broadly, critics used the criterion of dispassion to distinguish the work of a select group of Pop artists from Abstract Expressionism, certainly, but, more significantly, from consumer culture as well. Lippard, for instance, argued that Pop artists were distanced and objective observers of consumer culture, more concerned with formal issues than with parody, humor, or social commentary. In essence, she claimed that Pop artists directed their attention toward consumer culture, yet maintained a distance from their sources by adopting an attitude of formalist detachment.

Figuring Marisol's Femininities

These critics of the 1960s, as we saw in Chapter 3, implied that genuine, "hard-core" Pop artists adopted a pose of masculine detachment when they depicted American consumer culture and emulated – without succumbing to – its techniques of mass production.

The critical definition of a central core of Pop artists involved not only pitting their paintings and sculpture against Abstract Expressionism and against consumer culture; it also involved describing a margin within the realm of Pop art itself. A number of critics found Marisol a suitable artist to situate in a space peripheral to "hard-core" Pop, a space necessary as the foil against which to demarcate the center. This critical practice began in 1965 when two exhibitions devoted to Pop art, *The New American Realism* at the Worcester Art Museum and *Op and Pop* at the Sidney Janis Gallery, included examples of Marisol's sculpture, and, when, more or less simultaneously, critics such as Lippard and Rublowsky began to articulate the relationship between Marisol's sculpture and Pop art. These authors recognized some common ground, but, for the most part, they spent their critical energies explaining why Marisol's sculpture did not really qualify as Pop art. Of course, critics also located other artists such as Jim Dine, Robert Indiana, and George Segal in the margins of Pop art. But whereas authors of the period attributed the difference between, say, a Segal sculpture and hard-core Pop art to Segal's handcrafted style and humanist imagery, they most often defined Marisol's marginality in terms of gender.[8]

Lippard, who of all of the writers on Pop art devoted the most attention to Marisol's sculpture, described both the institutional affiliations of shared exhibitions and the iconographic similarities between Marisol's sculpture and Pop art.[9] Emphasizing Marisol's portraits of John Wayne and the Kennedys – Warhol had also depicted contemporary public figures – Lippard isolated characteristics of Marisol's work that she believed shared the Pop sensibility. Yet even Lippard ultimately situated Marisol's sculpture outside of Pop art and perhaps outside of high-art modernism altogether: "Hers is a sophisticated and theatrical folk art justifiably reflecting her own beautiful face. But it has little to do with Pop Art, aside from its deadpan approach and touches of humour. Marisol rarely, if

ever, uses commercial motifs, although her *John Wayne* and *The Kennedy Family* would fall within Pop iconography, and her wit is chic and topical."[10]

Other critics likewise attributed to Marisol's sculpture a unique combination of naïveté and urbanity that ultimately distinguished it from Pop art. In so doing, they borrowed from earlier critics who had emphasized the "folk," "childlike," or "primitive" qualities in Marisol's work.[11] Dorothy Miller, curator of the *Americans 1963*, provided an authoritative evaluation, quoted by several subsequent reviewers, when she described the sculpture by Marisol that she included in the show as "a very individual, sophisticated expression in a folk art medium."[12] Several years later, the art critic for *Time* magazine explicitly distinguished Marisol's work from the rest of Pop art using a potpourri of classifications that similarly combined naïveté and wisdom: "Although her art has been mistaken for pop, she is actually more the 'wise primitive.' She naturally admires the work of the Douanier Rousseau, as well as African, pre-Columbian and early American sculpture. Her statues can also suggest the hex of voodoo."[13]

Critics positioned Marisol's sculpture both inside and outside of the conceptual framework of Pop art. And as these critics marginalized Marisol's sculpture, they implicitly articulated the criteria by which they privileged the works of the "hard-core" Pop artists. In this sense, criticism of Marisol's art from the 1960s exemplified a broader tendency that has been described by Griselda Pollock: "Women as artists – like Dora's mother – solicit little interest in canonical art history as artists – though in the guise of the stereotype of femininity, the *woman artist* is perpetually figured in art-historical discourse as the essential negativity against which masculine preeminence is perpetually erected, yet never named."[14] Accordingly, discussions of the ostensibly naïve folk character of her sculpture accentuated the hard-edge commercial techniques and themes of "hard-core" Pop art.

Nowhere did this dynamic operate with greater efficacy than in the critical treatment of Marisol's humor, which distinguished her type of satire from Pop's "cool" sensibility. Lippard, who had found Marisol's "touches of humour" had something "to do" with Pop art,

nonetheless considered her "wit" to be "chic," a term strongly associated with femininity and fashion.[15] Lippard's evaluation of Marisol's wit echoed the judgment of numerous other critics who, beginning in 1962, suggested that Marisol's sculpture represented some form of humor, ranging from wit to satire.[16] More often than not these writers, like Lippard, tended to categorize her humor as the product either of an upper-class feminine charm – they used adjectives such as "gay," "sophisticated," "elegant," "amusing," "affectionate," and "gentle" to describe it – or of a childlike innocence.[17] The critical evaluation of Marisol's wit may have located her sculpture within the boundaries of Pop art but marked it with a feminine difference.

The negative definition of Marisol's wit as "mere" feminine playfulness and cleverness served to figure the seriousness of Pop art. In their discussions of hard-core Pop artists in the mid-1960s, critics generally played down any evidence of humor, subsuming it to the artists' ostensibly detached sensibility. Lippard reminded the reader several times in her chapter on "New York Pop" that Pop art's primary purpose was not satire, parody, or humor, but rather the resolution of serious formalist problems approached with a deadpan attitude. By comparison to the art of the principal Pop artists, Marisol's sculpture lacked cool objectivity, and, in turn, Pop art seen next to her work gained a greater currency as detached and controlled.

Marisol's sculpture thus served critics and historians as a means to define both the inside and outside of the Pop art movement. It may have been a paradox for writers to find both folk innocence and urbane wit in Marisol's works, but that paradox placed her sculptures in a liminal position from which it could productively stand in contrast to the ostensible centrality of the concerns of the unequivocal Pop artists. Without a feminine Pop, there could not have been a masculine Pop in opposition; without the soft periphery, there could have been no hard core.

The Mysteries and Mirrors of Marisol

During the early 1960s, Marisol, in her exceptional role of female artist, came under as much scrutiny in the press as did her sculpture.

A Taste for Pop

Many years later, Cindy Nemser asked Marisol: "How did you feel about this mythmaking around you in the sixties?" Marisol responded: "I went along with it, just for the experience."[18] Indeed, by "going along with it," by providing selective details in interviews about her education, travels, and leisure interests, Marisol contributed the means through which the press constructed a myth of her as an upper-class and exotic woman artist. Yet, at the same time, she consistently withheld her face and voice as signifiers of personality, thereby generating an aura of mystery around herself that the press equated with the feminine. The image of Marisol "the woman artist" that emerged in the 1960s thus contained a contradiction, positing her as both the knowable and unknowable feminine.

In 1965, *Time* magazine reported: "born in Paris of Venezuelan parents, Marisol (means 'sea and sun' in Spanish) dropped her last name, Escobar, as too masculine-sounding."[19] By renaming herself in this way, Marisol defied the practice of a generation of women artists affiliated with Abstract Expressionism who obscured their identities as women through the manner in which they signed their works. Whitney Chadwick has recently pointed out: "[Lee] Krasner and Elaine De Kooning both chose to sign their works with initials only, while [Grace] Hartigan briefly adopted the sobriquet 'George' (in homage to George Sand and George Eliot). In each case, the decision to erase gender as part of the creative process was less an attempt to hide their identities as women than to evade being labelled 'feminine.'"[20] Chadwick suggests that the artists disguised their gender to discourage the public from searching for evidence of a feminine sensibility in their paintings; these women artists apparently conceived femininity to be incompatible with Abstract-Expressionist subjectivity. Hartigan went even further by impersonating the machismo of the Abstract Expressionists as a means of eschewing the delicacy and fragility that she associated with femininity. When recalling her legendary toughness in an interview with Nemser, Hartigan claimed: "I lived like the men. . . . But then never in my life did I consider a woman to be a fading waterlily. I always thought I was a person."[21] Both the phrasing and bravado of Hartigan's comment implicitly gendered "person" as masculine and

declared personhood to be incompatible with the artist's notion of femininity.

In contrast to Hartigan, Marisol readily adopted a pose of womanliness, and the press, fascinated by her appearance, background, and personality, embraced Marisol as the archetypal feminine artist. Grace Glueck opened her article "It's Not Pop, It's Not Op – It's Marisol" in the *New York Times Magazine* with this passage:

> "Marisol? A Latin Garbo" exclaimed an admirer recently. "Marisol? She's that beautiful witch in a Charles Addams cartoon," said another. "Marisol! The first girl artist with glamour," Pop art star Andy Warhol has proclaimed. The object of this flourishing mystique is Marisol, an enigmatic young Venezuelan-American artist whose poetic name is now internationally known (in Spanish, it means "sea and sun"). . . . On the New York art scene, the Marisol legend is nourished by her chic, bones-and-hollows face (elegantly Spanish with a dash of gypsy) framed by glossy black hair, her mysterious reserve and faraway whispery voice.[22]

The adjectives that Glueck and other critics selected to evoke Marisol's physique – slim, chic, black-haired, wide-eyed, high-cheekboned, Spanish – conjured an aristocratic, foreign beauty. Likewise the biographical narrative spun around Marisol stressed her upper-class, cosmopolitan background: Born in Paris of wealthy Venezuelan parents and schooled in Paris and New York, Marisol spent her leisure time attending parties and screenings of French new-wave films, reading fashion magazines and shopping. Even Marisol's name, which the press equated at once with ethnicity and nature, contributed to her legend as an exotic woman artist. The truncated version of her name accomplished exactly the opposite of "L. K." or "George Hartigan" by giving Marisol an emphatically feminine identity.

Yet, as Glueck's comments suggest, Marisol's glamour in the media as a woman artist resulted as much from her willingness to expose herself to view as from her pose of reserve. The information offered and withheld by Marisol tantalized the press and invited a

series of investigations into Marisol's life and personality, each of which promised to reveal and characterize Marisol's innermost self. This is precisely the dynamic we saw at work in the fabrication of Marilyn Monroe's and Elizabeth Taylor's femininity in Chapter 4. As in the case of Monroe and Taylor, the repeated failure to find the key to unlock Marisol's mystery inevitably served to reinvent her as a sign of the unknowable feminine.

The press referred to various incidents in which Marisol hid herself from public scrutiny as evidence of her enigma. One oft-repeated tale about Marisol described her participation in a panel discussion on Assemblage at the Artist's Club in 1961. Grace Glueck relayed the story second-hand in the *New York Times Magazine*:

> "The four male panelists," recalls Al Hansen, who was there, "were dressed like kids looking for a job in a bank. But Marisol showed up wearing a stark white mask decorated in Japanese style, tied on with strings. The club members were apt to bully young unknowns unmercifully. The panel no soon got under way than people began to stamp and holler, 'Take off that goddam mask! Let's see your face!' When the noise got deafening, Marisol undid the strings. The mask slipped off to reveal her face, made up exactly like it."[23]

By twice frustrating the desire of the audience to see her face, Marisol presented herself as a riddle without an answer. Even the rhetorical form of Glueck's account reinforced this impression of inscrutability. Like Marisol's mask revealing another mask, Glueck's report contained beneath itself another report. And Glueck's article, typical of virtually all press accounts of the incident, did not ultimately ascribe a meaning to Marisol's behavior. Rather than resolving the ambiguities of her gesture, it simply recounted the event. The press thus represented the enigma of Marisol without offering its solution.

Even when Marisol uncovered her face, she frustrated the desire of critics to treat it as a transparent window onto her private self. Susan Stewart has recently commented on the common belief that the face presents a legible text, pointing out that "one of the great topoi of Western literature has been the notion of the face as

book."[24] Operating on the assumption that the face encoded the self, Gloria Steinem promised to reveal "Marisol: The Face Behind the Mask" in her article on the artist published in *Glamour*. Yet Steinem concluded: "Marisol's capacity for holding dead seems infinite and her face is not more open than a cat's." Having failed to decipher Marisol's countenance, Steinem concluded that Marisol was a "beautiful enigma."

Marisol's mystery resulted not only from her inscrutable face, but also from her silence. Her refusal to confess her private life received an enormous amount of attention in the early 1960s. Critics reported that Marisol delivered only terse answers in a quiet voice to their questions; otherwise she remained silent both in exchanges with interviewers and in social settings. Indeed, in many ways Marisol's secrecy conformed to the myth of the deep and silent artist. "She is a classic example of a non-verbal artist," Steinem commented; "Life goes on, for her, in the visual, and words mean very little." Nevertheless, critics, including Steinem, invariably feminized her silence by comparing her to public icons of grace and mystery, including Greta Garbo, Jeanne Moreau, and Jackie Kennedy.

Owing to Marisol's unfathomability, more than one critic associated her with the Sphinx. Steinem, confronting Marisol's legendary silence, declared:

> It's no wonder that some interviewers and a few acquaintances come away feeling that it is all a pose calculated to intrigue. One interviewer complained that asking a question of Marisol was like dropping it down a well, and another accused her of seeing too many plays by Harold Pinter. . . . Another writer began his interview by quoting one of her art-world detractors: "Who, Marisol? Why, she's a sphinx without a riddle!"[25]

The linking of Marisol to the Sphinx granted her a certain type of power: Her silence constantly challenged the desire of others to solve her conundrum. No interviewer succeeded, however, in breaking through Marisol's reserve, and this failure in and of itself both increased her mystery and authorized continual reinvestigation of her character.

A Taste for Pop

The press increasingly equated Marisol's sculpture with her enigmatic persona, especially after her one-person exhibition at the Stable Gallery in 1964 in which the majority of her sculptures bore images of her apparently unreadable face in the form of either plaster casts or black-and-white photographs. For instance, Brian O'Doherty's review of the exhibition at the Stable Gallery, entitled "The Enigma of the Self-Image," discussed Marisol's multiple self-portraits as physical manifestations of her mystery: "a widely multiplied enigma, Marisol is also an enigma to herself. Sometimes she sees herself sharp-featured and high-fashion, sometimes blunted and round, the face set in an Egyptian tunnel of hair, occasionally as a woman out walking with four faces looking simultaneously in all directions."[26] Published reviews of the exhibition at the Stable Gallery frequently included photographs that posed Marisol with her sculpture as if artist and artwork were indistinguishable from one another. O'Doherty's review was illustrated by a photograph of Marisol seated between the two sculpted women – each with replications of the artist's face – from the *Dinner Date* of 1963. Earlier, *Time* magazine had paired a photograph of Marisol's sculpture of the Mona Lisa, an icon often regarded as an exemplar of female mystery, with a photograph of the artist herself in which she took the same pose as her sculpture and imitated the secretive smile of Leonardo's model.[27] Other photographs posed Marisol as mirroring and mirrored by her sculpture: she stood face-to-face with one of the women from *The Party* of 1965–6 in the pages of the *New York Times Magazine* (fig. 58).[28] Criticism and photography positioned Marisol's sculpture as a representation not only of various women, but also of the enigma of the woman artist herself.

Paradoxically, however, to suggest that Marisol's sculptures reflected their creator attributed an alternative characteristic – likewise associated with the feminine yet in crucial respects antithetical to enigma – to Marisol and her works. Many critics pointed to Marisol's incorporation of images of her own face in her various sculptures of women as evidence of female narcissism. Where the figure of enigma ascribes to its object an always receding and unknowable essence, that of narcissism finds essence in surface appearance, an appearance that, in its iterability, becomes perfectly visible

and comprehensible. In this sense, narcissism, as a mechanism of revelation, functioned in opposition to the obfuscations of enigma.

As late as 1973, April Kingsley claimed of Marisol's sculpture: "Narcissism has always been one of the primary constituents of this content."[29] Somewhat ambiguous, Kingsley's statement can be understood in at least two ways (like Glueck's recounting of the incident at the Artist's Club, it is itself an enigmatic formulation). In a first reading of Kingsley's sentence, Marisol's sculpture represents women engaged in acts of narcissistic self-absorption. With their fashionable dress and erect stances, Marisol's figures embody a concern with self-presentation, and, within the psychoanalytic discourse from which the term derives, narcissism consists of a form of self-absorption and display that is considered naturally feminine.[30] The narcissism of Marisol's sculpted women was, with the possible exception of Kingsley, not noticed nor elaborated upon – presumably because it was regarded as a normal affect of bourgeois femininity.

In a second reading of Kingsley's statement, Marisol's repeated use of casts and photographs of her face manifests her obsessive concern with her own surface appearance. Marisol frequently defended herself against charges of narcissism. *Time* magazine quoted her as saying: "Some people have accused me of narcissism . . . but it is really easier to use myself as a model."[31] Wrote Leon Shulman for the catalogue that accompanied Marisol's exhibition at the Worcester Museum of Art: "Accusations of narcissism and self-love are probably unfounded."[32] That Marisol and various art critics repeatedly denied the artist's narcissistic self-absorption, however, indicates that such an interpretation existed, indeed that it may have been so readily available and automatically applied as to require little explicit articulation.

With the two readings it activates, Kingsley's ambiguous statement, like Glueck's account, in the end replicates the personality of the artist it describes. The narcissistic sculptures, it would seem, find their perfect reflection in a narcissistic Marisol and vice versa. Rather than resolving the enigma, rather than presenting the answer to the riddle, Kingsley suspends its mystery in the exact match between two sets of surface appearances.

There were, of course, different manners in which critics at the time could describe artistic self-absorption. Lawrence Campbell, in denying that Marisol was narcissistic, attempted to align her instead with what he believed to be an acceptable form of artistic interest in the self: "Self-love, not the same as Narcissism, is implicit in all behavior. Modern art, with its unsparing exhibitionism, emphasizes the discovery of self."[33] The Abstract-Expressionist painters and sculptors set a standard at the time for the practice of the modern artist concerned with self-discovery. As we have seen in Chapter 3, critics frequently explained that Jackson Pollock revealed his inner self in his paintings; they highlighted, however, the way in which Pollock, through the act of painting, transformed his self into general truths. Given this understanding of what constituted a model of artistic self-discovery, it is not surprising that Campbell and other critics would try and deflect the charge of narcissism from Marisol. Narcissism indicated a form of self-absorption focused on appearance, on surface illusion, rather than on internal insight. Moreover, the concept of narcissism equated the artist with her work reflectively, rather than granting her the powers of artistic transformation.

The self as knowable, visible on the surface of the body rather than hidden within. Such a formulation of the self aligned Marisol more with Warhol than with Pollock: Both Marisol and Warhol located their identities, at least in part, in surface appearances that could be duplicated. Indeed, the popular press did from time to time link the names of Warhol and Marisol. Warhol, perhaps sensing a female counterpart, embraced Marisol as "the first girl artist with glamour," appeared with her at parties, and included her in two of his movies, *The Kiss* and *13 Beautiful Girls*.[34]

Although Campbell and other critics attempted to save Marisol from narcissism by crediting her with some of the powers of Abstract-Expressionist transformation, allusions to her narcissism did ultimately foreclose her alignment in modernist histories with the practice of Pop artists, even Warhol's. Lippard's comment that Marisol's art reflected "her own beautiful face" implied a reciprocally reflexive relationship between the artist and her art, an over-identification that was at odds with the detached and objective

approach attributed to Warhol and the other male Pop artists. Although Lippard also called Marisol's approach "deadpan," most art critics insisted that she lacked the cool attitude of other Pop artists altogether. Indeed, John Rublowsky's *Pop Art* distinguished Marisol's work from Pop art by associating her with the sensibility of the previous generation of Abstract Expressionism. He wrote:

> On the periphery there were such artists as James Dine, George Segal, Marisol Escobar, Robert Indiana, and others who also approached pop art. They are, however, not pop artists in the strict sense of the term. Their artistic statement, though it borrows from the reality revealed by pop art, is more closely allied to the abstract-expressionist ethos in that their statements depend on sensibility and texture for the projection of an artistic aura.[35]

Rublowsky, who based his description of the "antisensibility" of Pop art on its rejection of painterliness, detected signs of Marisol's personal emotions on the surface of her work.[36] Both the traces of Marisol's hand and the imprints of her face on the surface of her sculpture led critics to conclude that her work lacked the impersonality of Pop art. By such accounts, Marisol's sculptures emerged as expressions of an implicitly feminine narcissism over and against the cool, masculine detachment of Pop art.

In the end, characterizations of both Marisol's enigma and her narcissism served to situate her within the category of the feminine rather than within that of the modern artist. Indeed, these descriptions together produced and managed her femininity through a paradox: where enigma suggested an unfathomable interiority, narcissism implied a visible exteriority where everything was reflected on the surface. Enigma and narcissism thus invoked the two modes of vision that Laura Mulvey argues are open to men when confronted with the image of woman: voyeuristic investigation and fetishistic scopophilia. Mulvey writes about classic Hollywood cinema:

> The woman as icon, displayed for the gaze and enjoyment of men, the active controllers of the look, always threatens to evoke the anxiety it originally signified. The male unconscious has two avenues of escape from this castration anxi-

ety: preoccupation with the reenactment of the original trauma (investigating the woman, demystifying her mystery) . . . or else complete disavowal of castration by the substitution of a fetish object or turning the represented figure itself into a fetish so that it becomes reassuring rather than dangerous (hence overvaluation, the cult of the female star). This second avenue, fetishistic scopophilia, builds up the physical beauty of the object, transforming it into something satisfying in itself.[37]

Likewise, the contradictory dynamic between enigma and narcissism authorized a (masculine) high-art viewer simultaneously to pursue the enigma of Marisol and to take pleasure in the spectacle of her narcissistically reflected image. Thus, the very conceptual processes used to come to terms with Marisol as a woman artist served to position her as the female object of the male investigatory and spectatorial gazes while perpetually rearticulating her identity as feminine.[38]

The Fashionable Artist and Art as Fashion

In the early 1960s, at the same time as art criticism relegated Marisol and her sculptures to the feminized margins of Pop art, fashion photography, itself marginalized as feminine, placed her at the center of the world of style. Several fashion layouts printed in both women's magazines and art periodicals cast Marisol as a graceful model or posed her sculptures as mannikins and props alongside *haute couture*. Marisol thereby participated in yet another visual practice that ultimately linked her with femininity and narcissism. Yet, in this case, the viewers posited by the fashion layouts were female consumers who were invited to adopt a gaze of narcissistic identification with the commercial image rather than to look at it with the distancing mechanisms offered to the reader of high-art criticism. Several of the critics I examined in the last section did publish their reviews in magazines such as *Cosmopolitan* and *Glamour* that, like the periodicals I will now examine, were addressed to women readers and often treated the subject of fashion. In essence, these magazines, somewhat cultural hybrids, required their readers,

as they paged through each issue, to switch their perspective back and forth between one of high-art detachment and one of consumer overidentification.

Several magazines cast the artist Marisol as a fashion model, a woman attentive to her external appearance and characterized by a distinctive style of dress. In October 1963, *Harper's Bazaar,* a large-format magazine that each month featured the latest designs in international *haute couture*, devoted an article and photospread to Marisol.[39] Yet, the magazine did not include her in the series devoted to avant-garde literature, film, and art entitled "Features and Fiction," which that month profiled artist Francis Bacon and writer Iris Murdoch. Rather, the magazine presented Marisol in the "Fashion Independent" series, which had been initiated two months earlier with the following editorial proclamation:

> This is the era of the Fashion Independent: that fascinating, very contemporary lady of indeterminate age, indeterminate income, but extremely definite and always exciting, if slightly non-conformist taste. Her way of dress suits her way of life. In fashion, as in spirit, she follows no preconceived, mass-formula pattern set down by "experts." Her personal, particular chic depends not upon what's current nor what's costly, but on the special, vital circumstances of her own existence; on her inner, intuitive sense of style. *Bazaar* believes in this woman and in her philosophy of living – so strongly that we propose to intimately present at least one Fashion Independent on these pages every month.[40]

To exemplify the taste of the Fashion Independent, the magazine selected a variety of women who purportedly led exceptional lives.[41] The third issue in the series featured the style of the fashionable woman artist, Marisol.

In the pages of *Harper's Bazaar* Marisol emerged as a woman with a particular style – not a style of sculpting but a style in consuming clothes. Her career as an artist did receive some acknowledgment: In all of the photographs taken by Duane Michals, she modeled attire in front of her sculptures, and the text opened by stating that the Museum of Modern Art had included her work in its exhibition

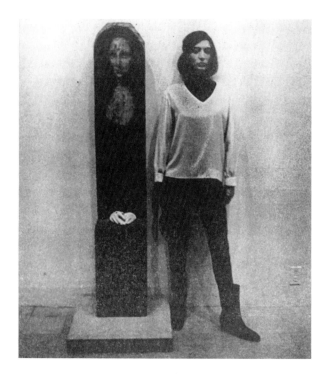

Figure 59. Duane Michals, *Marisol Escobar*, photograph published in *Harper's Bazaar* 97 (October 1963). Courtesy of Duane Michals.

Americans 1963. Yet the magazine's primary interest lay in her taste in clothes, which it characterized as "functional purity-cum-style." In three photographs, Marisol dressed the part of the bohemian artist in turtleneck, overblouse, and slacks (fig. 59). She also played the role of the elegant lady-of-leisure clad in a variety of ballgowns: Two photographs showed her with a "stark white crepe evening dress dramatized by a sweep of floor length stole" (fig. 60), and in a third photograph, she donned "a banker's gray wool flannel Empire lounging dress, cut low."[42] In short, *Harper's Bazaar* treated Marisol's status as an artist as just one more feminine role requiring one more fashionable costume.

Harper's Bazaar positioned Marisol as a participant in a well-established practice in the fashion world: She produced her identity as a "very feminine wood sculptor" through acts of narcissistic con-

Figuring Marisol's Femininities

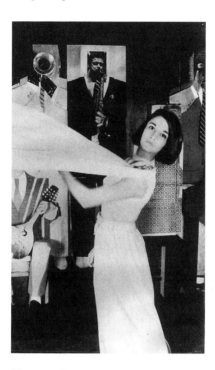

Figure 60. Duane Michals, *Marisol Escobar*, photograph published in *Harper's Bazaar* 97 (October 1963). Courtesy of Duane Michals.

sumption of clothes (the awkward placement of the adjective "wood" also had the effect, once again, of conflating the woman with her artistic productions). Consequently, Marisol's style, although presented by *Harper's Bazaar* as purely individual, was nevertheless available for mass consumption. The text identified the clothes, their prices, the stores that sold them, and the salon responsible for her coiffure. Recently, Mary Ann Doane has argued that "having and appearing are closely intertwined in the woman's purported narcissistic relation to the commodity. Commodification presupposes that acutely self-conscious relation to the body which is attributed to femininity."[43] Fashion magazines in general address the female consumer with a concern about her appearance – indeed, they take that concern for granted – and compel her to take

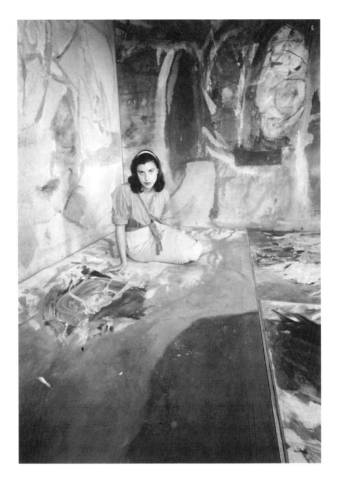

Figure 61. Gordon Parks, *Helen Frankenthaler*, photograph, *Life* 42 (May 13, 1957). Copyright © Time Inc.

the fashioned female body as the object of her attention. *Harper's Bazaar* assimilated Marisol into this system not only by offering her as a prototype of a woman who successfully produced her femininity through consumption, but also by inviting the female reader to adopt for herself the distinct style of Marisol the woman artist.

Marisol was not the first woman artist to present herself as fashionable in the popular press. For instance, even though some women Abstract-Expressionist artists such as Hartigan adopted a masculine persona, the popular press in the late 1950s and early 1960s

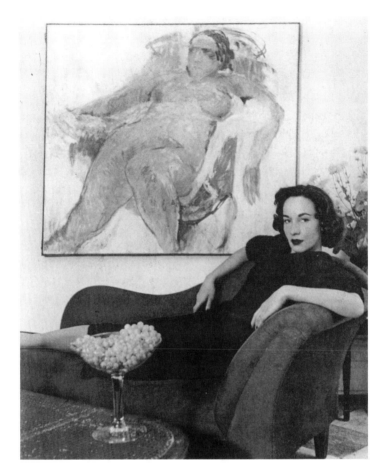

Figure 62. Gordon Parks, *Jane Wilson*, photograph, *Life* 42 (May, 13, 1957). Copyright © Time Inc.

often presented them as embodying a certain bohemain chic. In 1957, *Life* magazine featured "Women Artists in Ascendance," one of the most extensive articles on female Abstract-Expressionist art- ists published during this period. The article, however, did not in- clude views of women artists actually painting; only the photo- graph of Nell Blaine offered a glimpse of paintbrushes (all of which had clean tips) set upright in a can like a bouquet of flowers. *Life's* photo spread instead posed the women seated casually, sometimes even provocatively, next to or on top of completed paintings. For

instance, Helen Frankenthaler, wearing a narrow white skirt and looking rather diminutive, sat on a corner of her canvas leaning forward, legs tucked behind her in a serpentine pose (fig. 61). In another photograph, Jane Wilson, perfectly coiffed with red lipstick freshly applied, lounged on a sofa surrounded by flowers, fruit, and one of her painted nudes (fig. 62); the caption read, "Though she works as a New York fashion model, Jane Wilson spends up to eight hours a day painting."[44] Even if their poses did not stress their seductive feminine allure, the women's outfits matched the colors of their paintings as if artist and artwork were nothing more than decorative elements in a color-coordinated interior.

Paradoxically, however, even as feminine fashionability undercut the professional identities of the female Abstract Expressionists as artists in the *Life* photo spread, it also marked their bohemian status. None of these women adopted the conventional appearance or behavior associated with the homemaker; they posed in their studios rather than in domestic interiors. Indeed, in a telling comment from the period critic Eleanor Munro contrasted Joan Mitchell to the "other women involved in the Abstract-Expressionist movement [who] have adopted a manner more Parisian in combining bohemianism with cultivated femininity."[45]

Harper's Bazaar did not present Marisol as an artist who happened to be a fashionable woman, but as a fashion independent who happened to be an artist. Actively adopting and adapting postures from the repertoires of the female model, Marisol forged a public identity defined as much around her consumption of clothes and surface fashionability as her artistic production. Neither did her stint as a model go unnoticed by art critics. Campbell mentioned in passing: "Marisol Escobar is an extremely beautiful young woman with the kind of chic which attracts fashion magazine attention."[46] And critical reviews of Marisol regularly reported on her interest in clothes.[47]

Thus, on the one hand, as in the case of the female Abstract Expressionists, Marisol's fashionability and femininity served to mark her status as a bohemian artist: In the role of fashionable woman artist, Marisol functioned as a public sign of a consumer-oriented femininity and glamour opposed to the homemaker whose purportedly rational consumption centered around the private

realms of the home and family.[48] On the other hand, a fashion layout such as the one in *Harper's Bazaar* contributed to discussions of Marisol's glamour, beauty – and narcissism – among art critics. References in art criticism to her role in the fashion press reinforced the ascription of femininity to Marisol, an ascription that, as we have already seen, worked against her identity as a genuine modernist artist.[49]

If the high-art press could discuss fashion in its treatment of art, so, too, could the fashion press incorporate works of art into its presentation of clothes. Like Gene Moore's window displays at Bonwit Teller, fashion photography in the early 1960s defined a relationship between Pop art and *haute couture*. However, Marisol's sculpture took a somewhat troubled place in the magazine spreads juxtaposing Pop art and fashion.

In 1966, *Vogue* magazine ran six full-page color photographs by Horst in a spread entitled "Looks Men Like at Home." Each photograph juxtaposed outfits in the latest mod style with paintings and sculptures by Pop and Op artists, including one sculpture by Marisol (Plate VIII).[50] "Looks Men Like at Home" posited for its female readers an affinity between the artworks and the mod patterns of the costumes, and yet simultaneously used much of the art to exemplify a masculine standard against which to measure the femininity of its own fashion products. Although the photograph that used Marisol's sculpture as a background prop participated fully in the suggestion of a shared sensibility across the divide between fashion and Pop art, the image encountered telling difficulties in assigning gender to the fashion model and to high-art sculpture.

The *Vogue* feature proposed that Pop and Op art, along with dinner pyjamas and robes in a mod style, heralded a new taste for bold patterns and bright colors. Even the captions collapsed the difference between fashion designers and artists, treating both as brand names: Scassi dinner pyjamas, Robert earrings, Fabiola rings, Vasarely's *Onix 2*. By adopting this new taste as her own, the sophisticated female consumer of clothes could presumably distinguish herself from less discerning dressers through the purchases she made – and like the *Harper's Bazaar* spread on Marisol, "Looks Men Like at Home" provided extensive information about designers, retailers,

A Taste for Pop

and prices to facilitate that project. To appreciate the shared sensibility fully, viewers of the layout needed both an eye for fashion and a familiarity with the developments in contemporary art over the past five years. *Vogue*, catering to a female audience, apparently took the former for granted but could not afford to leave the latter to chance: The accompanying text began by identifying the art as "a striking group of contemporary paintings and sculpture photographed at the Sidney Janis Gallery." The layout thus did more than address itself to culturally literate female shoppers; it also helped produce that audience.

Pop art and mod fashion in *Vogue* went hand in hand with a new female type characterized by heavy eye makeup, exaggerated hairstyles, clunky and dangling jewelry. "Looks Men Like at Home" featured a new sixties woman at odds with the elegant and refined models of the sort that had posed in ballgowns in front of Jackson Pollock's paintings in *Vogue* fifteen years earlier.[51] Nor did she resemble the aproned homemaker of the 1950s whose clothing, as Elaine May points out, both exaggerated bust lines and curves yet protected the body in a fortress of undergarments.[52] Rather, Pop art and fashion signaled the "liberated" sexuality of the new sixties woman.

Women, suggested the *Vogue* layout, could even fashion themselves after nudes in Pop-art paintings. Two photographs posed models in front of paintings by Tom Wesselmann in such a way as to rhyme the living women to the female bodies – or parts of bodies – depicted by the artist. In a rather sexually explicit manner, one of these images has the model, dressed in dinner pyjamas and with hips thrust out, replicating with her body the same shape and angle of Wesselmann's *Mouth #7* of 1966 hanging behind her (fig. 63). This woman assumed the same formal characteristics and allure as the painting; and so, too, presumably, could the female consumer who purchased the dinner pyjamas.

Yet the evocation of sex in this photograph also had the effect of reestablishing a gendered difference between male artist and female model. Wesselmann's painting may depict female anatomy, but no one – then or now – would mistake these lips as a narcissistic reflection of the artist himself. Rather, the artist assumed the status of the

male viewer, the male connoisseur, of the female body. In a manner parallel to that of the painting, the model offered her body forth for the visual delectation of "men" who "like" this "look . . . at home." Ultimately, the photograph portrayed not the (reiterated) female body, but rather the male gaze onto woman and onto art.[53] Through this image, female readers of *Vogue* could view this act of viewing, but were given occasion to buy into (quite literally) the gendered dynamic primarily as the object of the artistic and erotic gaze.

Most of the juxtapositions of models and artworks in the *Vogue* layout likewise formulated a distinction between the masculinity of Pop and Op and the femininity of fashion, but did so through the more direct means of setting up stark contrasts between artworks and female models. The layout opened with a photograph of a model draped between two abstract Op paintings by Vasarely (fig. 64). The severe geometric shapes and cool colors of Vasarely's *Onix 2* of 1966 in the foreground and *Minta* of 1966 in the background differed markedly from the curvaceous body of the model clad in a costume that cascaded loosely around her legs. The text described the model's outfit in terms of her body, pointing out that "the robe billows out from a bowknot just beneath the bosom." An even more striking opposition emerged in the photograph that situated George Segal's *Walking Man* behind a tall, lithe model leaning against the wall in a provocative pose (fig. 65); the text characterized her as "the player in the white mink tennis dress, with legs like a maharani's in crushed silk tights striped to the toes . . . great form for the games people play at home." The text balanced references to leisured domesticity and titillating sexuality: The materials of silk and mink as well as the comparison to a maharani established the expense and exoticism of the costume, and the allusions to sports and the home promised a life of leisure and sexual adventure. In the photograph, the combination of the model's towering height, suggestive pose, and zebra-striped costume contained an implicit threat of sexuality – especially when seen next to Segal's sculpture of a man hunched over into himself – a threat mitigated only by the frivolity of her costume. In each photograph, artist and model, artwork and fashion, defined each other's gendered identities through clear oppositions.

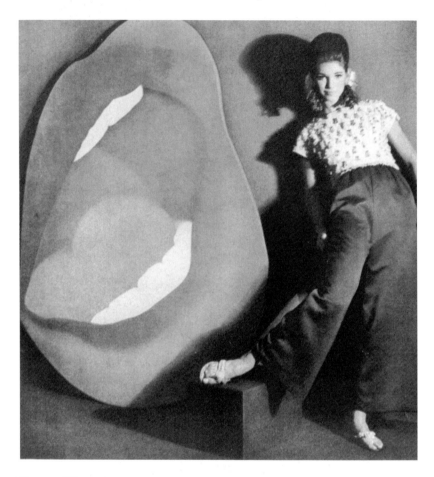

Figure 63. Horst, *Model with Tom Wesselmann's* Mouth #7, "Looks Men Like at Home," *Vogue* 148 (November 1966). Courtesy of Vogue. Copyright © 1966 by the Condé Nast Publications, Inc.

Figure 64. (*facing page top*) Horst, *Model with Vasarely's* Onix 2 *and* Minta, "Looks Men Like at Home," *Vogue* 148 (November 1966). Courtesy of Vogue. Copyright © 1966 by the Condé Nast Publications, Inc.

Figure 65. (*facing page bottom*) Horst, *Model with George Segal's* Walking Man, "Looks Men Like at Home," *Vogue* 148 (November 1966). Courtesy of Vogue. Copyright © 1966 by the Condé Nast Publications, Inc.

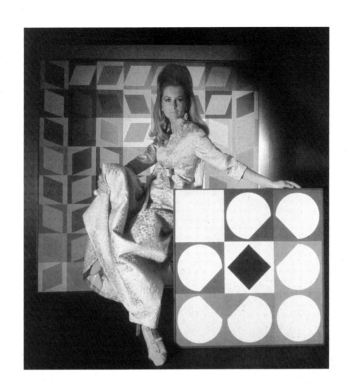

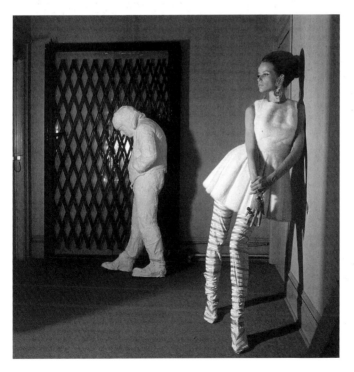

In a fashion layout in which the ruling logic measured the masculinity of high art against the femininity of fashion, Marisol's sculpture – the product of a person both an artist and a fashionable woman – could only be problematic. By 1966, when "Looks Men Like at Home" appeared, Marisol's sculpture had already been figured by both the art and fashion press as feminine. Accordingly, this particular layout could at first be seen to reinscribe the femininity of Marisol's sculpture by inverting the relationship between art and model formulated in the other photographs of the series. The sculpture in the background of the photograph, like so many of her works, represented Marisol herself: It had a photograph of the artist's face attached to its head, and sported a stylish wide-brimmed hat (Plate VIII). In front of the sculpture, a model sat and, with legs spread and hands firmly gripping her knees, adopted a pose usually associated with masculinity and authority. The bold, broad stripes of her pantsuit, although consisting of the same shades of pink and blue that appeared on Marisol's sculpture, made the sculpture's snowflake pattern appear fussy and decorative by comparison; the model was Vasarely to Marisol's feminine delicacy. The accompanying text accentuated the masculinity of the model's costume and posture: "Whirligig striped pyjamas – more man-power to them." Read in this manner, the photograph preserved the femininity of Marisol and converted fashion, however fleetingly, into a figure of masculinity.

The masculinization of the fashion model and the feminization of the sculpture, however, could not long be sustained. Many of those strong diagonal lines of the pantsuit, after all, pointed directly to the anatomical locus of, in psychoanalytic terms, the woman's lack. In a Freudian scenario, that anatomical lack threatens to raise the specter of castration that, to borrow Mulvey's phrase, the male unconscious disavows "by the substitution of a fetish object or turning the represented figure itself into a fetish."[54] Such a fetish substitute in the *Vogue* photograph stood readily at hand: Marisol's tall and erect sculpture, replete with shaft and articulated head, easily became the phallus. This reading of the image reinverted the previous inversion, reestablishing fashion as feminine and Marisol's sculpture as the sign of masculinity.

This second, psychoanalytic reading of the image, however, posits a male as the normative viewer, the person in need of the disavowal provided by the fetish. As Doane has pointed out, "fetishism . . . is . . . inaccessible to the woman, who has no need of the fetish as a defense against a castration which has always already taken place."[55] Inaccessible to the woman – I would amend Doane's formulation – except in the manner of the photograph of Wesselmann's *Mouth #7* and its accompanying model, which is to say, as the view onto someone else's male gaze. If the first reading grants "more man-power" to the model and by extension to the female consumer who can purchase the enabling garment, the second reading takes power – in this case, the power to fetishize – away again.

Ultimately, neither of the interpretations supersedes the other; the model and the sculpture oscillate continuously between masculine and feminine poles, the female reader of *Vogue* between a promised access to "man-power" and her exclusion from it. Marisol's sculpture in the context of fashion photography, in contradistinction to Marisol herself in the same setting, thus potentially disrupts the smooth assignation of gender roles to high art and fashion, as well as to their assumed viewers. Yet, in the end, the photograph of Marisol's sculpture and the model in *Vogue* is the exception that proved the rule. The problematic nature of the sculpture within the fashion plate highlights the high efficacy of that process of assignation in the remainder of the *Vogue* series as well as within fashion photography of the 1960s in general. Women's fashion magazines, though peripheral to the world of high art, for the most part rearticulated the same priority as did their counterparts in the art press, granting masculine vision and art precedence over feminine bodies and fashion. Both, despite the occasional disruption or act of marginalization, maintained quite clear distinctions between masculinity and femininity.

As it happens, *Art in America* around this same time published a layout that also addressed the relationship between art and fashion, and also included a work by Marisol. The layout in *Art in America* did not, however, incorporate either mass-produced clothing or paintings and sculpture; rather, it appropriated the trappings of fashion photography to feature women's coats designed by contem-

porary artists. In this layout, the femininity attributed to Marisol's coat proved central to the magazine's effort to define the gender and audience for such high-design objects and the relationship of high design to the categories of both art and fashion.

Art in America launched a series in 1961 entitled "Art for Everyday Living"; in a statement of 1963, the editors explained that with this series, the magazine hoped to encourage the best artists to be involved in the everyday life of the general population and to bring the painters and sculptors of the United States to the widest popular audience.[56] One of the subsequent articles in the series consisted of an admittedly rarefied view of the everyday: five models wearing furs painted by various contemporary Pop and Op artists, including one "anatomy study" by Marisol (fig. 66).[57] The brief paragraph of text accounted for the coats by explaining that M. Jacques Kaplan of Georges Kaplan furriers had commissioned the artists to paint designs on calf and pony skins, and had subsequently displayed these painted coats along side actual furs. *Art in America* featured only the painted coats in order to applaud the union of consumer design and high art.

High-design objects prove to be somewhat problematic entities because they do not fall clearly into the category of high art nor into that of mass-produced commodities. *Art in America,* in its presentation of the painted furs, kept this ambiguity in play. By identifying the patron who had commissioned the coats and the artists who had painted them, and by including the garments in a series on "Art for Everyday Living," the magazine appeared to treat the painted coats as works of art. Yet, at the same time, the magazine borrowed some of the conventions of fashion photography to display the painted furs: A group of female models stood in a pyramidal arrangement and exhibited the coats at various angles. This type of presentation treated the garments as commodities for female consumers and suggested that, although designed by Op and Pop artists, the painted coats were not examples of high art per se. The photograph in *Art in America* thereby positioned high-design objects on the line between high art and commodity culture.

In this layout, Marisol's coat worked to tip the balance in favor of the femininity of high design. Whereas the garments by Frank Stella

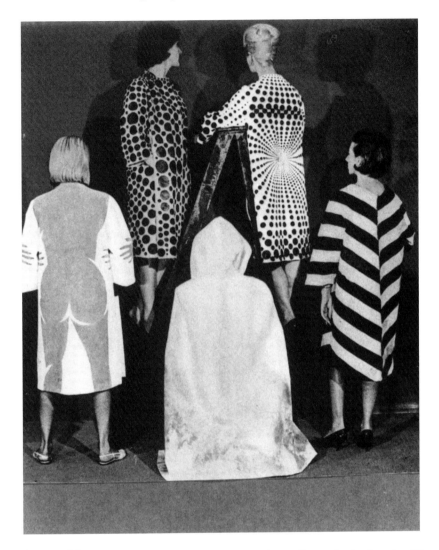

Figure 66. Malcolm M. Knapp, *Artists' Fur Coats*. From *Art in America* 51 (October 1963). Courtesy of Malcolm M. Knapp.

and Richard Anuszkiewicz featured geometric abstractions and a pastel landscape covered the coat by Jane Wilson, Marisol's coat represented a female nude painted in pink on the back (and on the front, according to written accounts); wrote one critic, Marisol's fur "caused a stir."[58] The photograph capitalized on Marisol's depiction of a nude

by displaying the coat on a model whose bare legs exactly matched the painted thighs of Marisol's nude. It thereby collapsed the difference between the representation of the female body and the real body beneath the coat: high-design object and woman became one.

The presentation of Marisol's coat by *Art in America* played a crucial role in defining the femininity of high design not only by eliding the difference between the coat and the female body, but also by positing a viewership position figured as feminine. The photograph invited the female viewer to identify narcissistically with the model – much as in the manner of fashion photography – and imagine the depicted body as her own. In so doing, however, she identified not only with the female object of the gaze, but also with the subject position of the woman artist, because the knowledge that Marisol the artist was a woman rather than a man opened up the possibility that the body on the coat was, narcissistically, a reflection of Marisol's own. The female viewer, much like the female consumer looking at Marisol modeling her various clothes in *Harper's Bazaar*, could thus identify with Marisol's act of self-fashioning. In this layout, therefore, Marisol's coat became a central rather than a marginal actor in casting high design as feminine.

Fashion layouts in both women's magazines and the art press attempted to appropriate and contain Marisol and her sculpture within the category of the feminine. Women's magazines managed the figure of Marisol as a woman artist by casting her as a narcissistic consumer who constructed her femininity through her selection in clothes. These same magazines, however, treated Marisol's sculpture not as feminine, but rather as something of a gender hybrid. In the end, women's magazines could assimilate Marisol, marked as feminine and narcissistic, much more easily than it could her sculpture, because the figuration of fashion as feminine itself ultimately depended on the foil of a high art unequivocally considered masculine. As far as this last practice – regarding high art as masculine – was concerned, women's magazines and the art press were in agreement. The art press assumed a masculine standard for high art whether it figured Marisol's sculpture as feminine and marginal within the orbit of high art or feminine and central within the realm of high design.

Marisol, Masquerade, Mimicry

By the 1970s, discussion of Marisol and her sculpture had virtually disappeared from the pages of art criticism. Marginalized or omitted altogether from books published in the late 1960s and 1970s about the history of American modern art or about Pop art in particular, Marisol's sculpture received scant attention from feminist art critics during this period as well.[59] This decline in critical attention in the 1970s seems, to a large extent, the direct consequence of the manner in which Marisol and her work had been positioned – by the art press, by the fashion press, by the artist herself – during the 1960s. A woman considered fashionable and sculpture regarded (at least by art critics) as quintessentially feminine apparently bore little attraction for a new breed of art writers who, as part of the feminist movement emerging in the late 1960s, sought new grounds for the valorization of art by women.[60] Although many feminist critics and historians wished to discover neglected women artists from the past, virtually none of them, as part of the process of articulating a woman's aesthetic, had much use for an artist and an oeuvre that appeared to reflect, uncritically, the values of a femininity perceived to be oppressive to women. When Nemser in 1975 prompted Marisol with the question, "Have you found that women liberationists are hostile and make you feel guilty for [your interest in clothes and parties]?" Marisol responded: "Yes. People come up to me and they talk about all those parties and getting all dressed up."[61] Marisol had apparently embraced a pose of femininity in the 1960s that many feminists rejected in the 1970s, and her reputation suffered in the 1970s from the fact that her work seemed to offer a straightforward representation of a now anachronistic femininity.

Marisol fared a bit better in the 1980s, when a handful of writers claimed that her sculptures documented the way in which middle-class women felt stultified and isolated by their prescribed social roles in the 1950s and early 1960s. In 1985, for example, Roberta Bernstein observed that Marisol's sculptures treating the themes of marriage and motherhood appeared concurrently with Betty Friedan's *Feminine Mystique* in 1963, and Bernstein argued that Marisol's works, like Friedan's book, "reveal the superficial and limited

lifestyles of women who are confined to traditional sex-segregated roles."[62] This assessment, however, was but the mirror image of the critical assumptions about Marisol of the 1970s: Where before Marisol and her work embodied femininity's surface, now they personified femininity's dark interior. In both cases, femininity as a practice preceded and to a large extent determined the meaning of the sculpture. In both cases, the sculpture represented, seemingly without much mediation, some aspect (positive or negative) of women's lives under the regime of prefeminist femininity.

There is a sense in which both the neglect of Marisol in the 1970s and her limited resuscitation in the 1980s perpetuated a crucial attribute of the regime of femininity as it existed in the 1950s and 1960s. Sociologists and psychologists published an enormous amount of literature on the "American Woman" in the 1940s and 1950s, and their expertise underwrote many articles and books on the roles, behavior, and happiness of American women in popular magazines.[63] An important conceit of both professional and lay investigations of the American woman was that she – her behavior, her roles, in short her femininity – could be known and represented. More: that she could be represented transparently, which is to say, represented in such an ostensibly direct and unmediated manner that the means of representation became invisible.

Consider the photograph that illustrated Ernest Havemann's article about "the modern American wife" published in *Life* in 1961 (fig. 67).[64] One woman, seen three times, perform three female roles: mother, wife, working woman. That the American woman could be understood as the sum of her divergent activities was a common rhetorical tactic in the literature on femininity. For instance, Diana Trilling, in an article from *Look* in 1959 entitled "The Case for . . . The American Woman," provided an impressive and seemingly exhaustive list of the various functions performed by the American woman: wife, mistress, mother, sports companion, intellectual companion, engineer, mechanic, carpenter, chauffeur, psychologist, economist, local politician, and bartender.[65] In the photograph from *Life*, each of the woman's three roles is unambiguously designated by

its own costume, props (including, in one case, children), pose, and facial expression; it would seem that this woman could be understood as the sum of her different roles.

Professional and popular texts enumerated and classified the multiple roles that the American woman played in her home and community after the Second World War without bringing attention to the visual codes used for representing femininity. An article on the suburban wife in *Time* magazine, for example, included a series of small, close-up photographs of women performing as den-mothers, ballet teachers, church members, and babysitters.[66] Each woman, dressed in the appropriate uniform for her role, accomplishes her task, apparently oblivious of the presence of the camera. As a result the photographs purports to offer the viewer an unmediated glimpse onto women behaving naturally in the suburban setting. At first, it might seem that the woman-in-triplicate of the photograph that illustrated Havemann's article in *Life* acknowledges the means by which she is known, for she looks out at the camera. Yet the multiple attitudes she displays – demure at the left, flirtatious in the center, gracious but self-assured to the right – are not the sort of looks one directs toward a technological apparatus. The caption that names her activities does so in such a way as to identify the person to whom she addresses her attentions: She is "dedicated mother and homebody," "her husband's glamorous companion," and his "working partner." The camera, in short, disappears as it is sutured into the fictive person of her husband, and, conversely, the proper roles of the feminine woman are seen from the perspective of that man.[67] The femininity of American woman as described by text and image in the 1950s and early 1960s, it would appear, could be known, and known in its varied entirety, not through the interventions of representation but directly through the eyes of man looking at woman. An advertisement for Bell Telephone published in *Look* in 1957 repeated the gesture with brutal forthrightness (fig. 68). Below the five smiling faces of a single woman variously cast as cook, nurse, chauffeur, maid, and wife is printed the bold-face caption: "This is Your Wife."[68]

Ironically, in accounts of Marisol that have since the early 1960s

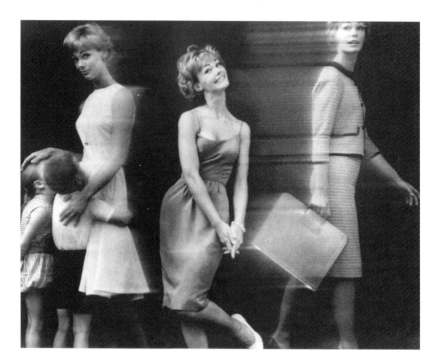

Figure 67. Howell Conant, *The Modern American Wife*. *Life* 51 (September 8, 1961). Copyright © Time Inc.

interpreted her work as either a reflection or a revelation of femininity, the concept of femininity itself, the transparency of its representation, and the capacity to know woman through the feminine have remained fundamentally unchallenged constructs. Armed with greater skepticism about the possibility of transparent representation and with accounts recently developed by feminist theorists about how femininity is fabricated, we can reassess Marisol's femininity. I propose thus to refigure Marisol and her sculpture from the early 1960s yet one more time, this time as actors capable of producing and disrupting – rather than reflecting and revealing – the established codes of femininity.

Certain aspects of Marisol's sculptures, to be sure, do at first stand out as startlingly direct renditions of the appearance of contemporary women. In *The Party*, for instance, Marisol seemingly bypassed the mediation of representation altogether when she outfitted her

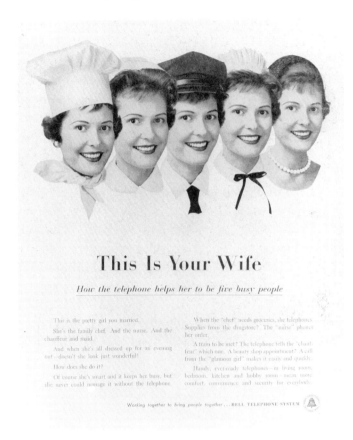

Figure 68. *This is Your Wife*, advertisement published in *Look* (October 1957). Courtesy of AT&T Archives. Copyright © AT&T.

numerous figures with actual dresses, shoes, gloves, and jewelry (fig. 69). And yet, it turns out, Marisol's apparently genuine items are not to be trusted. The fine gold needlework on a sumptuous ballgown proves, on closer examination, to be nothing more than white and gold paint applied to synthetic vinyl. The necklace of gems hanging across one elegant throat must own up that it is only the cheapest of costume jewelry. Time and again, the clothing and accessories at Marisol's *Party* reveal themselves to be inexpensive imitations of higher-priced goods.

High upon the dress of the woman with the necklace in a place of unavoidable comparison with the fake jewels, Marisol attached an advertising photograph of a presumably precious brooch. Against the actual presence of the fake, Marisol set up the iconic representation of the real. Yet other representational modes manifest themselves in Marisol's works. The plaster breasts attached to one of the strollers in *Women and Dog* (Plate VIII), actual physical impresses of a woman's chest, bear an indexical relation to woman's body (actually, as casts from a mold, they are indexes of indexes). And the rough-hewn wooden blocks that make up the torsos of virtually all of Marisol's women speak of "figure" in only the crudest of symbolic fashions. Marisol's figural groups express "woman" only through a babel of representational practices.

Any one of these modes on their own – actual presence, icon, index, symbol – might well manage to hide its representational mediations; certainly that is the pretense of, say, the iconic photograph from *Life*. Any one alone might present a coherent image of an essential femininity. Mixed together, however, they highlight each other's contingent status as representations. A photograph is but a flat picture next to the cast of a breast; a cast of a breast is but plaster next to an actual necklace; a necklace is but paste next to a photograph of real gemstones. Marisol's sculptures thus present the femininity they have come to represent not as a stable entity known transparently but as something cobbled together from representational parts. Indeed, the wooden blocks that form the bodies of most of Marisol's figures provide a visual representation of such makeshift construction: rough-hewn edges show the grain of wood, nails protrude at the joints, paint fails to cover up cracks and imperfections. The juxtaposition of various elements and the radical discontinuities between them draw attention to the processes of representation through which woman is known.

"Masquerade," argues Doane, "constitutes an acknowledgment that it is femininity itself which is constructed as mask – as the decorative layer which conceals a non-identity. . . . The masquerade, in flaunting femininity, holds it at a distance. Womanliness is a mask which can be worn or removed. The masquerade's resistance to patriarchal positioning would therefore lie in its denial of the

Figure 69. Marisol Escobar, *The Party*, 1965–6. Collection of Mrs. Robert B. Mayer, Chicago, Illinois. On Loan to the Minneapolis Institute of Arts. Copyright © 1996 Marisol/Licensed by VAGA, New York, NY.

production of femininity as closeness, as presence-to-itself, as, precisely, imagistic."[69] Marisol's sculptures, I contend, treat femininity as a masquerade. They occlude the unmediated view through representation of the feminine – the presumed "closeness" and "presence-to-itself" of conventional descriptions of femininity – and instead draw attention to the way in which representation itself – the masquerade of purses and brooches, and even of wooden boxes – makes femininity.

There is a risk, nonetheless, in imagining Marisol's sculpture as instances of the masquerade. I quoted Doane before: "The masquerade, in flaunting femininity, holds it at a distance." If Marisol's sculptures masquerade, the artist herself might well be regarded as distancing herself from femininity. Certainly Marisol's frequent use of parody would seem to place her at a mocking remove from the women she portrayed. We have seen the regimental stiffness and exposed breasts in *Women and Dog*; in a similar vein, one of the figures in *The Party* has hair stacked in a bun nearly a foot high, and another has a portable television for a head. Given Marisol's connections (however peripheral) to Pop art, there is an obvious place

A Taste for Pop

to locate Marisol from which she can be seen to parody women – and fashion, and television – from a distance: the Olympian heights of high art. Marisol, accordingly, appears less a woman – as she did, say, in the fashion press – and more an artist.

In two crucial respects, however, Marisol's sculptures frustrate this distancing of the "artist" from the "woman." First, the fact that Marisol constantly cast herself in the multiple roles of the women she depicted, folded herself, the artist, back into the process that produced femininity. Marisol's countenance appears on every head – save the dog's – in *Women and Dog*; each of the female figures in *The Party* likewise has the artist's face. The persona of Marisol, moreover, proves as unstable in these works as did the concept of femininity. In *Women and Dog*, an iconic drawn self-portrait contrasts with an indexical cast of Marisol's features; a photograph of Marisol's face is totally out of proportion with the symbolic wooden spheroid of a head to which it is attached. In her sculptures, Marisol emerges not as an artistic essence, but instead, like femininity, herself the product of the masquerade.[70]

By incorporating herself in her sculpture in this manner, Marisol can be seen to adopt the role of the mimic as that role is described by Luce Irigaray. To mimic, according to Irigaray, is to "assume the feminine role deliberately. Which means already to convert a form of subordination into an affirmation, and thus to begin to thwart it." Irigaray continues: "To play with mimesis is thus, for a woman, to try to recover the place of her exploitation by discourse, without allowing herself to be simply reduced to it. It means to resubmit herself . . . to ideas about herself, that are elaborated in/by a masculine logic, but so as to make 'visible,' by an effect of playful repetition what was supposed to remain invisible." In Irigaray's terms, Marisol, by "resubmit[ting]" herself to the masquerade, "makes visible" how "masculine logic" constructs femininity, and how it passes off that construction as transparency. And Marisol highlights the logic of femininity by "an effect of playful repetition" seen not only in the mixing of representational processes, but also in the hyperbolic features, parodic details, and theatrical poses of her sculpted women. But more than this, mimicry for Irigaray "also means 'to unveil' the fact that, if women are such good mimics, it is

because they are not simply reabsorbed in this function."[71] Marisol, accordingly, declares something other than "masculine logic" to be capable of producing femininity. Something other than that logic – the sort of logic attributed to the likes of artists – plays with the various representational fragments of femininity, juxtaposing an icon to an index, say, or performing the twist of parody. Marisol the mimic assumes the position of a subject that can work the systems of representation that construct the feminine and she does so without bifurcating the roles of woman and artist.

Second, Marisol's sculptures collapse the distance between the role of woman and that of artist by treating the signs of artistic masculinity as no less contingent, no less the product of representation, than are the signs of femininity. In one important regard, art-critical accounts of male artist heroes from the 1950s and early 1960s depended as much as contemporaneous sociological accounts of women on the myth of transparent representation: As we have seen, the hard-edged style of Pop art and Post-Painterly Abstraction was assumed to reveal, in a rather unproblematic manner, the dispassionate sensibility of the artist, just as earlier the Abstract-Expressionist brushstroke ostensibly reflected the passion of the painter. The coherence of a style underwrote the coherence of the artist behind it.

The surfaces of many of Marisol's sculptures include the loose brushstrokes associated with the passionate engagement and transformative powers of the male Abstract-Expressionist painters. In *Women and Dog*, for instance, Marisol did not conceal the sketchy pencil marks that outline the contours of the jacket and sweater of the woman walking the dog; the black-and-white design of her skirt has not been completed, and splatters of black paint drip into its white floral pattern. Yet these seemingly spontaneous and unfettered gestures must share space with cool and considered artistic traces. On the back of the child in *Women and Dog*, smoothly painted blue stripes form simple, clearly defined shapes that emphasize the surface of the figure as a continuous single flat plane, much in the manner of, say, a Frank Stella canvas. Either method of painting, on its own, might signal the artist's authentic hand. Juxtaposed, they underscore each other's standing as merely the means

229

of representing that authenticity. Marisol's sculptures treat the signs of artistic presence, like those of femininity, as so many fragments ready to be cobbled together in a masquerade.

Marisol is no more distanced from this masquerade than she was from the first. The hand that holds the purse of the woman closest to the dog in *Women and Dog* is none other than the artist's own – or rather it is a cast of her hand, a match to the multiple casts of Marisol's face that make up the head of the same figure. If the facial casts engaged Marisol the artist in the masquerade of femininity, this cast of a hand, I would insist, engages Marisol the woman in the masquerade of artistic identity. It is a feminine hand, certainly, replete with polished red fingernails; and it seems at least as powerful a sign of the presence of the actual artist as is the usual conception of an artist's hand, namely, that a painterly mark can be identified with a single artist's hand and thereby function as a sign of his individuality and aesthetic preoccupations.[72] Emulating multiple styles of painting and lending her own hand to the project, Marisol mimicked the role of the artist just as she did that of the fashionable woman.

Because Irigaray describes mimicry as a disruptive tactic for women to use, I suppose in the end I have here actually joined my earlier colleagues who have written on Marisol: We all, in our own ways, figure her femininity. Yet I hope that my reconsideration of Marisol's femininity – perhaps possible only now, after Doane, Irigaray, and others – may serve to recover Marisol and femininity from the margins to which they have so often been relegated. Marisol and her sculptures, seen in this new light, are indeed feminine, but only to the extent to which they insist on the social construction of femininity and claim some capacity to construct that femininity themselves. And they are also masculine, to the extent that they mimic the codes of artistic presence while nonetheless insisting on the social construction of those same codes. Marisol's femininity need not serve as a convenient cipher against which Pop art can measure its hardness, against which high art can measure its rejection of fashion; in short, against which men can measure their masculinity. Rather it can disclose the contingency, the basis in representation, of precisely such polarized antinomies of gender.

Conclusion

In this book, I have highlighted a select number of Pop-art images and exhibitions that intersected with practices of consumer culture considered feminine in the early 1960s. As we have seen, Pop art and its presentation in public pirated motifs, mimicked modes of display, and invited forms of evaluation associated with consumer culture. Consequently, Pop art and instances of its exhibition have, over the years, prompted numerous writers to measure the movement against the benchmark constituted by the culture of consumption so explicitly evoked in the works. Such readings, both in the 1960s and since, have often been motivated by a wish to determine conclusively, once and for all, the stance toward consumer culture adopted by Pop art; did the art celebrate or criticize the culture of the masses or, alternatively, did it manage to maintain an attitude of ambivalence toward it? To a certain extent, I have myself succumbed to this desire by engaging in a retrospective reading of Pop art and its display, and reaching certain conclusions about them. In all five chapters, I have analyzed paintings and exhibitions as well as the practices of consumer culture from which they borrowed, and I have argued that Pop art and its public presentation drew attention to the processes of representation that subtend gender differences. As we have seen, my argument has not always adhered strictly to the ways I believe Pop art was interpreted in the 1960s. Hence, I have measured my contemporary understanding of

A Taste for Pop

Pop art against my historical analysis of the dissemination of Pop art in exhibition venues, criticism, fashion, and advertising. And I have argued that in every instance, Pop art's reception functioned to produce fluctuating cultural boundaries between high art and consumer culture and to create the social identity and public visibility of a host of critics, collectors, and viewers.

In the early 1960s, Pop art yielded multiple and sometimes contradictory readings. The interpretation of Pop art varied according to who saw the images, and when and where they saw them. More importantly, I argue, both the differences and similarities between contemporaneous readings performed cultural and social work. For example, a formalist interpretation of Pop art, which demonstrated how Pop images transformed their sources in the interest of form, color, and space, could prove the modernist status of Pop art, differentiating it from consumer culture. Such a reading could distinguish a new group of art critics from, simultaneously, both shoppers of everyday artifacts and inflexible champions of purist modernism. And yet, at the same time, a formalist reading in different hands could also serve to demarcate and elevate congregations of shoppers such as the sophisticated shoppers at Bonwit Teller or the savvy consumers of Brazil coffee who demonstrated a taste for modernism through their purchase of goods. Or, to take another example, readings of Pop art that strove to close the gap between the movement and consumer culture or to imply that Pop shared the ostensibly artificial, hyperbolic, and feminine aspects of consumerism certainly existed, but such readings served the needs of both a group of cultural gatekeepers hostile to Pop art and a coterie of collectors and socialites sympathetic to the art movement owing precisely to its revelry in the commercial. The same interpretation of Pop art, in short, could either valorize or denigrate the movement, and such differences in assessment, positive or negative, could create groups of critics, collectors, and viewers who fervently believed that their interpretation of Pop art clashed fundamentally with that of their opponents.

The dissemination of Pop art, over time and place, produced shifting cultural and social antinomies. But, ultimately, I contend that all of the differences I have explored in this book – between

Conclusion

absorbed shoppers and art connoisseurs, between suburban interiors and Wesselmann's paintings, between Lichtenstein's canvases and Pop coffee advertisements, between fan magazines and Warhol's silk-screens; between art and commerce, between representation and reality, between masculinity and femininity; in short between Pop art and its various sources and derivatives – are contingent. Whether formulated in the early 1960s with the clarity of absolute certainty or presented at the time with all the anxieties of categories in crisis, such oppositions do not set the stage for subsequent acts of artistic criticism and cultural analysis; rather, they emanate precisely from such acts of interpretation and reinterpretation. We need not accept such divisions as historical verities; we need instead to inquire from whence they emerged, and to whose benefit: resourceful artists or canny advertisers, sophisticated shoppers or new collectors, critics or playboys or housewives. The mechanisms of cultural definition and social privileging, moreover, does not come to a close with the end of the art movement, nor with the publication of any given historical reckoning of it, including my own. As long as we continue to talk about Pop art, as long as we take interest in its always uncertain relations with the aspects of consumer culture from which it simultaneously distanced itself and found itself to be part, the boundary lines of culture – and their beneficiaries – will continue to remain in flux.

Notes

Introduction

1. Lucy Lippard, "Household Images in Art," *From the Center: Feminist Essays on Women's Art* (New York: E.P. Dutton, 1976), 56.

2. Cleve Gray, "Remburgers and Hambrandts," *Art in America* 51 (December 1963): 125.

3. Andreas Huyssen, "Mass Culture as Woman: Modernism's Other," in *After the Great Divide: Modernism, Mass Culture, Postmodernism* (Bloomington: Indiana University Press), 47, 48.

4. Huyssen, "Mass Culture as Woman: Modernism's Other," 61.

5. A remarkable number of reviews of Pop art were published in both the art and popular press in the early 1960s. For a discussion of the disagreement among critics as to whether Pop art endorsed or criticized consumer culture, see Carol Anne Mahsun, *Pop Art and the Critics* (Ann Arbor: UMI Research Press, 1987); and Mahsun, *Pop Art: The Critical Dialogue* (Ann Arbor: UMI Research Press, 1989). In her unpublished master's thesis Sandra Gillespie examines the wide range of critical responses to Pop art in the popular press. Sandra Gillespie, "Consuming Visions: Pop Art, Mass Culture, and the American Dream 1962–1965," M.A. thesis, University of British Columbia, 1992.

6. Max Kozloff, "'Pop' Culture, Metaphysical Disgust, and the New Vulgarians," *Art International* 7 (March 1962): 36.

Chapter I

1. Kozloff, "'Pop' Culture,' Metaphysical Disgust, and the New Vulgarians," 36.

2. Dorothy Gees Seckler, "Folklore of the Banal," *Art in America* 50 (Winter 1962): 57.

3. Generally, art galleries during the twentieth century, as Brian O'Doherty has demonstrated, increasingly dispensed with decorative ornamentation, which might distract from artworks; they painted their walls white, sealed their windows, and flooded their rooms with even light. Brian O'Doherty, *Inside the White Cube* (Santa Monica: Lapis Press, 1986). My understanding of displays of Color-Field painting is based on Joanna R. Roche, "The Rhetoric of Exhibition: Regarding Rothko," M.A. thesis, University of California, Los Angeles, 1991. The quasi-religious aura created by the art gallery exhibiting Color-Field painting finds its literal realization in the Rothko Chapel in Houston.

4. For a brief history of Bonwit Teller, see John Ferry, *The History of the Department Store* (New York: Macmillan, 1960), 88–90; and Robert Hendrickson, *The Grand Emporiums: An Illustrated History of America's Great Department Stores* (New York: Stein and Day, 1979), 165.

5. In a personal correspondence dated March 17, 1993, Gene Moore stated that he was responsible for the arrangement of the paintings and the mannequins in Bonwit Teller's windows in 1961.

6. One could say – and indeed, I will be explicitly arguing later – that these women are absorbed by the theatrical. In building this argument, I am, of course, breaking from Michael Fried's famous antithesis between absorption and theatricality in *Absorption and Theatricality: Painting and Beholder in the Age of Diderot* (Berkeley: University of California Press, 1980). My analysis derives instead from a body of feminist film analysis, most notably Mary Ann Doane's *Desire to Desire: The Woman's Film of the 1940s* (Bloomington: Indiana University Press, 1987), which describes women movie-goers drawn into the drama of film.

7. No author, "Behind the Glass," *Time* 52 (December 27, 1948): 37.

8. William Leach, *Land of Desire: Merchants, Power and the Rise of a New American Culture* (New York: Pantheon, 1993), 69.

9. Leonard S. Marcus, *The American Store Window* (New York: Whitney Library of Design, Watson-Guptill, 1978), 17. See also Stuart Culver's insightful discussion of L. Frank Baum in "What Manikins Want: The Wonderful Wizard of Oz and The Art of Decorating Dry Goods Windows," *Representations* 21 (Winter 1988): 97–116; and William Leach, "Strategists of Display and the Production of Desire," in *Consuming Vision: Accumulation and Display of Goods in America, 1880–1920*, ed. Simon J. Bronner (New York: Norton, 1989), 99–132.

10. A. E. Hurst, *Displaying Merchandise for Profit* (New York: Prentice Hall, 1939), 34.

11. *The WPA Guide to New York City* of 1935 stated that "Saks, Bergdorf-Goodman, Bonwit Teller, and a few other avenue shops are widely

known for their striking window displays, mounted with the care of a
Belasco stage-set." The Federal Writers' Project, *The WPA Guide to New
York City* (New York: Pantheon, 1935), 219. Achieving renown in
the late nineteenth and early twentieth centuries, Belasco's theatrical
productions narrated stories through a sequence of stage pictures in-
cluding tableaux, which were sometimes based on actual paintings.
A. Nicholas Vardac, *Stage to Screen: Theatrical Method from Garrick to
Griffith* (Cambridge: Harvard University Press, 1949), 109–110.

12. Harry Hepner, *Modern Advertising Practices and Principles* (New York:
McGraw-Hill, 1956), 280. See also Bill Cunningham, "The Most Ravish-
ing Show in New York Is FREE," *Chicago Tribune*, July 19, 1965, p. 4.

13. L. Frank Baum, *The Art of Decorating Dry Goods Windows and Interiors*
(Chicago: Show Window Publishing, 1900), 2.

14. Ibid., 87. Charles Tracy used this passage verbatim in *The Art of Decorat-
ing Show Windows and Interiors* (Chicago: Merchants Record, 1906–
1909), 101. See also Lewis A. Rogers, *The Art of Decorating Show Win-
dows and Displaying Merchandise* (Chicago: Merchants Record, 1924).

15. Baum, *The Art of Decorating*, 1, 82.

16. Jack T. Chord, *The Window Display Manual: A Complete Window Display
Course Including Fundamentals and Technique* (Cincinnati: Display Pub-
lishing, 1931), 7, 165. See also Robert Kretschmer, *Window and Interior
Display: Principles of Visual Merchandising* (Scranton: Laurel Publishers,
1952), 91; and Emily M. Mauger, *Modern Display Techniques* (New York:
Fairchild, 1954), 64–5. Chord, *The Window Display Manual*, 165.

17. Despite the fact that by the 1960s the urban department store was in
decline, the neighborhood around Bonwit Teller continued to draw
customers. Guidebooks published in the 1960s described Fifth Avenue
between 59th Street and 42nd Street as the "heart of the luxury shop-
ping district of New York," and Bonwit Teller's window displays as
"generally dramatic and unusual." Andrew Hepburn, *Complete Guide to
New York City* (New York: Doubleday, 1964), 50–1. For the history of the
rise and fall of the American department store, see Susan Porter Ben-
son, "Palace of Consumption and Machine for Selling: The American
Department Store, 1880–1940," *Radical History Review* 21 (Fall 1979):
202; Susan Porter Benson, *Counter Cultures: Saleswomen, Managers, and
Customers in American Department Stores, 1890–1940* (Chicago: Uni-
versity of Illinois Press, 1986); and William Leach, "Transformations in
a Culture of Consumption: Women and Department Stores, 1890–
1925," *Journal of American History* 71 (September 1984): 319–42.

18. Fred W. McDarrah, *New York, N.Y.* (New York: Corinth Books, 1964),
[unpaginated]. See also the description of shoppers on Fifth Avenue in
articles on Moore such as Bill Cunningham, "The Most Ravishing
Show," 4.

19. Lee Wilcox, "Meet Gene Moore," *House Beautiful* 102 (December 1960): 170.

20. Gene Moore, "Foreword," in *Window Display*, ed. Robert J. Leydenfrost (New York: Architectural Publishing, 1950), 6–7.

21. Marcus writes, "Andy Warhol, Jasper Johns, and Robert Rauschenberg all worked for Gene Moore at Bonwit Teller, starting in the early fifties. Once a year, through the early 1960s, Moore showed the serious work of artists on his staff in window displays" (Marcus, *The American Store Window*, 50). Because Moore paid artists a $200 rental fee when he incorporated their works in his window displays, an article in *Cosmopolitan* differentiated him from other display directors on Fifth Avenue who periodically incorporated works of art into their windows but did not pay the artists. Howard and Arlene Eisenberg, "The World's Largest Audience," *Cosmopolitan* 153 (December 1962): 73.

22. Aline Saarinen, "Window On Fifth Avenue," *Show* 5 (April 1965): 16. Many articles on Moore stressed his training as a painter, or simply called him an "artist" and his windows "works of art." See Tom Lee, "Gene Moore," *Graphis* 16 (November–December 1960): 528–33; "Behind the Glass," *Time* 52 (December 27, 1948): 37; and Virginia Lee Warren, "Display Director's Windows are Works of Art," *The New York Times* (February 27, 1965), p. 14.

23. Rémy Saisselin, *The Bourgeois and the Bibelot* (New Brunswick, NJ: Rutgers University Press, 1984), 45.

24. Leach, "Transformations," 319–42. See also Rachel Bowlby, *Just Looking: Consumer Culture in Dreiser, Gissing and Zola* (New York: Methuen, 1985); Leach, *Land of Desire*; and Saisselin, *The Bourgeois*, 33–49.

25. John Wanamaker, *Golden Book of the Wanamaker Stores: Jubilee Year 1861–1911* (Philadelphia: John Wanamaker, 1911), 250. According to Wanamaker, the collection consisted of 250 paintings.

26. Ibid., 249. Cited in Saisselin, *The Bourgeois*, 45–6.

27. See Marcus, *The American Store Window*, 29–34.

28. Hurst, *Displaying Merchandise*, 195. Although it is true that Baum and other early twentieth-century window designers stressed the importance of certain artistic skills such as harmony, color, and symmetry, their stress was not on the "art" of display. Their window displays did not present themselves primarily as artistic. As William Nelson Taft warned: "Timeliness, originality, simplicity, harmony and all the other elements which are commonly supposed to enter into the equation sink into insignificance beside this one question of *Sales Power*. That, and that alone, is the function of the window display" (William Nelson Taft, *Handbook of Window Display* [New York: McGraw-Hill, 1926], 3).

29. Frederick Kiesler, *Contemporary Art Applied to the Store and Its Display* (New York: Brentano's, 1930), [unpaginated]. As evidence of modern

display windows, Kiesler cited his own creations in 1927 at R. H. Macy's and in 1928 at Saks-Fifth Avenue, which, according to him, staged, respectively, the first representative exposition of modern interior decoration in America, and the first extensive presentation of modern show windows. Kiesler, *Contemporary Art*, [unpaginated]. On the "art" of window display in the 1920s and 1930s, see also Marcus, *The American Store Window*; and Jeffrey Meikle, *Twentieth Century Limited: Industrial Design in America, 1925–1939* (Philadelphia: Temple University Press, 1979).

30. Judith Goldman, *Windows at Tiffany's: The Art of Gene Moore* (New York: Abrams, 1980), provides an extensive bibliography on Moore.

31. Saarinen, "Window on Fifth Avenue," 20.

32. Wilcox, "Meet Gene Moore," 127.

33. Moore's lack of concern about the sanctity of art can also be seen in his willingness to rely on copies rather than originals to represent art in his displays. In 1962, to coincide with a series of Picasso exhibitions in New York City, Moore incorporated three-dimensional reproductions of some of Picasso's paintings along with necklaces and crystal glasses in the storefront windows of Tiffany's. Either actual works of art or their reproductions would do; Moore's practices of display resembled more the serial production of consumer items than the rituals for the preservation of the aura of the original exercised by museum or art gallery.

34. Warhol had at that point established a name for himself in the commercial art world, and he had also exhibited some of his pre-Pop artworks in art galleries.

35. Cited in Goldman, *Windows at Tiffany's*, 76.

36. Wilcox, "Meet Gene Moore," 170.

37. Kretschmer, *Window and Interior Display*, 91, 92.

38. Frank J. Bernard, *Dynamic Display: Technique and Practice* (Cincinnati: Display Publishing, 1952), 5. Many others agreed with Bernard's assessment. For instance, Mauger wrote: "Knowing that the shoppers of today are more often women than men, retailers appeal to the feminine flair for luxury, beauty and romance" (Mauger, *Modern Display Techniques*, 65).

39. Ellen Johnson, "The Living Object," *ArtInternational* 7 (January 1963): 43.

40. Claes Oldenburg's inventory of *The Store* from December 1961 lists 107 items and their prices. Claes Oldenburg and Emmett Williams, *Store Days* (New York: Something Else Press, 1967).

41. Mauger, *Modern Display Techniques*, 73. See also Lester Gaba, *The Art of Window Display* (New York: Studio Publications and T. Y. Crowell, 1952).

42. Marcus, *The American Store Window*, 18–19. Baum promoted "the simple artistic arrangement of a few attractive goods" in *The Art of Decorating*, 14.
43. Kretschmer, *Window and Interior Display*, 6.
44. Johnson, "The Living Object," 44.
45. Sidney Tillim, "Month in Review," *Arts* 36 (February 1962): 36.
46. Oliver E. Allen, *New York, New York: A History of the World's Most Exhilarating and Challenging City* (New York: Atheneum/Macmillan, 1990); McDarrah, *New York, N.Y.*; Andreas Feininger, *New York in the Forties* (New York: Dover, 1978); Victor Laredo, *New York City: A Photographic History* (New York: Dover, 1973); *New York City Guide and Almanac 1957–58* (New York: New York University Press, 1957); Allon Schoener, ed., *Portal to America: The Lower East Side 1870–1925* (New York: Holt, Rinehart and Winston, 1967); and Norval White, *New York: A Physical History* (New York: Atheneum, 1987).
47. Compare, for instance, the celebratory commemoration of the Lower East Side in Schoener, *Portal to America*, to the obvious disgust expressed in no author, *New York: A Guide to the Empire State* (New York: Oxford University Press, 1940).
48. See also Feininger, *New York in the Forties*, 133.
49. Jill Johnston, "Claes Oldenburg," *Art News* 61 (November 1962): 13. While Johnston is commenting on the Oldenburg exhibit at the Green Gallery, she is specifically discussing the plaster objects that were seen at *The Store*.
50. Sonya Rudikoff, "New York Letter," *ArtInternational* 6 (November 1962): 62.
51. Examples of this debate culled from reviews of exhibitions of Oldenburg's sculpture, including his work shown at the New Realists exhibit in 1962 at the Sidney Janis Gallery, include Dore Ashton, "High Tide for Assemblage," *Studio* 165 (January 1963): 25; Thomas Hess, "New Realists," *Art News* 61 (December 1962): 12–13; Johnson, "The Living Object"; Hilton Kramer, "Art," *The Nation* 195 (November 17, 1962): 334; "Pop Art: Cult of the Commonplace," *Time* 81 (May 3, 1963): 69–72; Pierre Restany, "The New Realism," *Art in America* 51 (February 1963): 102–4; Barbara Rose, "Dada Then and Now," *ArtInternational* 7 (January 1963): 25; Sonya Rudikoff, "New Realists in New York," *ArtInternational* 7 (January 1963): 39–40; and Irving Sandler, "In the Art Galleries," *The New York Post*, November 18, 1962, Sec. 2, p. 12.
52. Jack Kroll, "Situations and Environments," *Art News* 60 (September 1961): 16. This quotation actually refers to Oldenburg's exhibition in the fall at the Martha Jackson Gallery. The critic refers to the sculpture in that exhibit as "giantesque rummage sale, huge papier-mâché bargains in little girls' dresses, mink coats, prosthetic limbs, abandoned

flags and suicides' bathing suits." Many of these same items reappeared a few months later in *The Store*.

53. See, for example, Johnson, "The Living Object," 43; Hess, "New Realists," 13; Restany, "The New Realism," 102–4; and Sandler, "In the Art Galleries," 12.
54. Tillim, "Month in Review," 36.
55. Jill Johnston, "The Artist in a Coca-Cola World," *The Village Voice*, January 31, 1963, p. 24.
56. Barbara Rose writes that although *The Store* was a "rousing public success . . . only a small part of its 'inventory' was sold, and it closed with a net loss of $285." Barbara Rose, *Claes Oldenburg* (New York: Museum of Modern Art, 1970), 70.
57. "You Think This is a Supermarket?" *Life* 57 (November 20, 1964): 138–44.
58. Robert Atwan, Donald McQuade, and John W. Wright, *Edsels, Luckies, & Frigidaires: Advertising the American Way* (New York: Dell, 1979), 191. Gerald E. Critoph, who analyzes the way in which American eating habits changed after the Second World War, states that food "was sold increasingly in the 18,000 supermarkets across the country, constituting 5 percent of the 360,000 grocery stores, but accounting for nearly 50 percent of the total food sales" (Gerald E. Critoph, "The American Quest for Affluence," in *American Character and Culture in a Changing World*, ed. John A. Hague [Westport, CT: Greenwood Press, 1979], 30).
59. Philip B. Schnering, "Merchandising and the Package," *Management Bulletin: The Package, Key Component of Marketing Strategy* (New York: American Management Association, 1964), 5. Kenneth E. Clark, however, claims that 8,000 items were typically sold in a supermarket (Kenneth E. Clark, "Packaging the Product for Supermarket Distribution," *Management Bulletin: The Package, Key Component of Marketing Strategy* [New York: American Management Association, 1964], 16).
60. As Edward L. Brink and William T. Kelley, coauthors of a book on marketing, counseled: "Since there are no objective, easily dramatized product distinctions among soaps, whiskeys, cigarettes, and most packaged grocery and drug items, the advertiser must give his brand a sharply defined personality. He must treat it symbolically" (Edward L. Brink and William T. Kelley, *The Management Promotion: Consumer Behavior and Demand Stimulation* [Englewood Cliffs, NJ: Prentice Hall, 1963], 158). See also Donald F. Chambless, "Successful Marketing of New Products: Putting the Package in Perspective," *Management Bulletin: The Package, Key Component of Marketing Strategy* (New York: American Management Association, 1964), 2.
61. Harry Henry, *Motivation Research: Its Practices and Uses for Advertising, Marketing and other Business Purposes* (New York: Ungar, 1958), 88–9, 91.

62. Steuart Henderson Britt, *The Spenders* (New York: McGraw-Hill, 1960), 103. Explained Burleigh B. Gardner and Sidney J. Levy in the *Harvard Business Review*: "The net result is a public image, a character or personality that may be more important for the over-all status (and sales) of the brand than many technical facts about the product" (Burleigh B. Gardner and Sidney J. Levy, "The Product and the Brand," *Harvard Business Review* 33 [March–April 1955]: 35).

63. Critoph reports that in 1947, American businesses invested $5 billion on advertising, and in 1957, they spent $10.4 billion. Critoph, "The American Quest," 33.

64. United States Bureau of Labor Statistics, *How American Buying Habits Change* (Washington, DC: U.S. Department of Labor, 1958), 22. The consumer movement, according to Charles Kirkpatrick, began with the publication in 1927 of *Your Money's Worth* (Charles A. Kirkpatrick, *Advertising: Mass Communication in Marketing* [Boston: Houghton Mifflin, 1959], 42). One could, of course, also consult various journals, such as *Consumer Reports*, which evaluated product claims for the consumer. Stuart Ewen discusses the advertising industry's efforts to regulate itself and to establish the truth of advertisements in *Captains of Consciousness: Advertising and the Social Roots of the Consumer Culture* (New York: McGraw-Hill, 1976).

65. Britt, *The Spenders,* 41–2.

66. The notion of the shopper as rational and efficient home manager and consumer dated to the 1920s. See Sally Stein, "The Graphic Ordering of Desire: Modernization of a Middle-Class Women's Magazine 1914–1939," *Heresies* 5 (1985): 7–16.

67. Gilbert Burck, "What Makes Women Buy," *Fortune* 54 (August 1956): 94. See also Charles F. Phillips and Delbert J. Duncan, *Marketing: Principles and Methods* (Homewood, IL: Richard D. Irwin, 1960), 55.

68. Hepner, *Modern Marketing*, 275.

69. On motivation research, see *A Bibliography of Theory and Research Techniques in the Field of Human Motivation* (New York: Advertising Research Foundation, 1956); R. Clifton Andersen and Philip R. Cateora, *Marketing Insights: Selected Readings* (New York: Appleton, Century, Crofts, 1963); E. W. Cundiff and R. R. Still, *Basic Marketing: Concepts, Environment and Decisions* (Englewood Cliffs, NJ: Prentice Hall, 1964); Ernest Dichter, "A Psychological View of Advertising Effectiveness," *Journal of Marketing* 14 (July 1949): 61–6; idem, *Handbook of Consumer Motivations* (New York: McGraw-Hill, 1964); *Directory of Social Scientists Interested in Motivation Research* (New York: Advertising Research Foundation, 1954); *Directory of Organizations Which Conduct Motivation Research* (New York: Advertising Research Foundation, 1954); Robert Ferber and Hugh G. Wales, *Motivation and Marketing Behavior* (Homewood, IL: Richard D.

Irwin, 1958); Gardner and Levy, "The Product and the Brand," 33–9; Ralph Goodman, "Freud and the Hucksters," *The Nation* 176 (February 14, 1953): 143–5; Henry, *Motivation Research*; Gardner Lindzey, ed., *Assessment of Human Motives* (New York: Grove Press, 1958); Pierre Martineau, "New Look at Old Symbols," *Printer's Ink* 247 (June 4, 1954): 32–3, 85, 88–9; idem, *Motivation in Advertising: Motives that Make People Buy* (New York: McGraw-Hill, 1957); Joseph W. Newman, "Looking Around: Consumer Motivation Research," *Harvard Business Review* 33 (January–February 1955): 135–44; George H. Smith, *Motivation Research in Advertising and Marketing* (New York: McGraw-Hill, 1954); Perrin Stryker, "Motivation Research," *Fortune* 53 (June 1956): 144–232; and Joseph W. Wulfeck and Edward M. Bennett, *Advertising Foundation Publication: The Language of Dynamic Psychology as Related to Motivation Research* (New York: McGraw-Hill, 1954).

70. For the history of the relationship between the advertising industry and the discipline of psychology and debates about the role of image and text in advertisements prior to the Second World War, see Sally A. Stein, "The Rhetoric of the Colorful and the Colorless: American Photography and Material Culture between the Wars," Ph.D. dissertation, Yale University, 1991, forthcoming from the Smithsonian Institution Press, 1997. See also James Sloan Allen, *The Romance of Commerce and Culture: Captialism, Modernism, and the Chicago-Aspen Crusade for Cultural Reform* (Chicago: University of Chicago Press, 1983), 6–12; Merle Curti, "The Changing Concept of 'Human Nature' in the Literature of American Advertising," *Business History Review* 41 (Winter 1967): 335–57; Stuart Ewen, *Captains of Consciousness: Advertising and the Social Roots of the Consumer Culture*; idem, "Advertising as Social Production," in Armand Mattelart and Seth Siegelaub, eds., *Communication and Class Struggle*, 2 vols. (New York: International General, 1979), 1: 232–41; and Michael McMahon, "An American Courtship: Psychologists and Advertising Theory in the Progressive Era," *American Studies* 13 (Fall 1972): 5–18.

71. Ernest Dichter, "These are the Real Reasons Why People Buy Goods," *Advertising and Selling* 41 (July 1948): 34.

72. Edward H. Weiss, "Why do Consumers Really Buy Your Products?" *Advertising Age* 23 (November 24, 1952): 48.

73. Janet Wolff, *What Makes Women Buy* (New York: McGraw-Hill and Basic Books, 1958), 79. This book presents itself as a handbook for advertisers, manufacturers, copywriters, salesmen, buyers, designers, editors, and retailers who want to appeal to women customers.

74. Louis Cheskin, *How to Predict What People Will Buy* (New York: Liveright, 1957), 30. David Ogilvy promoted the use of color and photographs in advertisements while criticizing illustration, abstract art, and

the principles of the Bauhaus as ineffective in promoting sales (David Ogilvy, *Confessions of an Advertising Man* [New York: Atheneum, 1964], 115–25). See also Stephen Baker, *Visual Persuasion* (New York: McGraw-Hill, 1961), [unpaginated]; Vance Packard, *The Hidden Persuaders* (New York: David McKay, 1957), 109; and Wolff, *What Makes Women Buy*, 253.

75. Martineau Pierre, *Motivation in Advertising*, 46.

76. Packard, *The Hidden Persuaders*, 16–17. Britt recounts almost the same story – coffee instead of detergent – to demonstrate the *positive* impact of packaging (Britt, *The Spenders*, 108). By the late 1950s, proponents of motivation research began to incorporate defenses against Packard's critique into their texts, mainly by suggesting that motivation research did not create and manipulate hidden desires and needs, but simply uncovered them. See, for instance, Raymond A. Bauer, "Limits of Persuasion," in Martin M. Grossack, ed., *Understanding Consumer Behavior* (Boston: Christopher, 1966), 39–52; and Ernest Dichter, *The Strategy of Desire* (New York: Doubleday, 1960).

77. "Ads You'll Never See," *Business Week* (September 21, 1957): 30–1. See also John Brooks, "The Little Ad That Isn't There: A Look at Subliminal Advertising," *Consumer Reports* 23 (January 1958): 7–10; Alvin W. Rose, "Motivation Research and Subliminal Advertising," *Social Research* 25 (Autumn 1958): 271–84; and Ross Wilhelm, "Are 'Subliminal' Commercials Bad?" *Michigan Business Review* 10 (Janaury 1958): 26–9.

78. Packard, *The Hidden Persuaders*, 105–13. Packard agreed with Martineau that women were driven by status anxiety in consuming goods; advertisers, he argued, exploited the habits of class to shape sales appeal and in the process increased status anxiety (Vance Packard, *The Status Seekers: An Exploration of Class Behavior in America and the Hidden Barriers that Affect You, Your Community, Your Future* [New York: David McKay, 1959]).

79. Burck, "What Makes Women Buy," 92.

80. Calvin Tomkins, "Art or Not, It's Food for Thought," *Life* 57 (November 20, 1964): 143.

Chapter 2

1. The practice of housing design in the United States reorganized the interior after the Second World War in such a way as to turn the kitchen into a central family space: The kitchen in suburban ranch-style homes generally flowed into and overlooked the yard or the dining room where the family gathered. For information about postwar housing design, see, in particular, Clifford E. Clark, *The American Family Home, 1800–1960* (Chapel Hill: University of North Carolina Press, 1986). See also Ellen Lupton and J. Abbott Miller, *The Bathroom, The Kitchen and*

the Aesthetics of Waste: A Process of Elimination (Cambridge, MA: MIT List Visual Arts Center, 1992).

2. Prices for many of these items are given in Kay Hardy, *Room by Room: A Guide to Wise Buying* (New York: Funk and Wagnall, 1959).

3. United States Bureau of Labor Statistics, *How American Buying Habits Change* (Washington, DC: United States Department of Labor, 1958), 104. Gerald E. Critoph writes that increasingly food was produced in the 1950s by giant food factories such as Seabrook Farms of New Jersey and sold in supermarkets (Gerald E. Critoph, "The American Quest for Affluence," in *American Character and Culture in a Changing World*, ed. John A. Hague [Westport, CT: Greenwood Press, 1979], 30).

4. David M. Potter, *People of Plenty: Economic Abundance and the American Character* (Chicago: University of Chicago Press, 1954), 83–4. Many similar declarations exist: Gerald E. Critoph cites a survey from 1950 by the United Nations revealing how much richer Americans were than anyone else (Critoph, "The American Quest," 29).

5. Elaine Tyler May, *Homeward Bound: American Families in the Cold War Era* (New York: Basic Books, 1988), 163. Max Lerner claimed that during the Cold War, American living standards "were a main reliance in psychological warfare against Communist systems" (Max Lerner, *America as a Civilization* [New York: Simon and Schuster, 1957], 249).

6. The suggestion that postwar American society was classless appeared as well in articles published in women's magazines about suburbia. For instance, an article about the suburb of Bellevue, Washington, in *House and Garden* claimed, "Few class lines are drawn" ("Bellevue, Washington," *House and Garden* 107 [March 1955]: 116).

7. Clark, *The American Family Home*, 239.

8. Roland Marchand, "Visions of Classlessness, Quests for Dominion: American Popular Culture, 1945–1960," in *Reshaping America: Society and Institutions 1945–1960*, ed. Robert H. Bremner and Gard W. Reichard (Columbus: Ohio State University Press, 1982), 168–70.

9. Lerner, *America as a Civilization*, 253. Not all agreed. Michael Harrington challenged Lerner's rosy view of economic egalitarianism in *The Other America: Poverty in the United States* (Baltimore: Penguin, 1963). Exemplifying another critical vein, Vance Packard argued that in a period of material abundance, status anxiety actually increased and thus taste, especially taste exercised in household purchases, served to articulate class distinction. I will discuss taste as a sign of distinction later in the chapter. Vance Packard, *The Status Seekers* (New York: David McKay, 1959).

10. Marchand, "Visions of Classlessness," 169. See also Mary Beth Haralvich, "Sitcoms and Suburbs: Positioning the 1950s Homemaker," *Quarterly Review of Film & Video* 11 (1989): 61–83.

11. *Good Housekeeping*'s circulation, which first achieved over one million subscribers between 1926 and 1941, remained steady after the Second World War. In 1963, *Ladies Home Journal* was one of only four magazines to realize a circulation of above six million (Theodore Peterson, *Magazines in the Twentieth Century* [Urbana: University of Illinois Press, 1964], 60–4).

12. *House and Garden* first attained a circulation of over one million between 1926 and 1941, and in 1963, *Better Homes and Gardens* had circulation figures above six million (Peterson, *Magazines in the Twentieth Century*, 60–4).

13. "Beautiful, Budgetwise Three-Room Apartment," *Good Housekeeping* 157 (November 1963): 122–9.

14. Hardy, *Room by Room*, 184.

15. Lynn Spigel writes that the leading women's home and service magazines presented "idealized (upper) middle-class depictions of domestic space, and were addressed to a female-housewife, middle-class reader" (Lynn Spigel, "Installing the Television Set: Popular Discourses on Television and Domestic Space, 1948–1955," *Camera Obscura* 16 [January 1988]: 42). See also The Birmingham Feminist History Group, "Feminism as Femininity in the Nineteen-Fifties?" *Feminist Review* 3 (1979): 48–65; Mary Ann Doane, *The Desire to Desire: The Woman's Film of the 1940s* (Bloomington: Indiana University Press, 1987); and Roland Marchand, *Advertising the American Dream: Making Way for Modernity, 1920–1940* (Berkeley: University of California Press, 1983). During the 1950s, as well, many authors commented on the American woman's role as consumer. Max Lerner, for instance, wrote "It is the middle-class woman and her teen-age daughter, especially in the suburbs, who are America's type consumers" (Lerner, *America as a Civilization*, 254). In his article, David M. Potter claimed that the American woman in her new economic role as a consumer controlled the purse strings of the nation (David M. Potter, "American Women and the American Character," *Stetson University Bulletin* 62 [January 1962]: 20).

16. William Pahlmann, *The Pahlmann Book of Interior Design* (New York: Viking, 1955), 42.

17. Harriet Burket, *House and Garden's Complete Guide to Interior Decoration* (New York: Simon and Schuster, 1960), 9. Occasionally, the insistence that the homemaker's taste demonstrate individuality was framed as a response to accusations by social scientists and cultural critics that the United States, and especially life in the suburbs, demonstrated a dangerous trend toward conformity. Roy McMullen asked, "How can we begin to acquire the kind of independent judgment in the fine and applied arts which will save us from the degradation of snobbery and from the vacuity of 'mass' culture?" (Roy McMullen, "First Step to

Being Yourself," *House Beautiful* 95 [February 1953]: 88). Other texts treated individuality as a political responsibility: "We do not believe in taste dictators any more than in political dictators. We like self-expression" (Albert Kornfeld, "A Bill of Rights for Freedom of Taste," *House and Garden* 103 [February 1953]: 45).

18. See especially Nancy Armstrong for an analysis of how in eighteenth-century England "middle-class authority rested in large part upon the authority that novels attributed to women . . . the densely interwoven fabric of common sense and sentimentality that even today ensures the ubiquity of middle-class power" (Nancy Armstrong, *Desire and Domestic Fiction: A Political History of the Novel* [New York: Oxford University Press, 1987], 4–5).

19. Pierre Bourdieu makes the point that taste functions as a marker of class in his book entitled *Distinction: A Social Critique of the Judgement of Taste* (Cambridge: Harvard University Press, 1984).

20. Suzi Gablik, "Tom Wesselmann," *Art News* 64 (March 1965): 17.

21. Vivien Raynor, "Tom Wesselmann," *Arts* 37 (January 1963): 45.

22. William H. Whyte, Jr., *The Organization Man* (New York: Simon and Schuster, 1956). For a good survey of Whyte and other social scientists and cultural critics of this period, see Richard H. Pells, *The Liberal Mind in a Conservative Age: American Intellectuals in the 1940s & 1950s* (New York: Harper and Row, 1985). See also Andrew Ross, *No Respect: Intellectuals and Popular Culture* (New York: Routledge, 1989).

23. Whyte, *The Organization Man*, 280. Other key texts on suburbia and the middle class include Bruno Bettelheim, *The Informed Heart: Autonomy in a Mass Age* (Glencoe, IL: The Free Press, 1960); William M. Dobriner, *Class in Suburbia* (Englewood Cliffs, NJ: Prentice Hall, 1963); William M. Dobriner, ed., *The Suburban Community* (New York: Putnam's, 1958); David Riesman, *Abundance for What?* (Garden City, NY: Doubleday, 1964); idem, *The Lonely Crowd* (New Haven: Yale University Press, 1950); John R. Seeley et. al., *Creshwood Heights: A Study of the Culture of Suburban Life* (New York: Basic Books, 1956); A. C. Spectorsky, *The Exurbanites* (Philadelphia: Lippincott, 1955); and Robert C. Wood, *Suburbia: Its People and Their Politics* (Boston: Houghton Mifflin, 1958).

24. Clement Greenberg first formulated a difference between the avant-garde and kitsch in his "Avant-Garde and Kitsch," *Partisan Review* 6 (Fall 1939): 34–49. His later two-part article, "The Plight of Our Culture," transformed the binary opposition between the avant-garde and kitsch into a tripartite division of culture consisting of the lowbrow, the middlebrow, and the highbrow. Middlebrow culture, according to Greenberg, was a phenomenon of the postwar period (Clement Greenberg, "The Plight of our Culture: Industrialism and Class Mobility," *Commentary* 15 [June 1953]: 558–66; and idem, "The Plight of our

Culture, Part II: Work and Leisure Under Industrialism," *Commentary* 16 [July 1953]: 54–62). Helpful discussions of Greenberg's texts on mass culture include James D. Herbert, *The Political Origins of Abstract-Expressionist Art Criticism: The Early Theoretical and Critical Writings of Clement Greenberg and Harold Rosenberg* (Stanford: Stanford Honors Essay in Humanities, 1985); and Fred Orton and Griselda Pollock, "Avant-Gardes and Partisans Reviewed," *Art History* 4 (September 1981): 305–27.

25. Greenberg, "The Plight Of Our Culture," 566.
26. Bernard Rosenberg and David Manning White, eds., *Mass Culture: The Popular Arts in America* (Glencoe, IL: The Free Press, 1957). This book includes Greenberg's article from 1939, "Avant-Garde and Kitsch." Other key postwar books on mass culture include *America and the Intellectuals: A Symposium*, Partisan Review Series #4, 1953; Leon Bramson, *The Political Context of Sociology* (Princeton: Princeton University Press, 1961); Leon A. Dexter, ed., *People, Society, and Mass Communications* (Glencoe, IL: The Free Press, 1964); and Norma Jacobs, ed., *Culture for the Millions?: Mass Media in Modern Society* (Princeton: Van Nostrand, 1959).
27. Bernard Rosenberg, "Mass Culture in America," in *Mass Culture*, ed. Rosenberg and White, 9.
28. See Leslie Fiedler, "The Middle Against Both Ends"; and Gilbert Seldes, "The Public Arts"; both in *Mass Culture*, ed. Rosenberg and White.
29. One of most explicit versions of this argument is formulated by Dwight MacDonald in "A Theory of Mass Culture," in *Mass Culture*, ed. Rosenberg and White.
30. Irving Howe, "Mass Society and Post-Modern Fiction," *Partisan Review* 26 (1959): 422.
31. For an excellent analysis of the issues of value and evaluation see Barbara Herrnstein Smith, "Contingencies of Value," *Critical Inquiry* 10 (September 1983): 1–35.
32. Rosenberg, "Mass Culture in America," 6–7.
33. Paul F. Lazarsfeld and Robert K. Merton, "Mass Communication, Popular Taste and Organized Social Action," in *Mass Culture*, ed. Rosenberg and White, 466.
34. Russell Lynes, *The Tastemakers* (New York: Harper, 1949).
35. Russell Lynes, "High-brow, Low-brow, Middle-brow," *Life* 26 (April 11, 1949): 99–101.
36. Lynes, *The Tastemakers*, 332.
37. For example, *Great American Nude #8* of 1961 reverses Matisse's *Pink Nude* of 1935, as pointed out by Sidra Stich in *Made in U.S.A.* (Berkeley: University of California Press, 1987), 30.
38. Probably the most important book on Matisse to appear in English after the Second World War was Alfred Barr, *Matisse: His Art and His*

Public (New York: Museum of Modern Art, 1951). Jean Renoir's memoir about his father generated many articles in both art magazines and the popular press linking Renoir's paintings devoted to the "charms" of the feminine world to the romantic exploits of Renoir's personal life (Jean Renoir, *Renoir, My Father* [London: Collins, 1962]).

39. Articles and books published in the United States on Mondrian in the 1950s and early 1960s generally stressed the austerity, asceticism, and discipline of his work.

40. At the same time, such reproductions reaffirm the uniqueness of the original upon which they are based. As Richard Shiff has argued: "In one sense at least, the most theocentric one, abundance and repetition reinforce the original: if one returns to the 'original' or 'classic' meaning of *original* – having existed from the first – originality can only be enhanced by recreative replication" (Richard Shiff, "Mastercopy" *IRIS: Revue de théorie et du son* 1 [1983], 126).

41. No Author, "How to Live With Taste," *House and Garden* 104 (October 1953): 142.

42. Elizabeth Halsey, *Ladies Home Journal Book of Interior Decoration* (Philadelphia: Curtis, 1954), 123. See also Mary Brandt, *Good Housekeeping Book of Home Decoration* (New York: McGraw-Hill, 1957), 282; Hardy, *Room by Room*, 102; and Albert Kornfeld, *The Doubleday Book of Interior Decorating* (New York: Doubleday, 1965), 200.

43. See Halsey, *Ladies Home Journal Book of Interior Decoration*, 123–6; Frances Melanie Obst, *Art and Design in Home Living* (New York: Macmillan, 1963), 273; and Pahlmann, *The Pahlmann Book of Interior Design*, 138–46. The *Saturday Review* included a telling spoof on interior decoration: A painter turns from his easel to ask a homemaker, "Is your living room blue or gray?" (cartoon, *Saturday Review* 46 [November 23, 1963]: 40).

44. I am relying here on terminology that various feminist film theorists have appropriated from psychoanalysis to describe masculine spectatorship. Laura Mulvey offers the classic formulation of masculine spectatorship in Freudian terms in "Visual Pleasure and Narrative Cinema," *Screen* 16 (Autumn 1975): 6–18. See also Doane, *The Desire to Desire*, 13–22.

45. Jill Johnston, "Tom Wesselmann," *Art News* 61 (November 1962): 15. Many critics found Wesselmann's nudes appealing, sensual, and erotic; even negative criticisms of Wesselmann's nudes were articulated in terms of the desirability of the bodies. See J. A. Abramson, "Tom Wesselmann and the Gates of Horn," *Arts* 40 (May 1966): 43–8; Natalie Edgar, "Tom Wesselmann," *Art News* 56 (December 1961): 56; Jane Harrison, "Tom Wesselmann," *Arts* 38 (April 1964): 32–3; Leonard Horowitz, "Art," *The Village Voice*, February 20, 1964, p. 8; Jill Johnston, "Tom Wesselmann," *Art News* 63 (April 1964): 13; Brian O'Doherty,





"Art: 'Pop' Show by Tom Wesselmann Is Revisited," *The New York Times*, November 28, 1962, p. 36; Barbara Rose, "Filthy Pictures: Some Chapters in the History of Taste," *Artforum* 3 (May 1965): 20–5; Alan R. Solomon, "The New American Art," *ArtInternational* 8 (March 1964): 54; G. R. Swenson, "Wesselmann: The Honest Nude," *Art and Artists* 1 (May 1966): 54–7; and Marina Warner, "Tom Wesselmann: Art into Media, Media Into Art," *Isis* 1522 (November 2, 1966): 16–18.

46. Indeed *Playboy* magazine published photographs of young women taking baths or lounging in Playboy pads.

47. My account of female spectatorship, like my description of male spectatorship, relies heavily on feminist film theory. The literature theorizing the female spectator is vast, but central texts in the debate include Theresa De Lauretis, *Alice Doesn't: Feminism, Semiotics, Cinema* (Bloomington: Indiana University Press, 1984); Doane, *The Desire to Desire*; E. Ann Kaplan, "Is the Gaze Male?" in *Women and Film: Both Sides of the Camera* (New York: Methuen, 1983); Tania Modleski, *The Women Who Knew Too Much* (New York: Methuen, 1988); and Laura Mulvey, "On *Duel in the Sun*: Afterthoughts on 'Visual Pleasure and Narrative Cinema,'" *Framework* 6 (1981): 12–15.

48. Still the most compelling analysis of Manet's *Olympia* is T. J. Clark, *The Painting of Modern Life: Paris in the Art of Manet and his Followers* (New York: Knopf, 1985), chap. 2.

49. My thanks to Serge Guilbaut, who first pointed this out to me.

50. "The New Interior Decorators," *Art in America* 53 (June 1965): 52.

51. See also *Playboy's Party Jokes* (Chicago: Playboy Press, 1963).

52. My discussion of dirty jokes is indebted to Mary Ann Doane's analysis of Robert Doisneau's photograph *Un Regard Oblique* of 1948. Relying on Freud's analysis of jokes, Doane argues that Doisneau's dirty joke ensures a masculinization of the position of the spectator. As for the female spectator, she writes: "Doisneau's photograph is not readable by the female spectator – it can give her pleasure only in masochism. In order to 'get' the joke, she must once again assume the position of transvestite" (Mary Ann Doane, "Film and the Masquerade: Theorising the Female Spectator," *Screen* 23 [September–October 1982]: 85–7).

53. See citations in note 45.

54. Wesselmann, writing under the pseudonym of Slim Stealingworth, stated his preference for product brochures over magazine advertisments as a source for his cutouts because magazines were printed with bad inks on inferior-quality paper (Slim Stealingworth, *Tom Wesselmann* [New York: Abbeville Press, 1980], 24).

55. Walter Benn Michaels, *The Gold Standard and the Logic of Naturalism* (Berkeley: University of California Press, 1987), 161.

56. Doane, *The Desire to Desire*, 1, 14.

57. Norman Bryson analyzes this tradition of Dutch still-life painting and offers many insights about how still-lifes regulate abundance and consumption (Norman Bryson, *Looking at the Overlooked* [Cambridge: Harvard University Press, 1990]).

58. Emily Genauer, "Can This Be Art?" *Ladies Home Journal* 81 (March 1964): 151–5; Gray, "The House that Pop Art Built," 158–63; "Un Appartement Pop," *L'Oeil* 106 (October 1963): 12–19; "At Home With Henry," *Time* 83 (February 21, 1964): 68–71; "You Bought It, Now Live with It," *Life* 59 (July 16, 1965): 56–61; John Rublowsky, "Collectors and Galleries," in *Pop Art* (New York: Basic Books, 1965); Elizabeth Sverbeyeff, "Life with Pop," *The New York Times Magazine* (May 2, 1965): 98–9; Allene Talmey, "Art is the Core," *Vogue* 144 (July 1964): 116–23, 125; and Sidney Tillim, "Further Observations on the Pop Phenomenon," *Artforum* 4 (November 1965): 17–19.

59. Arthur Drexler and Greta Daniel, *Introduction to Twentieth Century Design from the Collection of The Museum of Modern Art New York* (Garden City, NY: Doubleday, 1959), 43.

60. Gray, "The House that Pop Art Built," 158.

61. Halsey, *Ladies Home Journal Book of Interior Decoration*, 24.

62. Clark, *The American Family Home 1800–1960*, 193–216; and Clifford E. Clark, Jr., "Ranch-House Suburbia: Ideals and Realities," in *Recasting America: Culture and Politics in the Age of Cold War*, ed. Lary May (Chicago: University of Chicago Press, 1989), 171–91. See also Thomas Hine, "The Search for the Postwar House," in *Blueprints For Modern Living: History and Legacy of the Case Study Houses* (Los Angeles: Museum of Contemporary Art, 1989), 167–81. Articles on modern architecture published in popular and women's magazines include "Clean and Handsome Example of the West's Familiar 'Ranch House,'" *Sunset* 110 (April 1953): 74–5; "Eastward Ho," *Life* 32 (March 17, 1952): 131–2; "From the Rancho, a Contemporary Style," *Life* 40 (January 16, 1956): 58; "Introducing Our House of Ideas," *House and Garden* 100 (July 1951): 31–63; "Oregon Ranch House," *Sunset* 113 (September 1954): 56–7; "Ranch House with One Open Wall," *Sunset* 113 (September 1954): 83; "Ranch Houses Suit Any Climate," *House Beautiful* 89 (January 1947): 60–9; "Story of the Western Ranch House," *Sunset* 121 (September 1958): 74; "This Oregon Ranch House Lives as Well as It Looks," *House and Garden* 95 (March 1949): 104–11; "Total Environment That Fosters a New Pattern of Living," *House and Garden* 119 (January 1961): 64–75.

63. For instance, Frances Melanie Obst wrote: "Modern design has come of age. It no longer looks strange. Today's design is varied to suit formal or informal living, large or small homes" (Obst, *Art and Design in Home Living*, 221).

64. Burket, *House and Garden's Complete Guide to Interior Decoration*, 105.

65. Gerd and Ursula Hatje, *Design for Modern Living: A Practical Guide to Home Furnishing and Interior Decoration* (New York: Abrams, 1962), 16. *Design for Modern Living* mediates between the definition of modernist design provided by middle-class journals such as *Ladies Home Journal* and elite art institutions such as the Museum of Modern Art. It includes high-design furniture by Eero Saarinen, Charles Eames, and Ludwig Mies van der Rohe, but also mass-produced furniture.

66. Clark, *The American Family Home*, 217.

67. "They like the gossip of the gossipy art world, the quarrels, the prices paid, the switch of a painter from one gallery to another, the dancing, the hot-dog parties" (Talmey, "Art is the Core," 118).

68. Ibid., 118, 119.

69. "Modern Living: A Playboy's Pad," *Playboy* 10 (May 1964): 71–6; "The Playboy Mansion," *Playboy* 13 (1966): 116; "Playboy Pad," *Playboy* 12 (October 1965): 97; "A Playboy Pad: Palm Springs Oasis," *Playboy* 13 (April 1966), 119; "A Playboy Pad: Texas Retreat," *Playboy* 13 (October 1966), 105; and "Playboy's Weekend Hideaway," *Playboy* 6 (April 1959): 53–4.

70. Barbara Ehrenreich, *Hearts of Men: American Dreams and the Flight from Commitment* (Garden City, NY: Anchor Books, 1983), 44.

71. For the Museum of Modern Art's position on modernist design and architecture in the 1930s, see Sidney Lawrence, "Clean Machines at the Modern," *Art in America* 72 (February 1984): 127–41, 166–8; and Terry Smith, *Making the Modern: Industry, Art, and Design in America* (Chicago: University of Chicago Press, 1993).

72. Edgar Kaufmann, *What Is Modern Interior Design?* (New York: Museum of Modern Art, 1953); and Drexler and Daniel, *Introduction to Twentieth Century Design*.

73. Johnson, "Preface," in *Built in USA*, 8.

74. Drexler and Daniel, *Introduction to Twentieth Century Design*, 4.

75. "The Playboy Mansion," 112; and Hugh Hefner, "The Playboy Philosophy," *Playboy* 10 (February 1963): 44. Several cartoons poking fun at Pop art were published in the pages of *Playboy*. See *Playboy* 12 (July 1965): 144; and *Playboy* 12 (August 1965): 162.

76. George Heard Hamilton, "The Collector as a Guide to Taste," *Art News* 57 (April 1958): 42. Most publications on collecting after the Second World War offered a variety of reasons to explain why people bought art. For instance, in 1944, Douglas and Elizabeth Rigby, in the self-proclaimed "first attempt in any language to offer a comprehensive picture of the field of collecting," listed as motivations: physical security, distinction, immortality, knowledge, and aesthetic satisfaction (Douglas and Elizabeth Rigby, *Lock, Stock and Barrel: The Story of Collect-*

ing (Philadelphia: Lippincott, 1944), xvii. Although monographic studies about either individual collectors or art collections in museums were published sporadically throughout the twentieth century, the first histories of American collecting date from after the Second World War. See W. G. Constable, *Art Collecting in the United States of America* (London: Thomas Nelson, 1964); and Aline Saarinen, *Proud Possessors* (New York: Random House, 1958).

77. Ben Heller, "The Roots of Abstract Expressionism," *Art in America* 49 (1961): 40–9.

78. Talmey, "Art is the Core," 118, 123. Referring to his purchase of *The Stove* by Claes Oldenburg, Mr. Scull stated: "Ethel thought I was crazy when the stove arrived. But now she calls it my emerald and she won't let anyone else touch it." "You Bought It, Now Live With It," 57. Emily Genauer reported: "Mrs. Scull was less receptive. Several purchases had to be kept in storage because she refused to allow them in the house" (Genauer, "Can This Be Art?" 153).

79. "You Bought It, Now Live With It," 58.

80. Rublowsky, *Pop Art*, 157.

81. Gray, "The House that Pop Art Built," 158, 162.

82. Talmey, "Art Is the Core," 118.

83. "At Home with Henry," 68.

84. Ibid., 68.

Chapter 3

1. In a telephone interview on January 31, 1990, Ken Mills, account executive at the advertising firm of BBDO, which developed the Sunlight campaign, used the term "cartoon style" to describe two television commercials that were part of the campaign (I will analyze these commercials at the end of this chapter). An article in the trade press about one of these commercials labeled it a "Pop-art/parody approach" (Debbie Seaman, "BBDO Dishes Out Sparkling Soap Spoof," *Adweek's Marketing Week* 29 [February 8, 1988]: 34).

2. Patricia Koch from Lichtenstein's staff initially provided me with a partial list of the titles of the comic books Lichtenstein used for his paintings, and I have found that all of these titles were first launched as comic-book series around 1950. They include *Secret Hearts* in 1949, *Young Love* in 1949, *Girl's Romances* in 1950, *Heart Throbs* in 1949, *Falling in Love* in 1955, *Teen Confessions* in 1959, *War Stories* in 1942, *Our Fighting Forces* in 1954, and *Our Army at War* in 1952.

3. Albert Boime published the first lengthy article analyzing the relationship between Lichtenstein's paintings and his comic-book sources (Albert Boime, "Roy Lichtenstein and the Comic Strip," *Art Journal* 28 [Winter 1968]: 155–9). More recently, Kirk Varnedoe's and Adam Gop-

nik's *High & Low: Modern Art and Popular Culture* included numerous comparisons between Lichtenstein's paintings and frames from comic books. Varnedoe and Gopnik, along with their research assistant, Matthew Armstrong, discovered that most of Lichtenstein's comic-book sources date from the early 1960s, and that sometimes his paintings – more often in the case of the war than romance paintings – combine images from more than one comic-book source. Most of the comparisons I make in this chapter between Lichtenstein's paintings and their comic-book sources were made possible by the exhibition and its catalogue.

4. In response to public outcry against comic books – best exemplified by the publication in 1954 of Frederic Wertham's *Seduction of the Innocents* – publishers of comic books joined to create the Comics Code Authority, which required that comic books be submitted for a seal of approval prior to publication. For a discussion of the Comics Code Authority, see M. Thomas Inge, "Introduction," *Journal of Popular Culture* 12 (Spring 1979): 632. See also James Gilbert, *A Cycle of Outrage: America's Reaction to the Juvenile Delinquent in the 1950s* (New York: Oxford University Press, 1986), for an analysis of the belief in the United States during the 1950s that mass culture, particularly comic books, provoked juvenile delinquency.

5. See, for example, John Cawelti, "The Concept of Formula in the Study of Popular Literature," *Journal of Popular Culture* 3 (Winter 1969): 381–90.

6. Jane Tompkins, "West of Everything," *South Atlantic Quarterly* 86 (Fall 1987): 357–77.

7. Susan Jeffords, *The Remasculinization of America* (Bloomington: Indiana University Press, 1989), 11.

8. Interestingly, the comic-book source portrays a crisis on the ground, with the hero in a visible state of panic, rather than triumph in the air.

9. The painting is called *Women Cleaning* in several articles published about Lichtenstein in the early 1960s. See, for instance, p. 39 of Robert Rosenblum, "Roy Lichtenstein and the Realist Revolt," *Metro* 8 (January–March 1963): 38–45.

10. Ruth Schwartz Cowan, "The 'Industrial Revolution' in the Home: Household Technology and Social Change in the 20th Century," *Technology and Culture* 17 (January 1976): 1–23; idem, "Two Washes in the Morning and a Bridge Party at Night: The American Housewife Between the Wars," *Women's Studies* 3 (1976): 147–72; idem, *More Work For Mother* (New York: Basic Books, 1983); Barbara Ehrenreich and Deirdre English, *For Her Own Good: 150 Years of the Experts' Advice to Women* (Garden City, NY: Anchor Press/Doubleday, 1978); Adrian Forty, *Objects of Desire* (New York: Pantheon, 1986); Glenna Matthews,

"Just a Housewife": The Rise and Fall of Domesticity in America (New York: Oxford University Press, 1987); and Susan Strasser, *Never Done: A History of American Housework* (New York: Pantheon, 1982).

11. The two other dialogue bubbles in the comic-book panel read: "THROUGH MY WINDSHIELD, I SAW A SIGHT I'LL NEVER FORGET . . . " and "KEEP POURING CALIBERS INTO THAT MIG, BROWN! HE'S BUSTIN' IN FOR A RAM JOB . . . TO SPLIT US APART!" Earlier in the story, the greenhorn expresses embarrassment and insecurity: "WHEN I FOUND OUT WHAT I'D CHEATED THE WHOLE SQUADRON OUT OF, I FELT LIKE A ROTTEN APPLE IN A BARREL OF GOOD ONES."

12. Kaja Silverman, *The Acoustic Mirror: The Female Voice in Psychoanalysis and Cinema* (Bloomington: Indiana University Press, 1988), 48.

13. As Wendy Steiner has noted, many of the romance paintings have present-participle titles (Wendy Steiner, *Pictures of Romance: Form Against Context in Painting and Literature* [Chicago: University of Chicago Press, 1988], 156).

14. The way in which Lichtenstein's heroines are at the same time contained in domestic interiors and linguistically confined by their internal thoughts corresponds to what Kaja Silverman says of film: "Hollywood's soundtrack is engendered through a complex system of displacements which locate the male voice at the point of apparent textual origin, while establishing the diegetic containment of the female voice. . . . Far from being a privileged condition . . . interiority in Hollywood films implies linguistic constraint and physical confinement – confinement to the body, to claustral spaces, and to inner narratives" (Silverman, *Acoustic Mirror*, 45).

15. Steiner, *Pictures of Romance*, 165.

16. The emphasis on "transformation" as a means of distinguishing Lichtenstein's paintings from their comic-book sources continues to this day. The most recent example is Varnedoe and Gopnik, *High & Low*, 199–208. In an interview about the exhibition, Varnedoe commented explicitly: "What we want to do, though, is to show how profoundly Lichtenstein transformed his comic sources" (Nicholas Jenkins, "High, Low, Hot and Cool," *Art News* 89 [October 1990]: 166).

17. Ellen Johnson, "The Image Duplicators – Lichtenstein, Rauschenberg and Warhol," *Canadian Art* 23 (1966): 13–18. The title of her article is itself an act of appropriation, lifted from Lichtenstein's painting *The Image Duplicator* of 1963.

18. Aline B. Saarinen, "Explosion of Pop Art: A New Kind of Fine Art Imposing Poetic Order on the Mass-Produced World," *Vogue* 141 (April 1963): 134.

19. Dorothy Seiberling, "Is He the Worst Artist in the U.S.?" *Life* 56 (January 31, 1964): 83. Seiberling's title is obviously a parodic reference to

the famous article published in *Life* in 1949 entitled, "Jackson Pollock: Is He the Greatest Living American Painter?" *Life* 8 (August 8, 1949): 42–5.

20. Linda Hutcheon has recently pointed out "[F. R.] Leavis's famous distaste, not to say contempt, for parody was based on his belief that it was the philistine enemy of creative genius and vital originality. . . . What is clear from these sorts of attacks is the continuing strength of a Romantic aesthetic that values genius, originality, and individuality" (Linda Hutcheon, *A Theory of Parody: The Teachings of Twentieth-Century Art Forms* [New York: Methuen, 1985], 4).

21. For examples of this type of criticism, see Lawrence Campbell, "Roy Lichtenstein," *Art News* 62 (November 1963): 12–13; Brian O'Doherty, "Lichtenstein: Doubtful But Definite Triumph of the Banal," *The New York Times*, October 27, 1963, p. 21; and Robert Rosenblum, "Roy Lichtenstein and the Realist Revolt."

22. John Rublowsky, *Pop Art* (New York: Basic Books, 1965), 48. See also Richard Morphet, *Roy Lichtenstein* (London: The Tate Gallery, 1968).

23. Leo Steinberg, "A Symposium on Pop Art," *Arts* 37 (April 1963): 40.

24. Andreas Huyssen, "Mass Culture as Woman: Modernism's Other," in *After the Great Divide: Modernism, Mass Culture, Postmodernism* (Bloomington: Indiana University Press), 46.

25. Erle Loran, "Pop Artists or Copy Cats?" *Art News* 62 (September 1963): 48–9, 61.

26. Idem, *Cézanne's Composition*, 2nd ed. (Berkeley: University of California Press, 1959 [1st ed., 1943]).

27. Loran, "Pop Artists or Copy Cats?" 48.

28. G. R. Swenson, "What Is Pop Art," *Art News* 62 (November 1963): 62. See also John Coplans, "An Interview with Roy Lichtenstein," *Artforum* (October 1963): 31.

29. Max Kozloff, "Art," *The Nation* 197 (November 2, 1963): 284, 287.

30. Mary Kelly, "Re-viewing Modernist Criticism," in *Art After Modernism: Rethinking Representation*, ed. Brian Wallis (New York: New Museum of Contemporary Art), 90.

31. Craig Owens, "The Discourse of Others: Feminists and Postmodernism," in *The Anti-Aesthetic: Essays on Postmodern Culture*, ed. Hal Foster (Port Townsend, WA: Bay Press, 1983), 58.

32. Hans Namuth's photographs appeared alongside an article by Robert Goodnough entitled, "How Pollock Paints a Picture," *Art News* 50 (May 1951): 38–41, 60–1. Harold Rosenberg, "The American Action Painters," *Art News* 51 (December 1952): 22–3, 48–50. As Annette Cox has pointed out, Namuth's photographs probably inspired Rosenberg to coin the term "Action Painting"; his now famous article, "The American Action Painters," appeared in *Art News* a little over a year after the

magazine published Namuth's photographs (Annette Cox, *Art-As-Politics: The Abstract Expressionist Avant-Garde and Society* [Ann Arbor: UMI Research Press, 1982], 135).

33. B. H. Friedman, "Jackson Pollock," *Art in America* 43 (December 1955): 59.

34. Dorothy Seiberling, "Baffling U.S. Art: What It Is About," *Life* 47 (November 9, 1959): 68–80. For a detailed assessment of Jackson Pollock's media image in the 1950s, see Mary Lee Corlett, "Jackson Pollock: American Culture, the Media and the Myth," *Rutgers Art Review* 8 (1987): 71–106.

35. Robert Rosenblum, "The Abstract Sublime," *Art News* 59 (February 1961): 56. In the late 1950s, as various critics and artists began to react against what was called the "excesses" of criticism influenced by Rosenberg, and adopted instead Greenberg's more formalist tone, other readings of Pollock's paintings emerged. Some critics found them rigorous and controlled. See, for instance, Donald Judd, "Helen Frankenthaler," *Arts* 34 (March 1960): 50.

36. Frank O'Hara, *Jackson Pollock* (New York: Braziller, 1959), 12.

37. William Berkson, "Roy Lichtenstein," *Arts* 40 (January 1966): 54.

38. "But the classical pop artist, by general consent, is Roy Lichtenstein, a youthful 41 with a straightbacked, pixie-faced stance and a humorous intelligence." "Discredited Merchandise," *Newsweek* 64 (November 9, 1964): 96. He is described as "a quiet, affable man of 40" in Sieberling, "Is He the Worst Artist in the U.S.?" 79. One author who stresses his educational background is Mario Amaya, *Pop Art . . . And After* (New York: Viking, 1965), 88. Rublowsky also emphasizes Lichtenstein's professionalism in *Pop Art*, 48.

39. Saarinen, "Explosion of Pop Art," 134.

40. Rublowsky, *Pop Art*, 43. The year Rublowsky published his book, Lichtenstein and his first wife divorced, and he became the primary caretaker of his two sons (Calvin Tomkins, *Roy Lichtenstein: Mural with Blue Brushstroke* [New York: Abrams, 1988], 27).

41. See Bradford Collins, "Clement Greenberg and the Search for Abstract Expressionism's Successor: A Study in the Manipulation of Avant-Garde Consciousness," *Arts* 61 (May 1987): 36–43.

42. William Rubin, "The New York School – Then and Now," Pts. 1, 2, *ArtInternational* 2 (March–April, May–June 1958): 23–6, 19–22. Other key articles in the critical debate include Clement Greenberg, "Louis and Noland," *ArtInternational* 4 (May–June 1960): 26–9; Allan Kaprow, "The Legacy of Jackson Pollock," *Art News* 57 (October 1958): 24–6, 55–7; "Is There a New Academy?" Pts. 1, 2, *Art News* 58 (Summer, September 1959): 34–7, 58–9 and 36–9, 58–60; and William Rubin, "Younger American Painters," *Art International* 4 (January–February 1960): 25–30.

43. Rubin, "The New York School," Pt. 1, 26.

44. Rubin, "Younger American Painters," 25.

45. Rubin, "The New York School," Pt. 2, 22. Anxieties about women dominating the Second Generation of Abstract Expressionism were perhaps fueled by the exhibition "The New York School: Second Generation," which took place at the Jewish Museum in March–April 1957 and included twenty-three artists, a number of whom were women. In May of that year, *Life* magazine also ran an article entitled, "Women Artists in Ascendance," featuring Frankenthaler, Hartigan, Blaine, and Mitchell (*Life* 42 [May 13, 1957]: 74–7).

46. Rubin, "The New York School," Pt. 1, 24.

47. This was not, of course, the first time in which social critics in the United States had drawn attention to a crisis in masculinity; for masculinity to be in crisis may, in fact, be its normative state. The concept of masculinity may well thrive precisely owing to its constant need of reaffirmation, because without an ongoing crisis, the concept may lack the imperative continuously to assert itself anew. A number of historians have recently analyzed crises of masculinity in the 1890s and the 1930s. See, for instance, Michael Kimmel, "The Contemporary Crisis of Masculinity in Historical Perspective," in *The Making of Masculinities*, ed. Harry Brod (Boston: Allen and Unwin, 1987), 121–53; and Barbara Melosh, *Engendering Culture: Manhood and Womanhood in New Deal Public Art and Theater* (Washington, DC: Smithsonian Institution Press 1991).

48. These texts include Myron Brenton, *The American Male* (Greenwich, CT: Fawcett, 1966), reviewed in *Saturday Review* 49 (July 30, 1966): 16–17, 29–31; Lawrence K. Frank, "How Much do We Know About Men?" *Look* 19 (May 17, 1955): 52, 54–60; Betty H. Hoffman, "Masculinity: What Is It?" *Ladies Home Journal* 80 (Winter 1963): 96, 123–4; Dr. Judson T. and Mary G. Landis, "The U.S. Male," *Collier's* 130 (July 19, 1952): 22–3, 48; George B. Leonard, "The American Male: Why Is He Afraid to Be Different?" *Look* 22 (February 18, 1958): 95–104; Margaret Mead, "American Man in a Woman's World," *The New York Times Magazine* (February 10, 1957): 11, 20–3; Malcolm Muggeridge, "Bedding Down in the Colonies," *Esquire* 58 (July 1962): 84–6, 115; "The New American Domesticated Male," *Life* 36 (January 4, 1954): 42–5; and Amran Scheinfeld, "The American Male," *Cosmopolitan* 142 (May 1957): 22–5. Wini Breines discusses some of the sociological texts published on gender in the 1950s in *Young, White and Miserable* (Boston: Beacon Press, 1992).

49. Philip Wylie first condemned the influence of the American mother over her sons in *A Generation of Vipers* (New York: Rinehart, 1942), particularly chap. 11. In 1946, Dr. Edward A. Strecker attributed the

emotional immaturity of American soldiers to their domineering mothers in *Their Mothers' Sons* (Philadelphia: Lippincott, 1946) and in "What's Wrong with American Mothers," *Saturday Evening Post* 219 (October 26, 1946): 14–15, 85–96, 99, 102, 104. Eric John Dingwall elaborated on Strecker's thesis in *The American Woman: An Historical Study* (New York: New American Library, 1958). Texts that focused on the wives of white-collar professionals include Amaury de Riencourt, "Will Success Spoil American Women?," *The New York Times Magazine* (November 10, 1957): 32, 98, 100–1; Dingwall, *The American Woman;* Lee Graham, "Who's in Charge Here? – Not Women!" *The New York Times Magazine* (September 2, 1962): 8, 38–9; Ernest Havemann, "Amid Profound Change Personal Crisis," *Life* 51 (September 8, 1961): 99–119; Morton M. Hunt, "What Is a Husband? What Is a Wife?" *Good Housekeeping* 151 (November 1960): 59, 122–8; Margaret Mead, *Male and Female* (New York: Morrow, 1949); Eve Merriam, "The Matriarchal Myth," *The Nation* 187 (November 8, 1958): 332–5; and J. Robert Moskin, "Why Do Women Dominate Him?" *Look* 22 (February 4, 1958): 77–80. Barbara Ehrenreich discusses the way in which women received the blame for men's conformity in the 1950s in *The Hearts of Men* (Garden City, NY: Anchor Press/Doubleday, 1983), 36–9. See as well Ehrenreich and English, *For Her Own Good.*

50. de Riencourt, "Will Success Spoil American Women?," 32, 98.

51. Moskin, "Why Do Women Dominate Him?," 78–9.

52. Diana Trilling, "The Case for . . . The American Woman" [ellipsis in the title is in the original], *Look* 23 (March 3, 1959): 51, 53.

53. Arthur Schlesinger, Jr., "The Crisis of American Masculinity," *Esquire* 50 (November 1958): 65.

54. Interestingly, Lichtenstein-derived images continue to address anxieties about masculinity. For instance, on the cover of the December 7, 1992, issue of *Newsweek* devoted to "The New Middle Age," a Lichtenstein-style male character slaps his brow and gasps: "Oh, God . . . I'm Really Turning 50!"

55. I am borrowing the term "remasculinization" from Susan Jeffords, who used it to discuss the gendering of the Vietnam War. Jeffords, *The Remasculinization of America.*

56. Clement Greenberg, "Modernist Painting," *Arts Yearbook* 4 (1961): 103. The other key articles by Greenberg are "After Abstract Expressionism," *ArtInternational* 6 (October 1962): 24–32; "Three New American Painters," *Canadian Art* 20 (May/June 1963): 172–5; and "Post Painterly Abstraction," *ArtInternational* 8 (Summer 1964): 63–4.

57. I am indebted here to Serge Guilbaut, who has recently proposed that Barnett Newman personified a new masculine ideal in the art criticism of the late 1950s, decisively replacing the anxious type exemplified by

Pollock (Serge Guilbaut in a discussion at the Annual Meeting of the American Studies Association, New Orleans, November 2, 1990).

58. Clement Greenberg, *Barnett Newman* (New York: French, 1959), [unpaginated]. Greenberg's essay was reprinted from the preface to the catalogue of Newman's first retrospective at Bennington College in 1958. The reprinted essay was preceded by a rejoinder to those "who amused themselves over the simplicity of Barnett Newman's paintings shown at Bennington College in May of 1958" in the form of a poem by Howard Nemerov about the simplicity of Moses and Elijah.

59. Hubert Crehan, "Barnett Newman," *Art News* 58 (April 1959): 12.

60. Barnett Newman, "Letter," *Art News* 58 (June 1959): 6.

61. "Picture of a Painter," *Newsweek* 53 (March 16, 1959): 58. In this same article, he stated: "The only thing is that you've got to be able to tell the men from the boys."

62. Morris Louis quoted in James McC. Truitt, "Art: Arid D.C. Harbours Touted New Painters," *The Washington Post* (December 21, 1961): 20. Greenberg, in a related gesture, characterized Frankenthaler as Louis's inspirational muse (Clement Greenberg, "Louis and Noland," *ArtInternational* 4 [May 1960]: 28).

63. See, for instance, Elaine Gottlieb, "Helen Frankenthaler," *Arts* 32 (January 1958): 55; Frank O'Hara, *Helen Frankenthaler* (New York: The Jewish Museum, 1960); Anne Seelye, "Helen Frankenthaler," *Art News* 59 (March 1960): 39, 57, 58; Sidney Tillim, "Helen Frankenthaler," *Arts* 33 (May 1959): 56; and Parker Tyler, "Helen Frankenthaler," *Art News* 56 (January 1958): 20.

64. Donald Judd, "Helen Frankenthaler," *Arts* 34 (March 1960): 55.

65. James Schuyler, "Helen Frankenthaler," *Art News* 59 (May 1960): 13.

66. E. C. Goossen, "Helen Frankenthaler," *ArtInternational* 5 (October 1961): 78.

67. Donald Judd, "Helen Frankenthaler," *Arts* 37 (April 1963): 54. See also Donald Judd, "Helen Frankenthaler," *Arts* 36 (January 1962): 38–9; and Irving Sandler, "Helen Frankenthaler," *Art News* 62 (March 1963): 11.

68. Greenberg wrote of Pop art: "Not that I do not find the clear and straightforward academic handling of their pictures refreshing after the turgidities of Abstract Expressionism; yet the effect is only momentary, since novelty, as distinct from originality, has no staying power" (Greenberg, "After Abstract Expressionism," 32).

69. Robert Rosenblum, "Roy Lichtenstein and the Realist Revolt," 38–9.

70. Lucy Lippard, *Pop Art* (London: Thames and Hudson, 1966), 85, 74, 125. The other hard-core artists in Lippard's list were Claes Oldenburg, James Rosenquist, Andy Warhol, and Tom Wesselmann.

71. Some of the key articles that defined a "1960s sensibility" include Matthew Baigell, "American Abstract Expressionism and Hard Edge: Some

Comparisons," *Studio International* 171 (January 1966): 10–15; Barbara Rose, "ABC Art," *Art in America* 53 (October 1965): 58–69; idem, "Pop in Perspective," 59–63; Barbara Rose and Irving Sandler, "Sensibility of the Sixties," *Art in America* 55 (January 1967): 44–57; Irving Sandler, "The New Cool Art," *Art in America* 53 (February 1965): 96–101. Donald Judd is another formalist critic who wrote positive reviews about both various Pop and Post-Painterly Abstraction artists. Even Greenberg himself, although he ultimately dismissed Pop art, admitted that Pop shared in the trend toward the openness and clarity exemplified by Post-Painterly Abstraction (Greenberg, "Post Painterly Abstraction," 62).

72. Sandler, "The New Cool Art," 101.
73. Rose, "Pop in Perspective," 62.
74. Barbara Reise notes Rose's debt to Greenberg's ideas by pointing out that Rose thanks Greenberg in her acknowledgments (Reise, "Greenberg and the Group," Pt. 2, 316). Sandler deferred often to Greenberg's authority in both *The New York School* and *The Triumph of American Painting*, calling him the most respected modernist critic after the Second World War. Clearly, a split existed among formalist critics in the 1960s between those who maintained the Greenberg line and those who appropriated his vocabulary to praise artists that Greenberg disliked. Numerous articles either defending or criticizing Greenberg and the three writers whom various critics called Greenberg's main disciples – Michael Fried, Rosalind Krauss, and Jane Harrison Cone – appeared in the late 1960s. A sampling would include Patrick Herron, "A Kind of Cultural Imperialism," *Studio International* 175 (February 1968): 62–4; Donald Judd, "Complaints," Pt. 1, *Studio International* 177 (April 1969): 182–8; Edward Lucie-Smith, "An Interview with Clement Greenberg," *Studio International* 175 (January 1968): 4–5; Barbara Rose, "The Value of Didactic Art," *Artforum* 5 (April 1967): 32–6; Barbara Rose, "The Politics of Art," Pt. 1, *Artforum* 6 (February 1968): 31–2; and Barbara Reise, "Greenberg and the Group: A Retrospective View," Pts. 1, 2, *Studio International* 175 (May, June 1968): 254–7, 314–16.
75. Many of the Pop-art advertisements appeared in the *New York Times Magazine*. More infrequently they were published in *Better Homes and Gardens, Cosmopolitan, Glamour, Ladies Home Journal, McCall's, Mademoiselle, New Yorker, Newsweek*, and *Seventeen*.
76. John Canaday, "Pop Art Sells On and On – Why?" *The New York Times Magazine* (May 31, 1964): 7, 48, 52–3. Canaday reviewed contemporary art, including several exhibitions of Pop art, for the *New York Times* during the early 1960s. This particular article included a reproduction of Lichtenstein's *Drowning Girl*.
77. Michael Renov, "Advertising/Photojournalism/Cinema: The Shifting

Rhetoric of Forties Female Representation," *Quarterly Review of Film and Video* 11 (1989): 14.

78. "Advertiser Turns Tables on Pop Art," *Advertising Age* 35 (May 18, 1964): 3.

79. Seaman, "BBDO Dishes Out," 34.

80. Another instance in which a Lichtenstein-derived illustration provoked heated controversy took place at UCLA in the winter of 1992 after the UCLA Community Directory published on its cover an image of a blonde – her face and manicured hands covered with visible Ben Day dots – sobbing into the telephone receiver: "What Do You Mean the 213 Area Code Has Changed?!" Several students immediately fired off letters to the student newspaper, *Daily Bruin*, criticizing "that third rate imitation of a Lichtenstein print" as a stereotype that did not adequately represent the UCLA community – either its diversity of race, ethnicity, and class or the intelligence and accomplishments of its female students. These students did not read the image as a parody, and their interpretation of the image was turned against them by those who argued that the image assumed a viewer "literate in pop culture." "Clearly, if the readers of the directory possess even a passing familiarity with Lichtenstein's work," argued one student, "they will regard the cover merely as a play on a major cultural icon, and not as a perpetuation of a negative stereotype." Not only did these women lack the cultural resources to recognize a parody, the argument ran, as feminists, they lacked a sense of humor. The controversy generated around the image, in other words, reproduced a hierarchical distinction between those who were apparently culturally literate and could take a joke and those who interpreted the image literally and had a political agenda to promote focused on issues of gender, race, class, and ethnicity. Letters, editorials, cartoons, and an interview with the artist, Joyce Hirohata, of the illustration appeared regularly in the *Daily Bruin* between January 17 and February 19, 1992.

Chapter 4

1. Thomas Crow suggests that Warhol combined two publicity photographs, including one from the film *Niagara*, in Thomas Crow, "Saturday Disasters: Trace and Reference in Early Warhol," *Art in America* 75 (May 1987): 133.

2. "Poor, Dear Little Cleopatra . . . " *Life* 52 (April 13, 1962): 41.

3. See Alice T. McIntyre, "Making the Misfits or Waiting for Monroe or Notes from Olympus," *Esquire* 55 (March 1961): 74; Richard Meryman, "Marilyn Lets Her Hair Down About Being Famous," *Life* 53 (August 3, 1962): 31–4; "Marilyn's New Role," *Time* 77 (February 17, 1961): 39–40;

and David Zeitlin, "Powerful Stars Meet to Play-Act Romance," *Life* 46 (August 15, 1960): 64–71.

4. Photographer Alan Grant unfortunately refused to grant me permission to reproduce this set of images. See Meryman, "Marilyn Lets Her Hair Down," 34.

5. An extremely serious strain of staphylococcus pneumonia almost killed Taylor in March of 1961.

6. "The New Cleopatra Complex," *Vogue* 139 (January 15, 1962): 40.

7. "They Fired Marilyn: Her Dip Lives On," *Life* 52 (June 22, 1962): 87–9.

8. Richard Meryman, "I Refuse to Cure My Public Image," *Life* 57 (December 18, 1964): 74.

9. Ibid., 81–2.

10. Richard Meryman, "A Last Long Talk With a Lonely Girl," *Life* 53 (August 17, 1962): 32–3, 63–71.

11. Clare Boothe Luce, "What Really Killed Marilyn," *Life* 57 (August 7, 1964): 68–72; and "I Love You . . . I Love You," *Newsweek* 60 (August 20, 1962): 30–1.

12. "Marilyn Monroe," *Vogue* 140 (September 1, 1962): 90.

13. Norman Mailer, *Marilyn: A Biography* (New York: Grosset & Dunlap, 1973).

14. Michael Leja, *Reframing Abstract Expressionism: Subjectivity and Painting in the 1940s* (New Haven: Yale University Press, 1993), 265.

15. "The Growing Cult of Marilyn," *Vogue* 140 (September 1, 1962): 190–7.

16. Jean Stein, *Edie: An American Biography* (New York: Knopf, 1982): 192.

17. See David Antin, "Warhol: The Silver Tenement," *Art News* 65 (Summer 1966): 47–8, 58–9; and Roberta Bernstein, "Warhol as Printmaker," in *Andy Warhol Prints: A Catalogue Raisonné*, ed. Frayda Feldman and Jorg Schellmann (New York: Abbeville, 1985), 15–16.

18. Richard Warren Lewis, "Hollywood's New Breed of Soft Young Men," *Saturday Evening Post* 235 (December 1, 1962): 75; and "People are Talking About . . . ," *Vogue* 139 (January 1, 1962): 81.

19. I was able to see the sources for the silk-screens of male movie stars at the Warhol Foundation.

20. J. Krantz, "The Night They Invented Troy Donahue," *McCall's* 89 (September 1962): 130; Lewis, "Hollywood's New Breed," 75; and John Sharnik, "The War of the Generations," *House and Garden* 110 (October 1956): 40.

21. See Krantz, "The Night They Invented Troy Donahue," 130; and "Elvis, A Different Kind of Idol," *Life* 41 (August 27, 1956): 101.

22. My thanks to Ann Bermingham, who suggested to me in conversation that Warhol's images of male stars suggest that heterosexuality is a drag.

23. Harold Rosenberg, "Masculinity," *Vogue* 150 (November 15, 1967): 106, 107, 159.

24. Daniel Boorstin, *The Image: Or, What Happened to the American Dream* (New York: Atheneum, 1962); published in paperback as *The Image: A Guide to Pseudo-Events in America* (New York: Harper, 1964), 61, 65. Warren Sussman analyzes the shift in American culture from an emphasis on character to personality in "'Personality' and the Making of Twentieth-Century Culture," in *Culture as History: The Transformation of American Society in the Twentieth Century* (New York: Pantheon, 1984), 271–85.

25. Warhol himself commented: "I'd been thrilled having Kennedy as president; he was handsome, young, smart – but it didn't bother me that much that he was dead. What bothered me was the way the television and radio were programming everybody to feel so sad" (Andy Warhol and Pat Hackett, *Popism: The Warhol '60s* [New York: Harper and Row, 1980], 60).

26. See Dora Jane Hamblin, "Mrs. Kennedy's Decisions Shaped all The Solemn Pageantry," *Life* 55 (December 6, 1963): 48–9; and "President Kennedy Is Laid to Rest," *Life* 55 (December 6, 1963): 38–47.

27. My thoughts here depend on Laura Mulvey, "Visual Pleasure and Narrative Cinema," *Screen* 16 (Autumn 1975): 6–18.

28. "President Kennedy Is Laid to Rest," 38.

29. Warhol, *Popism*, 22.

30. G. R. Swenson, "What Is Pop Art," *Art News* 62 (November 1963): 25.

31. Warhol, *Popism*, 7.

32. Peter Gidal, *Andy Warhol* (London: Studio Vista, Dutton Pictureback, 1971), 9.

33. Jack Kroll, "Saint Andrew," *Newsweek* 64 (December 7, 1964): 102.

34. Swenson, "What Is Pop Art," 25. This quotation became a refrain in the Warhol literature, repeated in *Newsweek* in 1964 and *Art News* in 1965.

35. Ibid.

36. Gidal, *Andy Warhol*, 9.

37. "Soup's On," *Arts* 39 (May–June 1963): 16–18.

38. Andy Warhol, *The Philosophy of Andy Warhol (From A to B and Back Again)* (New York: Harcourt Brace Jovanovich, 1975), 7.

39. "Modern Living," *Time* 66 (August 27, 1965): 65–6.

40. Warhol, *The Philosophy of Andy Warhol*, 33.

41. Stein, *Edie*, 182, 250.

42. One can infer the possibility of love from *The Philosophy of Andy Warhol*, in which Warhol writes about Edie (she is named Taxi in the book) in a chapter entitled "Love (Prime)."

43. Stein, *Edie*, 247. When he described this same scene in *The Philosophy of Andy Warhol*, Warhol used the compound adjective "fascinated-but-horrified" to account for his reaction. Warhol, *The Philosophy of Andy Warhol*, 36.

44. Other authors who have discussed the relationship between masculinity and Abstract Expressionism include Leja, *Reframing Abstract Expressionism*; and Kenneth E. Silver, "Modes of Disclosure: The Construction of Gay Identity and the Rise of Pop Art," in *Hand-Painted Pop: American Art in Transition 1955–62*, ed. Russell Ferguson (Los Angeles: Museum of Contemporary Art and Rizzoli, 1992), 179–203. Anne Wagner has written sensitively about the difficulty that Lee Krasner faced in defining a self in painting that could not be dismissed as female (Anne Wagner, "Lee Krasner as L.K.," *Representations* 25 [Winter 1989]: 42–57).

45. Recently, much important work has been done on both Warhol's sexual orientation and the way in which his cultural production makes possible the expression of gay desire. See Trevor Fairbrother, "Tomorrow's Man," in *"Success Is a Job in New York . . . ": The Early Art and Business of Andy Warhol* (New York: Grey Art Gallery, New York University, in association with the Carnegie Museum of Art, 1989), 55–73; Richard Meyer, "Warhol's Clones," *Yale Journal of Criticism* 7 (1994): 79–109; and Kenneth Silver, "Modes of Disclosure." My discussion of Warhol's nonself in no way contradicts the usefulness of Warhol's activities for the formation of a gay identity – the topic of many of these articles – because I am discussing here the effect of these activities within the context of mainstream American commercial and artistic culture, whereas in the early 1960s, the gay community still existed as a largely invisible and unacknowledged subculture. The following section on Camp touches again on the perception of gay identity in the mainstream press.

46. Susan Sontag, "Notes on Camp," reprinted in her *Against Interpretation and Other Essays* (New York: Farrar, Straus & Giroux, 1966), 292. John Adkins Richardson generally distinguished Pop from Camp based on Pop's apparent detachment and relation to commercial art (John Adkins Richardson, "Dada, Camp, and the Mode Called Pop," *Journal of Aesthetics* 24 [Summer 1966]: 549–58).

47. Thomas Meehan, "Not Good Taste, Not Bad Taste – It's 'Camp,'" *The New York Times Magazine* (March 21, 1965): 30. George Frazier claimed the word "identif[ies] a quality that resists being categorized merely as either good or bad. It is a quality so outlandish or artificial or inept that it is amusing and possibly even endearing, a quality that's *fun*" (George Frazier, "Call It Camp," *Holiday* 38 [November 1965]: 12, 16–17, 19, 21–3).

48. Meehan, "Not Good Taste," 114.

49. "Soup's On," 16.

50. Vivian Gornick, "It's a Queer Hand Stoking the Campfire," *The Village Voice* 11 (April 7, 1966): 20–1.

51. Sontag, "Notes on Camp," 290. The homophobia in the articles by Sontag and others is more implicit than Gornick's. In William Begert's unpublished essay, "Decamping: Rereading Susan Sontag's 'Notes on Camp,'" he convincingly argues that Sontag simultaneously outs homosexuality and deems it besides the point.

52. Gloria Steinem, "The Ins and Outs of Pop Culture," *Life* 59 (August 20, 1965): 84.

53. Of course, this can be read as another form of homophobia, an effort to enable straight people to identify with Camp without being labeled gay.

54. Rosalind Constable, "Modern Living," *Life* (February 26, 1965): 55–66.

55. Steinem, "The Ins and Outs of Pop Culture," 72–89.

56. "The Story of Pop," *Newsweek* (April 25, 1966): 56.

57. Steinem, "The Ins and Outs of Pop Culture," 75.

58. A sample of such articles includes John Crosby, "U.S.A.: Hotbed of Culture," *Holiday* 22 (July 1957): 95–6, 135–6; R. Philip Hanes, "We're Cultured Too," *Saturday Evening Post* 234 (February 25, 1961): 26–7, 77–80; Russell Lynes, "Proof That We Are Not Barbarians," *The New York Times Magazine* (July 6, 1958): 5, 21–2; C. J. McNaspy, "The Culture Explosion," *America* 104 (December 3, 1960): 340–2; and Alvin Toffler, "A Quantity of Culture," *Fortune* 64 (November 1961): 124–7, 166, 171–4.

59. D. W. Brogan, "The Taste of the Common Man," *Saturday Review* 436 (February 28, 1953): 48.

60. Sidney Tillim, "Art au Go-Go, or the Spirit of '65," *Arts* 39 (September–October 1965): 38.

61. Sherman L. Morrow, "The In Crowd and the Out Crowd," *The New York Times Magazine* (July 18, 1965): 12.

62. Morrow, "The In Crowd and the Out Crowd," 14.

63. "Saint Andrew," *Newsweek* 64 (December 7, 1964): 100–4.

64. "Society: Edie & Andy," *Time* 86 (August 27, 1965): 65–6.

65. Marco Livingstone, "Do It Yourself: Notes On Warhol's Techniques," in *Andy Warhol: A Retrospective*, ed. Kynaston McShine (New York: Museum of Modern Art, 1989), 75. See also David Bourdon, "Andy Warhol and the Society Icon," *Art in America* 63 (January–February 1975): 42–5; and Robert Rosenblum, "Andy Warhol: Court Painter to the 70s," in *Andy Warhol: Portrait of the 70s*, ed. David Whitney (New York: Whitney Museum of American Art, 1970), 18–20.

66. Marco Livingstone writes that "To exaggerate the painterly look, he [Warhol] would sometimes drag his finger quickly over the borders between two color areas while the paint was still wet" (Livingstone, "Do It Yourself," 75).

67. Vincent Fremont, Warhol's personal assistant, recalls that the painting

was a commission by Minnelli, and believes she provided the source photograph. Matt Wrabican of the Archive Study Center at the Warhol Museum was unable to locate the publicity still.

Chapter 5

1. Interestingly, in the one instance when Marisol sculpted a working-class family, in *The Family* of 1962, she did not incorporate any images of her own face. Critics have also referred to this work as *Family from the Dust Bowl* and compared it to images from the 1930s by Ben Shahn and Walker Evans. See, for example, Emily Genauer, "Happy Hunting In a Cornucopia," *New York Herald Tribune*, November 25, 1962, p. 6; and Suzanne Kiplinger, "Art," *The Village Voice*, December 20, 1962, p. 10. A few of her sculptural groupings from this period include anonymous men – a father and husband in *The Family* of 1963, for instance – but they are represented in more or less the same way as the women; with few exceptions, the men do not bear an imprint of Marisol's face. I will not analyze Marisol's men in this chapter because her central focus during this period is clearly on women.
2. Lucy Lippard, *Pop Art* (London: Thames and Hudson, 1966), 69.
3. The other artists that Lippard felt had erroneously been labeled Pop were Jim Dine, George Segal, and artists of the March Gallery Group. Lippard admitted one woman, Marjorie Strider, among the artists that she believed constituted a second wave of Pop art.
4. Curator Dorothy Miller juxtaposed a sculpture by Marisol with the painting and sculpture of various Op and Pop artists in the show *Americans 1963* at the Museum of Modern Art in 1963, and that same year, the Albright-Knox Gallery included a work by her in *Mixed Media and Pop Art*. The exhibition at the Albright-Knox Gallery consisted of three parts: mixed media, Jasper Johns and Robert Rauschenberg, and Pop art. Marisol's sculpture *The Generals* of 1961–2 appeared in the section on Pop art. A few interviewers subsequently asked Marisol whether she thought that her sculpture should be categorized as Pop art. John Gruen quoted her as saying, "I don't wish to belong to any group 'pop' or otherwise" (John Gruen, "Marisol – Top to Bottom," *New York Herald Tribune*, March 8, 1964, p. 30). However, when Marisol was asked in an interview for *Mademoiselle* if she objected to being associated with Pop art, Marisol responded, "No I like it – pop art. My work is considered on the fringes of it. I like that, too, because this way I get included in big shows." "Marisol," *Mademoiselle* 59 (August 1964): 281. Gloria Steinem repeats a somewhat altered version of this exchange in "Marisol: The Face Behind the Mask," *Glamour* 51 (June 1964): 137. Marisol also had some affiliation with Pop artists through her galleries. Initially, Marisol was represented by the Stable Gallery, where she had one-person shows

in 1962 and 1964; Stable, directed by Eleanor Ward, was the first gallery in New York to exhibit in 1962 Warhol's canvases of Campbell's soup cans and Marilyn Monroe. Marisol then joined the Sidney Janis Gallery, where she had one-person shows in 1966 and 1967. The Sidney Janis Gallery, although representing many Abstract Expressionists in the 1950s, took on a few Pop artists in the 1960s and sanctioned the art movement with its 1962 show *New Realists*.

5. Mario Amaya's *Pop Art . . . And After* (New York: Viking, 1965) did not mention Marisol. However, like Lippard and Rublowsky, Amaya pitted the Pop artists against Abstract Expressionism, and argued that they depicted banal objects in a depersonalized manner. Amaya's list of the "principal" Pop artists was a bit longer than Lippard's and Rublowsky's, and included along with the "hard-core" five Jim Dine, Robert Indiana, and George Segal. Other minor differences between the three retrospective texts, of course, did exist. Whereas Lippard considered Marcel Duchamp, Jasper Johns, and various Assemblage artists to provide the precedents of Pop art and Amaya added to this group the names of Robert Rauschenberg and Kurt Schwitters, Rublowsky identified the primary forefathers of Pop as Ferdinand Léger, Stuart Davis, and Gerald Murphy.

6. Barbara Rose, "Pop in Perspective," *Encounter* 25 (August 1965): 59–63; Barbara Rose, "ABC Art," *Art in America* 53 (October 1965): 57–69; Barbara Rose and Irving Sandler, "Sensibility of the Sixties," *Art in America* 55 (January 1967): 44–57; and Irving Sandler, "The New Cool-Art," *Art in America* 53 (February 1965): 96–101. See also Matthew Baigell, "American Abstract Expressionism and Hard Edge: Some Comparisons," *Studio International* 171 (January 1966): 10–15.

7. Sandler, "The New Cool-Art," 96. The textbooks on American art that Rose and Sandler subsequently published in 1967 and 1978, respectively (and which are still assigned today in numerous art history classes), codified the authors' characterization of Pop art as cool and dispassionate. See Barbara Rose, *American Art Since 1900* (New York: Praeger, 1967), 213; and Irving Sandler, *The New York School* (New York: Harper and Row, 1978), 292.

8. On Segal, see Lippard, *Pop Art*, 101–2.

9. Lippard pointed out that William Seitz included Marisol in the 1961 exhibition *Art of Assemblage* at the Museum of Modern Art, an exhibition considered by Lippard to mark a key transition from the work of Jasper Johns and Robert Rauschenberg to Pop art. To justify her claim that 1962 was the year when "New York Pop really arrived," Lippard offered the observation that Wesselmann, Oldenburg, Segal, Marisol, and Warhol all had uptown exhibitions that year (Lippard, *Pop Art*, 82–3).

10. Ibid., 101.

11. Critics aligned her sculpture with the "primitive" or "folk art" by suggesting that it derived from rocking horses and rotogravure illustration, from Mochica portrait jars of the Central Andes, from Mexican masks, from Pre-Columbian sculpture, and from early American art, all artifacts of "tribal" or artisanal communities rather than of industrialized Occidental cultures. A review that referred to both the "primitive" and "childlike" qualities of Marisol's sculpture was Lawrence Campbell, "Marisol's Magic Mixtures," *Art News* 63 (March 1964): 38–41, 64–5. Other references to the "childlike" aspect of her work include No author, "Marisol," *Time* 81 (June 7, 1963): 76–9; "Marisol's Mannequins," *Horizon* 5 (March 1963): 102–4; and Sidney Tillim, "Marisol," *Arts* 38 (April 1964): 28–9.

12. Critics who cited Miller include Edward Barry, "The Art of Marisol: Intriguing Objects Fashioned of Wood," *Chicago Tribune*, December 22, 1965, p. 9; and Grace Glueck, "It's Not Pop, It's Not Op – It's Marisol," *The New York Times Magazine* (March 7, 1965): 34. Thomas B. Hess also referred to Marisol's working methods as "folk" in "The Phony Crisis in American Art," *Art News* 62 (Summer 1963): 28, 59.

13. "The Dollmaker," *Time* 85 (May 25, 1965): 80. In later years, many continued to depend on the labels of folk or primitive to place Marisol's work on the periphery of Pop art. For example, Wayne Anderson, in a brief discussion of Marisol in 1975, contrasted her work to the commercial aspects of Pop: "Unlike hard-core Pop, Marisol approaches contemporary society through human psychology rather than machine technology; she depends on carpentry far more than on commercial techniques" (Wayne Anderson, *American Sculpture in Process: 1930/1970* [Boston: New York Graphic Society, 1975], 189). Even the catalogue for Marisol's first monographic museum exhibition at the Worcester Art Museum in 1971 identified her with the primitive: "Much of her work has its origins in the 'primitive' such as Mexican masks, Pre-Columbian ritual art and early Americana" (Leon Shulman, *Marisol* [Worcester, MA: Worcester Art Museum, 1971], [unpaginated]).

14. Griselda Pollock, book review of *Artemisia Gentileschi: The Image of the Female Hero in Italian Baroque Art* by Mary D. Garrard, *Art Bulletin* 72 (September 1990): 499. See also Griselda Pollock and Rozsika Parker, *Old Mistresses: Women, Art, and Ideology* (New York: Pantheon, 1981), preface and Chap. 1.

15. Lippard, *Pop Art*, 101. As we will see in the next section, a number of critics used the word "chic" to describe Marisol's physical appearance.

16. Such reviews include Lawrence Campbell, "The Creative Eye of the Artist Marisol," *Cosmopolitan* 156 (June 1964): 62–9; Campbell, "Marisol's Magic Mixtures," 38; John Canaday, "Art: 15 Exhibit at Modern,"

The New York Times, May 22, 1963, p. 38; Max Kozloff, "Marisol," *ArtInternational* 6 (September 1962): 35; "Marisol's Mannequins," 102–4; "New York Exhibitions: In the Galleries," *Arts* 37 (September 1963): 33; Vivien Raynor, "Marisol," *Arts* 26 (September 1962): 44–5; and, Tillim, "Marisol," 28–9.

17. Lawrence Campbell, writing for *Art News* in March 1964, remarked: "Her work is brilliant, daring and, above all, witty. Behind all the brilliance there remains the fun that a child once had in delighting her classmates with cut-out figures with cut-out dresses to match" (Campbell, "Marisol's Magic Mixtures," 38).

18. Cindy Nemser, *Art Talk: Conversation With Twelve Women Artists* (New York: Scribner's, 1975), 182.

19. "The Dollmaker," 80.

20. Whitney Chadwick, *Women, Art, and Society* (London: Thames and Hudson, 1990), 306. Marisol herself seems to have felt that the generation of women who preceded her enabled her to acknowledge her identity as a woman artist. She said in her interview with Nemser: "But Elaine de Kooning signed her name E. de Kooning and Grace Hartigan called herself George. Those women paved the way for me" (Nemser, *Art Talk*, 181).

21. Nemser, *Art Talk*, 152.

22. Glueck, "It's Not Pop," 34.

23. Ibid. There is some confusion as to whether this panel occurred in the 1950s or in 1961, and whether it took place at the Artist's Club or at the Museum of Modern Art.

24. Susan Stewart, *On Longing: Narratives of the Miniature, the Gigantic, the Souvenir, the Collection* (Baltimore: Johns Hopkins University Press, 1984), 127. Mary Ann Doane makes reference to Stewart's passage in "Veiling Over Desire: Close-ups of the Woman," in *Feminism and Psychoanalysis*, ed. Richard Feldstein and Judith Root (Ithaca, NY: Cornell University Press, 1989), 109. In his important discussion of nineteenth-century portrait photography, Allan Sekula writes: "Both [physiognomy and phrenology] shared the belief that the surface of the body, and especially the face and head, bore the outward signs of inner character" (Allan Sekula, "The Body and the Archive," *October* 39 [Winter 1986], 11).

25. Steinem, "Marisol," 127. One of the more famous tales about Marisol's silence has her attending a brunch for four hours without uttering a word.

26. Brian O'Doherty, "Marisol: The Enigma of the Self-Image," *The New York Times*, March 1, 1964, p. 23.

27. "Marisol," *Time* 81 (June 7, 1963): 79.

28. Glueck, "It's Not Pop," 35.

29. April Kingsley, "New York Letter," *ArtInternational* 17 (October 1973): 53.

30. Sigmund Freud delivered a paper in 1914 "On Narcissism" in which he postulated a primary narcissism in everyone because "a human being has originally two sexual objects – himself and the woman who nurses him." Puberty, according to Freud, intensifies the primary narcissism in women, and "especially if they grow up with good looks, [women] develop a certain self-contentment which compensates them for the social restrictions that are imposed upon them in their choice of object" (James Strachey, ed., *The Standard Edition of the Complete Psychological Works of Sigmund Freud*, vol. 14 [London: Hogarth Press, 1957], 88–9).

31. "The Dollmaker," 80.

32. Shulman, *Marisol*, [unpaginated].

33. Campbell, "The Creative Eye," 68.

34. Glueck, "It's Not Pop," 34.

35. Rublowsky, *Pop Art*, 30.

36. A number of subsequent writers on Pop art agreed with Rublowsky's assessment. In 1970, Michael Compton, for instance, wrote: "Marisol has also been considered in a Pop context. . . . Her style is purely personal and in no way connected with the public media" (Michael Compton, *Pop Art* [London: Hamlyn, 1970], 131). Lawrence Alloway stated in 1974: "Another artist who has often been assigned a place in Pop art is Marisol, but her art seems to belong elsewhere. She is a sophisticated naïve sculptor whose figures possess a folkloric decoration and fantasy that is quite unlike Pop art. The habitual self-references in her work also suggest an introspection allied to compulsive artists like Lucas Samaras, whose content is drawn from their own personality" (Alloway, *American Pop Art*, 23).

37. Laura Mulvey, "Visual Pleasure and Narrative Cinema," *Screen* 16 (Autumn 1975): 14–15.

38. Enigma and narcissism as conceptual practices that invoke a male gaze do not preclude the possibility of lesbian pleasure in looking at Marisol's sculpture. A lesbian reading of Marisol's sculpture – especially those groupings with women walking arm in arm and touching one another – would be another fruitful avenue of research. I do not pursue such a reading here because my focus is on the place of her sculpture in Pop-art criticism and in discourses about women and consumption.

39. "The Fashion Independent: Marisol," *Harper's Bazaar* 97 (October 1963): 198–201.

40. "The Fashion Independent: Inside East Europe," *Harper's Bazaar* 97 (August 1963): 82.

41. "The Fashion Independent" for August 1963 was Mrs. Horace Sutton, a

twenty-eight-year-old mother of two, wife of a travel writer, and formerly a ballet dancer. September 1963 featured Michele Entratter, a nineteen-year-old student of fine arts and daughter of Jack Entratter, president of the Sands Hotel in Las Vegas.

42. Likewise, for an article in *Cosmopolitan*, Marisol posed in "her work clothes" and in a ballroom gown being fitted by a fashion designer (Campbell, "The Creative Eye," 66, 69).

43. Mary Ann Doane, *The Desire to Desire: The Woman's Film of the 1940s* (Bloomington: Indiana University Press, 1987), 32.

44. "Women Artists in Ascendance," *Life* 42 (May 13, 1957): 77.

45. Eleanor Munro, "The Found Generation," *Art News* 60 (November 1961): 39.

46. Campbell, "The Creative Eye," 62.

47. See, for example, "She Likes Parties," *New York Herald Tribune*, April 19, 1966, p. 21.

48. I am indebted here to Erica Anne Carter's insightful analysis of the fashionable woman in Germany during the 1950s. She argues: "Female fashion consumption . . . transgressed the public/private boundaries that limited housewifely consumption to home and family. . . . Fashionable dressing was regularly figured as a singularly *public* mode of feminine activity: one divorced, then, from the domestic realm. . . . More than this: fashion consumption as a site of women's pleasure was depicted as opposed, indeed as threatening to a housewifely consumerism organized around the rational management of consumer desire" (Erica Anne Carter, "How German Is She? National Reconstruction and the Consuming Woman in the Federal Republic of Germany and West Berlin 1945–1960," Ph.D. diss., University of Birmingham, 1991, 241–2). My thanks to Lisa Tiersten for bringing this dissertation to my attention.

49. The ascription of femininity also worked against the women Abstract Expressionists. As we saw in Chapter 3, once women artists began to assume a position of dominance in Abstract Expressionism during the late 1950s, critics expressed concern that the art movement had lost its vitality and had become instead passive and formulaic. The women artists seemed well aware of the incompatibility between "artist" and "woman" and adopted various strategies to deny their female gender and the taint of femininity in their art. Marisol, choosing to capitalize on her gender and femininity, received more recognition in the press at the time than did the women Abstract Expressionists, but ultimately found herself marginalized by her femininity in the critical reception of Pop art.

50. "Looks Men Like At Home," *Vogue* 148 (November 15, 1966): 124–31.

51. "Spring Ball Gowns," *Vogue* 117 (March 1, 1951): 156–9.

52. Elaine Tyler May, "Explosive Issues: Sex, Women, and the Bomb," in *Recasting America*, ed. Lary May (Chicago: University of Chicago Press, 1989), 165–6.
53. I have derived this formulation from Slavoj Zizek, "Looking Awry," *October* 50 (Fall 1989): 31–55.
54. Mulvey, "Visual Pleasure," 368.
55. Doane, *The Desire to Desire*, 12–13.
56. "Editorial Statement," *Art in America* 51 (April 1963): 32. The "everyday objects" designed by artists that had previously appeared in *Art in America* included stamps, coins, and playing cards.
57. "Art for Everyday Living," *Art in America* 51 (October 1963): 97.
58. T. James, "Marisol Escobar," *Women's Wear Daily*, February 25, 1964, p. 10.
59. Marisol is discussed briefly in several of the encyclopedic surveys of women artists published in the 1970s: Elsa Honig Fine, *Women and Art: A History of Women Painters and Sculptors from the Renaissance to the 20th Century* (Montclair, NJ: Allanheld and Schram, 1978), 144, 219–21; Eleanor Munro, *Originals: American Women Artists* (New York: Simon and Schuster, 1979), 41; and Hugo Munsterberg, *A History of Women Artists* (New York: Potter, 1975), 97–101. However, no member of the feminist movement in the 1970s produced a substantial book or article on Marisol. Marisol herself was not active in the women's art movement of the 1970s.
60. For a more detailed description of feminist art and criticism during the 1970s, see Thalia Gouma-Peterson and Patricia Mathews, "The Feminist Critique of Art History," *The Art Bulletin* 69 (September 1987): 326–57.
61. Nemser, *Art Talk*, 184. Ironically, only Nemser, who took the position that feminists ought to celebrate great women artists rather than artistic expressions of female experience, suggested that Marisol's practice might have had any relevance to feminist concerns about female identity. In her interview with Marisol, she proposed: "It seems to me that, even then, you were a precursor of the women's movement in that you were looking for an identity – trying to explore different aspects of woman's identity." Marisol responded, "Every time I would take a cast of my face it came out different. You have a million faces." Marisol's answer, however, refused the assumption implicit in Nemser's question that her sculpture reflected various facets of woman's identity or that together they defined an essential and coherent experience of womanhood (Nemser, *Art Talk*, 181). For a discussion of Nemser's feminist position in the 1970s see Gouma-Peterson and Mathews, "The Feminist Critique," 327; as well as Carol Duncan, "When Greatness Is a Box of Wheaties," *Artforum* 14 (October 1975): 60–4.

62. Roberta Bernstein, "Marisol's Self-Portraits: The Dream and the Dreamer," *Arts* 59 (March 1985): 86–7. See also Chadwick, *Women, Art, and Society*, 310–11; and Joan Semmel and April Kinglsey, "Sexual Imagery in Women's Art," *Woman's Art Journal* 1 (Spring–Summer 1980): 2.

63. These popular publications include Laura Bergquist, "A New Look at the American Woman," *Look* 20 (October 16, 1956): 35–40; Eric John Dingwall, *The American Woman: An Historical Study* (New York: Signet, 1958); and Betty Friedan, *The Feminine Mystique* (New York: Norton, 1963). Several magazines devoted special issues to the American Woman, including "The American Female," *Harper's* 225 (October 1962); and "The Woman in America," *Daedalus* 93 (Spring 1964). "The Suburban Wife" was the subject of a feature article of *Time* 75 (June 20, 1960) and her image appeared on the cover. Barbara Ehrenreich has examined the history of advice literature addressed to women by "experts." She suggests that literature addressed to the problem of domestic discontent among American homemakers began in the early sixties; however, I have found abundant literature on this topic published in the 1950s as well. Her book was brought to my attention by Allan Sekula (Barbara Ehrenreich, *For Her Own Good: 150 Years of the Experts' Advice to Women* [Garden City, NY: Anchor Press/Doubleday, 1978]).

64. Ernest Havemann, "Amid Profound Change, Personal Crisis," *Life* 51 (September 8, 1961): 101.

65. Diana Trilling, "The Case For . . . The American Woman," *Look* 23 (March 3, 1959): 54.

66. "Americana," *Time* 75 (June 20, 1960): 14–18.

67. I derive the concept of suture from Kaja Silverman, *The Subject of Semiotics* (New York: Oxford University Press, 1983), chap. 5.

68. I am indebted to James Guimond who brought this advertisement to my attention in a talk, "'This Is Your Life' – An Analysis of *Life*'s 1947 'American Women's Dilemma' and *Look*'s 1956 'A New Look at the American Woman,'" delivered at the American Studies Association annual convention in New Orleans in November 1990.

69. Mary Ann Doane, "Film and the Masquerade: Theorising the Female Spectator," *Screen* 23 (September–October 1982): 81–2. A number of feminists have adopted the term "masquerade" from psychoanalyst Joan Riviere, who formulated the concept in 1929 to describe the case of an intellectual woman who adopted the pose of womanliness to allay the threat she posed to men (Joan Riviere, "Womanliness as a Masquerade," *The International Journal of Psychoanalysis* 10 [1929]: 303–13). In 1977, Luce Irigaray perpetuated Riviere's negative cast to the term by defining "masquerade" as "a role, an image, a value, imposed upon women by male systems of representation." According to Irigaray, women, by accepting the masquerade, acknowledge and submit to

man's desire, "but at the price of renouncing their own. In the masquerade, they submit to the dominant economy of desire" (Irigaray, *This Sex Which Is Not One*, trans. Catherine Porter and Carolyn Burke [Ithaca, NY: Cornell University Press, 1985]: 84, 133). Doane, in her article from 1982, attempts to recuperate "masquerade" as a useful tactic for feminism. Later, Doane developed greater reservations about the "masquerade"; Mary Ann Doane, "Masquerade Reconsidered: Further Thoughts on the Female Spectator," *Discourse* 11 (Fall/Winter 1988–9): 42–54.

70. My analysis of the relationship of Marisol's sculpture and concepts of artistic authorship has benefited from recent criticism about Cindy Sherman. For instance, Douglas Crimp has written: "[Sherman] is created in the image of already-known feminine stereotypes; her self is therefore understood as contingent upon the possibilities provided by the culture in which Sherman participates, not by some inner impulse. As such, her photographs reverse the terms of art and autobiography. They use art not to reveal the artist's true self, but to show the self as an imaginary construct. There is no real Cindy Sherman in these photographs; there are only the guises she assumes" (Douglas Crimp, "The Photographic Activity of Postmodernism," *October* 15 [Winter 1980]: 99).

71. Irigaray, *This Sex Which Is Not One*, 76.

72. Actually, the cast read as an icon (it looks like a hand) highlights the indexicality, and thus the rhetoricity, of the brushstroke, much as I earlier argued that the casts of Marisol's breasts read as indexes (they bear the impress of the artist's chest) highlighted the iconicity of the photograph of the brooch. This interplay of icon and index only reinforces the idea that the artist's hand is but a rhetorical construction, a masquerade.

Cited Sources

Abramson, J. A. "Tom Wesselmann and the Gates of Horn." *Arts* 40 (May 1966): 43–8.

"Ads You'll Never See." *Business Week* (September 21, 1957): 30–1.

"Advertiser Turns Tables on Pop Art." *Advertising Age* 35 (May 18, 1964): 3.

Allen, James Sloan. *The Romance of Commerce and Culture: Capitalism, Modernism, and the Chicago-Aspen Crusade for Cultural Reform.* Chicago: University of Chicago Press, 1983.

Allen, Oliver E. *New York, New York: A History of the World's Most Exhilarating and Challenging City.* New York: Atheneum/Macmillan, 1990.

Amaya, Mario. *Pop Art . . . And After.* New York: Viking, 1965.

America and the Intellectuals: A Symposium. Partisan Review Series #4. New York: Partisan Review, 1953.

"Americana." *Time* 75 (June 20, 1960): 14–18.

Andersen, R. Clifton, and Philip R. Cateora. *Marketing Insights: Selected Readings.* New York: Appleton, Century, Crofts, 1963.

Anderson, Wayne. *American Sculpture in Process: 1930/1970.* Boston: New York Graphic Society, 1975.

Antin, David. "Warhol: The Silver Tenement." *Art News* 65 (Summer 1966): 47–8, 58–9.

"Un Appartement Pop." *L'Oeil* 106 (October 1963): 12–19.

Armstrong, Nancy. *Desire and Domestic Fiction: A Political History of the Novel.* New York: Oxford University Press, 1987.

"Art for Everyday Living." *Art in America* 51 (October 1963): 97.

Ashton, Dore. "High Tide for Assemblage." *Studio* 165 (January 1963): 25–6.

"At Home With Henry." *Time* 83 (February 21, 1964): 68–71.

Atwan, Robert, Donald McQuade, and John W. Wright. *Edsels, Luckies, & Frigidaires: Advertising the American Way.* New York: Dell, 1979.

Cited Sources

Baigell, Matthew. "American Abstract Expressionism and Hard Edge: Some Comparisons." *Studio International* 171 (January 1966): 10–15.

Barr, Alfred. *Matisse: His Art and His Public*. New York: Museum of Modern Art, 1951.

Barry, Edward. "The Art of Marisol: Intriguing Objects Fashioned of Wood," *Chicago Tribune*, December 22, 1965, p. 9.

Baum, L. Frank. *The Art of Decorating Dry Goods Windows and Interiors*. Chicago: Show Window Publishing, 1900.

"Beautiful, Budgetwise Three-Room Apartment." *Good Housekeeping* 157 (November 1963): 122–9.

"Behind the Glass." *Time* 52 (December 27, 1948): 37.

"Bellevue, Washington." *House and Garden* 107 (March 1955): 116.

Benson, Susan Porter. "Palace of Consumption and Machine for Selling: The American Department Store, 1880–1940." *Radical History Review* 21 (Fall 1979): 199–221.

———. *Counter Cultures: Saleswomen, Managers, and Customers in American Department Stores, 1890–1940*. Chicago: University of Illinois Press, 1986.

Bergquist, Laura. "A New Look at the American Woman." *Look* 20 (October 16, 1956): 35–40.

Berkson, William. "Roy Lichtenstein." *Arts* 40 (January 1966): 54.

Bernard, Frank J. *Dynamic Display: Technique and Practice*. Cincinnati: Display Publishing, 1952.

Bernstein, Roberta. "Marisol's Self-Portraits: The Dream and the Dreamer." *Arts* 59 (March 1985): 86–7.

Bettelheim, Bruno. *The Informed Heart: Autonomy in a Mass Age*. Glencoe, IL: The Free Press, 1960.

A Bibliography of Theory and Research Techniques in the Field of Human Motivation. New York: Advertising Research Foundation, 1956.

Birmingham Feminist History Group. "Feminism as Femininity in the Nineteen-Fifties?" *Feminist Review* 3 (1979): 48–65.

Boime, Albert. "Roy Lichtenstein and the Comic Strip." *Art Journal* 28 (Winter 1968): 155–9.

Boorstin, Daniel. *The Image: Or, What Happened to the American Dream*. New York: Atheneum, 1962.

Bourdieu, Pierre. *Distinction: A Social Critique of the Judgement of Taste*. Cambridge: Harvard University Press, 1984.

Bourdon, David. "Andy Warhol and the Society Icon." *Art in America* 63 (January–February 1975): 42–5.

Bowlby, Rachel. *Just Looking: Consumer Culture in Dreiser, Gissing and Zola*. New York: Methuen, 1985.

Bramson, Leon. *The Political Context of Sociology*. Princeton: Princeton University Press, 1961.

Cited Sources

Brandt, Mary. *Good Housekeeping Book of Home Decoration*. New York: McGraw-Hill, 1957.

Breines, Wini. *Young, White and Miserable*. Boston: Beacon Press, 1992.

Bremner, Robert H., and Gard W. Reichard. *Reshaping America: Society and Institutions 1945–1960*. Columbus: Ohio State University Press, 1982.

Brenton, Myron. *The American Male*. Greenwich, CT: Fawcett, 1966.

Brink, Edward L., and William T. Kelley. *The Management Promotion: Consumer Behavior and Demand Stimulation*. Englewood Cliffs, NJ: Prentice Hall, 1963.

Britt, Steuart Henderson. *The Spenders*. New York: McGraw-Hill, 1960.

Brod, Harry, ed. *The Making of Masculinities*. Boston: Allen and Unwin, 1987.

Brogan, D. W. "The Taste of the Common Man." *Saturday Review* 436 (February 28, 1953): 10–11, 46, 48.

Bronner, Simon J., ed. *Consuming Vision: Accumulation and Display of Goods in America, 1880–1920*. New York: Norton, 1989.

Brooks, John. "The Little Ad That Isn't There: A Look at Subliminal Advertising." *Consumer Reports* 23 (January 1958): 7–10.

Bryson, Norman. *Looking at the Overlooked*. Cambridge: Harvard University Press, 1990.

Burck, Gilbert. "What Makes Women Buy." *Fortune* 54 (August 1956): 92–4.

Burket, Harriet. *House and Garden's Complete Guide to Interior Decoration*. New York: Simon and Schuster, 1960.

Campbell, Lawrence. "Roy Lichtenstein." *Art News* 62 (November 1963): 12–13.

———. "Marisol's Magic Mixtures." *Art News* 63 (March 1964): 38–41, 64–5.

———. "The Creative Eye of the Artist Marisol." *Cosmopolitan* 156 (June 1964): 62–9.

Canaday, John. "Art: 15 Exhibit at Modern." *The New York Times*, May 22, 1963, p. 38.

———. "Pop Art Sells On and On – Why?" *The New York Times Magazine*, May 31, 1964, p. 7, 48–53.

Carter, Erica Anne. "How German is She? National Reconstruction and the Consuming Woman in the Federal Republic of Germany and West Berlin 1945–1960." Ph.D. diss., University of Birmingham, 1991.

Cawelti, John. "The Concept of Formula in the Study of Popular Literature." *Journal of Popular Culture* 3 (Winter 1969): 381–90.

Chadwick, Whitney. *Women, Art, and Society*. London: Thames and Hudson, 1990.

Cheskin, Louis. *How to Predict What People Will Buy*. New York: Liveright, 1957.

Chord, Jack T. *The Window Display Manual: A Complete Window Display Course Including Fundamentals and Technique*. Cincinnati: Display Publishing, 1931.

Cited Sources

Clark, Clifford E., Jr. *The American Family Home, 1800–1960*. Chapel Hill: University of North Carolina Press, 1986.

Clark, T. J. *The Painting of Modern Life: Paris in the Art of Manet and His Followers*. New York: Knopf, 1985.

"Clean and Handsome Example of the West's Familiar 'Ranch House.'" *Sunset* 110 (April 1953): 74–5.

Collins, Bradford. "Clement Greenberg and the Search for Abstract Expressionism's Successor: A Study in the Manipulation of Avant-Garde Consciousness." *Arts* 61 (May 1987): 36–43.

Constable, Rosalind. "Modern Living." *Life* 58 (February 26, 1965): 55–64.

Constable, W. G. *Art Collecting in the United States of America*. London: Thomas Nelson, 1964.

Coplans, John. "An Interview with Roy Lichtenstein." *Artforum* (October 1963): 31.

Corlett, Mary Lee. "Jackson Pollock: American Culture, the Media and the Myth." *Rutgers Art Review* 8 (1987): 71–106.

Cowan, Ruth Schwartz. "The 'Industrial Revolution' in the Home: Household Technology and Social Change in the 20th Century." *Technology and Culture* 17 (January 1976): 1–23.

———. "Two Washes in the Morning and a Bridge Party at Night: The American Housewife Between the Wars." *Women's Studies* 3 (1976): 147–72.

———. *More Work For Mother*. New York: Basic Books, 1983.

Cox, Annette. *Art-As-Politics: The Abstract Expressionist Avant-Garde and Society*. Ann Arbor: UMI Research Press, 1982.

Crehan, Hubert. "Barnett Newman." *Art News* 58 (April 1959): 12.

Crimp, Douglas. "The Photographic Activity of Postmodernism." *October* 15 (Winter 1980): 91–100.

Crosby, John. "U.S.A.: Hotbed of Culture." *Holiday* 22 (July 1957): 95–6, 135–6.

Crow, Thomas. "Saturday Disasters: Trace and Reference in Early Warhol." *Art in America* 75 (May 1987): 129–36.

Culver, Stuart. "What Manikins Want: The Wonderful Wizard of Oz and The Art of Decorating Dry Goods Windows." *Representations* 21 (Winter 1988): 97–116.

Cundiff, E. W., and R. R. Still. *Basic Marketing: Concepts, Environment and Decisions*. Englewood Cliffs, NJ: Prentice Hall, 1964.

Cunningham, Bill. "The Most Ravishing Show in New York Is FREE." *Chicago Tribune*, July 19, 1965, p. 4.

Curti, Merle. "The Changing Concept of 'Human Nature' in the Literature of American Advertising." *Business History Review* 41 (Winter 1967): 335–57.

Cited Sources

De Lauretis, Theresa. *Alice Doesn't: Feminism, Semiotics, Cinema.* Bloomington: Indiana University Press, 1984.

de Riencourt, Amaury. "Will Success Spoil American Women?" *The New York Times Magazine*, November 10, 1957, pp. 32, 98–101.

Dexter, Leon A. *People, Society, and Mass Communications.* Glencoe, IL: The Free Press, 1964.

Dichter, Ernest. "These are the Real Reasons Why People Buy Goods." *Advertising and Selling* 41 (July 1948): 33–4.

———. "A Psychological View of Advertising Effectiveness." *Journal of Marketing* 14 (July 1949): 61–6.

———. *The Strategy of Desire.* New York: Doubleday, 1960.

———. *Handbook of Consumer Motivations.* New York: McGraw-Hill, 1964.

Dingwall, Eric John. *The American Woman: An Historical Study.* New York: New American Library, 1958.

Directory of Organizations Which Conduct Motivation Research. New York: Advertising Research Foundation, 1954.

Directory of Social Scientists Interested in Motivation Research. New York: Advertising Research Foundation, 1954.

"Discredited Merchandise." *Newsweek* 64 (November 9, 1964): 94–6.

Doane, Mary Ann. "Film and the Masquerade: Theorising the Female Spectator." *Screen* 23 (September–October 1982): 74–88.

———. *Desire to Desire: The Woman's Film of the 1940s.* Bloomington: Indiana University Press, 1987.

———. "Masquerade Reconsidered: Further Thoughts on the Female Spectator." *Discourse* 11 (Fall/Winter 1988–9): 42–54.

Dobriner, William M. *Class in Suburbia.* Englewood Cliffs, NJ: Prentice Hall, 1963.

Dobriner, William M., ed. *The Suburban Community.* New York: Putnam's, 1958.

"The Dollmaker." *Time* 85 (May 25, 1965): 80.

Drexler, Arthur, and Greta Daniel. *Introduction to Twentieth Century Design from the Collection of The Museum of Modern Art New York.* Garden City, NY: Doubleday, 1959.

Duncan, Carol. "When Greatness Is a Box of Wheaties." *Artforum* 14 (October 1975): 60–4.

"Eastward Ho." *Life* 32 (March 17, 1952): 131–5.

Edgar, Natalie. "Tom Wesselmann." *Art News* 56 (December 1961): 56.

Ehrenreich, Barbara. *Hearts of Men: American Dreams and the Flight from Commitment.* Garden City, NY: Anchor Books, 1983.

Ehrenreich, Barbara, and Deirdre English. *For Her Own Good: 150 Years of the Experts' Advice to Women.* Garden City, NY: Anchor Press/Doubleday, 1978.

Cited Sources

Eisenberg, Howard, and Arlene Eisenberg. "The World's Largest Audience." *Cosmopolitan* 153 (December 1962): 72–8.

"Elvis, A Different Kind of Idol." *Life* 41 (August 27, 1956): 101–49.

Ewen, Stuart. *Captains of Consciousness: Advertising and the Social Roots of the Consumer Culture*. New York: McGraw-Hill, 1976.

"The Fashion Independent: Inside East Europe." *Harper's Bazaar* 97 (August 1963): 82.

"The Fashion Independent: Marisol." *Harper's Bazaar* 97 (October 1963): 198–201.

Federal Writers' Project. *The WPA Guide to New York City*. New York: Pantheon, 1935.

Feininger, Andreas. *New York in the Forties*. New York: Dover, 1978.

Feldman, Frayda, and Jorg Schellmann, eds. *Andy Warhol Prints: A Catalogue Raisonné*. New York: Abbeville, 1985.

Feldstein, Richard, and Judith Root, eds. *Feminism and Psychoanalysis*. Ithaca, NY: Cornell University Press, 1989.

Ferber, Robert, and Hugh G. Wales. *Motivation and Marketing Behavior*. Homewood, IL: Richard D. Irwin, 1958.

Ferguson, Russell, ed. *Hand-Painted Pop: American Art in Transition 1955–62*. Los Angeles: Museum of Contemporary Art and Rizzoli, 1992.

Ferry, John. *The History of the Department Store*. New York: Macmillan, 1960.

Fine, Elsa Honig. *Women and Art: A History of Women Painters and Sculptors from the Renaissance to the 20th Century*. Montclair, NJ: Allanheld and Schram, 1978.

Forty, Adrian. *Objects of Desire*. New York: Pantheon, 1986.

Foster, Hal, ed. *The Anti-Aesthetic: Essays on Postmodern Culture*. Port Townsend, WA: Bay Press, 1983.

Frank, Lawrence K. "How Much Do We Know About Men?" *Look* 19 (May 17, 1955): 52, 54–60.

Frazier, George. "Call It Camp." *Holiday* 38 (November 1965): 12, 16–17, 19, 21–3.

Friedan, Betty. *The Feminine Mystique*. New York: Norton, 1963.

Friedman, B. H. "Jackson Pollock." *Art in America* 43 (December 1955): 49, 58–9.

"From the Rancho, a Contemporary Style." *Life* 40 (January 16, 1956): 58–9.

Gaba, Lester. *The Art of Window Display*. New York: Studio Publications and T. Y. Crowell, 1952.

Gablik, Suzi. "Tom Wesselmann." *Art News* 64 (March 1965): 17.

Gardner, Burleigh B., and Sidney J. Levy. "The Product and the Brand." *Harvard Business Review* 33 (March–April 1955): 33–9.

Genauer, Emily. "Happy Hunting In a Cornucopia." *New York Herald Tribune*, November 25, 1962, sec. 4, p. 6.

Cited Sources

————. "Can This Be Art?" *Ladies Home Journal* 81 (March 1964): 151–5.

Gidal, Peter. *Andy Warhol*. London: Studio Vista, Dutton Pictureback, 1971.

Gilbert, James. *A Cycle of Outrage: America's Reaction to the Juvenile Delinquent in the 1950s*. New York: Oxford University Press, 1986.

Glueck, Grace. "It's Not Pop, It's Not Op – It's Marisol." *The New York Times Magazine* (March 7, 1965): 34–5, 45–50.

Goldman, Judith. *Windows at Tiffany's: The Art of Gene Moore*. New York: Abrams, 1980.

Goodman, Ralph. "Freud and the Hucksters." *The Nation* 176 (February 14, 1953): 143–5.

Goodnough, Robert. "How Pollock Paints a Picture." *Art News* 50 (May 1951): 38–41, 60–1.

Goossen, E. C. "Helen Frankenthaler." *ArtInternational* 5 (October 1961): 78.

Gornick, Vivian. "It's a Queer Hand Stoking the Campfire." *The Village Voice*, April 7, 1966, pp. 1, 20–1.

Gottlieb, Elaine. "Helen Frankenthaler." *Arts* 32 (January 1958): 55.

Gouma-Peterson, Thalia, and Patricia Mathews. "The Feminist Critique of Art History." *The Art Bulletin* 69 (September 1987): 326–57.

Graham, Lee. "Who's in Charge Here? – Not Women!" *The New York Times Magazine* (September 2, 1962): 8, 38–9.

Greenberg, Clement. "Avant-Garde and Kitsch." *Partisan Review* 6 (Fall 1939): 34–49.

————. "The Plight of our Culture: Industrialism and Class Mobility." *Commentary* 15 (June 1953): 558–66.

————. "The Plight of our Culture, Part II: Work and Leisure Under Industrialism." *Commentary* 16 (July 1953): 54–62.

————. *Barnett Newman*. New York: French, 1959.

————. "Louis and Noland." *ArtInternational* 4 (May–June 1960): 26–9.

————. "Modernist Painting." *Arts Yearbook* 4 (1961): 103–8.

————. "After Abstract Expressionism." *ArtInternational* 6 (October 1962): 24–32.

————. "Three New American Painters." *Canadian Art* 20 (May/June 1963): 172–5.

Grossack, Martin M., ed. *Understanding Consumer Behavior*. Boston: Christopher, 1966.

"The Growing Cult of Marilyn." *Vogue* 140 (September 1, 1962): 190–7.

Gruen, John. "Marisol – Top to Bottom." *New York Herald Tribune*, March 8, 1964, p. 30.

Hague, John A., ed. *American Character and Culture in a Changing World*. Westport, CT: Greenwood Press, 1979.

Halsey, Elizabeth. *Ladies Home Journal Book of Interior Decoration*. Philadelphia: Curtis, 1954.

Cited Sources

Hamblin, Dora Jane. "Mrs. Kennedy's Decisions Shaped All the Solemn Pageantry." *Life* 55 (December 6, 1963): 48–9.

Hamilton, George Heard. "The Collector as a Guide to Taste." *Art News* 57 (April 1958): 41–3.

Hanes, R. Philip. "We're Cultured Too." *Saturday Evening Post* 234 (February 25, 1961): 26–7, 77–80.

Haralvich, Mary Beth. "Sitcoms and Suburbs: Positioning the 1950s Homemaker." *Quarterly Review of Film &Video* 11 (1989): 61–83.

Hardy, Kay. *Room by Room: A Guide to Wise Buying.* New York: Funk and Wagnall, 1959.

Harrington, Michael. *The Other America: Poverty in the United States.* Baltimore: Penguin, 1963.

Harrison, Jane. "Tom Wesselmann." *Arts* 38 (April 1964): 32–3.

Hatje, Gerd, and Ursula Hatje. *Design for Modern Living: A Practical Guide to Home Furnishing and Interior Decoration.* New York: Abrams, 1962.

Havemann, Ernest. "Amid Profound Change Personal Crisis." *Life* 51 (September 8, 1961): 100–19.

Hefner, Hugh. "The Playboy Philosophy." *Playboy* 10 (February 1963): 43–8.

Heller, Ben. "The Roots of Abstract Expressionism." *Art in America* 49 (1961): 40–9.

Hendrickson, Robert. *The Grand Emporiums: An Illustrated History of America's Great Department Stores.* New York: Stein and Day, 1979.

Henry, Harry. *Motivation Research: Its Practices and Uses for Advertising, Marketing and Other Business Purposes.* New York: Ungar, 1958.

Hepburn, Andrew. *Complete Guide to New York City.* New York: Doubleday, 1964.

Hepner, Harry. *Modern Advertising Practices and Principles.* New York: McGraw-Hill, 1956.

Herbert, James D. *The Political Origins of Abstract-Expressionist Art Criticism: The Early Theoretical and Critical Writings of Clement Greenberg and Harold Rosenberg.* Stanford: Stanford Honors Essay in Humanities, 1985.

Herron, Patrick. "A Kind of Cultural Imperialism." *Studio International* 175 (February 1968): 62–4.

Hess, Thomas B. "New Realists." *Art News* 61 (December 1962): 12–13.

———. "The Phony Crisis in American Art." *Art News* 62 (Summer 1963): 28, 59.

Hoffman, Betty H. "Masculinity: What Is It?" *Ladies Home Journal* 80 (Winter 1963): 96, 123–4.

Horowitz, Leonard. "Art," *The Village Voice*, February 20, 1964, p. 8.

Howe, Irving. "Mass Society and Post-Modern Fiction." *Partisan Review* 26 (1959): 420–36.

Hunt, Morton M. "What Is a Husband? What Is a Wife?" *Good Housekeeping* 151 (November 1960): 59, 122–8.

Cited Sources

Hurst, A. E. *Displaying Merchandise for Profit*. New York: Prentice Hall, 1939.

Hutcheon, Linda. *A Theory of Parody: The Teachings of Twentieth-Century Art Forms*. New York: Methuen, 1985.

Huyssen, Andreas. *After the Great Divide: Modernism, Mass Culture, Postmodernism*. Bloomington: Indiana University Press, 1986.

"I Love You . . . I Love You." *Newsweek* 60 (August 20, 1962): 30–1.

"Introducing Our House of Ideas." *House and Garden* 100 (July 1951): 31–63.

Irigaray, Luce. *This Sex Which Is Not One*. Trans. by Catherine Porter and Carolyn Burke. Ithaca, NY: Cornell University Press, 1985.

"Is There a New Academy?" *Art News* 58 (Summer and September 1959): 34–7, 58–9, and 36–9, 58–60.

Jacobs, Norma, ed. *Culture for the Millions?: Mass Media in Modern Society*. Princeton: Van Nostrand, 1959.

James, T. "Marisol Escobar." *Women's Wear Daily*, February 25, 1964, p. 10.

Jeffords, Susan. *The Remasculinization of America*. Bloomington: Indiana University Press, 1989.

Johnson, Ellen. "The Living Object." *ArtInternational* 7 (January 1963): 42–4.

———. "The Image Duplicators – Lichtenstein, Rauschenberg and Warhol." *Canadian Art* 23 (1966): 13–18.

Johnston, Jill. "Claes Oldenburg." *Art News* 61 (November 1962): 13.

———. "Tom Wesselmann." *Art News* 61 (November 1962): 15.

———. "The Artist in a Coca-Cola World." *The Village Voice*, January 31, 1963, p. 7, 24.

———. "Tom Wesselmann." *Art News* 63 (April 1964): 13.

Judd, Donald. "Helen Frankenthaler." *Arts* 34 (March 1960): 55.

———. "Helen Frankenthaler." *Arts* 36 (January 1962): 38–9.

———. "Helen Frankenthaler." *Arts* 37 (April 1963): 54.

———. "Complaints." *Studio International* 177 (April 1969): 182–8.

Kaprow, Allan. "The Legacy of Jackson Pollock." *Art News* 57 (October 1958): 24–6, 55–7.

Kaufmann, Edgar. *What Is Modern Interior Design?* New York: Museum of Modern Art, 1953.

Kiesler, Frederick. *Contemporary Art Applied to the Store and Its Display*. New York: Brentano's, 1930.

Kingsley, April. "New York Letter." *ArtInternational* 17 (October 1973): 53.

Kiplinger, Suzanne. "Art." *The Village Voice*, December 20, 1962, pp. 10, 32.

Kirkpatrick, Charles A. *Advertising: Mass Communication in Marketing*. Boston: Houghton Mifflin, 1959.

Kornfeld, Albert. "A Bill of Rights for Freedom of Taste." *House and Garden* 103 (February 1953): 45.

Cited Sources

——. *The Doubleday Book of Interior Decorating.* New York: Doubleday, 1965.

Kozloff, Max. "'Pop Culture,' Metaphysical Disgust, and the New Vulgarians." *ArtInternational* 7 (March 1962): 34–6.

——. "Marisol." *ArtInternational* 6 (September 1962): 35.

——. "Art." *The Nation* 197 (November 2, 1963): 284–7.

Kramer, Hilton. "Art." *The Nation* 195 (November 17, 1962): 334–5.

Krantz, J. "The Night They Invented Troy Donahue." *McCall's* 89 (September 1962): 130–42.

Kretschmer, Robert. *Window and Interior Display: Principles of Visual Merchandising.* Scranton: Laurel, 1952.

Kroll, Jack. "Situations and Environments." *Art News* 60 (September 1961): 16.

——. "Saint Andrew." *Newsweek* 64 (December 7, 1964): 100.

Landis, Judson T., and Mary G. Landis. "The U.S. Male." *Collier's* 130 (July 19, 1952): 22–3, 48.

Laredo, Victor. *New York City: A Photographic History.* New York: Dover, 1973.

Lawrence, Sidney. "Clean Machines at the Modern." *Art in America* 72 (February 1984): 127–41, 166–8.

Leach, William. "Transformations in a Culture of Consumption: Women and Department Stores, 1890–1925." *Journal of American History* 71 (September 1984): 319–42.

——. *Land of Desire: Merchants, Power and the Rise of a New American Culture.* New York: Pantheon, 1993.

Lee, Tom. "Gene Moore." *Graphis* 16 (November–December 1960): 528–33.

Leja, Michael. *Reframing Abstract Expressionism: Subjectivity and Painting in the 1940s.* New Haven: Yale University Press, 1993.

Leonard, George B. "The American Male: Why Is He Afraid to be Different?" *Look* 22 (February 18, 1958): 95–104.

Lerner, Max. *America as a Civilization.* New York: Simon and Schuster, 1957.

Lewis, Richard Warren. "Hollywood's New Breed of Soft Young Men." *Saturday Evening Post* (December 1, 1962): 74–5.

Leydenfrost, Robert J., ed. *Window Display.* New York: Architectural Publishing, 1950.

Lindzey, Gardner, ed. *Assessment of Human Motives.* New York: Grove Press, 1958.

Lippard, Lucy. *Pop Art.* London: Thames and Hudson, 1966.

"Looks Men Like At Home." *Vogue* 148 (November 15, 1966): 124–31.

Loran, Erle. *Cézanne's Composition.* Berkeley: University of California Press, 1943.

——."Pop Artists or Copy Cats?" *Art News* 62 (September 1963): 48–9, 61.

Luce, Clare Boothe. "What Really Killed Marilyn." *Life* 57 (August 7, 1964): 68–78.

Cited Sources

Lucie-Smith, Edward. "An Interview with Clement Greenberg." *Studio International* 175 (January 1968): 4–5.

Lupton, Ellen, and J. Abbott Miller. *The Bathroom, the Kitchen and the Aesthetics of Waste: A Process of Elimination.* Cambridge: MIT List Visual Arts Center, 1992.

Lynes, Russell. "High-brow, Low-brow, Middle-brow." *Life* 26 (April 11, 1949): 99–102.

———. *The Tastemakers.* New York: Harper, 1949.

———. "Proof That We Are Not Barbarians." *The New York Times Magazine* (July 6, 1958): 5, 21–2.

Mailer, Norman. *Marilyn: A Biography.* New York: Grosset & Dunlap, 1973.

Management Bulletin: The Package, Key Component of Marketing Strategy. New York: American Management Association, 1964.

Marchand, Roland. *Advertising the American Dream: Making Way for Modernity, 1920–1940.* Berkeley: University of California Press, 1983.

Marcus, Leonard S. *The American Store Window.* New York: Whitney Library of Design, Watson-Guptill, 1978.

"Marilyn Monroe." *Vogue* 140 (September 1, 1962): 190–7.

"Marilyn's New Role." *Time* 77 (February 17, 1961): 39–40.

"Marisol." *Time* 81 (June 7, 1963): 76–9.

"Marisol." *Mademoiselle* 59 (August 1964): 281.

"Marisol's Mannequins." *Horizon* 5 (March 1963): 102–4.

Martineau, Pierre. "New Look at Old Symbols." *Printer's Ink* 247 (June 4, 1954): 32–3, 85, 88–9.

———. *Motivation in Advertising: Motives that Make People Buy.* New York: McGraw-Hill, 1957.

Mattelart, Armand, and Seth Siegelaub, eds. *Communication and Class Struggle.* New York: International General, 1979.

Matthews, Glenna. *"Just a Housewife": The Rise and Fall of Domesticity in America.* New York: Oxford University Press, 1987.

Mauger, Emily M. *Modern Display Techniques.* New York: Fairchild, 1954.

May, Elaine Tyler. *Homeward Bound: American Families in the Cold War Era.* New York: Basic Books, 1988.

May, Lary. *Recasting America.* Chicago: University of Chicago Press, 1989.

McDarrah, Fred W. *New York, N.Y.* New York: Corinth Books, 1964.

McIntyre, Alice T. "Making the Misfits or Waiting for Monroe or Notes from Olympus." *Esquire* 55 (March 1961): 74–81.

McMahon, Michael. "An American Courtship: Psychologists and Advertising Theory in the Progressive Era." *American Studies* 13 (Fall 1972): 5–18.

McMullen, Roy. "First Step to Being Yourself." *House Beautiful* 95 (February 1953): 88.

McNaspy, C. J. "The Culture Explosion." *America* 104 (December 3, 1960): 340–2.

Cited Sources

McShine, Kynaston, ed. *Andy Warhol: A Retrospective*. New York: Museum of Modern Art, 1989.

Mead, Margaret. *Male and Female*. New York: Morrow, 1949.

———. "American Man in a Woman's World." *The New York Times Magazine* (February 10, 1957): 11, 20–3.

Meehan, Thomas. "Not Good Taste, Not Bad Taste – It's 'Camp.'" *The New York Times Magazine* (March 21, 1965): 30, 113–4.

Meikle, Jeffrey. *Twentieth Century Limited: Industrial Design in America, 1925–1939*. Philadelphia: Temple University Press, 1979.

Melosh, Barbara. *Engendering Culture: Manhood and Womanhood in New Deal Public Art and Theater*. Washington, DC: Smithsonian Institution Press 1991.

Merriam, Eve. "The Matriarchal Myth." *The Nation* 187 (November 8, 1958): 332–5.

Meryman, Richard. "Marilyn Lets Her Hair Down About Being Famous." *Life* 53 (August 3, 1962): 31–8.

———. "A Last Long Talk With a Lonely Girl." *Life* 53 (August 17, 1962): 32–3, 63–71.

———. "I Refuse to Cure My Public Image." *Life* 57 (December 18, 1964): 74–85.

Meyer, Richard. "Warhol's Clones." *Yale Journal of Criticism* 7 (1994): 79–109.

Michaels, Walter Benn. *The Gold Standard and the Logic of Naturalism*. Berkeley: University of California Press, 1987.

"Modern Living." *Time* 66 (August 27, 1965): 65–6.

"Modern Living: A Playboy's Pad." *Playboy* 10 (May 1964): 71–6.

Modleski, Tania. *The Women Who Knew Too Much*. New York: Methuen, 1988.

Morphet, Richard. *Roy Lichtenstein*. London: The Tate Gallery, 1968.

Morrow, Sherman L. "The In Crowd and the Out Crowd." *The New York Times Magazine* (July 18, 1965): 12–19.

Moskin, J. Robert. "Why Do Women Dominate Him?" *Look* 22 (February 4, 1958): 77–80.

Muggeridge, Malcolm. "Bedding Down in the Colonies." *Esquire* 58 (July 1962): 84–6, 115.

Mulvey, Laura. "Visual Pleasure and Narrative Cinema." *Screen* 16 (Autumn 1975): 6–18.

———. "On *Duel in the Sun*: Afterthoughts on 'Visual Pleasure and Narrative Cinema.'" *Framework* 6 (1981): 12–15.

Munro, Eleanor. "The Found Generation." *Art News* 60 (November 1961): 39.

———. *Originals: American Women Artists*. New York: Simon and Schuster, 1979.

Cited Sources

Munsterberg, Hugo. *A History of Women Artists*. New York: Potter, 1975.

Nemser, Cindy. *Art Talk: Conversation With Twelve Women Artists*. New York: Scribner's, 1975.

"New American Domesticated Male." *Life* 36 (January 4, 1954): 42–5.

"The New Cleopatra Complex." *Vogue* 139 (January 15, 1962): 40–1.

"The New Interior Decorators." *Art In America* 53 (June 1965): 52–61.

Newman, Barnett. "Letter." *Art News* 58 (June 1959): 6.

Newman, Joseph W. "Looking Around: Consumer Motivation Research." *Harvard Business Review* 33 (January–February 1955): 135–44.

New York: A Guide to the Empire State. New York: Oxford University Press, 1940.

New York City Guide and Almanac 1957–58. New York: New York University Press, 1957.

"New York Exhibitions: In the Galleries." *Arts* 37 (September 1963): 33.

Obst, Frances Melanie. *Art and Design in Home Living*. New York: Macmillan, 1963.

O'Doherty, Brian. "Art: 'Pop' Show by Tom Wesselmann Is Revisited." *The New York Times*, November 28, 1962, p. 36.

———. "Lichtenstein: Doubtful But Definite Triumph of the Banal." *The New York Times,* October 27, 1963, p. 21.

———. "Marisol: The Enigma of the Self-Image." *The New York Times*, March 1, 1964, p. 23.

———. *Inside the White Cube*. Santa Monica: Lapis Press, 1986.

Ogilvy, David. *Confessions of an Advertising Man*. New York: Atheneum, 1964.

O'Hara, Frank. *Jackson Pollock*. New York: Braziller, 1959.

———. *Helen Frankenthaler*. New York: The Jewish Museum, 1960.

Oldenburg, Claes, and Emmett Williams. *Store Days*. New York: Something Else Press, 1967.

"Oregon Ranch House." *Sunset* 113 (September 1954): 56–7.

Orton, Fred, and Griselda Pollock. "Avant-Gardes and Partisans Reviewed." *Art History* 4 (September 1981): 305–27.

Packard, Vance. *The Hidden Persuaders*. New York: David McKay, 1957.

———. *The Status Seekers: An Exploration of Class Behavior in America and the Hidden Barriers that Affect You, Your Community, Your Future*. New York: David McKay, 1959.

Pahlmann, William. *The Pahlmann Book of Interior Design*. New York: Viking, 1955.

Pells, Richard H. *The Liberal Mind in a Conservative Age: American Intellectuals in the 1940s & 1950s*. New York: Harper and Row, 1985.

"People are Talking About . . . " *Vogue* 139 (January 1, 1962): 81.

Peterson, Theodore. *Magazines in the Twentieth Century*. Urbana: University of Illinois Press, 1964.

Cited Sources

Phillips, Charles F., and Delbert J. Duncan. *Marketing: Principles and Methods*. Homewood, IL: Richard D. Irwin, 1960.

"The Playboy Mansion." *Playboy* 13 (1966): 116.

"Playboy Pad." *Playboy* 12 (October 1965): 97.

"Playboy Pad: Palm Springs Oasis." *Playboy* 13 (April 1966): 119.

"Playboy Pad: Texas Retreat." *Playboy* 13 (October 1966): 105.

Playboy's Party Jokes. Chicago: Playboy Press, 1963.

"Playboy's Weekend Hideaway." *Playboy* 6 (April 1959): 53–4.

Pollock, Griselda, and Rozsika Parker. *Old Mistresses: Women, Art, and Ideology*. New York: Pantheon, 1981.

"Poor, Dear Little Cleopatra . . . " *Life* 52 (April 13, 1962): 32–41.

"Pop Art: Cult of the Commonplace." *Time* 81 (May 3, 1963): 69–72.

Potter, David M. *People of Plenty: Economic Abundance and the American Character*. Chicago: University of Chicago Press, 1954.

"President Kennedy Is Laid to Rest." *Life* 55 (December 6, 1963): 38–47.

"Ranch Houses Suit Any Climate." *House Beautiful* 89 (January 1947): 60–9.

"Ranch House with One Open Wall." *Sunset* 113 (September 1954): 83.

Raynor, Vivien. "Marisol." *Arts* 26 (September 1962): 44–5.

———. "Tom Wesselmann." *Arts* 37 (January 1963): 45.

Reise, Barbara. "Greenberg and the Group: A Retrospective View." *Studio International* 175 (May and June 1968): 254–57, 314–16.

Renoir, Jean. *Renoir, My Father*. London: Collins, 1962.

Restany, Pierre. "The New Realism." *Art in America* 51 (February 1963): 102–4.

Richardson, John Adkins. "Dada, Camp, and the Mode Called Pop." *Journal of Aesthetics* 24 (Summer 1966): 549–58.

Riesman, David. *The Lonely Crowd*. New Haven: Yale University Press, 1950.

———. *Abundance for What?* Garden City, NY: Doubleday, 1964.

Rigby, Douglas, and Elizabeth Rigby. *Lock, Stock and Barrel: The Story of Collecting*. Philadelphia: Lippincott, 1944.

Riviere, Joan. "Womanliness as a Masquerade." *The International Journal of Psychoanalysis* 10 (1929): 303–13.

Roche, Joanna R. "The Rhetoric of Exhibition: Regarding Rothko." M.A. thesis, University of California, Los Angeles, 1991.

Rogers, Lewis A. *The Art of Decorating Show Windows and Displaying Merchandise*. Chicago: Merchants Record, 1924.

Rose, Alvin W. "Motivation Research and Subliminal Advertising." *Social Research* 25 (Autumn 1958): 271–84.

Rose, Barbara. "Dada Then and Now." *ArtInternational* 7 (January 1963): 23–8.

———. "Filthy Pictures: Some Chapters in the History of Taste." *Artforum* 3 (May 1965): 20–5.

———. "Pop in Perspective." *Encounter* 25 (August 1965): 59–63.

———. "ABC Art." *Art in America* 53 (October 1965): 57–69.

Cited Sources

———. *American Art Since 1900*. New York: Praeger, 1967.

———. "The Value of Didactic Art." *Artforum* 5 (April 1967): 32–6.

———. "The Politics of Art." *Artforum* 6 (February 1968): 31–2.

———. *Claes Oldenburg*. New York: Museum of Modern Art, 1970.

Rose, Barbara, and Irving Sandler. "Sensibility of the Sixties." *Art in America* 55 (January 1967): 44–57.

Rosenberg, Bernard, and David Manning White, eds. *Mass Culture: The Popular Arts in America*. Glencoe, IL: The Free Press, 1957.

Rosenberg, Harold. "The American Action Painters." *Art News* 51 (December 1952): 22–3, 48–50.

———. "Masculinity." *Vogue* 150 (November 15, 1967): 106, 107, 159.

Rosenblum, Robert. "The Abstract Sublime." *Art News* 59 (February 1961): 38–41.

———. "Roy Lichtenstein and the Realist Revolt." *Metro* 8 (January–March 1963): 38–45.

Ross, Andrew. *No Respect: Intellectuals and Popular Culture*. New York: Routledge, 1989.

Rubin, William. "The New York School – Then and Now." *ArtInternational* 2 (March–April, May–June 1958): 23–6, 19–22.

———. "Younger American Painters." *ArtInternational* 4 (January–February 1960): 25–30.

Rublowsky, John. *Pop Art*. New York: Basic Books, 1965.

Rudikoff, Sonya. "New York Letter." *ArtInternational* 6 (November 1962): 62.

———. "New Realists in New York." *ArtInternational* 7 (January 1963): 39–40.

Saarinen, Aline B. *Proud Possessors*. New York: Random House, 1958.

———. "Explosion of Pop Art: A New Kind of Fine Art Imposing Poetic Order on the Mass-Produced World." *Vogue* 141 (April 1963): 86–8, 134, 136, 142.

———. "Window On Fifth Avenue." *Show* 5 (April 1965): 16–21.

"Saint Andrew." *Newsweek* 64 (December 7, 1964): 100–4.

Saisselin, Rémy. *The Bourgeois and the Bibelot*. New Brunswick, NJ: Rutgers University Press, 1984).

Sandler, Irving. "In the Art Galleries." *The New York Post*, November 18, 1962, p. 12.

———. "Helen Frankenthaler." *Art News* 62 (March 1963): 11.

———. "The New Cool Art." *Art in America* 53 (February 1965): 96–101.

———. *The New York School*. New York: Harper and Row, 1978.

Scheinfeld, Amran. "The American Male." *Cosmopolitan* 142 (May 1957): 22–5.

Schlesinger, Arthur, Jr. "The Crisis of American Masculinity." *Esquire* 50 (November 1958): 63–5.

Cited Sources

Schoener, Allon, ed. *Portal to America: The Lower East Side 1870–1925*. New York: Holt, Rinehart and Winston, 1967.

Schuyler, James. "Helen Frankenthaler." *Art News* 59 (May 1960): 13.

Seckler, Dorothy Gees. "Folklore of the Banal." *Art in America* 50 (Winter 1962): 56–61.

Seeley, John R. *Creshwood Heights: A Study of the Culture of Suburban Life*. New York: Basic Books, 1956.

Seelye, Anne. "Helen Frankenthaler." *Art News* 59 (March 1960): 39, 57, 58.

Seiberling, Dorothy. "Baffling U.S. Art: What It Is About." *Life* 47 (November 9, 1959): 68–80.

———. "Is He the Worst Artist in the U.S.?" *Life* 56 (January 31, 1964): 79–83.

Sekula, Allan. "The Body and the Archive." *October* 39 (Winter 1986): 3–64.

Semmel, Joan, and April Kinglsey. "Sexual Imagery in Women's Art." *Woman's Art Journal* 1 (Spring–Summer 1980): 1–6.

Sharnik, John. "The War of the Generations." *House and Garden* 110 (October 1956): 40.

"She Likes Parties." *New York Herald Tribune*, April 19, 1966, p. 21.

Shiff, Richard. "Mastercopy." *IRIS: Revue de théorie et du son* 1 (1983): 113–27.

Shulman, Leon. *Marisol*. Worcester, MA: Worcester Art Museum, 1971.

Silverman, Kaja. *The Subject of Semiotics*. New York: Oxford University Press, 1983.

———. *The Acoustic Mirror: The Female Voice in Psychoanalysis and Cinema*. Bloomington: Indiana University Press, 1988.

Smith, Barbara Herrnstein. "Contingencies of Value." *Critical Inquiry* 10 (September 1983): 1–35.

Smith, George H. *Motivation Research in Advertising and Marketing*. New York: McGraw-Hill, 1954.

Smith, Terry. *Making the Modern: Industry, Art, and Design in America*. Chicago: University of Chicago Press, 1993.

"Society: Edie & Andy." *Time* 86 (August 27, 1965): 65–6.

Solomon, Alan R. "The New American Art." *ArtInternational* 8 (March 1964): 54.

Sontag, Susan. *Against Interpretation and Other Essays*. New York: Farrar, Straus & Giroux, 1966.

"Soup's On." *Arts* 39 (May–June 1963): 16–18.

Spectorsky, A. C. *The Exurbanites*. Philadelphia: Lippincott, 1955.

Spigel, Lynn. "Installing the Television Set: Popular Discourses on Television and Domestic Space, 1948–1955." *Camera Obscura* 16 (January 1988): 11–46.

"Spring Ball Gowns." *Vogue* 117 (March 1, 1951): 156–9.

Stealingworth, Slim. *Tom Wesselmann*. New York: Abbeville, 1980.

Stein, Jean. *Edie: An American Biography*. New York: Knopf, 1982.

Cited Sources

Stein, Sally A. "The Graphic Ordering of Desire: Modernization of a Middle-Class Women's Magazine 1914–1939." *Heresies* 5 (1985): 7–16.

———. "The Rhetoric of the Colorful and the Colorless: American Photography and Material Culture between the Wars." Ph.D. dissertation, Yale University, 1991.

Steinem, Gloria. "Marisol: The Face Behind the Mask." *Glamour* 51 (June 1964): 92–7, 127–9, 137.

———. "The Ins and Outs of Pop Culture." *Life* 59 (August 20, 1965): 72–89.

Steiner, Wendy. *Pictures of Romance: Form Against Context in Painting and Literature*. Chicago: University of Chicago Press, 1988.

Stewart, Susan. *On Longing: Narratives of the Miniature, the Gigantic, the Souvenir, the Collection*. Baltimore: Johns Hopkins University Press, 1984.

Stich, Sidra. *Made in U.S.A.* Berkeley: University of California Press, 1987.

"The Story of Pop." *Newsweek* (April 25, 1966): 56.

"Story of the Western Ranch House." *Sunset* 121 (September 1958): 74.

Strasser, Susan. *Never Done: A History of American Housework*. New York: Pantheon, 1982.

Strecker, Edward A. *Their Mothers' Sons*. Philadelphia: Lippincott, 1946.

———. "What's Wrong with American Mothers." *Saturday Evening Post* 219 (October 26, 1946): 14–15, 85–96, 99, 102, 104.

Stryker, Perrin. "Motivation Research." *Fortune* 53 (June 1956): 144–232.

"Success is a Job in New York . . . ": The Early Art and Business of Andy Warhol. New York: Grey Art Gallery, New York University, in association with the Carnegie Museum of Art, 1989.

Sussman, Warren. *Culture as History: The Transformation of American Society in the Twentieth Century*. New York: Pantheon, 1984.

Sverbeyeff, Elizabeth. "Life with Pop." *The New York Times Magazine* (May 2, 1965): 98–9.

Swenson, G. R. "What is Pop Art." *Art News* 62 (November 1963): 24–7.

———. "Wesselmann: The Honest Nude." *Art and Artists* 1 (May 1966): 54–7.

Taft, William Nelson. *Handbook of Window Display*. New York: McGraw-Hill, 1926.

Talmey, Allene. "Art is the Core." *Vogue* 144 (July 1964): 116–23, 125.

"They Fired Marilyn: Her Dip Lives On." *Life* 52 (June 22, 1962): 87–92.

"This Oregon Ranch House Lives as Well as It Looks." *House and Garden* 95 (March 1949): 104–11.

Tillim, Sidney. "Helen Frankenthaler." *Arts* 33 (May 1959): 56.

———. "Month in Review." *Arts* 36 (February 1962): 36–8.

———. "Marisol." *Arts* 38 (April 1964): 28–9.

———. "Art au Go-Go, or the Spirit of '65." *Arts* 39 (September–October 1965): 38–40.

———. "Further Observations on the Pop Phenomenon." *Artforum* 4 (November 1965): 17–19.

Cited Sources

Toffler, Alvin. "A Quantity of Culture." *Fortune* 64 (November 1961): 124–7, 166, 171–4.

Tomkins, Calvin. "Art or Not, It's Food for Thought." *Life* 57 (November 20, 1964): 143–4.

Tompkins, Jane. "West of Everything." *South Atlantic Quarterly* 86 (Fall 1987): 357–77.

"Total Environment That Fosters a New Pattern of Living." *House and Garden* 119 (January 1961): 64–75.

Tracy, Charles. *The Art of Decorating Show Windows and Interiors.* Chicago: Merchants Record, 1906–9.

Trilling, Diana. "The Case for . . . The American Woman." *Look* 23 (March 3, 1959): 50–4.

Truitt, James McC. "Art: Arid D.C. Harbours Touted New Painters." *The Washington Post,* December 21, 1961, p. 20.

Tyler, Parker. "Helen Frankenthaler." *Art News* 56 (January 1958): 20.

United States Bureau of Labor Statistics. *How American Buying Habits Change.* Washington, DC: United States Department of Labor, 1958.

Vardac, A. Nicholas. *Stage to Screen: Theatrical Method from Garrick to Griffith.* Cambridge: Harvard University Press, 1949.

Wagner, Anne. "Lee Krasner as L.K." *Representations* 25 (Winter 1989): 42–57.

Wallis, Brian, ed. *Art After Modernism: Rethinking Representation.* New York: New Museum of Contemporary Art.

Wanamaker, John. *Golden Book of the Wanamaker Stores: Jubilee Year 1861–1911.* Philadelphia: John Wanamaker, 1911.

Warhol, Andy. *The Philosophy of Andy Warhol (From A to B and Back Again).* New York: Harcourt Brace Jovanovich, 1975.

Warhol, Andy, and Pat Hackett. *Popism: The Warhol '60s.* New York: Harper and Row, 1980.

Warner, Marina. "Tom Wesselmann: Art into Media, Media Into Art." *Isis* 1522 (November 2, 1966): 16–18.

Warren, Virginia Lee. "Display Director's Windows are Works of Art." *The New York Times,* February 27, 1965, p. 14.

Weiss, Edward H. "Why Do Consumers Really Buy Your Products?" *Advertising Age* 23 (November 24, 1952): 48–9.

White, Norval. *New York: A Physical History.* New York: Atheneum, 1987.

Whitney, David, ed. *Andy Warhol: Portrait of the 70s.* New York: Whitney Museum of American Art, 1970.

Whyte, William H., Jr. *The Organization Man.* New York: Simon and Schuster, 1956.

Wilcox, Lee. "Meet Gene Moore." *House Beautiful* 102 (December 1960): 127, 170.

Wilhelm, Ross. "Are 'Subliminal' Commercials Bad?" *Michigan Business Review* 10 (January 1958): 26–9.

Cited Sources

Wolff, Janet. *What Makes Women Buy*. New York: McGraw-Hill and Basic Books, 1958.

"Women Artists in Ascendance." *Life* 42 (May 13, 1957): 74–7.

Wood, Robert C. *Suburbia: Its People and Their Politics*. Boston: Houghton Mifflin, 1958.

Wulfeck, Joseph W., and Edward M. Bennett. *Advertising Foundation Publication: The Language of Dynamic Psychology as Related to Motivation Research*. New York: McGraw-Hill, 1954.

Wylie, Philip. *A Generation of Vipers*. New York: Rinehart, 1942.

"You Bought It, Now Live with It." *Life* 59 (July 16, 1965): 58–61.

"You Think This is a Supermarket?" *Life* 57 (November 20, 1964): 138–40.

Zeitlin, David. "Powerful Stars Meet to Play-Act Romance." *Life* 49 (August 15, 1960): 64–71.

Zizek, Slavoj. "Looking Awry." *October* 50 (Fall 1989): 31–55.

Index

Index

Index

domestic interior, manuals 52, 57–8, 69–71, 78, 84–7, 94

economy of domesticity, the 52, 53, 84
Cold War, and the 54–5
issues of class, and 53–6
in Pop art 52, 53, 56–7, 60, 81

Fortune 32, 40, 42, 60
Frankenthaler, Helen 134–5, 210

gaze, the
of the female consumer 72–3, 77, 81, 187, 204, 213, 217, 220
of the male voyeur 72–3, 76–81, 83, 203–4, 213, 217
Gill, James
Marilyn 155, *157*
Glueck, Grace 197, 198, 201
Gornick, Vivian 178–9
Greenberg, Clement 61, 62, 117, 132–3, 135, 136, 173

Harper's Bazaar 205–10, 220
Hartigan, Grace 196, 208
Heller, Ben 95, 98
highbrow, the 63–4, 65, 72, 82, 98, 139, 181–2, 183

House and Garden 44, 46, 70, 84, 97
House Beautiful 15, 18, 21
Huyssen, Andreas 2, 3, 120

Irigaray, Luce 228, 230

Johnson, Ellen 24, 26, 118–9, 180
Johnston, Jill 27, 29

Kennedy, John F. 164–6
Kiesler, Frederick 16–8
kitchen design 1, 57, 69, 72, 92, 141–2
Kitchen Debate, the (Nixon and Krushchev) 54–6
Kozloff, Max 3, 4, 7, 122–3
Kraushar, Mr. and Mrs. 50, 83–4, 87, 88, 90–1, 96, 98, 182

Ladies Home Journal 84, 97
Lichenstein, Roy 5, 90, 91, 189, 192, 233
comic book sources,
gender roles in 104–10
image vs. text in 111–5
naturalism in 116–7
paintings by,
criticized as copies 120–2
defended by formalist criteria 118–20, 135–6, 140
foreground gender roles 104–10

Index

Index

compared to folk art 194
compared to Jackson Pollock 202
compared to Pop art 189–91, 193–5
compared to Post-Painterly Abstraction 229
art criticism on art by, in the 1970s and 1980s 221–2
artist,
 as bohemian 210
 as fashion model 205–6, 210
nude in art by, the 218–20
persona of,
 as feminine 196–7, 204, 211, 220, 221
 as narcissistic 200–4
 as unknowable 196, 197–200, 203
self-portraiture by 188, 200, 228
use of masquerade by 226–7, 230
use of mimicry by 228–9, 230
use of parody by 187–8, 194–5, 227
works,
 Americans 206
 The Party 225–8, *227*
 Women and Dog 187–8, 228–9
Marlowe, Derek
 A Slight Misfit 157, 158
masculinity, crisis of 130–2, 162
Mass Culture: The Popular Arts in America 61–2

middlebrow, the 61, 63–4, 65, 72, 82, 98, 139, 181
Monroe, Marilyn 148–54
Moore, Gene 10, 14–5, 18–9, 21
Motivation Research 34, 39, 42
 advocates of 32, 34–5, 36, 37
 critics of 36, 37–8, 44

Nemser, Cindy 196, 221
New York Times Magazine 138–40, 197–8, 200
Newman, Barnett 133–4, 135, 136, 192
 Vir Heroicus Sublimus 133
Newsweek 134, 153, 180, 183

Oldenburg, Claes 98, 189
 Green Gallery exhibition of art by 8
 representation vs. real in art by 28
 works,
 Bedroom Ensemble 78, *79*, 88
 The Store 8, 22–9

Packard, Vance 37–8
Playboy 79, 91–5
Pollock, Jackson 94, 124–7, 128–9, 137, 170, 177, 202, 212
 Number 1, 1948 124
 Pop art, aesthetic of
 defined in the press 179, 180

Index

Index

Index